www.wadsworth.com

www.wadsworth.com is the World Wide Web site
for Thomson Wadsworth and is your direct
source to dozens of online resources.

At *www.wadsworth.com* you can find out about
supplements, demonstration software, and stu-
dent resources. You can also send email to many
of our authors and preview new publications
and exciting new technologies.

www.wadsworth.com
Changing the way the world learns®

From the Wadsworth Series in Broadcast and Production

ALBARRAN
- *Management of Electronic Media,* Second Edition

ALTEN
- *Audio in Media,* Seventh Edition
- *Audio in Media: The Recording Studio*

CRAFT/LEIGH/GODFREY
- *Electronic Media*

EASTMAN/FERGUSON
- *Broadcast/Cable/Web Programming: Strategies and Practices,* Sixth Edition

GROSS/WARD
- *Digital Moviemaking,* Fifth Edition

HAUSMAN/BENOIT/MESSERE/O'DONNELL
- *Announcing: Broadcast Communicating Today,* Fifth Edition
- *Modern Radio Production,* Sixth Edition

HILLIARD
- *Writing for Television, Radio, and New Media,* Eighth Edition

HILMES
- *Connections: A Broadcast History Reader*
- *Only Connect: A Cultural History of Broadcasting in the United States*

MAMER
- *Film Production Technique: Creating the Accomplished Image,* Third Edition

MEESKE
- *Copywriting for the Electronic Media: A Practical Guide,* Fourth Edition

STEPHENS
- *Broadcast News,* Fourth Edition

VIERA/VIERA
- *Lighting for Film and Digital Cinematography,* Second Edition

ZETTL
- *Sight Sound Motion: Applied Media Aesthetics,* Fourth Edition
- *Television Production Handbook,* Eighth Edition
- *Television Production Workbook,* Eighth Edition
- *Video Basics,* Fourth Edition
- *Zettl's VideoLab 3.0*

SECOND EDITION
LIGHTING
FOR FILM AND DIGITAL CINEMATOGRAPHY

DAVE VIERA
LATE OF CALIFORNIA STATE UNIVERSITY, LONG BEACH

MARIA VIERA
CALIFORNIA STATE UNIVERSITY, LONG BEACH

WITH THE COLLABORATION OF PATRICK VAN OSTA

THOMSON
WADSWORTH

Australia • Canada • Mexico • Singapore • Spain • United Kingdom • United States

THOMSON
WADSWORTH

Publisher: *Holly J. Allen*
Assistant Editor: *Shona Burke*
Editorial Assistant: *Laryssa Polika*
Senior Technology Project Manager: *Jeanette Wiseman*
Senior Marketing Manager: *Kimberly Russell*
Marketing Assistant: *Andrew Keay*
Advertising Project Manager: *Shemika Britt*
Project Manager, Editorial Production: *Mary Noel*
Art Director: *Robert Hugel*
Print/Media Buyer: *Judy Inouye*
Permissions Editor: *Kiely Sexton*

Production Service: *Thompson Steele, Inc.*
Text Designer: *Lisa Henry*
Photo Researcher: *Sarah Evertson/Image Quest*
Copy Editor: *Thompson Steele, Inc.*
Illustration: *Thompson Steele, Inc.*
Cover Designer: *Irene Morris*
Cover Image: *Arrangements made by Edward Noeltner.*
 Cries and Whispers, © 1973 AB Svensk
 Filmindustri/still photographer Bo-Erik Gyberg
Compositor: *Thompson Steele, Inc.*
Printer: *Banta Book Group/Menasha*

For more information about our products, contact us at:
Thomson Learning Academic Resource Center
1-800-423-0563

For permission to use material from this text or product, submit a request online at
http://www.thomsonrights.com.
Any additional questions about permissions can be submitted by email to
thomsonrights@thomson.com.

Library of Congress Control Number: 2004101229

ISBN 0-534-26498-0

Thomson Wadsworth
10 Davis Drive
Belmont, CA 94002-3098
USA

Asia
Thomson Learning
5 Shenton Way #01-01
UIC Building
Singapore 068808

Australia/New Zealand
Thomson Learning
102 Dodds Street
Southbank, Victoria 3006
Australia

Canada
Nelson
1120 Birchmount Road
Toronto, Ontario M1K 5G4
Canada

Europe/Middle East/Africa
Thomson Learning
High Holborn House
50/51 Bedford Row
London WC1R 4LR
United Kingdom

Latin America
Thomson Learning
Seneca, 53
Colonia Polanco
11560 Mexico D.F.
Mexico

Spain/Portugal
Paraninfo
Calle Magallanes, 25
28015 Madrid, Spain

This second edition of Lighting *was written, rewritten, and amended by my friend Dave Viera, who died early in 2003. There were only a few bits and pieces left undone, which his wife, Maria, finished. Dave was an exceptional filmmaker—one more interested in the images than the narrative, more interested in the light and the way that one could convey emotion and sensory perception and movement by the grace of light. He and I spent many late afternoons walking the golf courses of Southern California—looking at the sky in the setting sun, the moon rising over the trees, and the colors that Southern California's smog added to the diorama—all infinitely more important than our always forgotten and yet not-to-be forgotten golf game.*

Dave understood film, and he taught film and its methods to many students who now carry with them his knowledge and love of the visual image. He loved making sensory and abstract films (as most of his own films were) by using chiaroscuro, back lighting, shadow, natural light, overexposure, darkness, and the many filters and film stocks—of which he had infinite knowledge—to show on film or video the way he saw the world, its weather, and nature.

During his career he attended the London School of Film and then went on to teach. Because he was bored and wanted "to have some fun," he then earned a law degree from the University of Southern California. He later taught at several universities, where he helped develop film programs in which film making was hands-on rather than lecture and text.

His friends and students respected his knowledge and enjoyed his Zen Buddhist ways, whether he was playing golf or basketball with them, or bouncing from one multiplex theater to another—sneaking early out of one film and late into another—because once he had seen a cinematographer's images and use of light, he had seen everything he needed to see.

It was fun just watching Dave enjoy the changing weather.

—Rafael Zepeda

BRIEF CONTENTS

CONTENTS

PART III 99

LIGHTING APPLICATIONS

APPROACHES TO LIGHTING STYLE 101 CHAPTER SEVEN

LIGHTING INTERIORS 119 CHAPTER EIGHT

PART IV 155

DIGITAL CINEMATOGRAPHY

PREFACE

Cinematographers are responsible for creating interesting film and video images, but they must have the support and collaboration of directors to sustain images of great aesthetic value. This is why we often speak of director/cinematographer teams—Ingmar Bergman/Sven Nykvist, D. W. Griffith/Billy Bitzer, Sergei Eisenstein/Eduard Tisse, Orson Welles/Gregg Toland, Francis Coppola/Vittorio Storaro, and Woody Allen/Gordon Willis. The contents of this book derive from the wonderful images these and other cinematographers have put on the screen.

Lighting is an art that requires awareness of the visual properties of images, technical knowledge about how to achieve visual effects, and the ability to respond to unforeseen and unforeseeable production factors. One way to advance aesthetic awareness and technique is to analyze the work of other cinematographers. This book thus concentrates on improving your ability to "read" the screen. It provides the vocabulary and set of principles and concepts, including a lighting system—key, fill, rim, background, and facial and subject/background ratios—to serve as analytical tools. The conceptual approach used integrates technical and aesthetic concerns and emphasizes that the best "text" for learning lighting is the study of film examples. This book will help make that "text" accessible.

APPROACH

A fundamental premise of this book is that exposure theory and its relationship to the film stock's emulsion provide the scientific basis for understanding the possibilities and techniques of lighting. Without exposure theory cinematographers cannot dissect and analyze such techniques as lighting ratio or the placement of the most important zones in the image on the characteristic curve of the film stock. The exposure sections examine the function of the incident meter and how it relates subject luminance range to an emulsion's characteristic curve.

To analyze a film's lighting requires a vocabulary. To that end the zone system has been adapted to film and video to allow for a precise relation of visual values in the subject to screen values and the film emulsion. The zone system thus functions as a language for exposure. In addition, lighting terminology based on the work of Walter Nurnberg is used for referring to light placements and lighting ratios. This second language is more functional and can serve as a guide for exploring lighting both as a technique and as an aesthetic dimension in the final film.

Lighting can be studied through an intensive analysis of videotape copies of films and also through analysis of paintings, theater productions, and photographs. Aspiring cinematographers can choose a body of work to analyze based on their particular goals. Those who aspire to a Hollywood career might study Oscar nominees and winners for best cinematography and films singled out by the American Society of Cinematographers. Others might prefer to learn from foreign or independent cinematographers, and still others might select documentary or experimental works to study.

TERMINOLOGY

Two terms, **feel** and **look**, are used extensively and require some explanation. Like the jazz term *soul*, these terms are inherently vague, perhaps because they are used to describe visual qualities that are difficult, if not impossible, to verbalize. As used here *feel* means all the emotional, subjective nuances of a shot—its rhythms, textures, colors, and tonal values. These subtle distinctions are what cause viewers to say a shot has the feel of emptiness or richness, of boredom or vitality. *Feel* goes to the depth of the image—to its connotative meaning level. In contrast, *look* refers to the surface properties and visual style of images. Adjectives such as slick, hard, soft, bright, or dark are used to describe a film's *look*. You can also talk about the *look* of a particular cinematographer's work, such as Nestor Almendros's work in *Days of Heaven*, or the *look* of a certain type of film, such as a music video or television commercial. *Feel* is the emotional experience of the image; *look* is the more sensory experience.

In general the term "cinematographer" is used rather than "director of photography." The term "director of photography" (DP) conjures up images of large-scale, feature films practices. Even if your goal is the Hollywood-scale shoot, in the beginning you will face different sorts of problems and may find methods other than standardized Hollywood techniques useful. Through use of the term "cinematographer," this book seeks to reference types of filmmaking besides features: documentaries, poetic, and experimental films, student and amateur films. Such films may have small crews or even one person handling the cinematography.

STRUCTURE

This book adapts a conceptual approach to lighting as it seeks a balance between theory and practice. The integrating theme throughout the book is

that lighting is a combination of the art of seeing and the science of exposure. The book is divided into six parts. Part I reviews fundamental lighting concepts and basic lighting placements. A new chapter, Basic Working Methods, concentrates on the concept of lighting ratios as a tool for creating lighting setups. Part II covers exposure theory, including the zone system, and contains a significant change from the first edition in a reworked Chapter Six which is now titled Creative Exposure Techniques. Part III explores the applications of lighting theory, including approaches to lighting styles, lighting interiors and exteriors, planning lighting setups and a detailed lighting example of a lighting setup for an interior café scene. Part IV applies film lighting techniques to video. Part V discusses controls over color and image look with two new chapters covering lighting for color and lab and postproduction controls. Part VI provides detailed analyses of lighting examples. Throughout the book an underlying consideration is the application of filmic lighting theory and practice to emerging digital technology. Although there will be the inevitable developments in image-making technology, the art of creating meaningful, evocative, or even beautiful images will remain.

NEW TO THIS EDITION

- New and revised chapters in this edition include Lighting for Color, Lab and Postproduction Controls, and Basic Working Methods, Lighting Ratios.

- New sections on color temperature and the incident meter, T-stops and the Zone System have been added to Chapter 1, Basic Lighting Concepts.

- Chapter 11, Video the Film Way contains three new sections including, The Video Formats: From Standard to High Definition, Using a Monitor to "Expose" Video and The Digital HD Video Revolution.

- A new case study, Shooting on Digital Video, and a new section on 24p HD video have been added to Chapter 12.

FEATURES

- A balance of the aesthetic and technical aspects of lighting.
- Conceptual system/analytical tools: key, fill, rim, background, and facial and subject/background ratios.
- More than 150 photographs (lighting examples) and diagrams—a wide variety of photographic examples illustrate various lighting points. Examples are taken from films as well as photography and exemplify a number of lighting styles.
- Lighting Analyses of Selected Shots (at the end of the book) provide insights into aesthetics and style; accompanying lighting diagrams

demonstrate "how to." Appendix A provides a review and supplementary information and data on lighting and grip gear. Appendix B offers a variety of exposure and lighting exercises.

—Dave Viera and Maria Viera

ACKNOWLEDGMENTS

This edition could not have been realized without the contribution of Patrick Van Osta, who as photo editor, not only digitized and, in some cases, restored the negatives of photos used from the first edition, but also shot many of the new photos. I also thank Susan McLain for her enthusiastic support and contribution to the photo component of this edition.

I would like to thank Ray Zepeda, Kevin O'Brien, Edward Noeltner, and Brian Alan Lane for their help and advice. I also thank Lee Scott, Michael Rubin, and Nikola Stanjevich for their color photographs. In addition, I thank all the models who posed to illustrate the lighting examples.

Thanks also to photo researcher Cassandra Ward; editorial researcher Trudy Anderson; Holly Allen, publisher; Laryssa Polika, editorial assistant; Mary Noel, project manager; and Andrea Fincke, project editor. A special thanks goes to Becky Hayden, publisher of the first edition.

In addition, thanks to all the reviewers who provided many suggestions which guided the revision process: Warren Bass, Temple University; William Brand, Hampshire College; John Douglass, American University; LeAnn Erickson, Temple University; Robert Harris, Fitchburg State College; Douglas Heil, University of Wisconsin, Oshkosh; Charles J. LaMendola, Texas Christian University; and Michael Mulcahy, University of Arizona.

Most importantly, I would like to thank those who helped sustain me throughout this project: Marcia Hesselroth, Mary Humboldt, Thomas Litecky, Barbara Matthews, Joanne Gordon, Ryan Cathcart, Kassie Thornton, Hugh O'Gorman, Sharon Olson, and Nancy Hoch. I thank them for their love, help, and inspiration.

—Maria Viera

FUNDAMENTALS OF LIGHTING

There is only one way of learning how to build up photographic lighting—by learning to "see." There is also only one way of learning how to apply this photographic lighting—by learning to feel sensitively and to think intelligently.

~WALTER NURNBERG
Lighting for Photography

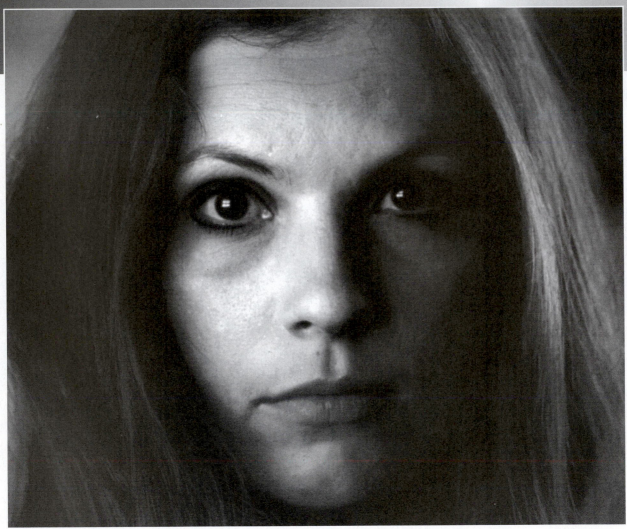

SOFT LIGHT

Basic Lighting Concepts

Four basic features of light are crucial to the cinematographer: the photographic quality of the light, the color temperature of the light, the direction of the light, and the resulting pattern of light and shadow. In this chapter, we explore these four concepts along with more technical matters—the incident meter, T-stops, and the zone system. In the next two chapters, we will discuss ways of working with these concepts to create lighting setups.

N CONTEMPORARY CINEMATOGRAPHY and digital videography, almost any light source can be used for filming: Household bulbs, neon lights, kerosene lamps, torches, flashlights, candles, street lights, and, of course, naturally available daylight. Fast lenses, improved emulsion speeds, and increased-sensitivity video cameras allow for a wide range of possibilities. But whether the cinematographer uses Kino Flos, a Musco light, 12,000-watt HMIs or 25-watt household bulbs, the essential lighting challenge remains: To create images with mood and significance, images that generate interesting film spaces.

There is a tendency for beginners to become fascinated by all the grip and lighting gear used in film and video. An experienced cinematographer, however, concentrates on the "look" of the images. Lighting and grip gear are tools the cinematographer uses to create the desired image look. Certain lighting tools are, however, essential for certain lighting styles, and the cinematographer must be aware of this. See Appendix A, "Lighting and Grip Gear," for a description of these tools.

Throughout, we will use the term "cinematographer" for both film and video. Even though this evidences a pro-film bias, it seems that cinematographic production concepts and attitudes are branching into video and not vice versa. Recent video technological advances, such as high definition, emulate film ways of conceptualizing images. Technically, Sony pushes high definition forward as a rival to film and references its technology to 35mm film.

In *Professional Cinematography*, noted Hollywood cinematographer Charles Clarke states that all lighting is premised on humanity's years of experience with the sun, the basic light source. For example, the fact that the sun is high above most of the time makes lighting from above seem natural. The variety of atmospheric conditions we encounter render us sensitive to the differences between **hard light**—direct, high-contrast sunlight—and **soft light**—indirect, low-contrast twilight or the gray light on an overcast day. These extremes of light quality produce a variety of moods that cinematographers learn to exploit in their images.

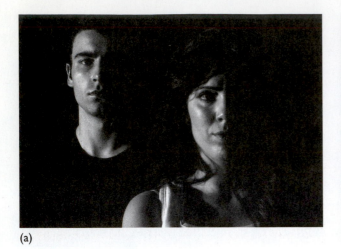

(a)

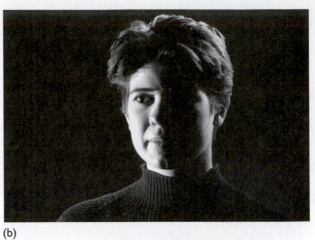

(b)

FIGURE 1.1

HARD AND SOFT LIGHT

Faces lit with hard light (a and b) and soft light (c an d) reveal dramatically different shadows and moods. ▉▉

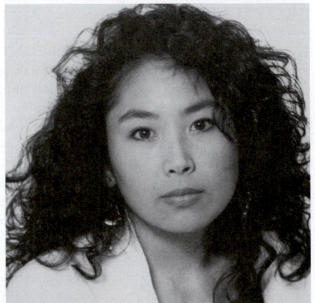

(c)

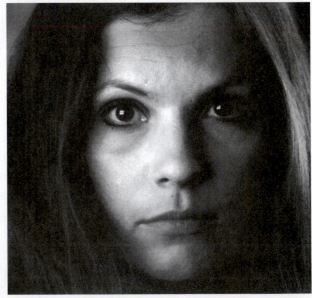

(d)

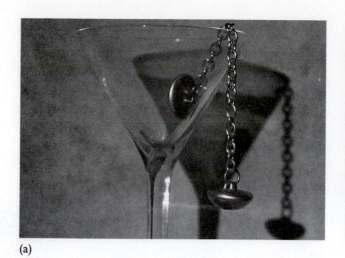

(a)

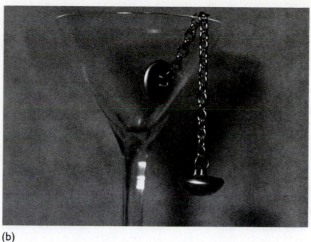

(b)

LIGHT QUALITY

An important lighting decision centers around what kind of light to apply to a scene. This is true whether we are using artificial illumination or **available light**—light naturally present at the location, for example, the daylight coming into a room from a window or the neon signs and street lights on a big city street.

Light is "hard" when its shadows are sharply defined. Hard light is inherently high in contrast and thus gives us very black shadows. It is also highly directional and focused, like a spotlight. Hard light emanates from small point sources. Direct sunlight and ellipsoidals are good hard light sources (see Figure 1.1).

Light is "soft" when its shadows are formed gradually with indistinct edges. Soft light is lower in contrast than hard light and consequently has lighter, more gray shadows. It is less directional than hard light and is often called omnidirectional or "directionless." Large light sources that are heavily diffused, bounced, reflected, or filtered yield light which is soft in quality. Examples include the painter's north light—reflected sky light such as in a Vermeer interior—the shadows under a tree, a gray overcast sky, softlights, and bounced lights (see Figure 1.2).

The current range of possibilities from hardest sunlight to softest twilight is as follows:

- Direct sunlight
- Ellipsoidal spotlights
- Fresneled lights—HMIs and Quartz
- PAR bulbs
- Open-face lamps of all kinds, mainly Quartz types: Broads, Floods, Scoops, Lowell DPs, and the like
- The above lights diffused—usually open-face lights but sometimes Fresnels, with diffusion positioned between lamp and subject, either mounted on the lamp or as self-standing frames. Diffusion is accomplished with gels such as Tough Frost or Tough Silk, or materials such as tracing paper, muslin, silk, and other fabrics.

FIGURE 1.2

SHADOWS

A glass and a button lit with hard light (a) and soft light (b) illustrate the different shadow properties resulting from the quality of the light.

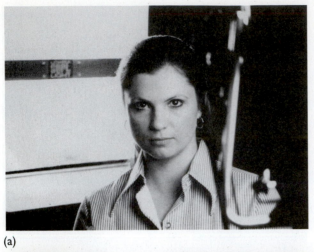

(a)

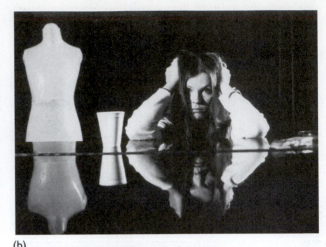

(b)

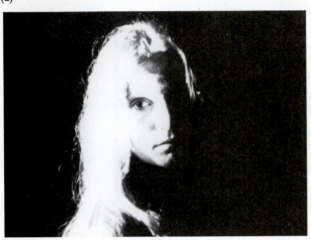

(c)

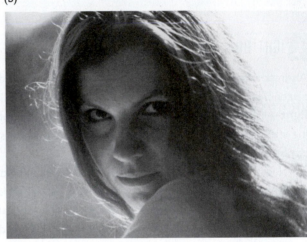

(d)

FIGURE 1.3

LIGHT SOURCE DIRECTIONALITY
DETERMINES SHADOW
FORMATION

Shadows become more and more domi-
nant as the angle of light-incidence
increases. Light comes from the front (a),
the three-quarter front (b), the side (c),
and the back (d). Comparing a–d shows
that the light quality and the relative pro-
portions of light and shadow determine
image mood. ▪▮▯

- Fluorescents, photofloods, and frosted household bulbs
- Softlights
- Bounced light—Fresnels or open-face lamps bounced off foam core, white walls, and the like
- Gray overcast skies, fog
- Twilight and deep-shade situations such as in a forest or cave entrance

COLOR TEMPERATURE

In Chapter 13, we will look at the role color plays in lighting styles, but here
we will look at one property of light that impacts on images at all levels—the
color temperature of white light. White light is an illusion in that it consists
of all wavelengths of light—the Newtonian spectrum—and is deemed "white"
by our minds. In fact white light may be bluish, orangish, greenish, pinkish; it
comes with a tint so to speak. We even have words for this fact—we say light
is warm or cool depending on whether it leans towards the reddish or bluish.

Color temperature is how we talk about this in film and video. Color
temperature is a measurement of the relative proportions of blue to red
wavelengths in what appears to be "white" light. This is important because film
emulsions and video cameras do not perceive as we do. We compensate auto-

matically for changes in color temperature, but film and video reproduce any tint faithfully, and this impacts on the colors of the image.

Most color corrections in film and video are done in lab and telecine procedures, but we do attempt to match the initial color temperature of the light to the color temperature balance of the emulsion or video system. Two standards suffice for this—an indoor balance often referred to as **3200 degrees Kelvin (K)** and an outdoor balance of **5600 degrees Kelvin (K)**.

Film and video lights are manufactured to the same 3200 or 5600 color temperature balances. Ordinary household bulbs, garage lights, and the like have a variety of color temperatures, seldom at 3200 K. Ordinary daylight is a mixture of sun and skylight with a rough average of 5600 K.

As you might imagine, film emulsions are balanced for shooting under either 3200- or 5600-degree lighting (see list of stocks in Table 4.1). For accurate color reproduction, you match the color temperature of the emulsion with the color temperature of the light you are using. Normally, you use a tungsten balanced emulsion indoors with tungsten balanced quartz lights and daylight emulsions when shooting outdoors or when using HMI lights that are balanced for daylight. Alternatively, it is possible to balance an indoor emulsion for daylight lighting by adding an orangish filter to the lens. The bluish nature of daylight is warmed by the orange filter—a Wratten 85 in Kodak parlance—and arrives at the emulsion with approximately a 3200 color temperature. You could also use a daylight emulsion and a bluish filter (Wratten 80 B) with warm indoor lighting, although this is seldom done because you lose quite of bit of exposure to the filter itself.

One creative possibility immediately pops up in front of us. What if we intentionally mismatch color temperatures? What if we use an indoor emulsion, with warmer-than-normal indoor lights, say candles, and allow the light outside the window to go bluish—a warm/cool effect? Or, we might light faces with a correct color balance, light other parts of the frame warmish with household light bulbs, and let outdoor parts go cool—a three-part color temperature combination. In Chapters 8 and 13, we shall look further at these warm/cool effects.

Video operates exactly the same way as film. On the video camera, there will be a filter designation system—filter on for shooting outdoors, filter off for shooting indoors. It is the same exact filter as with film. In video this is called **white balance**—balancing the 3200 K-designed chips to different kinds of white light. For higher precision balancing, video uses an automatic electronic system. You point the camera at a white surface, and push a button for very precise adjustment of the color temperature.

White balancing opens up another creative possibility—white balance on auto mode while pointing the camera at a nonwhite surface. For example, if you point the camera at a light yellow T-shirt, the auto system will yield a slightly bluish image effect. The auto system overcompensates and arrives at the complement of the surface you point the camera at. If you use a bluish surface, you will arrive at a warmish image. Note, however, the effect is on the entire frame, unlike the earlier example of the intentional mismatch of color temperatures of various subjects and/or objects within the same shot—effects that can also be accomplished in video.

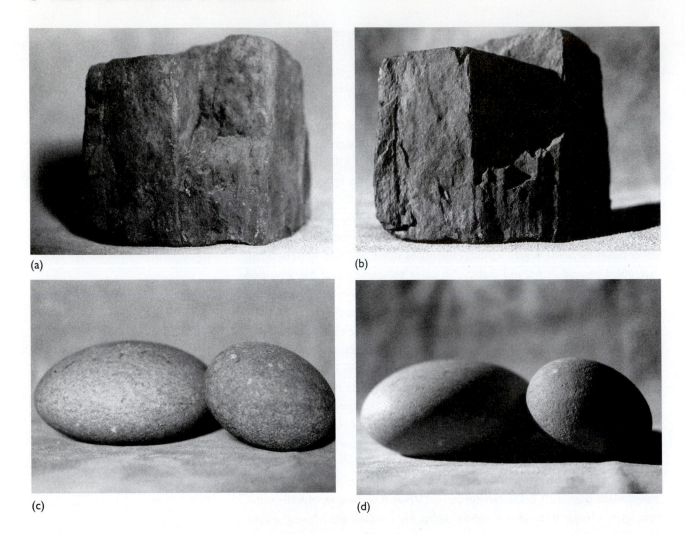

(a) (b) (c) (d)

FIGURE 1.4

LIGHT SOURCE DIRECTIONALITY INFLUENCES HOW AN OBJECT APPEARS

Rocks lit frontally with soft light (a and c) and from the side with hard light (b and d) reveal the importance of the direction of the light in defining an object's shape.

LIGHT SOURCE DIRECTION

The direction a light source comes from has an important influence on the amount of shadow area in the frame. Shadows become more and more dominant as the angle of light-incidence increases—as the lighting moves from front to back positions. This in turn affects the overall mood of the image (see Figures 1.1 and 1.3).

Light may come from various positions relative to the subject: Front (zero degrees), side (90 degrees), back (180 degrees), or anywhere in between. The angle the principal light source comes from, the **key light**, can strongly influence the appearance of the photographic subject, particularly for unfamiliar objects (see Figure 1.4). Frontal light minimizes shadows and texture and tends to flatten and hide an object's true shape. Side light creates shadow and texture patterns that reveal the object's three-dimensional shape.

To establish the illusion of reality and give a naturalistic logic to the lighting, cinematographers utilize "motivated" lighting schemes. **Motivated lighting** means the illumination appears to come from a particular light source such as a window, table lamp, or ceiling light. This light source is either in-shot or has been identified previously. Once established, the logic of this source direction is usually maintained throughout the scene. Where there is no in-

(a)

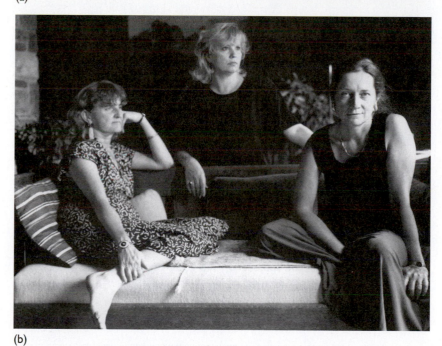

(b)

FIGURE 1.5
MOTIVATED LIGHTING
Although not visible in the shot, windows frame left and right provide "motivation" for the lighting in shots (a) and (b), respectively. ▮▮▮

shot light source to motivate the lighting, the cinematographer often invents one so the lighting looks as if it comes from an out-of-frame source (see Figure 1.5).

Light source direction also has important effects on color saturation. Fullest saturation is obtained with frontal lighting. Desaturation results from back lighting. Tracing the color changes in the blue of the sky, the green of the shrubs, or the red of the bricks in Color Plates 1–3 reveals the effect light angle has on color saturation. The choice of light source direction is very important in creating image looks.

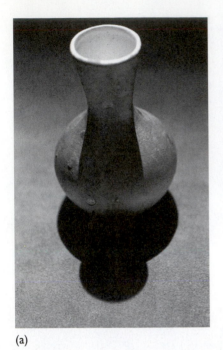

(a)

(b)

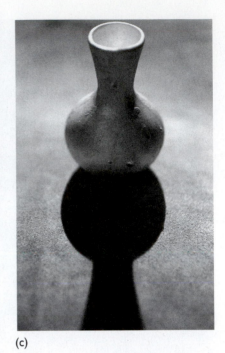

(c)

FIGURE 1.6

EFFECTS OF LIGHT SOURCE
ELEVATION ON SHADOW SIZE

This vase is lit from behind by a hard light
from a 70-degree elevation (a), from a
45-degree elevation (b), and from a
20-degree elevation (c). The effects on
the object's shadow are quite dramatic.
At 45 degrees, the length of the shadow
is equal to the height of the vase.

LIGHT AND SHADOW

Some cinematographers say the most important thing in lighting is what you do
not light. They are referring to the relative effects of light and shadow, the lit
and unlit parts of the frame. The amount and arrangement of shadows and
dark areas of the frame are extremely important in creating image atmo-
sphere and moods.

The elevation of the illumination influences the shape of the shadow. This
can be seen in Figure 1.6. Controlling the degree of blackness in the shadows
requires adding light to illuminate the shadow areas. This light is called a **fill
light** (see Figure 1.7).

Shadows play an important role in rendering texture. To maximize tex-
ture, we use side (cross) lighting. Side lighting creates long shadows that inter-
act with the lit parts of the subject to yield good texture patterns (see Figure
1.8). To minimize texture, we use frontal light since it is "shadowless" (see
Figure 1.4).

THE INCIDENT METER, T-STOPS, AND THE ZONE SYSTEM

Three controls are basic for working with light and analyzing images: The inci-
dent meter, T-stops, and the zone system. The incident meter is used for both
lighting and exposure. To use the meter, follow these simple steps:

1. Set the meter for the EI/ASA being used.

2. Stand in the light falling on the subject and point the meter at the camera. It
 doesn't matter where the camera is; just point the meter at it. The hemispheric
 disk on the meter takes into account the angle of incidence of the light—the
 direction of the light—by substituting its own three-dimensionality for that of the
 object.

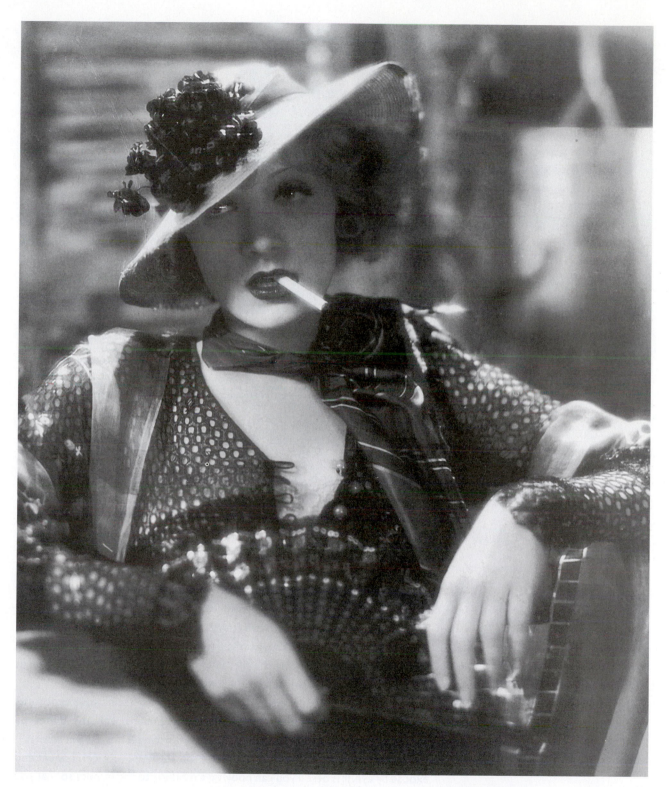

FIGURE 1.7

FILL LIGHT

The shadow area under the hat has been illuminated with soft light from the front. This fill light creates reflections in the eyes ("eyelights") that bring life to the face. (*Blonde Venus*, © 1932 Paramount, Publix Corporation. Courtesy of Universal Studios Licensing LLLP.) ▮▮▮

FIGURE 1.8

SIDE LIGHT

Side lighting reveals an object's texture (photos by James Naysmith, 1874).

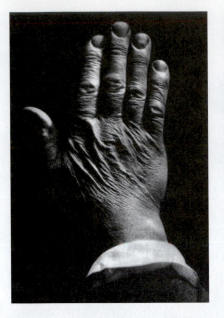

3. Match up the needle reading with the shutter speed for your camera, usually a 1/50th. You do this by turning a dial. Of course, if you have a digital meter, the T-stop (F-stop) is displayed automatically. On manual meters you will have to read the T-stop off the scale.

The basic hypothesis operating here is simple: If you want what you see ("correct" exposure), you expose for the indicated meter reading. Remember, wherever the meter is placed—what you choose to expose for— is given a "correct" exposure. This rule operates over a wide range of angles of incidence. Ninety percent of the time we expose for the actors, but there are times we expose for other parts of the frame; for example, we expose for the background in the case of silhouettes.

Exposure for backlight situations is trickier because the meter tends to overexpose the shadow areas. Some cinematographers take a reading in the normal way and then close down somewhat to preserve the shadow values. This is done by shutting down a half stop or more. A similar technique is to expose halfway between the normal toward-the-camera reading and the reading obtained by pointing the meter toward the light source. Some cinematographers expose for the latter value only (see Figure 6.9).

You will find that incident readings are simple to take and your exposures will be consistently correct. You can master exposure with the meter by shooting several rolls of slide film and analyzing your results on the screen.

On a video shoot, you should turn off the autoexposure component and expose by eye. It is best if you can hook up a monitor to the camera so that you can see clearly as you adjust the T-stop manually. If you do not have a monitor, you will have to use the camera's viewfinder instead. Ideally, you are working with a camera that can generate color bars which you can use to calibrate the monitor initially. But on most mini-DV cameras, you will be winging exposure through the viewfinder. Even so, the images will be better than with "autoexposure."

We shall look at video further in Part IV: Digital Cinematography. For now, even if we intend to specialize in digital or high definition video, we are better off learning film techniques as well—not only because currently we are

FIGURE 1.9
T-STOP SCALE ▮▮

The Standard T-stop Scale is:

1, 1.4, 2, 2.8, 4, 5.6, 8, 11, 16, 22, 32

just as likely to originate on film as video for video release—but because such a study will improve our ability to create lighting styles in our video work.

T-STOPS

T-stops are true f-stops, that is, they are measured rather than calculated mathematically. This means they take into account light loss inside the lens as it forms an image. T-stops are what an incident meter indicates when we take an exposure reading—the theoretical, true f-stop. We will use the term T-stop throughout this book where others use "f-stop." In reality, except for very cheap lenses found on some Super 8 cameras, they are synonyms for all practical purposes.

The T-stop scale is based on a doubling idea where moving from one T-stop to the next represents a halving or doubling of the amount of light allowed through the lens depending on whether we are opening up or closing down the lens iris. Figure 1.9 should be studied with great care.

A concrete example: If T 1 allows 1000 **footcandles (fcs)** through the lens, then 1.4 would allow 500 fcs, T 2 250 fcs, and so forth. This is simple enough, except for one thing: Why such an odd progression of numbers in the T-stop scale, for example, from T 2 to T 2.8 = 1 stop? Since the scale represents a doubling factor, why isn't T 2 to T 4 one stop? Why doesn't the scale go 1, 2, 4, 8, 16, and so on? The explanation is mathematical and relates to how f-stop was originally defined—better just to memorize the scale.

THE ZONE SYSTEM

The T-stop scale allows us to combine a reading of the intensity of the light on the subject with the speed (EI/ASA) of the emulsion and shutter speed of the camera to arrive at a "correct" exposure. We will look at the theory of this later in Part II: Fundamentals of Exposure, but for now one important point: Picture in your mind T 5.6. You know what 5.6 means because you memorized the scale, but what does 5.6 look like? There is no answer to this question because it depends on how intense the light was and which emulsion was used to take the image. There is nothing for you to picture except the image itself. In and of itself, T 5.6 represents no particular visual value which is odd because we are dealing with images right in front of us.

Let us say this another way. If we look at the cover photo for this chapter, we see that it is a person in front of a wall which goes from gray to black (in reality the wall was white). But, we don't have a clue as to what T-stop was used to take the photo. It could have been 2.8 or 11. We have no visual way of knowing. Yet, the person looks like a person because the flesh tone is correct from our experience.

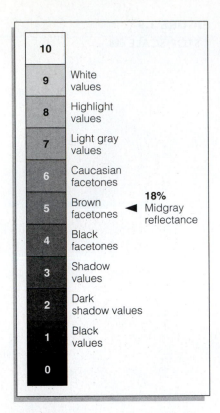

FIGURE 1.10

THE ZONE SYSTEM SCALE

How can we analyze this photo in visual terms, putting aside the realm of the abstract, mathematical T-stop scale? The answer: Use a language composed of visual elements. In this book, we will use the **zone system** for lighting and exposure analysis as well as for previsualizing how our lighting will look on film.

The eleven steps or zones of the gray scale form the basis for the zone system as devised by photographer Ansel Adams. Figure 1.10 describes the typical contents of each zone.

By far the most useful zones in film are 4, 5, and 6 because most face-tones and other important subject values fall within this range. The next most important zones are the highlight zones, 7, 8 and 9. Our eyes go to bright areas of the screen after scanning the image for faces.

Adams based his system on how the human eye perceives brightnesses. The zones of the gray scale make a geometric progression and represent equal spacings for the eye. As we ascend the scale, each zone is twice as bright as the one before; for example, zone 4 is twice as bright as zone 3, zone 5 is twice as bright as zone 4, and so forth.

An important similarity exists between the zone scale and T-stops. Both are based on a geometric progression of 2x; that is, from one zone to the next is equivalent to a multiple of two, and opening up one T-stop to the next is equivalent to a doubling of exposure.

Because both zones and T-stops represent a doubling of values, they are often used synonymously. For example, we say we intentionally overexposed the facetones two stops, or we moved the facetones up two zones. Opening up a stop is equivalent to moving a value up one zone, opening up two stops will move a value up two zones, and so on.

We shall revisit the zone system in Part II, but for now we have enough information to be able to analyze images with it—assuming we have memorized this visual language. We can also convey our findings to others who "speak" this handy language. More important, we can use zones to previsualize our lighting setups as discussed in Chapter 6.

Let us return to our discussion of the chapter cover photo. We know that if we put the face at a standard zone 6 and light the background darker so that the zone 8 white wall behind her becomes a pattern of zones 3–5 grays and zones 1–2 blacks, we can reproduce a rather accurate copy of this lighting setup. This is because we can previsualize zones in advance and imagine what our visual values will look like. And note, we might light the subject to a T 2.8 level or to a brighter T 8 level. Other than possible effects on depth of field, there will be no discernable difference between the two versions.

Study carefully Figure 1.11 which identifies the zones present in the photo, rather, the half tone book reproduction of the original photo. Better yet, duplicate the lighting setup yourself with the same light quality, the same relationship of face to background, and, of course, the same composition. Try duplicating the photo with at least two different T-stops. Try it with slides or film as well as video. Note the differences. To duplicate the image on video will require a different lighting setup from that with a slide.

If you can do this, you are well on your way to mastering lighting because eventually you will be able to analyze an image look or particular lighting style and be able to recreate it yourself in your film work. See Chapters 2 and 3 for techniques to use in duplicating the photo.

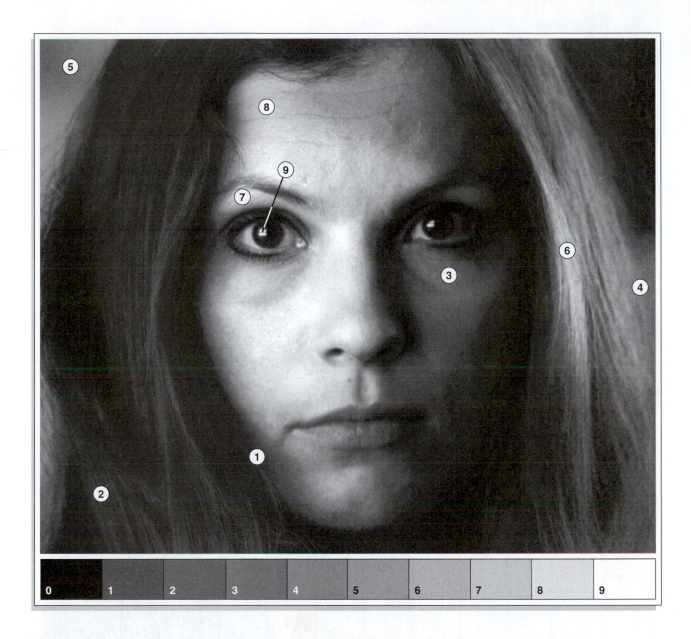

FIGURE 1.11
PHOTO WITH ZONES IDENTIFIED

SUMMARY

● A central challenge to the cinematographer is to create images with mood and significance. When lighting, cinematographers work with four basics of illumination: Quality, color temperature, direction, and shadow configuration. Together, these four create a field of light and shadow and color hues with gradations from white to gray and black.

● Quality, direction, and shadow are intertwined; changing one alters the other. Changing light quality alters the "feel" of shadows. Changing source direction allows control over shape and the location of shadows.

● Color temperature and white balancing allow for creative controls over color renditions throughout parts of the frame.

● The incident meter, T-stops, and the zone system give us control over both lighting and exposure and a means for discussing visual values precisely.

KEY LIGHT

Lighting Setups: Basic Light Placements

Establishing a lighting setup may be divided into five central concerns: choosing a direction for the source and placing key lights based on the logic of that direction; adding fill light to control shadows; adding rim and back light to model actors and create subject/background separations; placing set and background lights to complete the realistic illusion; and positioning specialized lights to add depth and emphasis to characters and objects.

A S WITH ALL artistic skills, lighting can be mastered only through personal experience and analysis of acknowledged works of excellence. This chapter lays out the basic light placements for creating and analyzing lighting setups. The distinctions used here derive from English photographer Walter Nurnberg, who developed a very precise system for analyzing lighting.[1] We use a simplified version of Nurnberg's system throughout this book to label and identify light placements.

Because lighting terminology derives from a mixture of concepts and terms from physics, photography, theater, and film, it is not yet standardized and its vocabulary remains loose. You should also remember that terms vary from geographic region to geographic region as well as from country to country. For example, a "cross" light in England is a three-quarter front light, whereas in the United States it would be a "side" light.

With all this in mind, lighting can be broken down into the following basic functions:

- *Key light* is the main subject light that establishes the direction of the light, the logic for the lighting scheme, source motivation, mood, and shape.
- *Fill light* supplements key lights by lightening shadow densities, principally on faces. The fill light should create no new shadows.
- *Back and rim light* supplements key and fill lights. It models, accentuates, and separates actors and objects from backgrounds.
- *Background and set light* illuminates backgrounds relative to key light intensities. The background context is as important to the overall feel and look of the shot as the key and other subject lights.
- *Specialized lights* include eyelights and hair lights used to fine-tune the setup.

KEY LIGHT

As its name implies, the key light, or key, is the most important light source affecting the shot. It establishes the direction and source motivation for the lighting and determines the placement of facial shadows. A number of lights

FIGURE 2.1

KEY LIGHT POSITIONS

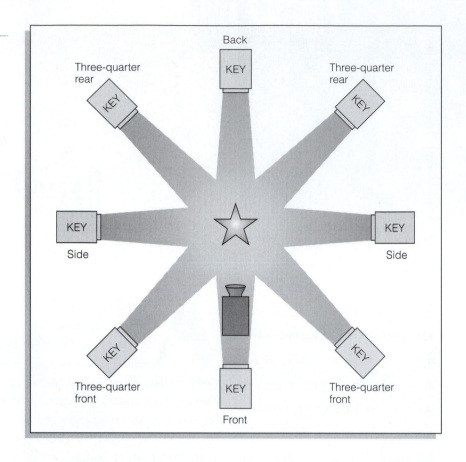

may be used to establish the key light source, particularly where there is a lot of actor movement to cover. In order to maintain the overall motivated lighting scheme, these lights are usually arranged so as to appear to come from a single direction.

Because the subject moves in film and video, we have to design lighting combinations to cover ordinary changes such as a head turn. Sometimes, a lighting setup is so restrictive that an actor must stay on a certain mark in order to be in the light. At other times the lighting is "looser" and allows for freer actor movement. Chapter 10 provides a detailed example of designing lighting for actor or camera movement.

As we saw in Chapter 1, front, side, and back are the principal directions used for lighting a subject. Figure 2.1 elaborates this further and presents a working vocabulary for referring to key light placements. In the horizontal plane, we can identify five important positions: Front, three-quarter front, side, three-quarter rear, and back. These designations result from a simple 45-degree scale and are referenced to the camera/subject axis.

These five placements for the key are for our convenience in talking about lighting and are not to be construed as "rules" for key light placement. An actual key light is usually positioned by eye with reference to its effects on the particular subject. These descriptions are thus only approximations made for our verbal convenience.

In the vertical plane, keys may be positioned at a variety of elevations. Four placement positions are adequate for description: Below (low angle), camera level, above (30 to 60 degrees but commonly about 45 degrees), and high (typically 60 to 90 degrees, the latter being called "top" lighting). Most key

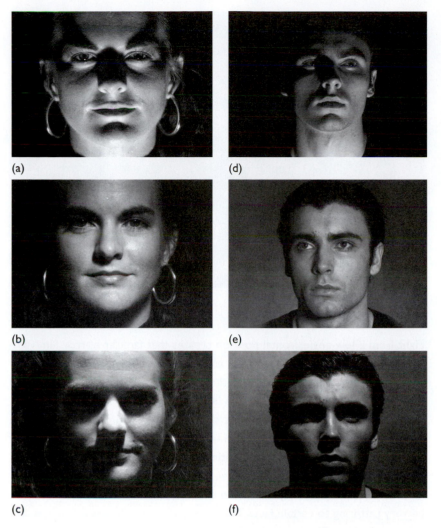

(a)

(b)

(c)

(d)

(e)

(f)

FIGURE 2.2

FRONTAL KEY ELEVATIONS

Different elevations for a key light produce differing facial shadows and facial effects. In these shots, the key light positions are from below (a and d), from slightly above camera level (b and e), and from a high angle (c and f). Although rather unflattering, the higher elevations, such as in (c) and (f) can be useful—see the lighting on Marlon Brando in *The Godfather*.

lights come from elevations around 45 degrees above the subject. The higher positions are used mostly for hair and back lighting although Gordon Willis utilized them effectively as keys in the *Godfather* films where the darkened eye sockets caused by the high angle enhanced the feel of the characters, particularly Marlon Brando (see Figure 2.2c and f). Camera-level placements are used for fill lighting and frontal or side key effects. Because of distortions, we tend to avoid low-angle placements except for special effect.

Besides these source positionings, we have to factor in the quality and shadow differences of soft and hard light. Add to that the fact that actors are in constant movement, and the complexities of lighting may seem insurmountable.

Let us start our investigation of this complex art by illustrating these major key light placements more fully. We will take the simplest possible situation—a portrait of an actor. Two truisms concerning lighting, which are important when lighting actors' faces, should be stressed:

- The effect of a particular key on a particular subject is variable; that is, different faces demand different light positionings. Thus we often have to test lighting combinations on faces to ascertain their photogenic effects.

- Lighting is basically done by eye. This means the cinematographer must be sensitive to the particular subject and how light affects it.

FIGURE 2.3

FRONTAL KEY AT CAMERA LEVEL

FRONTAL KEYS

Light from a low-angle, frontal position creates that familiar horror film/vampire picture look that we duplicated as kids by putting flashlights under our chins. Sunlight and most interior lighting come from overhead. Lighting from below seems strange because it is so unusual (see Figure 2.2a and d).

When placed at camera level or slightly above, a frontal key produces a flat, straight-on illumination that de-emphasizes depth and creates a feeling of two-dimensionality. Such frontal lighting minimizes the effects of wrinkles, lines, and other marks on the face (see Figure 2.3).

As we elevate the key above camera level, we obtain positions that can be very flattering to certain faces. This is because cheek bones and noses cast pleasing shadows. The frontal key, from 30 to 45 degrees above, is often used on film stars. It gives a bit of modeling to the face but still softens facial features and minimizes skin textures. Used in combination with diffusion, it is a very popular, Hollywood star lighting style (see Figure 2.4).

As the higher positions are reached, we lose the glamour effect. Texture appears, eye sockets become dark and black, and elongated shadows appear under the lips and nose. Instead of glamour, we now have an unflattering effect—an effect all too common under ordinary fluorescent ceiling lighting (see Figure 2.2c and f).

THREE-QUARTER FRONT KEYS

The three-quarter front key is the favored position for the key in classic Hollywood-style lighting (see Figure 2.5). It comes from above at about a 45-degree angle and creates the familiar triangle-shaped patch of light on the shadow side of the face. This key was so prevalent during the 1940s and 1950s that for many people "key" meant three-quarter front. Today, cinematographers are more free with their key placements, although three-quarter front is still considered a very useful position.

A reminder: How high a three-quarter front key should be positioned and the exact angle to be utilized depend on the aesthetic intent of the shot and the particular actor's face—whether it is oval or angular, for example.

FIGURE 2.4
HOLLYWOOD STAR
LIGHTING STYLE

(a)

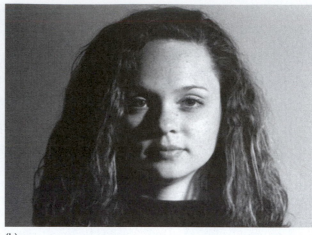
(b)

FIGURE 2.5

THREE-QUARTER FRONT KEYS
(above)

This is a very popular key light position.
Sometimes the shadow side eye is in the
patch of light.

SIDE KEYS

A camera-level side key on a frontal face is a classic lighting setup. The lighting divides the face in half with a vertical shadow (see Figure 2.6).

The side key provides a great deal of visual variety to hold our attention. Interesting effects are obtained with this key as the subject turns from front to three-quarter to profile position (see Figure 2.7).

FIGURE 2.6

SIDE KEYS AT CAMERA LEVEL ▥

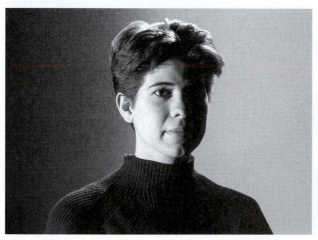
(a)

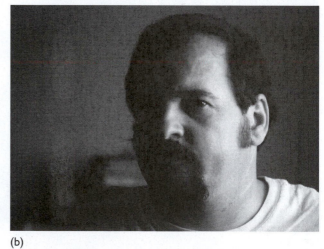
(b)

(a)

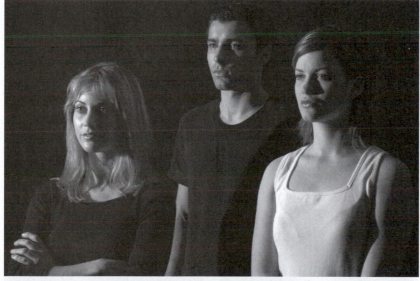

(b)

(c)

FIGURE 2.7

EFFECTS OF SIDE KEYS ON ACTOR MOVEMENT

A common situation is where the key light starts as a side key (a), turns into a three-quarter front effect as the actors turn their heads (b), and ends as a full face effect as the actors reach profile (c).

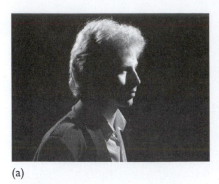

(a)

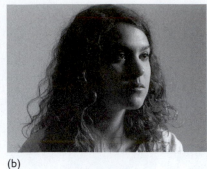

(b)

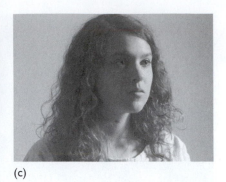

(c)

FIGURE 2.8

THREE-QUARTER REAR KEYS

Various effects of keys from the three-quarter rear position are illustrated. Note the different mood obtained in (c) by exposing for the shadow side of the face as compared to (b), which is exposed for the lit side of the face. This effect is often used to simulate the effects of window light.

THREE-QUARTER REAR KEYS

The three-quarter rear key is the backside version of the three-quarter front key. It is a very dramatic, moody key that is often used for night exteriors. The three-quarter rear key works best using a hard light source with a film noir or melodrama lighting scheme (see Figure 2.8).

A raw facial effect can be obtained by using two three-quarter rear keys, one from each side of the figure. These create a strong, well-modeled style of lighting (see Figure 2.9). Another use for two three-quarter rear keys is in two-shot situations. The key on one actor's face rims the other actor's head and back (see Figure 2.9c).

FIGURE 2.9

DOUBLE-THREE QUARTER KEYS

Use of two three-quarter rear keys produces a distinct lighting style (a) in which a shadow area is left on the center of the face. The effects of this lighting setup on actor movement are shown in (b) and (c). In two-shot situations, one actor's key is the other actor's rim (c).

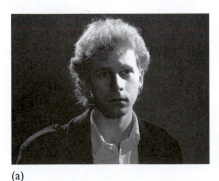

(a)

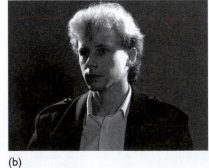

(b)

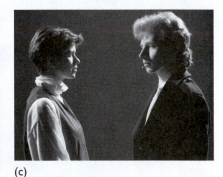

(c)

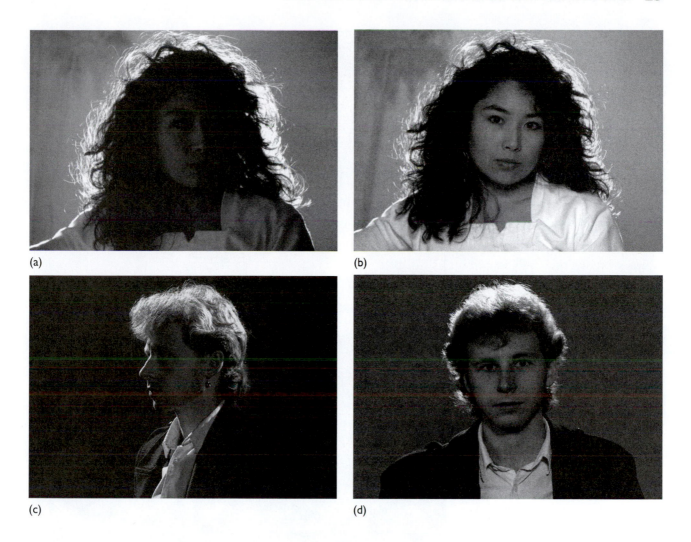

(a) (b)

(c) (d)

BACK KEY POSITIONS

A light from the rear is the key when it is the dominant light on the figure. Applying a back key to a person automatically creates a dark, moody effect useful for night interiors and exteriors (see Figure 2.10). Where the actor is in profile, back light can create very interesting images. We see little detail but obtain mystery and darkness.

Like the three-quarter rear key, back light positions are often used for supplemental modeling light. This function will be discussed shortly.

FIGURE 2.10

BACK KEY POSITIONS

A back key light comes from behind the actor and emphasizes the hair and outline of the head. Frontal fill light has been added in (b) and (d).

F ILL LIGHT

The key light determines shadow placement. The fill light is used to lighten (fill in) those shadows while avoiding the formation of new shadows. Fill lights are almost always soft, even when keys are hard. This is because the slow falloff of soft light provides a more natural "fill," almost invisible in its effects. Fill lights are used to create and control moods, and when done well are unobtrusive. There are many good examples of fill light throughout the book. Have a look at the fill light effects in Figures 1.7 and 2.21.

Fills tend to be placed in one of four positions (see Figure 2.11). The first and most common is from a frontal position along the camera/subject axis

FIGURE 2.11

FILL LIGHT POSITIONS

Three common positions for the fill are (1) frontal from slightly above the camera, (2) slightly off-axis on the key side of the subject, and (3) slightly off-axis on the shadow side of the subject.

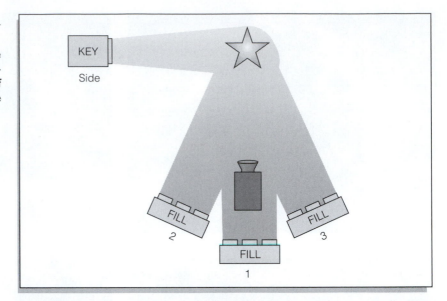

FIGURE 2.12

DOUBLE THREE-QUARTER FRONT SETUP

Both key and fill come from three-quarter front positions and create distracting double nose shadows as well as double wall shadows in cases where the actor is close to the wall.

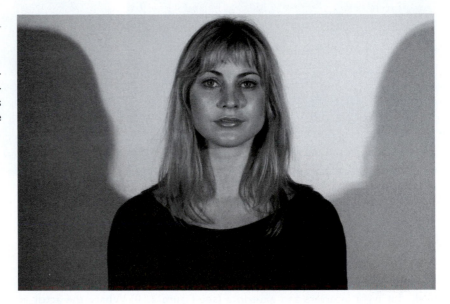

slightly above the camera. This position is preferred because it creates no new shadows of its own. A second position for the fill is from the key side of the camera/subject axis. This position allows for a more modeled effect than does the camera/subject axis position. Another possibility is to fill from the off-key side of the face, taking great care not to create a new set of shadows, particularly on the nose. This position also allows for a modeled effect, but because of actor movement can easily lead to shadow problems.

Some texts define the fill light as light coming from the side of the face opposite the key at what amounts to a three-quarter front position. With close-ups this is not a recommended position for the fill because it yields unflattering, double nose shadows and, if the subject is near the background, a double shadow on the wall (see Figure 2.12). With such a fill position, you risk destroying the mood effects of the key unless you keep the fill at very low levels. A frontal key without fill is generally preferable.

For long shots, the effects of this double frontal 45-degree position are not so devastating. In fact, two three-quarter keys can be used to create a

broad area of overall illumination, flat but useful, particularly for television news coverage of, for example, a board meeting.[2]

A last fill position is from high above, such as diffused overhead lighting on a set, a technique used by Swedish cinematographer Sven Nykvist. Its main advantage is that it lessens the risk of casting multiple shadows on the walls behind a moving subject.[3] Shadows cast by lighting from above tend to fall onto the floor. The higher the light, the closer the shadow is cast to the actor's feet. This fact is useful for key light placement as well. A possible disadvantage is the lack of fill in eye sockets and other facial indentations due to the high angle of incidence.

A variation on the frontal fill is the **roving fill** used with tracking and dolly shots. The light is either mounted on the camera or dolly, or carried by a grip. The idea is that wherever the camera goes, the fill will follow. For example, the camera follows two dancers in a large ballroom scene. As they turn and revolve, they will be filled in by the camera-mounted light. The moving fill, or even moving key, is very useful and has a large number of applications.

The intensity of the fill light has important effects on image mood. These are sometimes referred to as "high-key" and "low-key." In **high-key**—light, bright, cheery moods and effects—the fill light will be nearly as bright as the key light (see Figure 2.13a). With **low-key** effects and their accompanying mysterious, morose, dark moods, the fill will be of low intensity relative to the key light (see Figure 2.13b). Sometimes no fill is used at all (see Figures 2.8 and 2.9).

The use of "key" to indicate the overall mood of the lighting should be distinguished from the concept of key light discussed earlier. The two have little to do with one another and are an unfortunate terminological overlap.

The exact position of the fill in a particular shot will be determined by moving shadow considerations and the overall mood desired. Mood also derives from how foregrounds and backgrounds are treated relative to the subject area. See the discussion of background light later in this chapter.

B ACK, RIM, AND KICKER LIGHT

In most general terms, light from the rear of the subject is called *back lighting*. Back lighting may be further differentiated, depending on the angle it comes from and its effect on the subject (see Figure 2.14).

We will use three terms to describe the different types of back lighting: *back light*, *rim light*, and *kicker light*. Light coming from directly behind the subject and usually from above will be termed **back light**. Back light is used to highlight hair and separate the subject from the background. Angled light from the rear that "rims" or outlines all or part of the subject will be called **rim light**. Rims are also used to create the highlights on hair and edges of cheeks to which we have become accustomed. Some authors use the term *kicker* for this light. Still others call it a back light, but we will use the term *rim*, which emphasizes the effect and allows for more than one of these lights in a particular setup (see Figure 2.15).

Kicker will be used in this book to stand for a particular type of rim light—light from a three-quarter rear position used in conjunction with a three-quarter front key (see Figure 2.16c). In the 1940s when the three-quarter

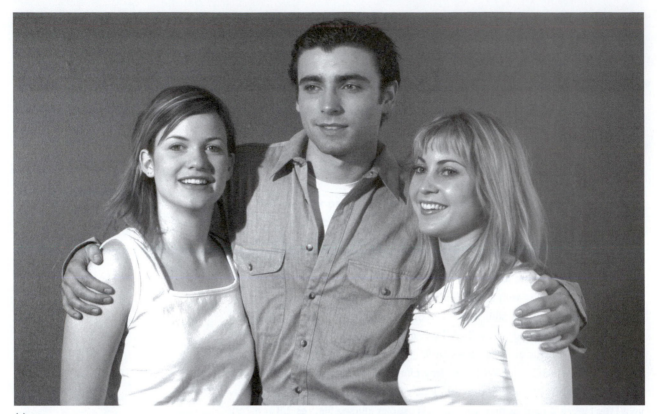

(a)

(b)

FIGURE 2.13

EXAMPLES OF HIGH- AND LOW-KEY LIGHTING

The intensity of the fill light, where present is a factor in creating either a high-key mood (a) or a low-key effect (b).

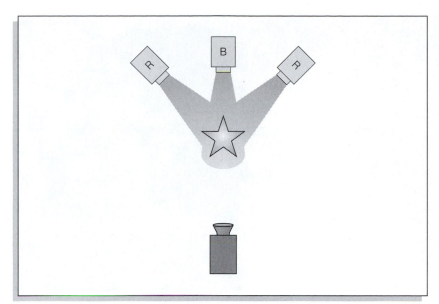

FIGURE 2.14

BACK LIGHTING DEFINED

The diagram shows how this book distinguishes between back light and rim light. If the rim in either of the three-quarter rear key positions were accompanied by a three-quarter front key, the rim would be labeled a "kicker."

front key was the favored key position, the "kick light" came from the three-quarter rear directly across the subject from the key.[4] Kicker is also used to mean a light that selectively highlights a certain portion of the shot, say a bottle of perfume in a commercial. This type of kicker would not necessarily come from a rear position.

The main functions of back, rim, and kicker lights are to create depth, to model the subject, and to separate the subject from the background. Referenced to keys, rim lights go best with three-quarter front and side keys; back lighting works best with frontal keys.

Rim and back lights are often used for window effects. For example, assume a sunny early-morning interior with a subject sitting at a kitchen table. We can use a rim light from outside the window to create the effect of daylight streaming in. A side key is also usable for this effect.

Hard light sources are commonly used for rim and back lighting because they minimize the danger of lens flare and unwanted light spilling onto areas of the set. With rim and back light, it is often necessary to flag the lens because matte boxes and lens shades often are not enough to prevent flare.

ATMOSPHERIC EFFECTS

Back light is essential in order to show fog or smoke and is used to establish atmosphere in locations such as smoke-filled bars. Without quite a bit of back light, the effect would be invisible to the camera. Likewise, artificial smoke is put into the air so that a beam of light can be seen—a favorite effect in music videos that was developed earlier in feature films such as *Blade Runner*. Back light also reveals rain and other translucent atmospheric effects—situations in which intentional underexposure may be desirable.

THREE-POINT LIGHTING STYLE

The triple combination of three-quarter front key, fill, and kicker (three-quarter rim) forms a **three-point lighting** style (see Figure 2.16). Based on

FIGURE 2.15

RIM AND BACK LIGHT

Rim and back lights are generally from high elevations and are capable of a variety of effects, from the facial effects in (a), to the hair accent in (b), and the full-figure effect in (c), which is from $8\frac{1}{2}$ (Corinth Films, Inc., 1963).

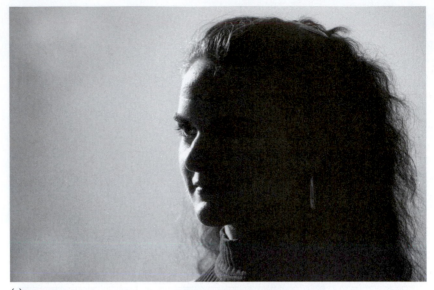

(a)

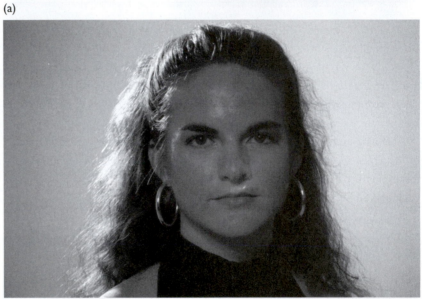

(b)

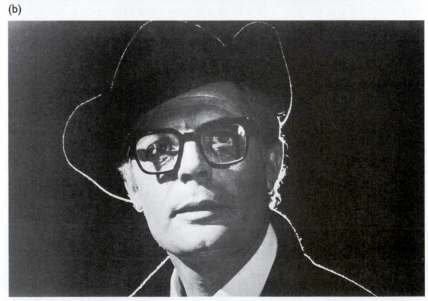

(c)

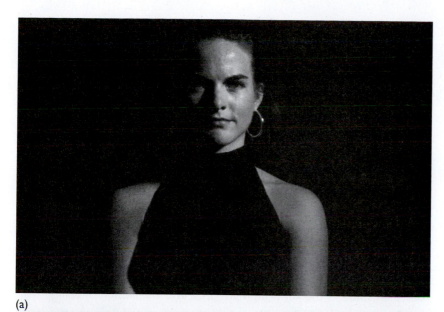

(a)

FIGURE 2.16

THE REMBRANDT

The three-point lighting style consists of a three-quarter front key (a), to which is added a fill (b) and a kicker (c). The term is also used to refer to any combination of key, fill, and back light. ■■■

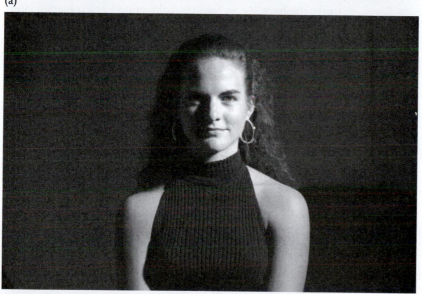

(b)

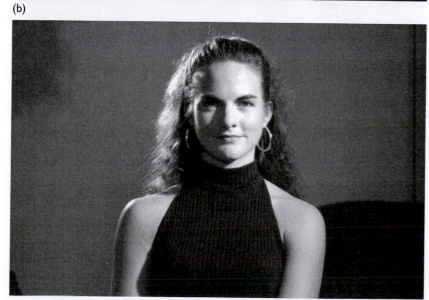

(c)

the **Rembrandt effect** and its familiar triangle-shaped patch of light on the shadow side of the face, the three-point technique was the standard way to light actors in the classic Hollywood film style and is still common today, both for indoor and outdoor effects. Although perhaps overused, the technique offers a good starting point for face and figure lighting in cinematography.

ACKGROUND AND SET LIGHTING

Lighting is generally conceptualized in terms of subject, background, and foreground planes. Where actors are staged in depth, we have more than one subject plane. When possible, we light backgrounds and foregrounds separately from subject areas (see Figure 2.17). Our choice of the principal plane determines the overall T-stop used. The other planes are lit at levels referenced to that T-stop. Standard practice is to illuminate backgrounds with the same source direction as the key light, which preserves the illusion of reality.

Some cinematographers like to light the background first, creating interesting visual patterns there and then working up to subject areas.[5] Others begin with the subject and work their way to the background. In either case, while director and actors are rehearsing or shooting on one set, preliminary lighting (prelighting) can be set up on another.

Through the 1970s, cinematographers often applied an overall base-level fill light ("filler") to the set, which ensured that all objects within the frame would be at a minimum acceptable level. This technique is generally not used much today except in television, because the improved quality of current film

FIGURE 2.17

A TYPICAL BACKGROUND LIGHT

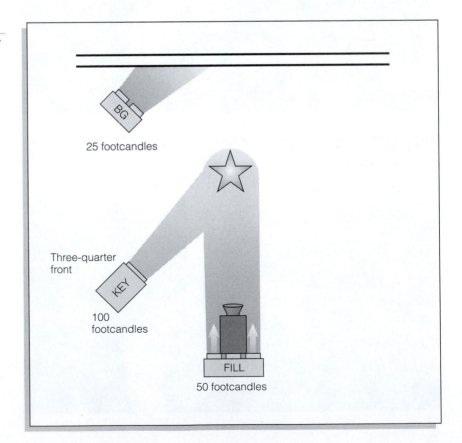

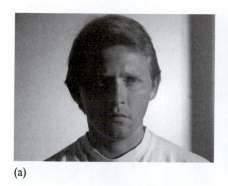
(a)

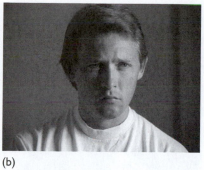
(b)

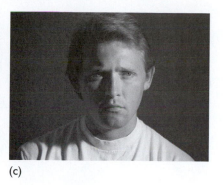
(c)

emulsions allows for more shadow detail without our having to light for those shadow values.

Day interiors and night interiors are often shot on the same set but appear different because of how the backgrounds are lit, night being represented by darker levels than day. Typically, backgrounds and foregrounds are kept roughly one stop darker than the subject (see Figure 2.18).

Backgrounds lit to levels about the same as the subject plane are a feature of high-key lighting. These backgrounds are generally light-toned and brightly colored as well (see Figure 2.19). Low-key styles require differentiations greater than one stop between background or foreground and subject (see Figure 2.18b). This can be accomplished by set design as well as background lighting.

To create the illusion of reality and to avoid visual boredom, it is best not to light a background evenly. Instead, cinematographers strive to establish the tonal variations found in real-life situations. This is done by flagging (cutting out light), scrimming (cutting back on intensity), and utilizing natural light falloff (see Figure 2.20).

It is sometimes useful to add background or foreground accents for compositional reasons. For example, we might light a selected portion of the background to create a visual balance within the frame (see Figure 2.21).

FIGURE 2.18

BACKGROUND LEVELS

The same three-quarter key setup on the actor is used to obtain different moods by altering the intensity of the fill and background lighting in (a), (b), and (c). ▮▮▮

FIGURE 2.19

HIGH-KEY BACKGROUNDS

A high-key effect is created by the cinematographer through use of the window, blinds, and curtain effect as background (8½, Corinth Films, Inc.) ▮▮▮

FIGURE 2.20

BACKGROUND LIGHTING USED
TO CREATE VISUAL VARIETY

The background has been divided into a
black and white field that functions to
separate the two characters and create
an interesting pattern of light and shadow
(*The Third Man*, Studio Canal Image,
1949). ▮▮▮

FIGURE 2.21

BACKGROUND LIGHT USED TO
CREATE COMPOSITIONAL
BALANCE

Note how the lighting of the building and
piazza pavement has been composed so
as to create diagonals frame left that lead
our eyes to the face (*8½*, Corinth Films,
Inc. 1963). ▮▮▮

FIGURE 2.22

SHADOW PROJECTED ON BACKGROUND

The shadow pattern is also used on the actors in this example.

In TV commercials and music videos, backgrounds are sometimes kept intentionally nondescript, putting the subject in a visual limbo. The background is made just one color, without shadow or depth, so that the image space becomes flat and indefinite. This is particularly effective with product commercials, where the goal is to get the audience to watch only the product and not the background.

By using separate lighting for subjects and backgrounds, we are able to avoid shadow problems on the background. In small, documentary-style, TV news situations, wall shadows are often a problem because the key light illuminates the background as well as the subject. There is no aesthetic advantage to using the same light for both subject and background, just less expense and faster setups.

In the classic B & W style of lighting, it was very popular to project shadows onto background walls. Think of the horror films with their shadow of the monster appearing on the wall; or the *film noir* style where the venetian blinds are shadowed on the background. This effect is also common in "color *noir*" films such as *The Two Jakes, Blade Runner,* and *Body Heat.* In general, background projections are associated with stylized lighting such as *noir*.

To create a shadow on a background, we can place a **cucaloris** ("cookie") between the wall and the set light, or we can use a **shadow projection device**. The latter is a special spotlight designed to project a variety of patterns onto walls or even onto subjects (see Figure 2.22).

FIGURE 2.23

EYELIGHTS

The small eyelights coming from the fill light in (b) bring the actor's eyes alive in comparison to (a), which lacks an eye-light. ▋▊▋

(a)

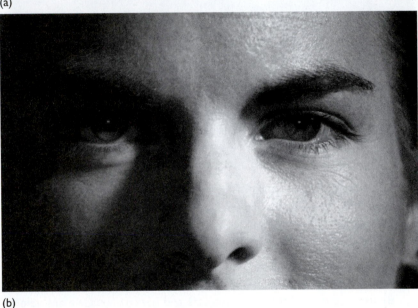

(b)

SPECIALIZED LIGHT PLACEMENTS

Once we have completed lighting the subject and set, we sometimes need to fine-tune our lighting setup. To do this we use a variety of specialized lights.

EYELIGHTS

The eyelight is very important. It is used not to illuminate in the exposure sense but to create a reflection and give a sense of aliveness to the eyes (see Figure 2.23). Eyelights are also used for special effects. For example, eyelights with odd shapes or colors are used to create a feeling of strangeness or an alien nature—a technique used in the film *Cat People*.

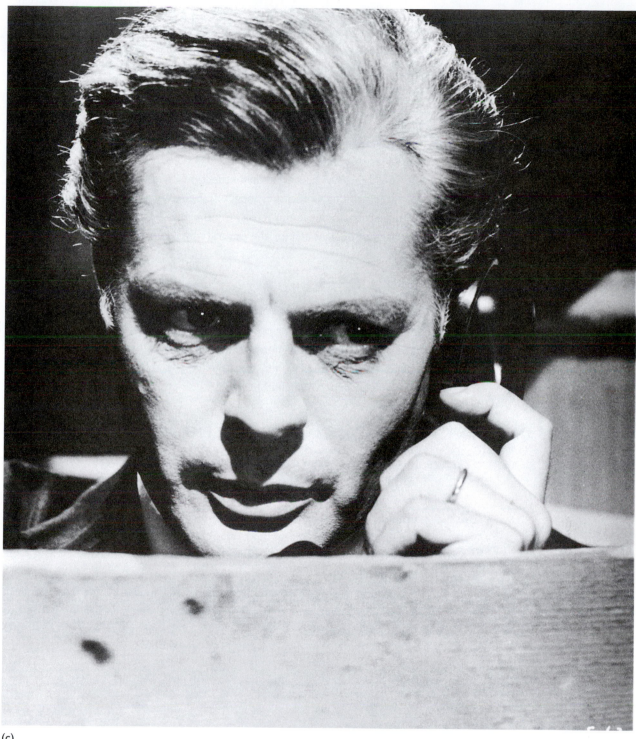

(c)

FIGURE 2.23 (continued)

The eyelight in (c) gives a very interesting look to the eyes (*8½*, Corinth Films, Inc. 1963). Without this eyelight, the eyes would have been lost in pools of shadow. Many of the photos in this book have interesting eyelights. See, for example, Figure 1.1c and d. ▪▫▪

Eyelights are easy to arrange. A fill light positioned on the camera/subject axis will simultaneously function as an eyelight. Where there is no such fill, we can mount a small light above the camera, as with a roving fill light. Wherever the camera is pointed, there is a light that reflects in the eye. Another technique is to use a hand-held light close to the subject on the camera/subject axis. During the shot it can be moved as necessary. The eyelight does not have to illuminate the subject, just reflect off the eyes. Eyelights are generally of low intensity; any open filament bulb will suffice. Some cinematographers even use flashlights to create eyelights.

Set lights can cause multiple reflections in the eyes. Usually more than two is disturbing, unrealistic, and undesirable. A good rule of thumb when lighting actors for close-ups is to check the eyes, both for the deadness caused by a lack of eyelight and for the opposite problem of too many reflections.

HAIR LIGHTS

In shampoo commercials and glamour cinematography, hair light plays an important role. There are several types of **hair lights**: from directly overhead (see Figure 2.23c), from more oblique angles that can be used for dramatic effects (see Figure 2.24), and from behind the subject giving a kind of halo effect (see Figure 2.10a and b).

OTHER SPECIALIZED PLACEMENTS

It is frequently necessary to light a specific object such as an iron railing or a leafy fern or a significant prop. These objects often provide compositional balance or require thematic emphasis. Details like this add to the image's sophistication. Object lights are common in product commercials where they are applied to food, beverages, and other products to be sold. Sometimes the objects can be lit by lights present in the shot (**practicals**), such as a table lamp or a candle.

Clothing is often isolated from the key/fill applied to the face and given its own treatment with a clothes light. Many times, side lighting is used to emphasize texture.

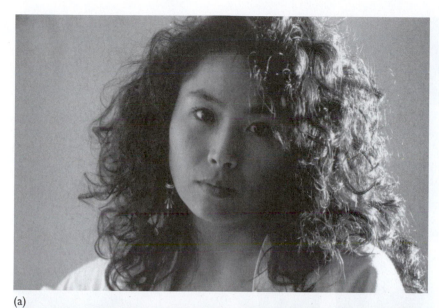

(a)

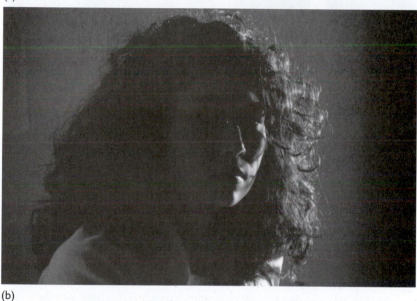

(b)

FIGURE 2.24

HAIR LIGHTS

Both hair lights in (a) and (b) are from the side. Note the different moods created by the amount of darkness in the facial shadows. See also the examples in Figure 2.10.

SUMMARY

We have identified five basic light placements in this chapter: key, fill, rim/back, background/set, and a variety of specialized lights. These five lighting concepts provide the cinematographer a starting point for establishing a lighting scheme (see Figure 2.25).[6]

It must be emphasized that the concepts presented in this chapter do not depend on the use of artificial light sources. Many of the effects described can be accomplished with the selective use of available light. In the final analysis, lighting is a series of visual choices, not the automatic turning on of lighting units.

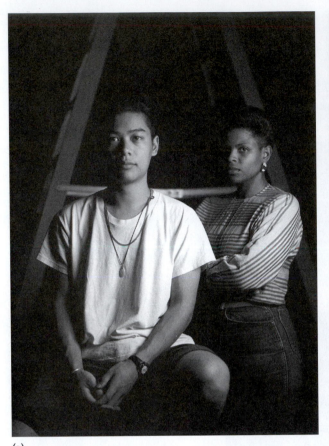

(a)

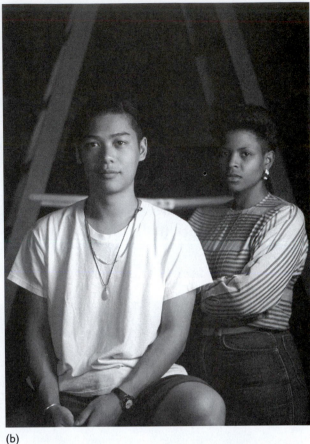

(b)

FIGURE 2.25

BASIC LIGHTING SCHEME
USING FOUR LIGHTS

Building a lighting scheme using (a) key
only, (b) key and fill, (c) key, fill, and hair
light, and (d) key, fill, hair, and background
light.

NOTES

1. See Walter Nurnberg, *Lighting for Photography,* 16th rev. ed. (Philadelphia: Chilton, 1968), and *Lighting for Portraiture,* 7th ed. (Philadelphia: Chilton, 1969).

2. Advocacy of this position for the fill light seems to derive from television lighting texts. I can find no film lighting book that recommends this fill placement. The notion of a 45-degree fill probably derives from earlier theater techniques and found its way into film around 1912 with Vitagraph Studio films (see Barry Salt, *Film Style and Technology: History and Analysis* [London: Starword, 1983], pp. 98, 139, 141). In a personal correspondence, Warren Bass points out that "double 45-degree lighting was codified into classic lighting theory [for theater] by Stanley McCandless in the 1930s." Bass notes that since early television lighting designers tended to come from theater and not film, the position became institutionalized in television—hence the use of a 45-degree fill position in television texts.

3. See Kris Malkiewicz, assisted by Barbara J. Gryboski, *Film Lighting* (New York: Prentice-Hall, 1986), pp. 118–19.

4. See Charles G. Clarke, *Professional Cinematography,* 2nd ed. (Hollywood: American Society of Cinematographers, 1968), pp. 97, 104, 106.

5. Ibid., pp. 101–2.

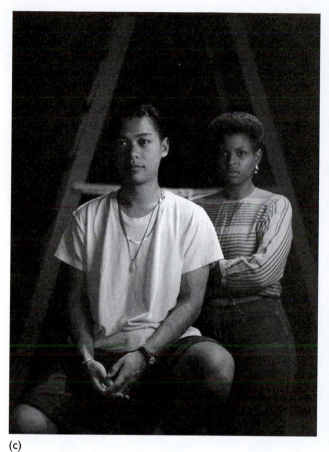

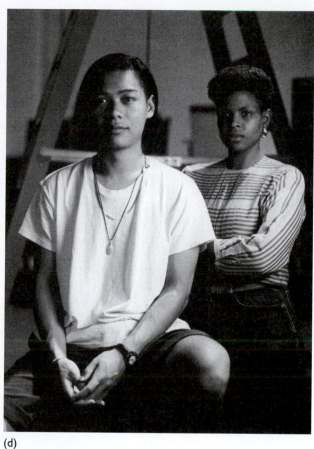

(c)

(d)

6. Lighting as we know it developed in Hollywood throughout the studio era. Cinematographers used an Eight Light Technique (sometimes seven depending on who was doing the counting). Charles G. Clarke lists the seven basic lights he utilized as: key, fill, back, set, kick, eye, and clothes light. This system amounts to the triangle technique of key, fill, and back/kick with the addition of set and supplemental lights. (See Charles G. Clarke, *Professional Cinematography,* pp. 97–109.)

 John Alton lists the following eight lights as the Hollywood style: fill light, keylight, filler light (this is the additional eighth light—overall set illumination), clothes light, back light, kicker light, eyelight, and background light. See John Alton, *Painting with Light,* (New York: Macmillan), 1949, p. 99.

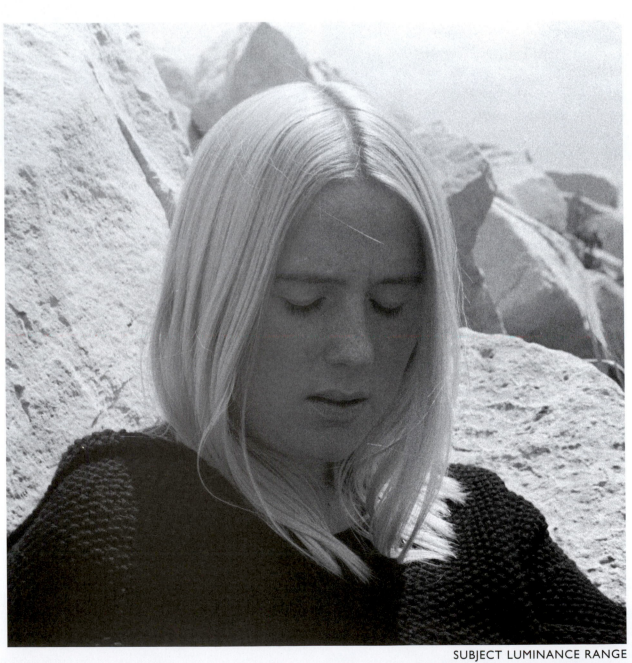

SUBJECT LUMINANCE RANGE

Basic Working Methods: Lighting Ratios

Lighting ratios and subject/background ratios are lighting concepts used to control luminance range. Lighting ratio is defined as the ratio between the light and shadow sides of a subject. Subject/background ratio is the ratio in lighting intensity between the subject plane and the background or foreground. Both of these ratios are fundamental in mood creation. We use incident meters and video monitors to set both these ratios in our lighting.

N THE TWO PREVIOUS CHAPTERS, we examined important lighting concepts—quality, direction, motivation, and light positions. Here we will learn to use the incident meter to establish lighting ratios which will enable us to use those lighting concepts to establish image moods and styles.

There are three distinctly different ratios involved in lighting. Although contrast—the relation between highest value and darkest—is integral to all three, there is no standard terminology used to refer to the three ratios. Here are the terms we will use.

1. **Lighting ratio**—the ratio between the light and shadow sides of a subject created by key and fill light. We will sometimes call this **facial ratio** when the subject in question is an actor or actors and the representation of the face is important.[1]

2. **Subject/background ratio**—the ratio between the lit subject area, such as the actors, and other parts of the frame, most commonly the background (bg) or foreground.[2]

3. **Luminance range**—the ratio between the brightest significant luminance and the darkest significant luminance in the frame. We will explore this term extensively in Part II: Fundamentals of Exposure. Luminance range is where lighting and exposure intersect. When lighting is complete, the luminance range is rendered onto the film emulsion by an exposure setting.[3]

We commonly express these ratios in mathematical terms referenced to footcandle (fc) values, such as 4:1 or 16:1, or to T-stops—the face was lit with 200 fcs on the light side and 50 on the shadow side, a 4:1 ratio; or, the subject was lit two stops brighter than the background. To facilitate clarity, we will carefully distinguish these terminologies using the arithmetic ratio terminology when discussing lighting ratios and reserving the T-stop language for discussions of subject/background ratios.

LIGHTING RATIOS/FACIAL RATIOS

Lighting ratio refers to the intensity difference between the light and shadow sides of a subject. This difference results from the variety of key and fill light

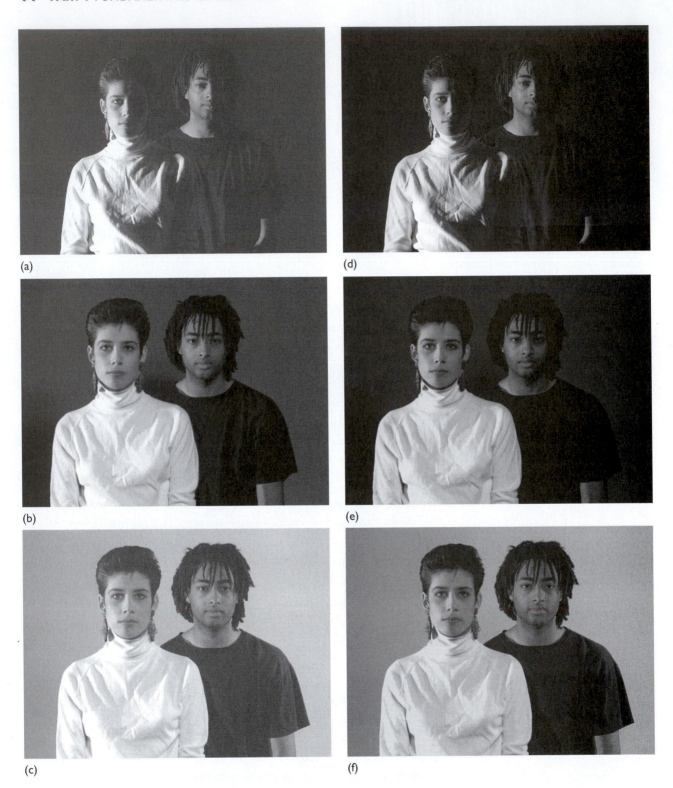

(a)

(d)

(b)

(e)

(c)

(f)

FIGURE 3.1

SUBJECT LIGHTING RATIOS

Side key with various lighting ratios: (a) 8:1, (b) 2:1, (c) 2:1 with background light raising back wall to light gray; (d), (e), and (f) are the same as (a), (b), and (c) but printed one stop darker.

combinations. As mentioned previously, the amount of fill light applied to shadows greatly affects image mood. In the case of lighting ratios, what we are interested in is setting keys and fills to create and control these moods.

As an aid in learning lighting, we construct lighting ratios mathematically. Over time, with enough experience and testing, we learn to visualize how a certain ratio will look on the screen and can instruct the gaffer to set lights accordingly.

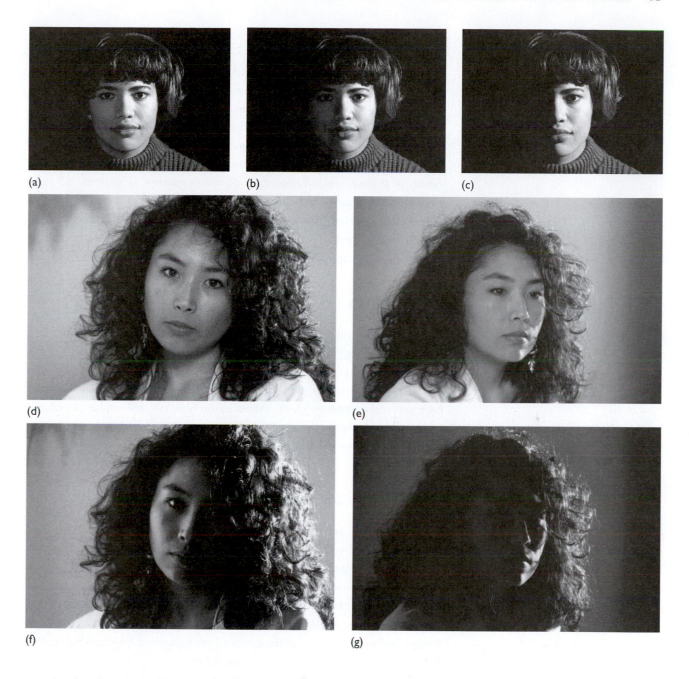

(a) (b) (c)

(d) (e)

(f) (g)

Some cinematographers say they like to set lighting ratios "by eye." This means they have sufficient experience to previsualize the effects of a certain fill light intensity; that is, they have attuned their eye to a particular stock's contrast properties. This is fine as long as you know in advance what the image will look like on the screen. In the beginning, the best way to learn how a particular ratio will look is to run lighting ratio tests on the various motion picture stocks, or, better yet, to shoot a number of films using the different emulsions. The latter method is preferable because it will give you experience and a feel for an emulsion's visual properties.

Lighting ratios allow us to re-create select moods by defining the intensity of the fill light relative to the key. Note the different moods available in Figures 3.1 and 3.2 and in various other examples throughout the book.

FIGURE 3.2

SAMPLE SUBJECT LIGHTING RATIOS (FACIAL RATIOS)

(a) 2:1, (b) 4:1, (c) 32:1, (d) 1:1, a frontal key (e) 4:1, (f) 8:1, (g) 16:1.

SETTING FACIAL RATIOS

Point the meter at each light; shield it from all other lights. Some cinematographers use the flat disk for this rather than the photosphere. Either way, the needle will give you a footcandle value. Use these footcandle readings to set up your ratios. For example, say you want a 4:1 facial ratio. You point the meter at the key light and obtain a reading of 80 footcandles. You would divide 80 by 4 to obtain a value of 20 footcandles for the fill.[4] Note: Establishing the values for these ratios has nothing to do with exposure. To determine T-stop, you follow the procedure explained in Chapter 1—stand in the light falling on the subject, and point the meter at the camera. This is a simplified method and we will explain further what is going on in Part II, but you should be able to expose correctly and set facial ratios accurately with these procedures.

ISN'T VIDEO SIMPLER?

With video, you will most likely determine facial ratios by looking at the monitor while adjusting the fill light rather than by measurement. Assuming the monitor or eyepiece is near correct calibration, what you see is what you'll get. Remember, however, although video seems deceptively easier, it is just as hard to create interestingly-lit images as on film. We will explain all of this when we deal with video explicitly in Part IV: Digital Cinematography. For now, use your eyes to establish ratios.

SUBJECT/BACKGROUND RATIOS

The relationship between subject and background may be conceptualized exactly as we did with lighting ratio. The subject—equivalent to the light side of the face—is placed in a background context—equivalent to the shadow side of the face—within a known ratio. This subject/background ratio also applies to subject/foreground. We meter the **background** and **foreground planes** by putting the incident meter in the lighting on the background or foreground and pointing it at the camera in the standard manner. This reading is then compared to the reading for the subject.

The first step in lighting a background is to determine whether the **subject plane** or the background is to be the basis for the exposure of the particular shot. For example, if the subject is lit to T 8, we might then light the background to a T 5.6 level, thus underexposing it one stop. The T-stop for exposure is determined with the initial lighting setup, be it the subject or background. Alternatively, we could light and plan exposure around the background level of, say, T 2. We would then light the actors to the desired level relative to the background.

The principle to remember: Whichever plane we expose for will be rendered accurately—it will be given a correct exposure and look like itself. The other plane will render lighter or darker than normal because of our decision to expose for the first plane.

Let us look at another example. Suppose you wish to have a dark background and correctly exposed actors. This amounts to a high subject/back-

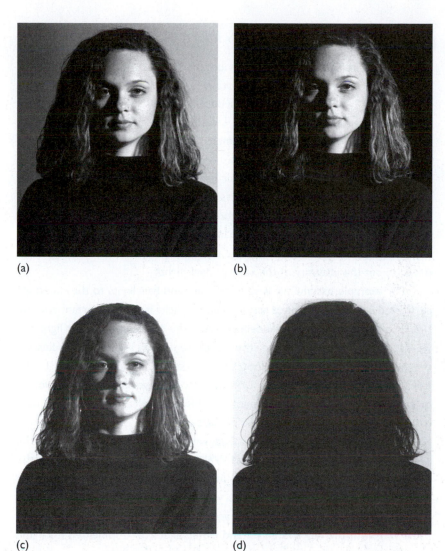

(a) (b)

(c) (d)

FIGURE 3.3

SUBJECT/BACKGROUND RATIOS

Starting with a white screen, we can control how it reproduces by changing the intensity of the background light while holding the lighting on the subject at the same intensity.

In (a) we have a 16:1 subject/background ratio for the gray part of the screen on the left. This means it was underexposed four stops and renders as a zone 5 instead of its normal zone 9.

In (b) the screen is underexposed eight stops. This renders it as a zone 1 black instead of zone 9. The subject/background ratio would be 256:1.

In (c) the screen is lit to the same intensity as the subject and thus reproduces its normal zone 9 value.

In (d) we create a silhouette by lighting the screen and not the subject. Underexposing the facetones at least five stops while exposing for the white screen in the background ensures that the facetones are rendered at zone 1 instead of the standard zone 6.

ground ratio, say 3 stops underexposed for the background. Exposure will be for the actors, so you first determine that T-stop. Let us say you obtain T 4. If you remember your T-stop scale, then you know that 3 stops underexposure would mean you light the background to obtain an exposure reading of T 1.4. On the T-stop scale: 1, 1.4, 2, 2.8, 4, and so on, we can easily count three stops down from T 4 to obtain the 1.4. To be clear, you stand in the background, point the meter at the camera, and adjust the lights to obtain T 1.4. You expose the shot for the actors at T 4, though, because that was your initial reference point.

The conventional rule of thumb is to underlight backgrounds one stop. This places the emphasis on the actors and minimizes background distractions. The photos in the section on background lighting in Chapter 2 provide a variety of examples of the effects of different subject/background ratios (see Figures 2.18 through 2.21).

Figures 3.3a, b, and c show basic background choices using a simple white background. The shot in Figure 3.3d shows we create **silhouettes** by turning off the light on the actor—in effect lighting only the background.

SETTING INTENSITIES FOR RIMS AND BACK LIGHTS

When taking readings for ratios, it is usual to shield the meter or turn off other lights. On large production shoots, cinematographers work with gaffers to determine where to position lights. Because light source intensity is measured, the subject need not be present. Lighting can be roughed-in while awaiting the actors and director for final camera angle determination. The exposure reading will be taken once the camera setup is finalized.

Other lights, such as rims and hair lights, are set relative to the intensity of the key. Generally, rim and back lights are "hotter" (higher in intensity) than the key, from two to eight times brighter depending on the mood intended. For subtle modeling effects, rim and back lights will be set to the same intensity as the key. We need to know the intensity of the key in footcandles in order to set the intensity of the various back lights.

For example, assume we wish to add rim and hair lights to the situations illustrated in Figure 3.1. Let us assume the hair light is very important and the rim is to be used for subtle modeling effects. We start with the hair light and we decide to overexpose it two stops. Because the key is 110 footcandles, we set the hair light initially to 440 footcandles to establish the two-stop, 4:1 relationship. Next, we judge the effect on the actor by eye. We might then lower or raise the hair light's intensity, recording this value in case reshooting is necessary (see Figures 2.10a and b and 2.15a, b, and c).

Because the rim light is to be subtle, we would set it initially at about the same level as the key, 110 footcandles. While supervising the placement of the rim by eye, we might intensify it slightly to make it more noticeable (see Figures 3.2d–f). To obtain these values, you point the meter at the rim or hair light, turning other lights off to obtain accurate readings. Exposure is taken the usual way with the key and fill on and other lights off or shielded from the meter. Again, with video, you would set rim and hair lights by eye.

For this basic portrait setup, we next check the eyes. There should be a nice reflection from the fill in this instance. If not, add eyelight as necessary.

The last step in building up this lighting setup is to balance the background, or foreground, to the subject by lighting it to intensity levels based on the subject plane, generally the most important plane for lighting purposes.

WORKING TO A FIXED T-STOP

Many cinematographers work to a predetermined T-stop in order to maintain visual consistency or a particular depth of field. Once the decision is made to expose at a certain T-stop, key lights are set for that level. The fill is added to approximately the right intensity after the keys are placed. Because fills will affect exposure more at 2:1 than at 32:1, once the desired ratio is set up, lights will often have to be readjusted to maintain the selected T-stop, or, alternatively, a slightly different T-stop can be used.

SUMMARY

In this chapter, we looked at how lighting contrast ratios are used to establish lighting setups. We have only described how to set ratios. The explanation of how they impact on film emulsions is the subject of Part II. The central concepts examined so far are:

- *Lighting ratio*—the ratio between the light and shadow sides of a subject created by key and fill light.
- *Subject/background ratio*—the ratio in lighting intensity between the subject and the background or foreground.
- *Setting intensities for rim and backlights*—the intensity is generally from two to eight times brighter than that of the key light.

The overall goal is to be able to previsualize the effect of a certain ratio on the film image. Once you have some experience, you will be able to relate specific ratios to specific visual moods. You can memorize these relationships and use them when necessary (see Figure 3.2).

In the section on subject/background ratio, we saw that the cinematographer can control the rendition of backgrounds by manipulating the intensity of the background lighting and that various effects may be obtained. We saw that rim and back light intensities are set relative to the key light.

In Part II, we will look at the role exposure plays in creating image looks and how that relates to lighting. In Part III we will return to lighting, in particular the creation of lighting styles for interiors and exteriors.

NOTES

1. Various other terms exist in the literature. Alan J. Ritsko uses "lighting ratio." Gerald Millerson calls it "contrast ratio," "lighting contrast ratio," and "fill light ratio." Phillip Courter uses "lighting ratio" and "lighting contrast ratio." Anton Wilson uses "lighting ratio." Harry Mathias and Richard Patterson use "contrast ratio" and "lighting ratio." Charles G. Clarke calls it "light ratio."

2. This is also called "exposure ratio" (Ritsko), "contrast ratio" and "face and background contrast" (Millerson), and "subject illumination to background illumination ratio" (Courter).

3. Common alternative designations include "luminance range" (Ritsko); "luminance ratio" (Ritsko, Wilson); "contrast range," "subject brightness range," and "brightness ratio" (Millerson); "scene contrast range" (Courter); and "brightness range," "contrast range," and "contrast ratio" (Mathias and Patterson).

4. We are using the simplest method for calculating ratio. There are other ways. For example, the lit side of the face in our example actually has key and fill light on it while the shadow side has only fill. Rather than with our simple method where we calculate key/fill, we could define facial ratio as key + fill over fill. This ratio may be established by using the incident meter pointed at the camera from both sides of the face or by using a spot meter to measure the lit and shadow sides of the face.

 In our text example, we hypothisized a key with 80 fcs and a fill of 20 fcs; that is, K/F = 4 or a 4:1 ratio. But the numbers change when we use K+ F/ F because

the lit side is now 100 fcs (K + F) divided by 20, a 5:1 ratio. The same exact lighting setup is represented by different mathematical ratios. But so what? Both of us will expose at the same T-stop and arrive at identical shots on the screen.

Think of ratio as a tool for you to use and not as an end in itself. What matters is consistency of method. As you get to know what 4:1 means visually, you can previsualize other ratios like 8:1. As long as you stick to a single method, you will be able to control image mood on faces. Eventually, you might even set fill light by eye and not even calculate ratio. What is important is the visual effects of your lighting.

PART II

FUNDAMENTALS OF EXPOSURE

*T*he proper use of light can embellish and dramatize every object—and that carries us into the province of the artist. . . . We cannot see without light, and we cannot photograph without it. Therefore the knowledge of what light means and how it affects what it strikes is the first step in the direction of what photography means.

~JOSEF VON STERNBERG
Fun in a Chinese Laundry

ZONE 5 EXPOSURE

CHAPTER FOUR

Basic Exposure Concepts

Exposure is an important technical basis for the art of lighting. Exposure consists of relating the range of luminances in front of the camera to the characteristic curve of the emulsion. Our tool for doing this is the incident meter. For many cinematographers, exposure is as creative as lighting. To master exposure technique and to control the look of images requires a knowledge of light, an awareness of the subject's visual properties, and experience with the various film emulsions.

IGHTING AND exposure techniques are inseparable and inter-dependent. **Lighting** is the creation and control of luminance range. **Exposure** is the placing of that range onto the characteristic curve of the negative in a controlled manner. These chapters on exposure apply mostly to film although many of the ideas introduced here will be discussed relative to video in Chapters 11 and 12. This chapter and the next are the most technical in the book, so do not get discouraged—relief is in sight.

If exposure is viewed as a creative act, then ultimately "correct exposure" is what the cinematographer wants. But this presumes years of experience—which is why most books define correct exposure in more conventional fashion, something like the following:

> A placement of the subject's luminance range onto the characteristic curve of the negative so as to retain a full scale of brightness values, from black to white, with density increases proportional to original subject luminance increases.

To understand this definition requires an explanation of luminance range and characteristic curves.

LUMINANCE RANGE

Objects can absorb, transmit, or reflect incident light. **Reflected light** allows us to perceive objects as well as photograph them. The light reflected by an object is expressed as a percentage of the light falling onto it—the **incident light.** This percentage of light reflected is called the object's **diffuse reflectance** or **reflection factor.** We will simplify and refer to them both as **reflectance.**

For example, a white object reflects most of the light falling onto it, 90% or more, and is said to have a high reflection factor. A black object absorbs most of the incident light and reflects small amounts; consequently it has a low reflection factor, around 2%–4%. If we shine 100 footcandles of light onto

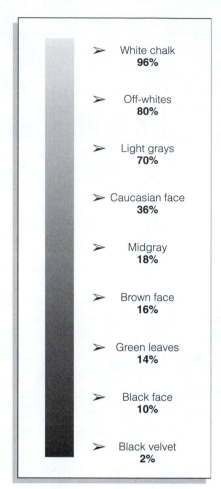

FIGURE 4.1

TYPICAL REFLECTION FACTORS (DIFFUSE REFLECTANCES)

White chalk 96%

Off-whites 80%

Light grays 70%

Caucasian face 36%

Midgray 18%

Brown face 16%

Green leaves 14%

Black face 10%

Black velvet 2%

white chalk, it reflects 96% of the footcandles, expressed as 96 **footlamberts**. Similarly, black velvet reflects 2%, or 2 footlamberts.

The typical range of natural reflectances—from whitest white to blackest black—is about 96% to 2%, usually expressed as the ratio 48:1. (See Figure 4.1.) Photographic pioneers Hurter and Driffield found that the average of all diffuse reflectances in nature is about 18%, a calculation of importance to exposure theory as will be explained shortly. *Midgray* and *zone 5* are more common ways to identify an 18% reflectance.

Reflectance is a natural property of the object and does not change. If you shine 500 fcs onto a midgray card, it will reproduce accurately if you expose for it—the same goes for 100 fcs. We assure a constant zone 5 reproduction for the gray card by adjusting T-stop.

Lighting usually comes from an angle. This automatically results in a secondary, shadow range of luminances. This shadow range still has a 48:1 ratio, but it is at a different intensity level than the lit side. The **overall luminance range** is defined as the ratio of highest significant luminance in the shot to the lowest. This commonly extends to 500:1 or more (see Figure 4.2).

For example, imagine a sunny-day exterior scene with a deep forest in the shot. The ratio of the highest luminance in the sunlit meadow to the lowest luminance in the shadow of the dark forest would determine the subject's overall luminance range. If we were to measure these luminances with a spot meter, we might find that a white sunlit object measures 10,000 footlamberts whereas a black object in the shadows measures 5 footlamberts. The result is a ratio of 2000:1 (about 11 zones/T-stops).

According to Hollywood cinematographer Joseph Mascelli, luminance ranges outdoors go from 30:1 to 800:1 with 160:1 a good average. A flat, foggy scene may be only 10:1. A sunny, harsh contrast subject may reach 1000:1. The standard way to alter and control this range is through lighting. Many cinematographers keep the overall luminance range—ratio of brightest significant object to darkest significant object—at 256:1 (eight stops) for color negative. Others exceed this regularly, allowing the extended range of the negative to capture shadow values as best possible.

When filming for color TV, there is a significant luminance range limitation. Consequently, luminance range is usually reduced to 50:1 or lower. Video is unable to translate as much luminance range as a film negative, a defining disadvantage. It is hoped **HDTV (high definition television)** will improve this situation (see Part IV: Digital Cinematography).

What is important to realize is that a cinematographer often faces a wide range of interwoven luminances in the subject to be filmed. Because a film stock can handle only a limited range of subject luminances, the cinematographer must choose what to expose for as well as how to light the scene.

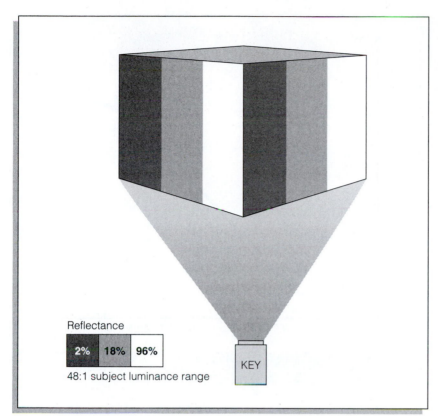

(a)

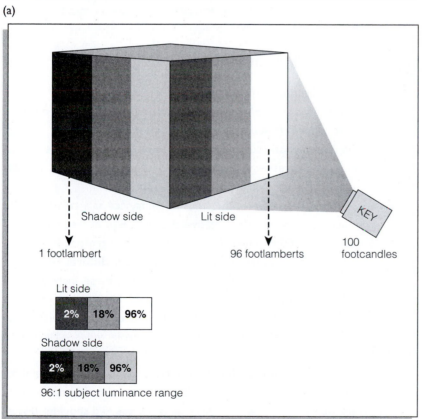

(b)

FIGURE 4.2

SUBJECT LUMINANCE RANGE

Where a subject already has a luminance range from white to black of 48:1 as in (a), the addition of light from an angle will create a second, shadow-side range of 48:1 (b). The ratio between the luminance values of the white strip on the lit side of the cube and the dark strip on the shadow side constitutes the subject luminance range, in this case about 96:1. The white strip lit by 100 footcandles reflects 96 footlamberts. The black strip lit by 50 footcandles of ambient bounced light reflects 1 footlambert (50 fc × .02 = 1 footlambert). This gives us a ratio of 96:1.

FIGURE 4.3

PLACEMENT OF SUBJECT
LUMINANCE RANGE: IDEALIZED
NEGATIVE WITH A GAMMA OF 1.0

A film stock is able to reproduce a cer-
tain luminance range in the final print so
that higher luminance values reproduce
as whites, middle values as grays, and
lower values as blacks. On a negative, as
here, high values have high densities and
are black. This is, of course, reversed on
the final print. In this figure, the toe is the
curved region to the left of point A. The
shoulder is to the right of point B, and
the straight line is from A to B.

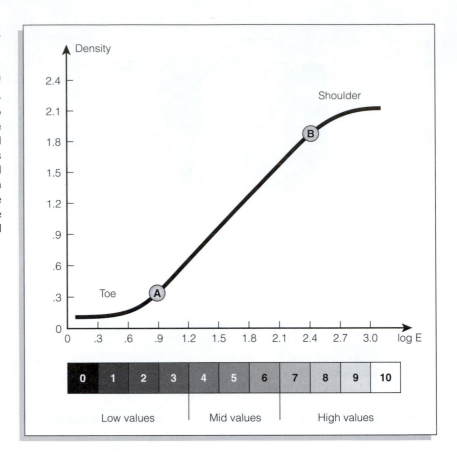

THE CHARACTERISTIC CURVE

For exposure and lighting purposes, we are interested in the range of lumi-
nances—expressed in terms of T-stops or zones—that we can place onto the
characteristic curve (C-curve) of a particular film emulsion through
exposure. The characteristic curve allows us to understand the placement of
these subject luminances—the translation of reality into photographic
images—and is the basis for understanding exposure theory.

In effect, exposure recreates the subject luminances as a corresponding
range of density values, first in the negative, then in the print (see Figures 4.3
and 4.4 for basic definitions). Luminances placed on the **straight line** of the
C-curve will be represented by **proportional density differences** on the
negative and subsequent prints. It does not matter if these increments of
exposure and density are the same, only that they are consistent—directly
proportional. This means their original subject luminance relationships will be
reproduced in the negative and on the screen when projected (see Figures 4.5
and 4.6).

The **toe** and **shoulder** of the characteristic curve are also useful for
rendering luminance range. However, density values for the toe and shoulder
are not proportional to log E values. This means the toe and shoulder distort
visual relationships in the subject, but there is enough differentiation to
enhance the image. For example, in Figure 4.5, the zone 2 (.3 log E) range from
.6 to .9 is translated by the curve into approximately half the density given to
values falling on the straight line (.15 as compared to .3).

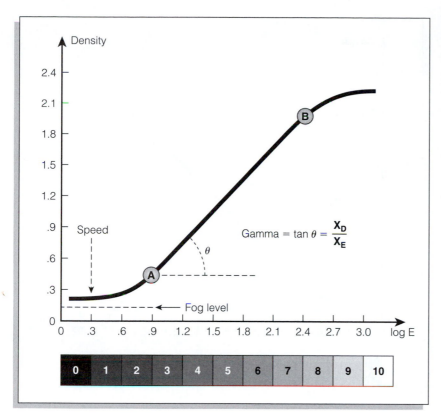

FIGURE 4.4

BASIC DEFINITIONS FOR A CHARACTERISTIC CURVE

Speed = the distance from the density axis to the beginning of an emulsion's reaction t o light. The closer to the density axis, the faster the emulsion. Fog level = the innate density of the emulsion and base as measured by processing with no exposure to light. Gamma = the tangent of θ. By definition, this is equivalent to the change in density (X_D) divided by a given increase in exposure (X_E).

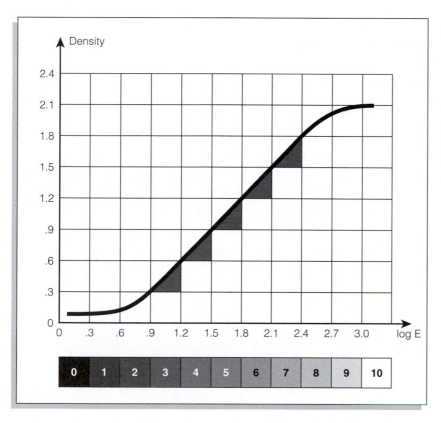

FIGURE 4.5

TRANSLATING LOG E VALUES INTO DENSITY DIFFERENCES: IDEALIZED NEGATIVE WITH A GAMMA OF 1.0

Log E values with a .3 difference—for example, the .3 range from 1.5 to 1.8—are translated into .3 density increments—in this case, from .9 to 1.2—by the straight line on an idealized negative with gamma of 1.0.

FIGURE 4.6

RELATION BETWEEN EXPOSURE
AND DENSITY RESPONSE

For low exposure levels, the density
increases slowly (the toe). Then the emul-
sion reacts linearly: Equal increments of
exposure in log E units yield equal incre-
ments of density increase. On the shoul-
der, the exposure/density relationship
again becomes nonproportional. Increas-
ing the exposure just barely increases
density. In short, an emulsion requires a
certain amount of exposure just to react
to light, then it responds in linear fashion
along a certain range of log E values, and
then its reaction ceases since it is com-
pleted.

 Gamma is defined as X_D over X_E and
is referenced to the straight line portion
of the curve. In this example, gamma =
1.0 since $X_D = X_E$.

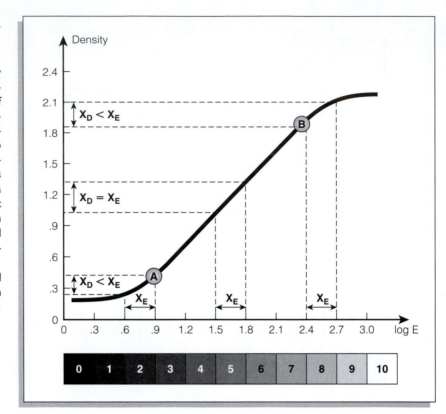

By projecting the straight line portion of the curve onto the log E axis,
we can calculate the amount of luminance range in log E values that the emul-
sion can handle accurately. This we will refer to as the **log E range of the
straight line** or the **length of the straight line.** The combination of
straight line plus toe and shoulder we will call the **overall useful range (lat-
itude)** of the film stock. The longer the straight line and overall useful range,
the more the range of luminances that can be translated and reproduced, and
the more subtle the visual renditions possible (see Figures 4.7 and 4.8).

 Current color negative emulsions provide straight lines capable of han-
dling luminance ranges from 32:1 to over 128:1. This amounts to from 5 to 7
zones or T-stops. The same emulsions can handle overall luminance ranges
(using the straight line plus toe and shoulder) on the order of 512:1 to
1,024:1. This represents an overall range of from 9 to 10 zones.

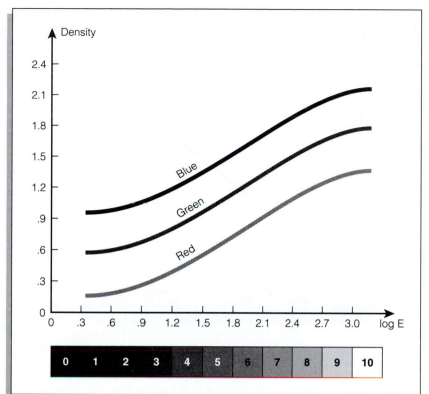

FIGURE 4.7

TYPICAL COLOR NEGATIVE:
GAMMA = .65–.70

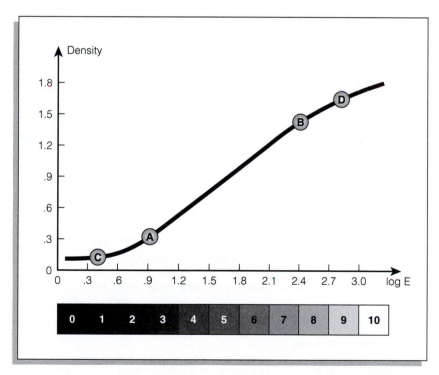

FIGURE 4.8

STRAIGHT LINE LENGTH AND
OVERALL USEFUL RANGE ON A
TYPICAL COLOR NEGATIVE (RED
CURVE ONLY) WITH A GAMMA
OF .65

If we project the straight line portion
(A–B) of this emulsion onto the log E
axis, we see that it can translate a range
of 1.65 log E into density differences.
Adding in the toe and shoulder (C–D)
increases the range to about 2.4 log E.

Straight line (A–B) = 1.65 log E range
(2.55–0.9 = 1.65). This equals 5½ zones
(50:1).

Overall useful range (C–D) = 2.40 log
E range (3.0–0.6 = 2.4). This equals 8
zones (256:1).

FIGURE 4.9

RELATING ZONES TO CHARACTERISTIC CURVES: TYPICAL B & W NEGATIVE WITH A GAMMA OF .8

Straight line (A–B) = 1.5 log E (2.4–0.9). This equals 5 zones (32:1).

Overall useful range (C–D) = 2.4 log E (2.8–0.4). This equals 8 zones (256:1).

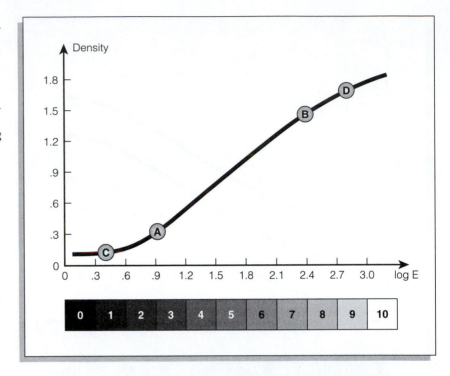

RELATING ZONES TO CHARACTERISTIC CURVES

Because each zone of the gray scale represents a .3 log E, correlating zones to the characteristic curve is simple. The 11 zones are represented on the negative as indicated in Figures 4.1–4.5. To obtain the **zone range of the straight line**, divide the log E range by .3. For example, if a color negative has a straight line of 1.5 log E, it has a five-zone range (1.5 divided by .3 = 5). If a color negative has an overall range of 2.7 log E, this is equivalent to a 9 zone overall range, although in this case lower and upper subject zones will be compressed relative to the all-important middle ones that fall on the straight line (see Figure 4.9).

Z ONE 5 EXPOSURE——THE LINK

The discussion of luminance range and emulsion characteristic curves should allow us to understand our working definition of exposure:

> A placement of the subject's luminance range onto the characteristic curve of the negative so as to retain a full scale of brightness values, from black to white, with density increases proportional to original subject luminance increases.

Placement of zone 5 is the basis for cinematographic exposure—what we have called *correct exposure*. The incident meter is designed to reproduce zone 5, midgray, 18% reflectances at the nominal **mid-density point** on the characteristic curve. This is called a **zone 5 exposure**. Exposing for zone 5

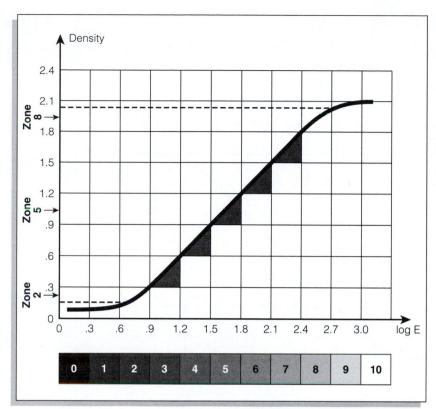

FIGURE 4.10

ZONE 5 EXPOSURE

A zone 5 exposure is the normal exposure in film and faithfully reproduces key middle zones by placing the zone 5 subject luminance at the mid-density point on the characteristic curve. The rest of the zones then progress outward from that key point. Zones which fall outside the straight line onto the shoulder and toe will be compressed as are zones 2 and 8 in this example. Luminance values outside those for zones 2 and 8 will be represented as a black and a white respectively.

To place zone 5 at the mid-density point still leaves one very important variable: which subject luminance to place at zone 5. The incident meter answers this automatically: an 18% reflectance. The reflected meter requires a decision by the cinematographer.

places the other two middle zones, 4 and 6, highlight zones 7 and 8, and lower values 2 and 3, at their respective density points (see Figure 4.10). Note the placement is focused on the middle zones where most facetones fall.[1]

Exposure index (EI) measures the relative speed by which an emulsion reacts to light. By setting the ASA/ISO scale on the light meter we are in effect calibrating the meter to that particular film stock. Over a number of scenes, as the illumination varies, the meter will indicate a variety of exposure combinations. On the emulsion, however, all zone 5 values will have the same density and, hence, will look the same when projected onto the screen.

The basic "theory" of exposure in film, then, is to have a method by which a defined key reflectance—in this case a midgray, 18% reflectance—can be placed consistently onto the characteristic curve. The incident meter ensures this through a zone 5 placement for midgray.

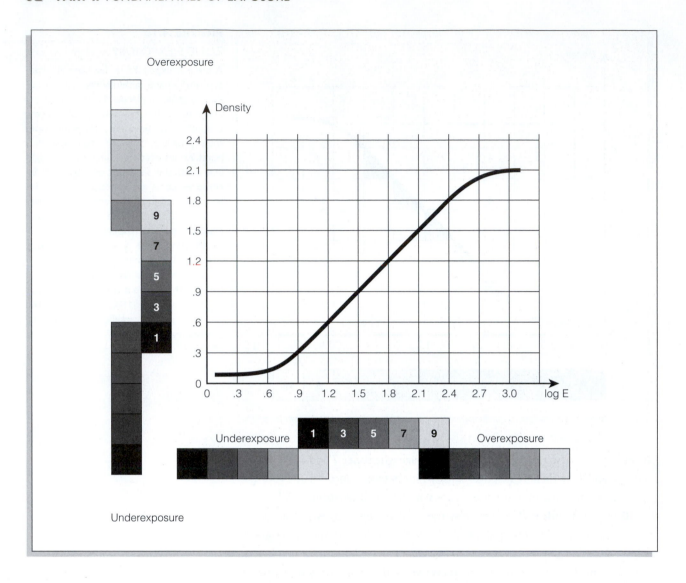

FIGURE 4.11

NORMAL ZONE 5 EXPOSURE COMPARED WITH OVER- AND UNDEREXPOSURE

This graph illustrates extreme (four-stop) over- and underexposure. The results as portrayed on the density axis are suggestive only and do not portray the true result, which would be mostly white for the overexposure and mostly black for the underexposure.

VER- AND UNDEREXPOSURE

Overexposure means placing the luminance range too high onto the characteristic curve. The result is an untrue subject reproduction with the highlights becoming compressed and the lower tones being lightened to gray. The overall feeling of such a picture is "washed-out" (see Figure 4.11).

In zone system terminology, overexposure for a negative means that zone 5 has been pegged to a higher density than the normal mid-density. Needless to say, unless intentional, only a misreading of the incident meter can lead to this. Overexposure effects can be visualized without difficulty in terms of zones (see Figures 6.1d, 6.2c and 6.3d).

Underexposure results when a subject is placed too low onto the characteristic curve, with an accompanying lack of separation in the dark tones and a loss of the white end of the scale. The overall impression of underexposure is dark, dreary, and murky (see Figure 4.12a). Underexposure is used for night effects, but usually the cinematographer creates a few bright tones in the shot to prevent any possible "dead" feeling (see Figures 4.12b and c). A conventional night setup has a lot more light than one might imagine and is not at all underexposed (see Figure 4.12d).

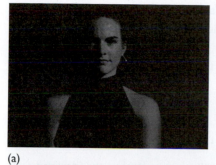

(a)

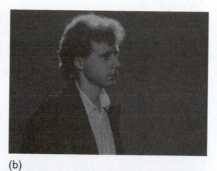

(b)

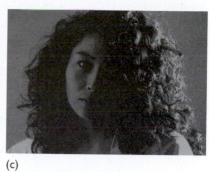

(c)

(d)

FIGURE 4.12

UNDEREXPOSURE EFFECTS

The almost complete absence of highlight values results in a muddied look (a). Adding a hair light (b) and a slight rim on the hair and shoulder (c) adds visual interest to the shot. The standard night exterior (d) has much more lighting than might be expected (*The Third Man,* Studio Canal Image, 1949). ▮▮

Over- and underexposures as "mistakes" are obviously undesirable. But giving over- and underexposures to selected areas of the frame relative to a main subject exposure is important for mood creation. We usually talk about this effect referenced to lighting rather than exposure, however. The topic will be covered further in Chapter 8.

ACTUAL CHARACTERISTIC CURVES

Actual characteristic curves are more difficult to read than the idealized ones we have looked at so far. Figure 4.13 is a redrawing of the curve for Eastman EXR 7248. Do not let the logarithmic scalings depress you. Just read the caption and contemplate the fact that you can calculate straight line and overall useful range by measuring the curve with a ruler and doing some simple math.

Kodak has taken pity and has started deciphering their curves for us using T-stops. Figure 4.14 is the published curve for Vision 200T, 7274.

Immediately, we see Kodak has moved the log E scale to the top of the curve and added a scaling in T-stops at the bottom. In this case they tell us that the straight line is $2\frac{1}{3} + 2\frac{2}{3} = 5$ stops/zones referenced to normal exposure "N"—what we have been calling a zone 5 exposure. As for overall range, we again can measure with a ruler to the points where no density change is found (by using the bottom red curve). We measure about 4 zones in the "latitude" areas Kodak talks about in its caption, making a total of 9 zones for the overall useful range. Exact measurement is not important here, just an understanding of how labs and film manufacturers standardize emulsion and processing through use of C-curves and densitometer readings to ensure proper development of the negative. Kodak and Fuji publish information sheets for all their film stocks.

Table 4.1 Available Kodak and Fuji Film Stocks

Fuji Super F Series	
8622 64 D	
8623 125 T	
8625 250 T	
8662 250 D	
8672 500 T	

Kodak Vision Series	*Kodak Extended Range Series*
7274 200 T	7245 EXR 50 D
7246 250 D	7248 EXR 100 T
7277 320 T	
7278 500 T	
7284 500 T known as *Expression* 500T	
7289 800 T	

FIGURE 4.13

MEASURING STRAIGHT LINE AND OVERALL USEFUL RANGE ON EASTMAN EXR 7248

Approximation scaled as per published Eastman curves.

Straight line (A–B) = 2.3 log E units ($\overline{2}.2$ + 0.1 = 2.3). This equals 7⅔ zones.

Overall useful range (C–D) = 2.8 log E units (2.7 + 0.1 = 2.8). This equals 9⅓ zones.

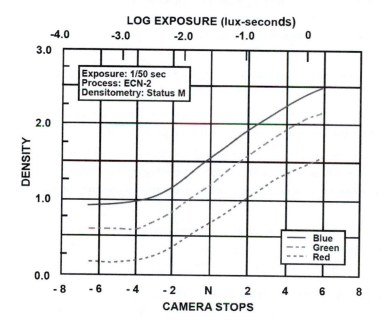

KODAK VISION 200T
Color Negative Film 5274 / 7274
SENSITOMETRIC CURVES

FIGURE 4.14

PUBLISHED KODAK CURVE FOR VISION 200T, 7274

SUMMARY

Exposure and lighting give the cinematographer complete creative control of the image. Once the main subject is "visualized," the cinematographer decides where to put the light meter for a reading. The meter pegs the important middle and high zones into place on the characteristic curve, taking into account the brightness of the illumination by indicating a set of T-stop/shutter speed combinations.

Any zone 5 value in the main subject lighting will be rendered at a mid-density point on the characteristic curve for that emulsion, and all other zones will fall into place proportionally. With the incident meter, any given object will have the same look under varying illuminations because it will be reproduced with the same density value on the negative. Not only that, all other reflectances will maintain their uniformity as well. This gives the cinematographer a fixed point from which to work.

Exposure relates the subject's luminance range to the emulsion's characteristic curve in controllable ways. The following concepts were examined in detail:

● *Luminance range*—the ratio of the highest to the lowest significant luminance value in the subject.

● *Characteristic curves* graphically illustrate how an emulsion reacts to light. On the straight line, the reaction is proportional—increments of exposure (log E) are given proportional increments of density. This relationship is distorted on the toe and shoulder of the curve.

● *Log E range of the straight line* is the length of the straight line in log E units determined by projecting the straight line onto the log E axis.

● *Overall useful range (latitude)* adds the toe and shoulder to the straight line to determine the total number of zones the emulsion can translate.

● *Relating zones to the characteristic curve.* Both straight line and overall useful ranges can be scaled in zone values. This is done by dividing their log E ranges by .3 log E. Remember, a change of .3 log E represents a change of one zone or one T-stop.

● *Zone 5 exposure* was defined as the normal exposure in film which faithfully reproduces key middle zones by placing zone 5 luminances at the nominal mid-density point on the C-curve. In other words, you get what you see.

Taken together, these concepts show us that exposure is not a mechanical act. Rather, exposure is a creative choice—a choice selected from a number of possibilities.

NOTE

1. Incident meters ensure precise consistency because they calculate exposure for all lighting setups from the same object—the meter's photosphere (lumisphere), which is equivalent to an inbuilt **gray card**. In fact the incident meter was initially a reflected meter with half a ping pong ball taped over its light sensitive cell. The only variables—the intensity and angle of the illumination—are accounted for through T-stop adjustments to the exposure given. The result is that within a scene, a particular actor's face is rendered with a consistent density and the illusion of reality is maintained.

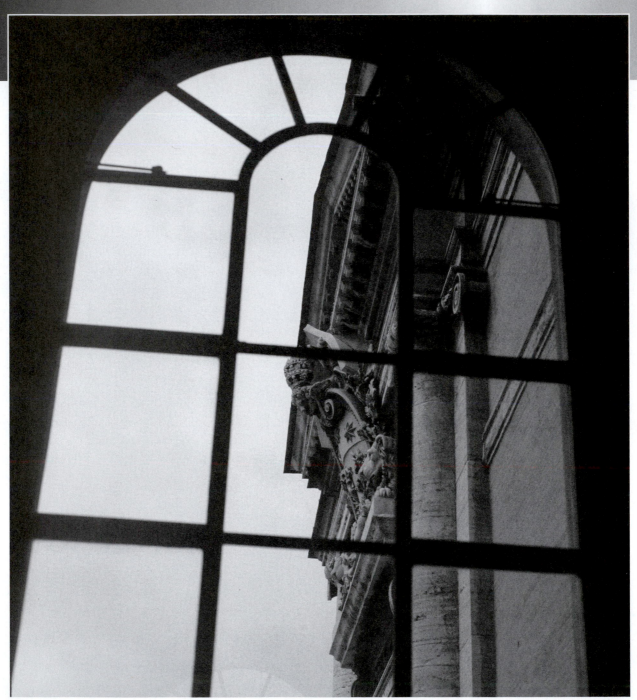

EXPOSING SUBJECT LUMINANCE RANGE

Additional Exposure Concepts You Need to Know

In this chapter, reflected light readings and additional zone concepts will be explored. We shall carefully examine concepts such as gamma, overall gamma, and printing and projection contrast to further our understanding of film emulsions and the log E scale—the sensitometric equivalent to luminance range. We need to know these in order to work with one of our main partners in image control—the lab.

REFLECTED LIGHT READINGS

Reflected light readings are used to calculate exposure under certain conditions. The spot meter is the best tool for reflected readings although we occasionally use an averaging-type meter such as the Gossen Luna Pro, or a Sekonic with a reflected light attachment. With the averaging-type meter, we try to use a gray card or close-up reading technique to make the meter more precise. Inbuilt, through-the-camera-lens meters are reflected meters, not as precise as spot meters but more selective than averaging types because you can zoom in to take readings.

Like an incident meter, reflected meters are calibrated to render a zone 5 subject value at the mid-density point on the characteristic curve. The problem is that the reading from a spot meter, or any other reflected meter, must be modified by the user's experience. The meter itself always assumes that it is being pointed at an 18% gray card—that is, reflected meters are "dumb." When pointed at a particular luminance—no matter whether white, black, or gray—a spot meter gives a reading which will render that luminance value as a zone 5 midgray on the C-curve. The situation is worsened by use of an averaging-type meter because it is difficult to even know which luminances are being metered.

In cinematography, we rely mainly on the incident method because our main concern is with the zonal renditions of facial and highlight portions of the frame. However, some special circumstances require a reflected reading for exposure determination. A good example is where **luminous objects** are present—a situation we will discuss thoroughly in Chapter 6.

We also use reflected meters to determine T-stop when it is impossible or impractical to take an incident meter reading. An example: You are in a jet and need an exposure through the window. This kind of reflected reading is usually of the overall averaging variety and is done on an emergency basis. Some cinematographers just use their experience and "guess" the exposure.

The last common use for reflected readings, in this case a spot meter, is to check luminance range and lighting ratios. Television and video cannot handle the same ranges as film; in fact this is video's biggest limitation.

Consequently, television lighting directors use spot meters and **waveform monitors** (electronic means for measuring video signals) regularly to ensure luminance ranges are within acceptable tolerances. This is not usually necessary with film because most film negatives can easily handle all but extraordinary luminance ranges.

Some cinematographers like to know how a specific subject value will reproduce and thus rely on spot meters for measuring luminance values which can be compared to the main subject. For example, if a white object is present in the subject, we do not really know whether it will render as zone 8 or 9 with an incident meter. We know it will reproduce as white—assuming it is in the same light as the subject—but not its exact zone rendition. This holds for many of the other objects in the scene. We can measure these values with a spot meter and determine their exact placement. We normally do this only for very important or troublesome objects at the extremes of luminance range. Mostly we rely on our experience.

ADDITIONAL ZONE CONCEPTS

COLORS CONCEIVED AS ZONES

For simplicity and historical reasons, we have approached exposure from a black and white perspective, yet most of our work is in color. The reason for this anomaly is that lighting is fundamentally concerned with luminance values, not actual colors. This is not to say that color visualization is not important, but that lighting is more easily conceptualized in terms of gray scales and luminance range. As well, much creation of color is centered in the production design and costume departments—areas not directly controlled by the cinematographer.

The cinematographer does have to take color into account and in some instances, such as much of Vittorio Storaro's work, it is preeminent. To start to control color, just remember that moving a color up or down the zone scale is equivalent to changing its tint or shade. For example, if a red object is progressively overexposed, it becomes lighter and desaturated, culminating in white, total overexposure. Likewise, if a red object is underexposed and moved down the gray scale, it becomes a darker shade of red. Because the object moves up or down in zonal increments, with practice it is possible to visualize these changes. This is particularly important in lighting where we often want to balance a background for a certain subject. The technique is used to visualize what will happen to the background colors if, for example, they are lit two zones darker than the subject. We will look at color in more detail in Chapter 13.

RELATIVITY OF THE ZONES

The zone system is totally relative because an on-screen zone represents no fixed luminance value. With the aid of a light meter, we can place any luminance value on any specific zone as desired. For example, a cinematographer may place a black object at its normal zone 1 value or, through manipulation of lighting and exposure controls, render it at any other zone. A background wall can be made dark gray, gray, light gray, or even white through controlled under- or overexposure.

AUTOMATIC LUMINANCE PLACEMENT

Once a certain luminance is placed on a certain zone, all other luminances automatically fall into place on their respective zones. For example, if we expose so that a Caucasian face with a luminance value of 200 footlamberts is placed on zone 6, then other subject luminances, if present, will fall onto zones 0–10 automatically, as shown in Table 5.1. This is very important. We get a choice, but only one. Once the key value is exposed for, the others shift inevitably into their respective zones. There is an advantage here, however: Selecting the key element in the shot, or creating the desired key element through lighting, allows the cinematographer to know what will happen with all other luminance values.

For most exposure purposes, we rely on a zone 5 exposure technique. That is, we expose for the actors, but there are a variety of subtle possibilities available where we underexpose faces intentionally such as with semi-silhouettes. This will be discussed later in Chapter 6.

In cases where the luminance range exceeds the overall useful range of the emulsion, it is impossible to retain details in all values of the subject. The cinematographer has to choose whether to alter the luminance range through lighting or to render only part of the subject faithfully, letting other parts go to shadow or burned-out values. This common situation and how to deal with it will be discussed in Chapters 6 and 8. Luckily, current emulsions have "extended ranges" and thus allow for quite a bit of shadow detail. This is what gives film its advantage over video with its relative inability to capture as much of the real world as film emulsions.

Table 5.1

Zone	Value in Footlamberts*
10	3200
9	1600
8	800
7	400
6	200
5	100
4	50
3	25
2	12
1	6
0	3

*Rounded off to whole numbers

FIGURE 5.1

DEFINING GAMMA: IDEALIZED
NEGATIVE WITH A GAMMA OF 1.0

Gamma = X_D divided by X_E

Where $X_D = X_E$ gamma = 1.0

Where $X_D < X_E$ gamma is less than 1.0

Where $X_D > X_E$ gamma is greater than 1.0

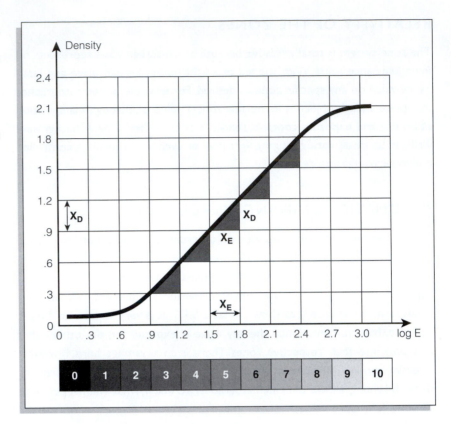

GAMMA AND OVERALL GAMMA

The concept of gamma is important to our understanding of how different film stocks translate luminance range into a range of densities. Gamma also involves the workings of the processing department in the film lab, which uses it for standardization techniques. Figure 5.1 defines and illustrates gamma. A gamma of 1.0 means the film stock faithfully reproduces the subject's luminance range, or at least the important part of it, by providing a corresponding density range such that increments of X_D and increments of X_E are equal. Although what is on the screen "looks like" the original subject, this is a visual translation, not an exact reproduction.

The only problem with a camera original of gamma 1.0 is that it would miss out translating a lot of the luminance range available because of the 45 degree angle it forms with the log E axis. Consequently, Kodak and Fuji negatives are manufactured with gammas of approximately .7 (see Figure 5.2a). This allows them to capture more reality. When printed with relatively high contrast print stocks with gammas of 2.6–2.8, the final print result approaches gamma 1.7 which results in an on-screen image of gamma of 1.4 (see Figure 5.2b and c). The reason the final gamma is not 1.0 is that research has shown that audiences prefer a screen image slightly more contrasty than reality.[1]

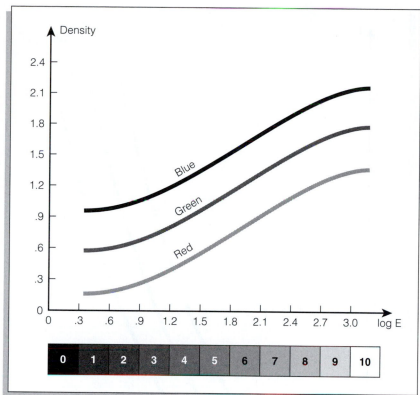

(a)

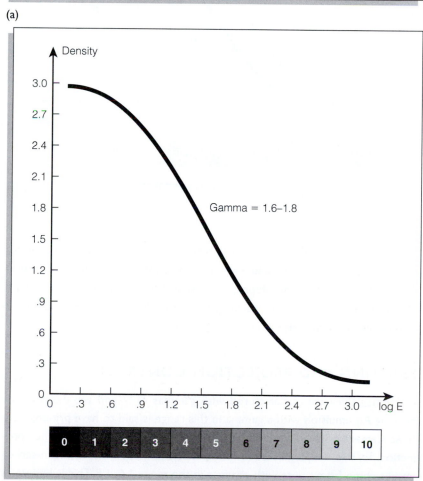

(b)

FIGURE 5.2

TYPICAL COLOR NEGATIVE AND PRINT GAMMAS

In (a) a typical color negative with a gamma of .65–.70; in (b) a typical release print with a gamma of 1.6–1.8; in (c) (page 74) a typical color print stock with a gamma of 2.6–2.8. The combination of a color negative with a gamma of .65 and a color print stock with a gamma of 2.6 results in a release print with a gamma of 1.7 (.65 × 2.6 = 1.7).

FIGURE 5.2 (continued)

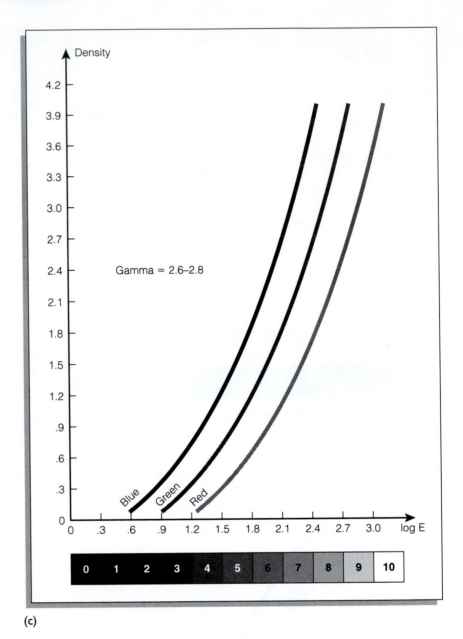

(c)

Gamma can be discussed only in terms of the straight line since the toe and shoulder are curved and have no consistent proportional response. Gamma is a function of development; consequently, pushing (over developing) a film stock yields an increase in gamma. Visually speaking, an increase in gamma means an increase in contrast (see Figure 5.3).

PRINTING AND PROJECTION CONTRAST

Color negatives are manufactured with gammas of .7 and are designed for printing. An emulsion with a gamma in this range is said to have printing contrast. Camera originals are designed to yield the best possible prints for projection. To this end, it has been found that the most acceptable on-screen images come from prints with gammas in the range 1.6–1.8. This is known as

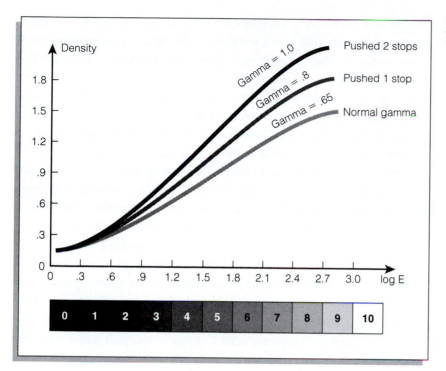

FIGURE 5.3

PUSHING INCREASES GAMMA

projection contrast. This gamma range is reduced by projector flare, screen reflectance, and ambient light to near the ideal 1.4 by the time it is on the screen.

Reversal stocks are designed with projection contrast and have gammas around 1.6–1.8. Such gammas cause reversal stocks to have too much contrast when printed. Reversals also have shorter overall useful ranges compared to negatives. Negatives are much favored because of the subtlety of their visual renditions. This is due to their long straight lines, a direct result of their low gamma values. Because of these straight lines, negatives are able to translate larger ranges of log E values into density differences compared to reversal originals.

W ORKING WITH THE LAB

Timing (making minor color and/or exposure corrections to a film or video image) is as much art as science. In this sense, we need to be able to work with the lab to create, control, and retain our image looks in the final release prints.

Instead of T-stops, the lab timer works with printer points (printer lights). Point settings determine both color balance and density of the print being struck. Most labs use automatic printers such as the Bell and Howell additive printer, which has 50 printer light settings with increments of .025 log E each. The nominal middle setting is usually around light 25 (termed point 25). This is not a universal standard, however, and varies slightly from lab to lab; some labs may be at a 30, for example.

To vary the colors in a film image, additive printers utilize light valves for the three primaries (red, green, and blue). Each color may be varied by the 50 points so that a color setting is typically expressed as follows: R25 G30 B18. Blue almost always has a lower number because it is necessary to remove the orange bias from the neg itself. Other labs use a yellow, cyan, magenta designation for their points, but the result is the same.

Lights are usually in the 20s and 30s, but small variations are normal: For example, 36–34–25 is quite acceptable. The higher the light number, the greater the amount of light being used to print the negative. The use of higher printer lights indicates the negative is "heavy" and overexposed. Most negatives print in the 30–35 light range. Some cinematographers intentionally overexpose their negatives from 1/2 to 2/3 of a stop on the theory that heavier negatives produce more satisfactory colors and release prints.

To aid in timing, a video color analyzer is usually employed. This allows the timer to see in advance the effect of various color and density changes on the original. Such subtle controls enable a high precision fine-tuning of the image. With additive printers, approximately 7–8 mid-scale points are equivalent to one T-stop on the density scale. The rule of thumb is that a negative is correctable for density up to two stops in either direction with the proviso that after about a stop or stop and one-half, print quality falls off.

The relationship between the lab and a cinematographer can be a frustrating one. Spoken language invariably fails to convey the necessary information about the visual image. We are left to communicate with the timer in words that only hint at the visual possibilities in printing (e.g., a touch darker, too bluish). How the timer is supposed to translate this verbal imprecision into printer lights is a major barrier to overcome in arriving at the final, timed answer print.

Many feature cinematographers work out a specific light valve combination with the lab prior to principal photography and have the lab print all negatives with that combination. Different combinations are often used for night and day exteriors and interiors. These provide a fixed reference point for subsequent lighting. It also ensures that a timer's visual preferences do not enter in, but then one can lose the timer's experience and possible input.

SUMMARY

In this chapter, the following concepts were examined in some detail: Reflected light readings, zone items like color previsualization, the flexibility of zone placement, and the automatic placement of all luminances once exposure for the main subject is determined. In addition, we looked at emulsion gammas and how lab printers operate. The following concepts are central:

● *Gamma* refers to the angle the straight line makes relative to the log E axis. Gamma measures how the emulsion allocates density values to log E increments. In theory, a gamma of 1.0 represents an accurate reproduction of the range of luminances in the original subject.

- *Overall gamma* factors in all the components of the imaging system—from the negative gamma to the gamma of the cinema screen—in determining the contrast properties of the system. The current standard overall gamma is around 1.45.

- *Printing contrast.* Negatives designed for printing have low-contrast properties with gammas in the range of .7. These low-contrast gammas allow the negative more log E to use in translating luminance ranges.

- *Projection contrast.* Prints and reversal camera originals are designed for projection and exhibit relatively high gammas—in the 1.6 to 1.8 range. Projection contrast makes it difficult to arrive at high-quality prints from the original.

- *Printer points*—used by lab timers to fine-tune both colors and density values in the final prints.

NOTE

1. Theoretically, a gamma of 1.0 would be the ideal overall gamma to strive for on the screen. In practice, however, other factors are involved, such as projector lens flare and screen reflectance. A camera original is but one link in a complete system involving print stock, internegative, processing specifications, and so on. Overall gamma is the term for linking these disparate elements together. Overall gamma equals the product of the gammas of the individual components in the total imaging system. In *Photographic Theory for the Motion Picture Cameraman,* Russell Campbell gives the following example of overall gamma for B & W films:

Original Scene		Lens Flare		Neg Gamma		Printer Gamma		Print Stock		Projector/ Cinema		Overall Gamma
1.0	×	.9	×	.65	×	.95	×	2.6	×	.9	=	1.3

Source: Russell Campbell (ed.), *Photographic Theory for the Motion Picture Cameraman* (New York: A. S. Barnes, 1981), p. 104.

Currently, the ideal overall gamma is equal to about 1.4 depending on intended use. This means that increments of X_D are greater than increments of X_E. The screen image exhibits a greater contrast than the original subject. In his article "Film to Tape Mysteries Unraveled," Frank Reinking lists the ideal overall as 1.45 for cinema projection (1.6 for final print gamma × .9 for the projection = 1.44) and recommends a careful control over gamma when transferring film to video. Gamma for such transfers depends on whether the Rank Cintel transfer is from a negative, CRI, or print which may be standard or low contrast. Frank Reinking, "Film to Tape Mysteries Unraveled," *American Cinematographer* (September 1989): 73–80.

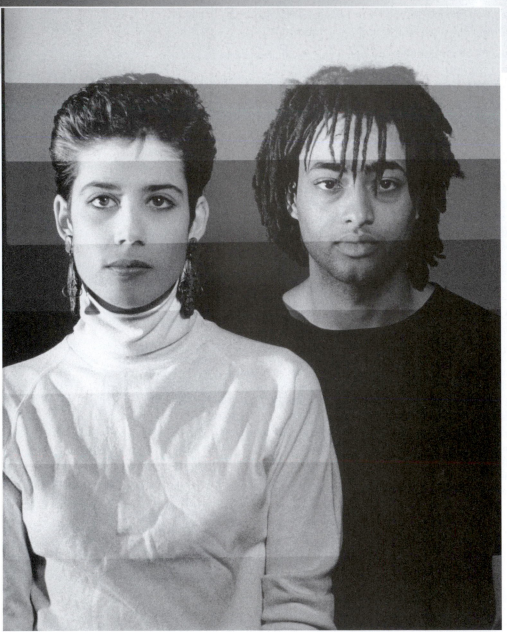

THE ZONE SYSTEM

CHAPTER SIX

Creative Exposure Techniques

Because exposure has creative possibilities, the cinematographer has choices when selecting what to expose for. This important choice is highlighted in the handling of luminance range through exposure controls—the topic of this chapter. In addition, we will investigate a number of recurring exposure situations for their creative possibilities as well as the problems they present. These include compromise exposure, semisilhouettes, the handling of luminous objects, integrating incident and reflected readings, all-dark/all-light subjects, and pulling T-stop.

AS WE HAVE SEEN, the incident meter reliably pegs key zones and handles the problem of light intensity (brightness), but the problem of luminance range remains the cinematographer's. Lighting technique allows control over the luminance range, which may be previsualized using the zone system or measured with a spot meter. The characteristic curve reveals sensitometric data, but to coordinate all of this requires more than just measurement and data. It requires visualization and artistry. The cinematographer must rely on mind and eye as much as on the light meter.

By now, it should be obvious that exposure is a form of lighting—both involve a creative act and the application of techniques for controlling the look and feel of an image. Exposure presents choices, and choices yield previsualizations of on-screen effects. In this sense, exposure and lighting are like two sides of the same coin.

REVISUALIZING EXPOSURE CHOICE

One of the powers of the zone system is that it allows us to previsualize what happens to objects not in the same lighting intensity as the main subject. Take, for example, a two-person interior setup with a window effect at frame right. Obviously the person nearer the window will be brighter than the person to frame left (see Figure 6.1). Now suppose there is a three-stop difference in lighting intensity between the two figures. Exposure for the person frame right will correctly render that person and underexpose the person frame left by three stops; that is, she will be rendered at zone 3 rather than zone 6 (see Figure 6.1a). Likewise, exposure for the person frame left will render her correctly at zone 6 but overexpose the person at frame right by three zones (see Figure 6.1d).

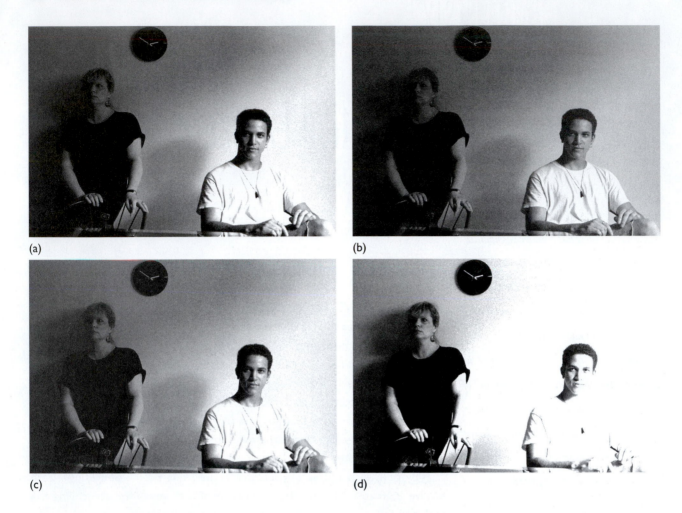

(a)　　(b)

(c)　　(d)

FIGURE 6.1

EXPOSURE POSSIBILITIES FOR A DAYLIGHT INTERIOR WINDOW EFFECT

In the standard day interior, there are three exposure choices: Expose for the person nearer the window (a), use a compromise exposure (b and c), or expose for the person farther from the window (d). Exposure for either person impacts on the rendition of the other.

Of course, it is possible to expose somewhere in between the two extremes and arrive at acceptable placements (see Figure 6.1b and c). The point is that by taking an incident reading for each person, we can determine the difference in lighting intensity, previsualize how each will render in terms of zones, and make an exposure choice based on that previsualization.

The same is true for the cat in the window in Figure 6.2. Exposure for outside the window (Figure 6.2a) and the shadow side of the cat (Figure 6.2c) gives us two extremes, both of which we can previsualize based on the difference between the actual T-stop readings, which in this case is about five stops. Again, exposure for somewhere in between may be acceptable if we are unable to boost the lighting on the cat or bring down the outside intensity with neutral density (ND) gels on the window (see Figure 6.2b).

One last example may make this power of the zone system clearer. Suppose we have a shot of a person on a chair and an unlit bed and white pillow in the background. Suppose the exposure reading for the person is T 5.6. The question is how will the white pillow appear if we expose for the person. Normally it would be rendered at zone 8, but that assumes it is in the same lighting as the person. Here it is unlit.

FIGURE 6.2

EXPOSURE POSSIBILITIES FOR A CAT IN THE WINDOW

There are three choices: Expose for outside the window (a), use a compromise exposure (b), or expose for the shadow side of the cat (c).

(a)

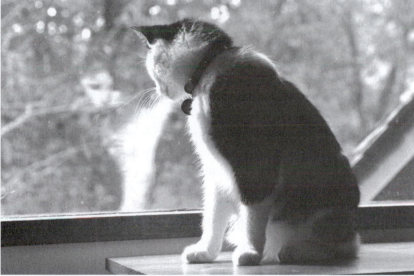

(b)

(c)

To determine how the pillow would be rendered under these conditions, we first take an incident reading for it. Assume we obtain T 2. This means the pillow is lit three stops under the main subject. Exposure at T 5.6 will underexpose the white pillow by three stops (three zones). The pillow will be rendered as a zone 5 midgray rather than its normal zone 8 white. Other parts of the shot can be previsualized in exactly the same way. For example, if there were a gray cat (normally zone 4) by the pillow, we know it would come out at zone 1, a black cat.

If the lighting on the pillow were at the same level as the main subject, it would be given a normal exposure and would reproduce at its standard zone 8. Had the lighting on the pillow been brighter than on the subject, say T 11, then we know the pillow would be reproduced two zones above normal, that is, zone 10 maximum white. The cat in this case would be rendered at zone 6 light gray.

We can determine overall luminance range using this same method. First, take a reading for the brightest significant luminance and determine its T-stop reading and then zonal rendition relative to the subject exposure, as we did with the white pillow above. Then do the same for the darkest significant object. This provides us with our highest and lowest zone values, that is, the luminance range expressed in zones. A spot meter could also be used to measure these values.

Many cinematographers will not measure luminance range but will rely on experience and light by eye, letting dark values fall where they may. These cinematographers would, however, still be careful to balance white highlight values to the key light so that such highlights would not distract from the subject. This balancing is done when lighting.

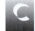ONTROLLING OVERLAPPING LUMINANCE RANGES WITHOUT LIGHTING

A common situation is when the subject consists of several overlapping luminance ranges. Even in a very simple subject with a single light source, there are two luminance ranges: the lit side and the shadow side. Along with the luminance range of the background, these two ranges are the most important in cinematography.

Cinematographers must learn to control one luminance range relative to the other. Lighting is the most powerful tool at their disposal to handle these situations, but exposure also offers possibilities. Exposure for one range of subject luminances automatically excludes exposing for another. Exposure for the bright range automatically means the shadow range will fall lower down the zonal scale.

So, faced with two or more luminance ranges, how do we choose an exposure? There is no simple answer, but there are several approaches to a solution. Take, for example, the portrait in Figure 6.3. Assume an incident measurement shows that six times as much light falls on the bright side of the face as on the shadow side, for instance, 100 footcandles to approximately 17 footcandles. Exposure for the light side (placing the face at zone 6) will yield

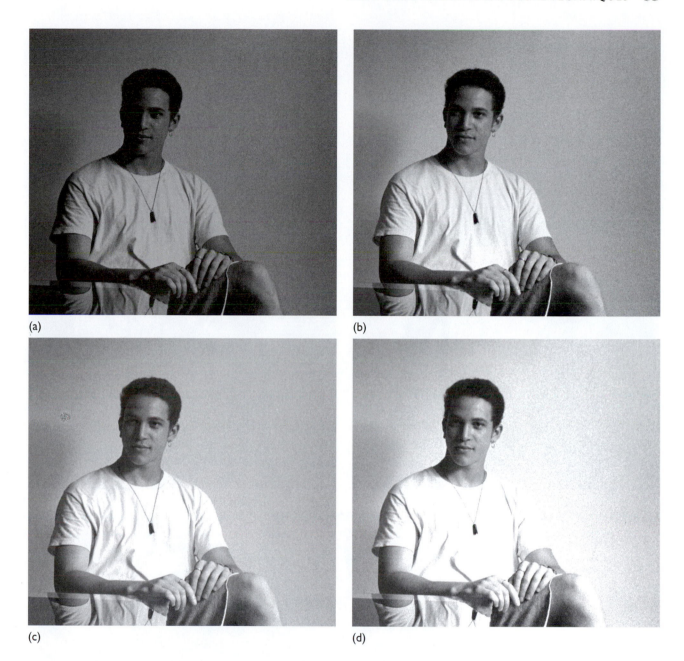

(a)

(b)

(c)

(d)

facial shadows 2½ zones darker than the light side, a 6:1 ratio as in Figure 6.3b. This is the normal manner of working: Expose for the light side and let the shadow side fall where it will or where you have placed it with a fill. In this example, exposure for the bright side puts the face at zone 6 and the shadow side at zone 3½ (see Figure 6.3b, also Figures 2.8b and c).

As we have seen, there are alternatives to this normal, "correct" exposure. For example, we might choose to expose for the shadow range and place it at zone 6 ("correct" exposure) on the characteristic curve. Then, values in the shadows will reproduce normally and only an impression of shadows will remain. Values on the light side of the face will automatically reproduce 2½ zones lighter than normal at zone 8½, which is very white. The result is a lighter version of the first and can be preferable, depending on context (see Figure 6.3d).

FIGURE 6.3

EXPOSURE POSSIBILITIES FOR LIT AND SHADOW SIDES OF A FACE

Exposure for the lit side of the face (b) and for the shadow side (d) offers different possibilities. Other possibilities include one-stop underexposure (a) and a compromise placement (c).

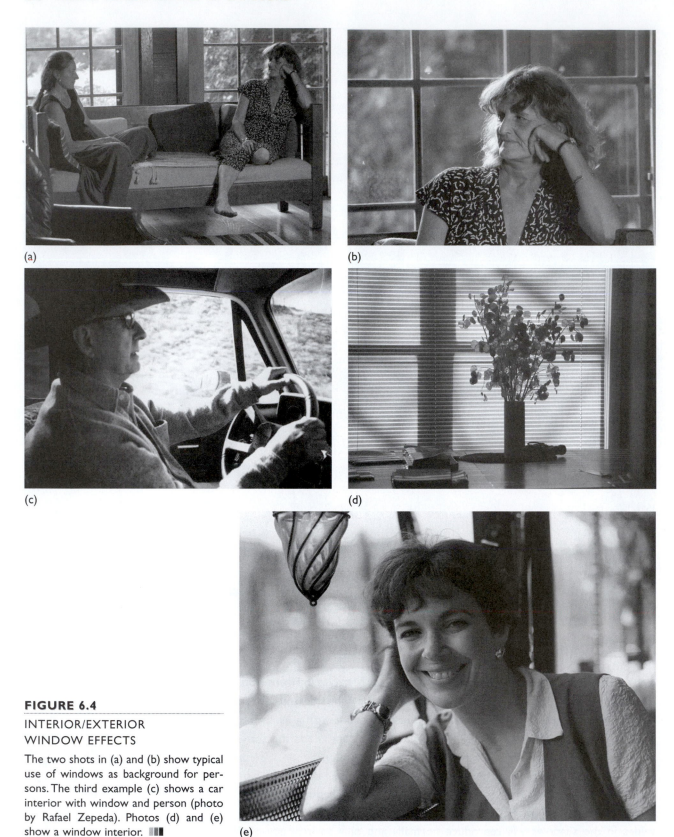

FIGURE 6.4

INTERIOR/EXTERIOR
WINDOW EFFECTS

The two shots in (a) and (b) show typical use of windows as background for persons. The third example (c) shows a car interior with window and person (photo by Rafael Zepeda). Photos (d) and (e) show a window interior. ▮▮▮

The alternative is to expose in between the two extremes, a **compromise exposure.** If we expose halfway in between, the light side of the face will fall around zone 7–7½ and the shadows around 4½–5. Nothing significant will be at zone 6 (see Figure 6.3c and Figure 6.1b and c).

Study the Part VI lighting analyses for the interior/exterior examples in Figure 6.4a and b. Note the cinematographer's choices of how to render the windows and where to place the interior facetones.

It is evident that because we can place only one luminance range on the zone scale "correctly," we must choose which of those ranges to expose for. Other subject ranges will fall higher or lower automatically. Of course, it is just these other ranges overlapping the main range that create the mood of the image, like overtones in music. As we shall see in Part III, we can manipulate these other ranges for effect through lighting as well.

The point here is that even with only exposure choice, we can control and utilize luminance range overlaps through the selection of which range to expose for and where to place it on the zone scale. Visualization in advance is essential because it is only then that we can control the image through exposure choice, lighting, change of camera-angle, or movement of the subject.

COMPROMISE EXPOSURE

We have mentioned "compromise exposure" several times and have looked at several examples, but this comes up over and over again with mixed interior/exterior situations and needs more explicit investigation.

At times the documentary and student cinematographer are unable to light, yet luminance range is a problem. We find typical examples of this in interior/exterior situations—an actor sitting in front of a window with the street outside, a character driving a car with the sunlit street visible through the windows—and face/sky situations—a character with large hat framed against the sky. The best solution to these situations is found in lighting technique, but there are possible exposure solutions. Let us take as an example, the mixed interior/exterior problem, the case of someone sitting by a window (see Figure 6.5).

Typically, an exposure reading outside for EI 200 will be around T 16; we shall assume the light inside measures T 2.8. This is a difference of five stops. Exposure for the person overexposes ("burns out") the street by five stops and moves everything five zones up the zone scale, although this may be the effect we want (see Figure 6.5a). Exposure for the street outside underexposes the person by five stops. This means the person is a silhouette or almost a silhouette depending on their facetone; again, this may be fine (see Figure 6.5f).

A compromise exposure may be preferable to these two alternatives. Sometimes the compromise is halfway between the two readings, in this case midway between T 5.6 and T 8, as in Figure 6.5d. At other times, the compromise is closer to one end than the other. In this case, perhaps a half stop over T 4 (T 4/T 5.6) is a better compromise, because facetones will be underexposed only 1½ stops (zone 4½) although, of course, the street background will

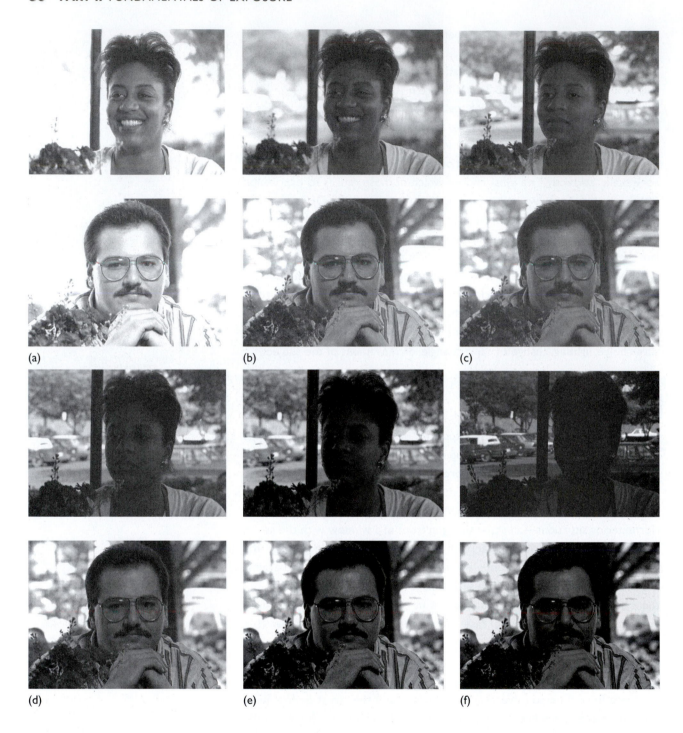

(a) (b) (c)

(d) (e) (f)

FIGURE 6.5

COMPROMISE EXPOSURES FOR
ACTORS IN WINDOW

Exposure choices for this situation range
from exposure for the faces (a) to expo-
sure for the street outside the window
(f). The series illustrates the effect of one-
stop increments between the two
extremes. ▪▪

be 3½ stops overexposed. This is okay if the background is less important (see
Figure 6.5c). Note also that the black facetone and white facetone are best
rendered at different compromise T-stops—the black facetone as in Figure
6.5b and c, the white as in Figure 6.5c and d.

With compromise exposures, you are pushing exposure technique into
areas best controlled by lighting. Sometimes this works; sometimes not—after
all, it is called "compromise" exposure.

(a)

(b)

(c)

(d)

USING ZONES TO PREVISUALIZE SUBJECT/BACKGROUND RATIOS

The zone system allows for an accurate previsualization of subject/background relationships. For example, take the simplest case, a person foregrounded against a white wall. If we want to duplicate what we see, we need to light the person and the wall to the same T-stop so that the wall will render white (see Figure 6.6c).

But suppose the director desires a midgray background. This means the white wall must be rendered at zone 5 rather than at its standard zone 9 value. In this instance, it must be underlit by four stops (four zones) relative to the subject. For example, if the subject is lit to a T 8 level, we make sure the light on the wall is at T 2. Exposure at T 8 will then render the subject as normal in front of a midgray background (see Figure 6.6a).

In the same manner, by underlighting the background eight stops, we can make the white wall black, a zone 1 value (see Figure 6.6b). To do this we must light the subject eight stops brighter than the background. If we light the subject to T 16, then the wall can be held to T 1.0 and rendered as a zone 1 black value.

Treating the subject/background as a ratio problem allows for a precise previsualization in zones which, in turn, tells us how much relative light intensity to give each plane. We work from subject to background or from background to subject depending on which plane is more important for exposure determination.

FIGURE 6.6

SUBJECT/BACKGROUND RATIOS

Starting with a white screen, we can control how it reproduces by changing the intensity of the background light while holding the lighting on the subject at the same intensity.

In (a) we have a 16:1 subject/background ratio for the gray part of the screen on the left. This means it was underexposed four stops and renders as a zone 5 instead of its normal zone 9.

In (b) the screen is underexposed eight stops. This renders it as a zone 1 black instead of zone 9. The subject/background ratio would be 256:1.

In (c) the screen is lit to the same intensity as the subjects and thus reproduces at its normal zone 9 value.

In (d) we create a silhouette by lighting the screen and not the subject. Underexposing the facetones at least five stops while exposing for the white screen in the background ensures that the facetones are rendered at zone 1 instead of the standard zone 6.

SILHOUETTES AND SEMISILHOUETTES

As an example of working from the background plane, take a person against a light gray, zone 7 wall, and assume we want to create a silhouette against a white wall. A silhouette by definition means we light the background and not the subject. The question is, how much do we light the background relative to the subject? For a pure black silhouette, the Caucasian facetone (zone 6) must be rendered at zone 2 and preferably zone 1. We will underexpose it five stops (five zones).

To create a white background, we must overexpose the light gray in order to render it as zone 9. In this case, we will need a two-stop overexposure. Starting with the background, we provide overall flat illumination so that we obtain a T-stop of 16 intending to expose at T 8. We then meter the subject and find the person measures around T 1.4 or lower, because no light is allowed to fall on her. This means that with an exposure at T 8, the back wall will go from zone 7 to zone 9, and the face will go from zone 6 to zone 1; from T 8 to T 1.4 is five stops. We thus obtain our silhouette effect (see the similar example in Figure 6.6d).

The silhouette is an extreme example, but more subtle **semisilhouette** effects work on the same principles. The central difference with semisilhouettes is that we retain detail in the face (see Figure 6.7).

The semisilhouette has two key features: (1) The facetones are underexposed about two stops, and (2) the background is zone 7 or higher and often contains a feeling of light luminosity. Usually exposure for the background is determined first, and then the faces are lit to carefully place them on zones 3 and 4 rather than on the standard 5 and 6.

Semisilhouettes are often melancholy and usually beautiful in mood. They also create visual variety since the facetones are at nonstandard zone placements. In a sense, we have chosen to place our facetones in more creative ways to obtain this visual variety. Look at the facetone placements throughout a film. Where there is good lighting, there is a lot of variety. In fact, boring lighting may be a result of an overly-mechanical approach to facetone placement. We will explore these ideas further in Chapters 7, 8, and 9 where we will see that for a variety of different lighting effects, the relationship between subject and background can be analogized to this basic semisilhouette technique.

(a)

FIGURE 6.7

SEMISILHOUETTES

Darker-than-normal placement of face-tones (semisilhouettes) retain detail in the face. In (a) the face is just slightly darker than normal and in (b) we see a more typical semisilhouette (photos by Maria Viera).

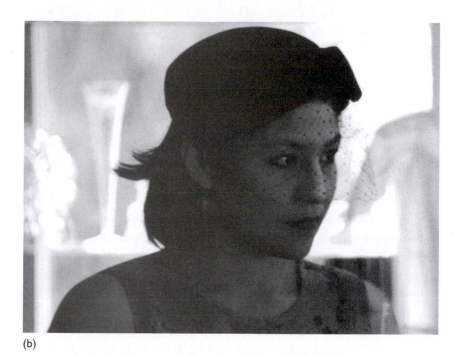

(b)

EXPOSURE FOR LUMINOUS OBJECTS

The most common use of reflected readings involves calculating an exposure for a subject not lit by incident light—for example, when filming light sources or other **luminous objects**. These are quite common and include neon signs, sunsets, light bulbs, fires, reflections on water, stained-glass windows, steamed-up windows and shower glass, even sunny street exteriors seen through billowing white curtains. A reflected technique is used whenever it is important to retain the feeling of light, the subtle values of luminosity.

Exposing for luminous objects has many interesting variations, but there are two main situations:

- When the luminous object is the main part of the shot—a light bulb, a sunset over the ocean, a candle flame.

- When the luminous object is only part of the shot, and not necessarily very important—practicals, such as a lamp in a living room, or a stained-glass window in a church, or an exterior close-up framed against the sky.

In the first situation, we use the spot meter (or averaging meter with a close-up technique) to obtain the highest maximum reading possible. With a light bulb or sunset, this is easily obtained by pointing the meter at the bulb or sun. Other subjects, such as a candle flame or a lamp, are more difficult to meter, and more than one reading may be necessary. Remember that exposure for the highest reading will render that object as a zone 5 value. Such a placement will be certain to differentiate highlight values and give us a starting point for capturing the feeling of luminosity, which is often the goal when filming luminous objects (see Figure 6.8).

But such a placement may be too dark as well. Thus, it is usual to overexpose this maximum reading from one to four stops in order to represent the "glowing feeling" of light. This would give us a zone 6, 7, 8, or 9 value for the object. None of these are "right" or "wrong" exposures; the choice depends on the exact subject and what you wish to do with it (see Figure 6.8). Spot meter readings tend to require more overexposure than averaging-type readings because they are more apt to exclude darker parts of the subject in the reading and thus indicate higher T-stops than the averaging type.

Light bulbs, sunsets, the sky, neon signs, and other luminous objects are handled in exactly the same way, obtaining the highest possible meter reading and working from that point. Do not be afraid to experiment. Generally, from one to three stops overexposure is required, but in some situations—say, a sunset in the fog over the ocean—a zone 5 placement might be best to convey the feeling of the luminosity.

In the second situation, where the luminous object is in view but not the main part of the shot, it is necessary to calculate the exposure as above and then light the rest of the shot referenced to this level. For example, if you decide the luminous background will render best at T 5.6, the rest of the lighting is planned around this T-stop and the shot is exposed at 5.6. For more on this, see the discussion of luminous objects in Chapter 8. On feature films, most practicals are controlled by dimmers so their T-stop level can be adjusted as necessary. There may be color temperature problems, however.

FIGURE 6.8 (opposite page)
EXPOSURE SERIES
WITH A LIGHT BULB

In photo (a), the bulb is given a zone 5 exposure. The rest of the series increases the exposure in one-stop increments. The movie theater effect in (g) depends on a correct choice of exposure for the projector light coming from the projection booth (8½, Corinth Films, Inc, 1963).

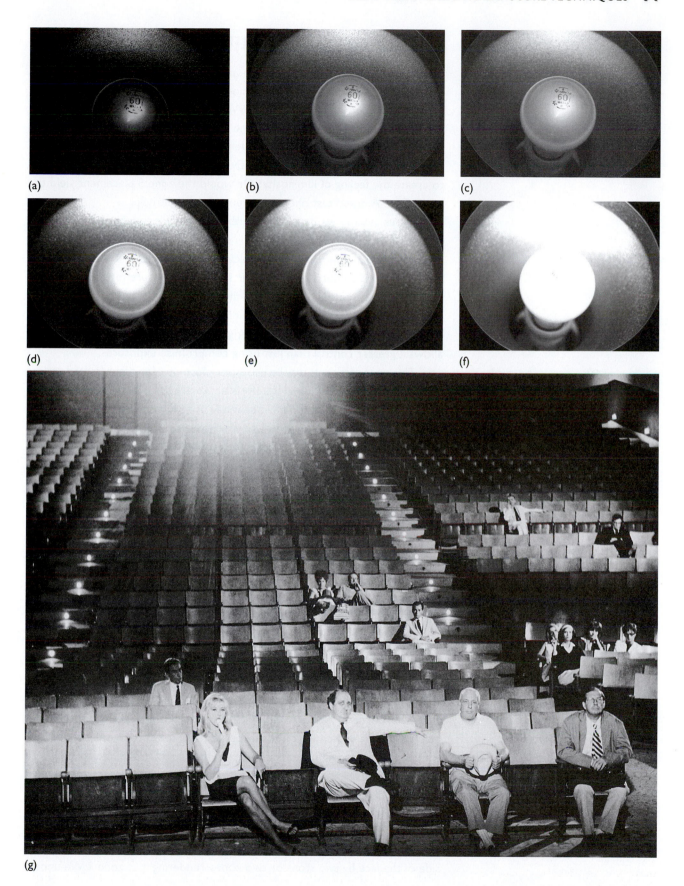

(a)

(b)

(c)

(d)

(e)

(f)

(g)

COMBINED INCIDENT AND REFLECTED READINGS

Let us look at an example of how an incident and reflected reading work in tandem. Take our usual example of an actor in front of a window, except this time the window glass is translucent. We now have a luminous object to deal with. Taking a spot meter reading of the brightest part of the window gives us T 16 for a zone 5 placement. An incident reading shows T 2.8 for the face. In this example, there is a new variable: Do we wish to overexpose the window to create the feeling of luminosity? Or would the zone 5 placement yield the best effect? A digital test photo, or even video, might help.

Let us assume we decide to overexpose the window by two stops, that is, give a T 8 exposure to the shot. This exposure leaves the faces three stops underexposed at zone 3. We might decide to try T 5.6 or T 4 instead—a better facial rendition but a three or four stop overexposure for the window.

It would be better to determine the best T-stop for the translucent window, and then light the faces for best effect. Note that the luminous window determines the initial exposure setting, and that lighting the interior faces allows a greater control than just using compromise exposures.

This same technique may be used for a close-up of an actor framed against the sky. A reflected reading of the sky is necessary since it functions as a luminous background. A decision must be made as to how much overexposure to give it. A typical sky is about zone 8, so we choose to overexpose it three stops, leaving the person about two stops underexposed (semisilhouette). We would either accept this or change it by lighting—using either a reflector or an artificial light such as an HMI.

There is a danger here to avoid. Overlighting the faces in either of the above situations will yield an artificial result. Here we are looking only at exposure possibilities. In Chapter 8, we will look at lighting solutions for these situations.

HANDLING THE EFFECTS OF RATIOS ON WHITE AND BLACK FACES

The above common situations—in-shot luminous objects and interior/exterior shots—are similar to the luminance range problems we examined earlier in this chapter. To summarize that discussion: Using a zone system terminology, a 4:1 ratio means we have a difference of two zones between light and shadow side of a face. If we expose for the light side of a Caucasian face, a nominal zone 6, then we can easily previsualize the shadow side of the face, which in this case will fall at zone 4. If we have an 8:1 ratio, the shadow side of the face will fall at zone 3. A 16:1 ratio is a four-zone difference and would mean the shadow side falls at zone 2.

This assumes we are exposing for the light side of the face. As we have seen, it is possible, for example with a 16:1 ratio (four zones), to expose halfway between—a compromise exposure. We then overexpose the bright side of the face by two stops or two zones, rendering it as zone 8. We under-

expose the shadow side by two stops or two zones, thus rendering it as zone 4. It is also possible to expose for the shadow side of the face rather than the light side. This helps create the feeling of light falling on the face (see the series of shots in Figures 6.1 and 6.3).

With a darker facetone, if we expose for the light side of the face with a 4:1 ratio, that side will fall on zone 4 and the shadow side on zone 2. With an 8:1 ratio, the shadow side will fall at zone 1. At 16:1 the shadow side will fall at zone 0. One problem with exposure for darker facetones is immediately apparent: The shadow sides of the face tend to render as pure black tones. This is because there is little visual difference on the screen between zones 2 or 1 and zone 0.

One obvious solution is to overexpose the facetone a stop or two compared to the rest of the shot so that the facetone will be placed on zone 5 instead of 4, and shadow values will likewise render lighter (see Figure 6.5). Of course, this works only if there are just dark facetones in the shot.

Where multiple facetones are present—for example, white and black actors—one solution is to light the black facetone a stop "hotter" than other faces in the shot and thus preserve more detail in the face. This might mean a "hotter" key, a "hotter" fill, or both. This was done for the shots in Figure 2.25. More fill light can be used in some cases, but this tends toward a 2:1 ratio, which can become overly repetitious with little mood.

EXPOSURE FOR REAR KEYS AND RIMS

In Chapter 3, we discussed briefly how to do this, but we can again have a better understanding if we look at the topic once more. Exposing for three-quarter rear and back keys with an incident meter can be tricky. One technique is to point the incident meter at the light, rather than the camera, and expose for the indicated reading. This tends to leave the subject too dark (see Figure 6.9c). Pointing the meter at the camera tends to overexpose the lighting about a stop for a three-quarter rear light to three or four stops for a back light. The amount of overexposure depends on how intense the rear or back light is compared with the frontal lighting, if any, on the subject (see Figure 6.9a).

Some cinematographers expose halfway between these two readings— a compromise exposure. With a three-quarter rear key, you will arrive at the same effect by pointing the meter at the camera in the usual way and then intentionally underexposing one-half to one stop (see Figure 6.9b).

The addition of fill light complicates the exposure determination. At a certain point, the fill becomes functionally more important than the back light and the rim or back light becomes supplemental. In this case, exposure is taken for the frontal fill light in the normal way.

FIGURE 6.9

EXPOSING FOR THREE-QUARTER
REAR AND BACK KEY POSITIONS

In this example, three exposure possibil-
ities are shown: (a) exposure for face,
(b) exposure in between (compromise ex-
posure), and (c) exposure for back light.
Note the various effects the different ex-
posures have on the background.

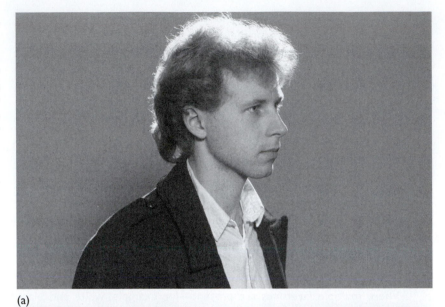

(a)

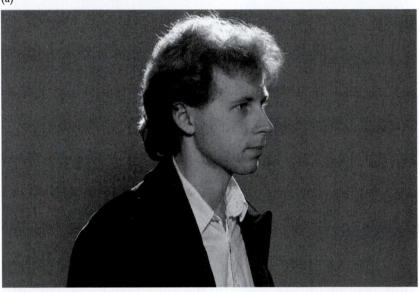

(b)

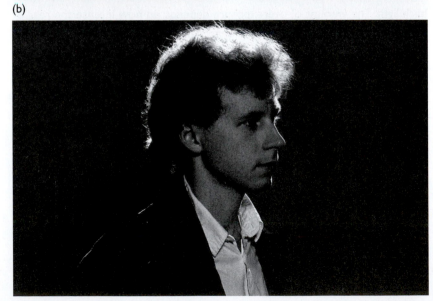

(c)

RIM AND BACK LIGHTS

Rim and back lights used for modeling effects do not affect exposure. Exposure is a function of key plus fill. You generally set key and fill, determine an exposure reading, and then position the rim light. When taking an exposure reading with the incident meter, you turn off the rim and back light or shield the meter from them.

For example, let us say the key is 100 fc and we want to overexpose a rim or back light by the typical two stops. We set the rim or back light for 400 fc to accomplish this. This measurement can be determined simply. Take care to block out other lights, and point the meter directly at each light for its reading.

Not only are rim and back lights overexposed, they are often colored as well. One technique is to overexpose the rims about two stops while using a bluish gel. This, coupled with warmer keys, is used to create night interior/exterior looks.

ALL-LIGHT/ALL-DARK SUBJECTS

It is common to utilize over- and underexposure with certain extreme subjects—subjects that lack normal tonal distributions—for example, all light-toned subjects such as white dogs playing in snow, all dark-toned subjects like black cats playing in coal, or subjects with low contrast. For example, it is common to underexpose an all-white subject by a stop to ensure highlight separation. It is standard practice to overexpose exceptionally dark subjects for the same reason.

Another situation where underexposure is used is with panoramic, landscape shots, particularly when there is haze and side or back lighting. Atmospheric haze tends to lighten the shot by rendering dark tones a zone or two brighter than normal. Consequently, one may give a stop or more underexposure on shots of this type.

It is possible to use an adjusted incident reading for such shots:

1. Take a standard incident reading for the shot.

2. Take an additional reading by pointing the meter toward the sun.

3. Expose halfway between. You could also expose for the reading obtained in number 2.

Underexposure by a stop or more is almost always used when the main part of the subject involves atmospheric effects or the feeling of light—for example, sky, reflections in water, and fog. The underexposure is used to retain as much gradation of the highlight values as possible on the negative. Note that underexposure here means relative to a zone 5 incident reading. It would also be possible in some of these examples to apply the reflected light technique for luminous objects described earlier.

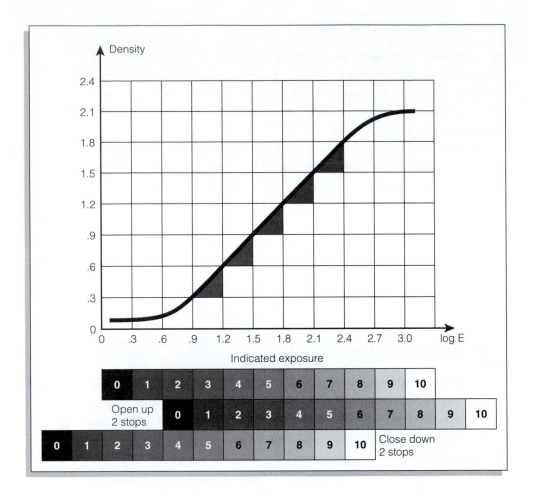

FIGURE 6.10

TWO-STOP OVER- AND
UNDEREXPOSURE

Over- and underexposure are accomplished by varying the T-stop setting indicated by the light meter. This moves the range of values up or down on the characteristic curve. Opening up two stops is equivalent to shifting the range of subject luminances up the characteristic curve by two zones; zone 6 becomes zone 8, and so forth (see Figure 6.10).

PULLING T-STOP

Similar to situations that require either lighting or a compromise exposure technique are shots where the lighting intensity changes as the shot progresses. This can happen with a panning shot—one part of the room to another—or a tracking or hand-held shot—from outdoors to indoors, or from a bright room to a dark one. The most extreme example involves filming a person walking down the street and following that person into a house or building all in one shot, a common problem in vérité documentary.

The luminance-range problem is not unlike the previous example of the person in the window. The best solution, not always available in documentary, is to light the interior rooms and balance them to the exterior. Sometimes a compromise exposure is feasible. The other nonlighting possibility is to **pull T-stop**, which involves moving the T-stop ring while filming; it is similar to a focus pull but much harder to hide.

Assume the T-stop has to go from T 16 outdoors to T 2.8 indoors as the person changes location. It is difficult to hide the T-stop pull. Here, we would pull the stop as we move from exterior to interior. As with a focus pull, the camera assistant can set and mark the lens in advance. In a true vérité documentary situation, you probably would have to guess the exposure for the interior because there is no preplanning. Some documentary/news cinematographers have so much experience they can do this by eye, using the viewfinder as a reference point. The rest of us need a camera assistant.

One can also try to avoid these situations by choosing alternative locations and shots, or different times of day to shoot. If this were a Steadicam shot in a feature film, the interiors would be lit as necessary.

SUMMARY

We have dealt with seven common "tricky" exposure problems: (1) exposure for luminous objects such as sunsets and light sources, (2) exposure for interior/exteriors, (3) exposures combining luminous objects with incident readings, (4) exposure for mixed facetone situations, (5) exposure for rear keys and rims, (6) exposure compensations for all-light/all-dark subjects, and (7) changing exposure by pulling T-stop.

As we have seen, there is room for creativity in exposure technique. Many looks can be accomplished with exposure techniques as well as lighting because controlling select areas of the frame relative to the principal subject involves both exposure and lighting. It might be helpful to summarize all of this by listing the steps taken when exposing with the zone system.

1. Through experience, we imagine normal subject relations and how a shot of the subject will look on the screen. A face, a white and black cat, an early morning kitchen, a blue sky—all are imagined in terms of zones.

2. We know that exposure for the luminance range from one angle of lighting automatically determines the zone placement of the other luminance ranges present.

3. We know that whatever is exposed for will be faithfully rendered. All we have to do is set the T-stop as indicated by the incident meter.

4. We can intentionally alter the zonal representation of a subject by changing T-stop. Opening up one stop overexposes by one stop and moves everything up one zone. Conversely, underexposing by one stop automatically moves everything down one zone. What normally would have been zone 6 becomes zone 5. We can therefore intentionally create a lighter or darker rendition of the subject through over- or underexposure. Control is possible because we first visualize the normal and the over and under renditions before making a choice.

We know that areas of the shot under lighting conditions different from the main subject range will be rendered brighter or darker than normal. They will fall into zones higher and lower than normal in proportion to how much their lighting intensity differs from the one exposed for.

We will cover more of these problems in detail in Part III where we return to our study of lighting.

LIGHTING APPLICATIONS

When it comes to lighting, one of my basic principles is that the light source must be justified. . . . I try to make sure that my light is logical rather than aesthetic. . . . In a studio set I imagine that the sun is shining from a certain point outside, and I decide how the light would come through the windows. The rest is easy.

~Nestor Almendros
Light Years

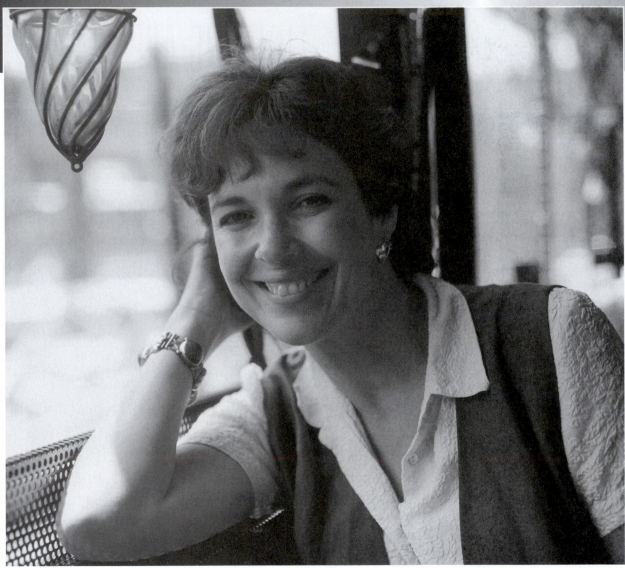

NATURAL LIGHT

CHAPTER SEVEN

Approaches to Lighting Style

Lighting is an art, therefore, the cinematographer must be able to react to a variety of unique situations. There can be no fixed rules. In this chapter, we will look at a set of lighting considerations that can be formulated to guide us in conceptualizing and executing a lighting setup. First, we must select an overall look for the film and determine the impacts of lighting on the theme and mood. Once such base determinations are made, we have a variety of options available to execute our ideas and create a lighting style.

IGHTING STYLE—the ultimate goal. Think of the most visual films you have seen lately and you realize there are infinite possibilities inherent in the concept of lighting style. The range of styles varies from the naturalistic to the stylistic, from black and white to color, from hard to soft.

The concept of style can refer to several different ideas: (1) the style of a film overall—whether high- or low-key, soft or hard, naturalistic, realistic, or stylized; (2) the style of a certain cinematographer throughout a series of films or a particular film—Nykvist's soft light style, Almendros's magic hour style, Hall's hard light style, Wexler's documentary style; or (3) the type of lighting applied to a certain genre—*film noir* style, musical comedy style, TV commercial style. Choice of style varies with the approach of the cinematographer, the meaning of the film, and the views of the director.

Color and how it is used is a key element of style. Many cinematographers and directors take the position that color film does not mean *color*, but selective use of certain color hues. It is this sensitivity and awareness of the image's effects that yield a lighting style. Think of the desaturated colors in *Saving Private Ryan*, and consider these words of Sven Nykvist, the famous Swedish cinematographer:

> Making the transition from black-and-white to colour was not easy for Ingmar [Bergman] and me. We felt that colour raw stock was technically too perfect; it was difficult not to make it look beautiful. When we came to shoot *The Passion of Anna*, we wanted to control the colour palette so it would reflect the mood of the story. We managed to find a location with very little colour, and everything in the film's design was intended to simplify the colours in front of the camera. . . . I used a similar technique on *The Sacrifice* for Tarkovsky, where we took out the red and the blue, giving us a look that was neither black-and-white nor colour—it was 'monocolour.' . . . [as quoted in Peter Ettedgui, *Cinematography/ Screencraft*, Focal Press, 1998, p. 42. All the following quotes are also from this book.]

Consider a totally different aspect of style—the quality of the light and listen to the poetic feelings Indian cinematographer, Subatra Mitra, has for "bounced light":

> [B]ounce lighting became an integral part of my working method. It enabled me to create convincing effects that I could not have got otherwise—such as bringing out the difference between direct sunlight and ambient diffused light in an interior day scene, or lighting up an interior in the studio to create the effect of fading daylight when cut with scenes shot in location exteriors at dusk. Apart from its capacity to simulate natural light, bounce lighting has a delicate artistic quality. For me, shooting with nothing but direct light inside the studio is like photographing the exteriors using only sunlight, sacrificing all the subtle tints of a rainy day or overcast sky or a dawn or as a dusk. It is like refusing to shoot in the mist, or remaining indifferent to the poetry inherent in a rainy day. [Ettedgui, p. 54]

Some cinematographers such as Laslo Kovacs link lighting to painting in direct ways:

> When I'm lighting I like to feel that every light has a dramatic logic and function in the composition. It really is like painting: each piece of light is a brush-stroke, giving different emotional values, defining and texturing each part of the shot from foreground to background, highlighting what's important for the audience to see. [Ettedgui, p. 93]

Awareness of style sometimes means consciousness of the unforeseeable events that will impact on the image when shooting—a Jackson Pollack action painting:

> However much preparation you do, a film never truly comes alive until you show up on the first morning of the shoot, and all the elements combine for the very first time. As far as it's possible, you have to keep an open mind about how you're going to shoot something until you begin to see what the actors are doing. That's why I've never done floor plans, because a scene may not happen the way you anticipate. [Laslo Kovacs, Ettedgui, p. 91]

> It's a perfect example of what can happen when you're well prepared and incredibly focused—you begin to 'feel' the scene rather than think about it. It's at such times that the industrial aspects of film-making can be transcended, and you start to use the mechanical process to make unconscious material visible. [Michael Chapman talking about working with Scorsese on *Raging Bull*, Ettedgui, p.135]

And then there is, of course, your overriding approach to lighting—how to learn lighting, how to "listen" to nature:

> I'd know that there was nothing I could do to the light in that location that was going to be anywhere near as interesting as the light itself—so the best thing I could do was to try to transfer that light onto film as it was, perhaps supplementing it with a little fill-light for the actors' faces.

In so doing, I began to realize that the basis for cinematography is the reality you see. If you trust what you see, you have a guide of how things look—not how they should look, but how they *do* look—and that gives you a basis to work from. [Michael Chapman Ettedgui, pp. 131–132]

And how many lights do you use? Where do you put them?

Often I'll light a big sequence and I won't have a single conventional film light on the set. *Kundun*, the film I shot for Martin Scorsese, was lit mainly with oil lamps, and with little kit bulbs on dimmers to give the effect of candlelight. [Roger Deakins, Ettedgui, p. 162]

Deakins expresses one school of thought, but you cannot light a film like *Gladiator* or *Hannibal* with oil lamps. Large scale lighting, like John Mathieson uses in those films, also yields interesting image looks and visual styles.

We have quoted feature film cinematographers from a variety of backgrounds and time frames to prove the point that lighting style results from a philosophy, from a commitment to mood and script, from a love of light and color. Lighting style itself is beyond the scope of this book, but this introduction to the subject hopefully will inspire others to become psychologically involved with the image's surface and depth. But Sven Nykvist says it better:

Sufficient time is rarely taken to study light. It is as important as the lines the actors speak, or the direction given to them. . . . Light is a treasure chest: once properly understood, it can bring another dimension to the medium. . . . As I worked with Ingmar, I learned how to express in light the words in the script, and make it reflect the nuances of the drama. Light became a passion which has dominated my life. [Ettedgui, p. 38]

◉ VERALL LOOK

As is obvious from the above quotes, the determination of an overall look for a film is a key consideration. This look derives from consultation with the director and his or her visual interpretation of the script. Input also comes from interactions with the production designer, as well as set and costume designers. Once the overall look is agreed on, the cinematographer will be left to execute and interpret the requirements of that look from scene to scene.

A film's look derives from a variety of visual sources external to film itself and, of course, from film conventions and fads then in effect. For example, a film like *Dick Tracy* clearly derives its look from comic books. Painting is used a lot for look ideas. For example, consider the use of Edward Hopper's painting style in *Pennies from Heaven* or Caravaggio's chiaroscuro painting style in the biographical film, *Caravaggio,* or the van Gogh look in Robert Altman's *Vincent and Theo.*

As for film style conventions, the use of *film noir* techniques and looks in *Blade Runner* derives from the older black and white *noir* films; but the use of lots of backlit smoke in *Blade Runner* was part of a "smoke" fad during the late 1970s and 1980s evident in films as diverse as *A Man Called Horse* and *Flashdance,* as well as a host of music videos.

MOOD AND THEMATIC CONCERNS

Mood is created through the patterning of light and shadow and is controlled by manipulating facial and subject/background ratios. The cinematographer works to establish mood and emotional responses to his or her images. This is possible on an overall level as well as on a scene-to-scene basis depending on the specific needs of the production.

Lighting has strong impacts on the meaning levels of a film. Consider the scene in *Close Encounters of the Third Kind* where the spaceship descends and the alien appears. The scene is bathed in an aura of light and "otherworldliness" which is, of course, a principal thematic element. Through selective lighting, cinematographers can emphasize characters, objects, and other details which in turn contribute to the meaning of the film.

APPROACHES TO LIGHTING SETUPS

An interior may be in a studio or on location. In the studio situation, we light everything and have lots of control. At a location, either we block off available light so that we can treat the location as a studio interior or we use the available light along with supplemental lighting as necessary.

Lighting is generally roughed-in on a set-wide basis. We move to close-ups and medium shots from that basic scheme. It is the long shot that takes the most time to light. Asking yourself who and what is important makes the execution of the lighting setup more efficient. These questions force you to concentrate on the framing of the shot through the camera viewfinder. This is where lighting should be perfected, not outside the framelines.

NATURAL LIGHT APPROACH

When filming on location, many cinematographers work with **available light**—ambient daylight, light bulbs, and lighting fixtures present at the location—in an attempt to preserve the natural look, which is one of the reasons the location was selected in the first place; see the shot opening this chapter. Available light is seldom totally acceptable and is commonly supplemented with artificial units. For example, we often use a large HMI from outside a window to simulate daylight or sunlight.

The **natural light** approach was in vogue during the 1960s and 1970s and was made possible by the introduction of high-speed lenses and faster film emulsions. Prime examples would be cinematographer Raoul Coutard's work on the *nouvelle vague* films and Nestor Almendros's use of twilight in *Days of Heaven*.[1] Philosophically, the natural light approach was a reaction against the glossy, overly fine-tuned studio lighting of the time with its large amount of "artificial" back light and "perfected" close-ups.

Consider the following quote discussing the lighting of Claude Chabrol's film *Madame Bovary* by cinematographer Jean Rabier. "Prior to production, Rabier and Chabrol discussed lighting in great detail. 'Again, we wanted to be very true to the soft local light, and wherever possible, we've shot in natural daylight with a minimum of lights,' says Rabier."[2]

With the natural light approach, lighting setup time is generally minimized, and the overall look for that scene is more open to spontaneous change. With this style, your lighting plan springs out of the natural location. The use of actual candlelight for key lighting by John Alcott in *Barry Lyndon* provides a good example of natural light pushed to the extreme. The photographs in Figure 7.1 illustrate the range from natural light to artificial studio lighting.

As an example of how the natural light method works, suppose the location is a poolroom in the back of a tavern. The determination has been made to use what is already available—lights over the pool tables, neon signs provided by the various beer companies, small lights on a couple of tables. This means we will be working at very low levels, around T 2, and will need to use small units for supplementing so that they fit in with the feel of the place. After scouting the location, you plan your lighting setup on paper, elaborating which, if any, supplemental units to use, where to place them, where to use filtration, diffusion, and so forth. Available light, supplemented with key lighting on the two people, was used on the shot in Figure 8.3. Much the same effect can be created with artificial light.

FIGURE 7.1

LIGHTING STYLES: FROM NATURAL LIGHT TO ARTIFICIAL STUDIO LOOKS

(a) illustrates a natural lighting style; (b) illustrates a "natural" studio style, while (c) and (d) demonstrate a highly artificial studio style. The publicity still in (b) is from *Raggedy Man,* © 1981 Universal Pictures (Courtesy of Universal Studios Licensing LLLP); (c) *8½,* Corinth Films, Inc., 1963; (d) *Touch of Evil,* © 1958 Universal Pictures Company, Inc. (Courtesy of Universal Studios Licensing LLLP)

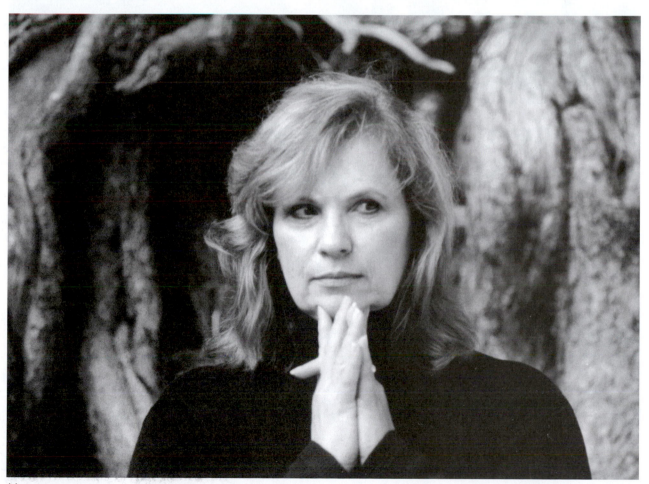

(a)

(b)

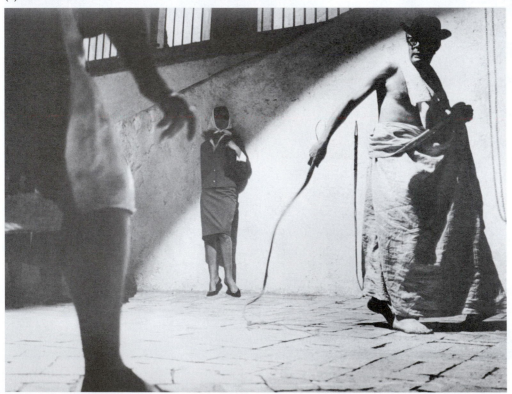

(c)

FIGURE 7.1
(continued)

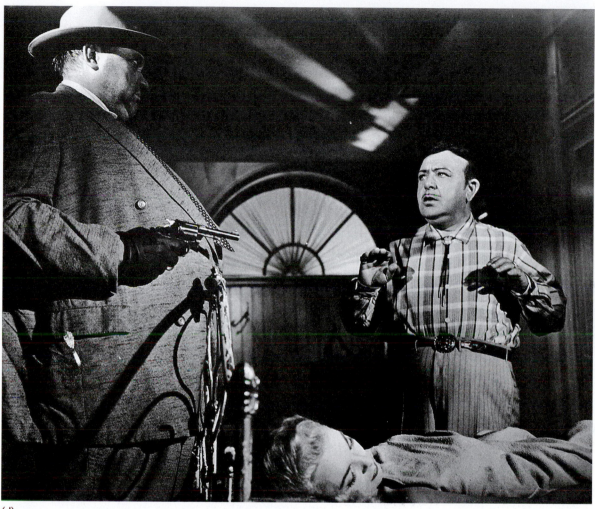

(d)

STUDIO APPROACH

FIGURE 7.1 (continued)

The alternative to a natural light approach is to light everything from scratch, the normal procedure in a studio situation. This approach to lighting generally indicates a large production unit with lots of equipment, a commercial or feature film shoot. This tradition encourages large-scale interactions—if done well, the subtlety of natural light is replaced with the subtlety of artificial light. The lighting in *The Color Purple*, *Superman*, and *GoodFellas*, as well as TV shows like *NYPD* and numerous, stylized music videos, such as Michael Jackson's *Black or White*, illustrates the studio approach and the many possibilities for using artificial light.

If our poolroom example were in a music video, available lights would be used or switched off to the degree they fit in with the imposed style. A heavily smoked, back lighting would likely be applied. Localized setups would highlight singers and other select subject areas. Background lights and neon signs would be hung as props. With lighting-from-scratch styles, the lighting in effect "creates" the location.

A cinematographer must be able to work with both natural light and studio methods because in any given film both approaches are almost always utilized. Interesting images can result from either method although certain looks require a particular working method. In general, Hollywood feature films, commercials, and television programming result from an interventionist, large-unit studio style. Documentary, student, and independent features use more natural light approaches.

USE OF LIGHTING PLANS OR PLOTS

Lighting proceeds through a series of trials and errors. While setting lights, new problems and new ideas will arise and be dealt with. Initial lighting execution (roughing in) is a very creative act as well as a very empirical one. You continually ask yourself: Is this what I want? A variety of devices are used to help establish the setup: digital photos, video monitors, viewing glasses, or if time permits, stills and film tests. Fine-tuning perfects the setup and is judged through the camera viewfinder.

Although lighting plots are not always done in film and seldom done in video, for student work a lighting plot should be made of the final setup, as shown in Figure 7.4. The plot schematizes the lighting setup and maps the types of lighting units used along with the position, angle, intensity level, and degree of diffusion or color filtration for each. This written record will facilitate lighting during reshooting, should that be necessary. A photo or video of the lighting setup can also be useful.

OVERLIGHTING: A DANGER TO AVOID

Overlighting means the tendency to use too much light, particularly fill and rim, on actors and overly high intensities on backgrounds. The result is actors who always look lit and backgrounds that are overly bright and intrusive. Overlighting destroys the moods inherent in an actual location and inhibits the creation of mood in a studio situation.

Overlighting derives from insecurity and leads to unnecessary lighting in beginning work. Inexperienced cinematographers light background actors not within the frame, or perfect the lighting on lead actors regardless of their movements or insignificance in a particular shot. In the worst case, lighting is set for the long shot, which generally takes a lot of time, when only close-ups and medium shots are asked for.

SPECIFIC PROBLEMS

There are a number of recurring lighting problems that need addressing in every film. Some involve the lighting for the film as a whole, and some are more scene-specific. The basic considerations that must be addressed include:

where to place facetones, whether to use stylized partial lighting, whether to shoot everything with the same T-stop, where to set the source motivation, whether to prelight sets, whether to light backgrounds first, how to accommodate actor movement, how to check the balance of the lighting intensities for the setup, which gear to use, and how to position that gear. Although written from a film point of view, these considerations also apply to HD video and other video productions moving beyond the "video" look. We will now look at these recurring problems in more detail.

FACETONE PLACEMENTS

One subtle technique is to place facetones higher or lower than the normal zone 5 exposure placement, which renders black facetones at zone 4, brown facetones at zone 5, and Caucasian facetones at zone 6. In Chapter 6, we discussed exposing for the shadow side of a face. This results in a zone 7, or higher, placement of facetones. The result is a light, "up" mood (see Figure 6.3d).

Higher-than-normal facetones can also be flattering to actors because overexposure minimizes wrinkles. Where the facial ratio is 2:1–4:1, exposure for the shadow side overexposes the light side a stop or two. This technique was utilized in the Swedish film *Elvira Madigan* as part of its overall romantic, Impressionistic lighting style.

Another possibility is to peg facetones at levels lower than normal, imbuing them with a heaviness and gray sobriety. Many beautiful effects result from this use of semisilhouettes. With semisilhouettes, exposure is usually pegged to the background, which, for best effect, is lighter than the actors. The result can be romantic or morose depending on specifics. With a semisilhouette technique, facetones are around zone 4, two stops under the standard zone 6 (see Figure 7.2a–d).

In the series of shots in Figures 6.1, 6.2, and 6.3, we discussed the effects obtainable with a compromise exposure. For a given facial ratio, it is possible to split the exposure between the light and shadow sides of the face. With high facial ratios, say, 16:1, you overexpose the light side two stops and underexpose the shadow side two stops. Little importance is attached to zone 6. This technique was used in Jean-Gabriel Albiccoco's *Girl With the Golden Eyes* to create an abstract pattern of light and dark within a moody, low-key context. Such an effect derives from the use of high facial ratios, rear keys, and minimal fill (see Figures 7.2f–g and 1.3c).

Variations in facetone placement may be utilized throughout a scene or an entire film. The cinematographer should remain alert to placement potentials, even though 90% of facetones are at a standard zone 5 exposure placement.

FIGURE 7.2

FACETONE PLACEMENTS:
SEMISILHOUETTES AND
COMPROMISE EXPOSURE EFFECTS

Darker-than-normal placement of face-tones (semisilhouettes) can have very interesting effects on mood. In (a) the face is just slightly darker than normal. In (b) we see a more typical semisilhouette effect, with the face about two to three stops darker than normal (photo b is by Maria Viera).

In (c) and (d) we see that the semi-silhouette (c) is created by underexposing the foreground actors about two stops relative to the background, which is held constant for both normal (d) and semisilhouette (c) effects. See in this regard the discussion of silhouettes in Figure 6.6d.

Another interesting facetone placement is illustrated in (e), (f), and (g). Hard light and a high subject lighting ratio, 128:1 or more are used. A compromise exposure is then given so that the lit side of the face is three or more stops overexposed and the shadow side underexposed a similar amount. The result can be very dramatic.

(a)

(b)

(c)

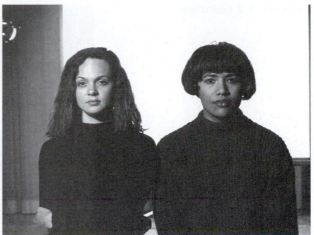

(d)

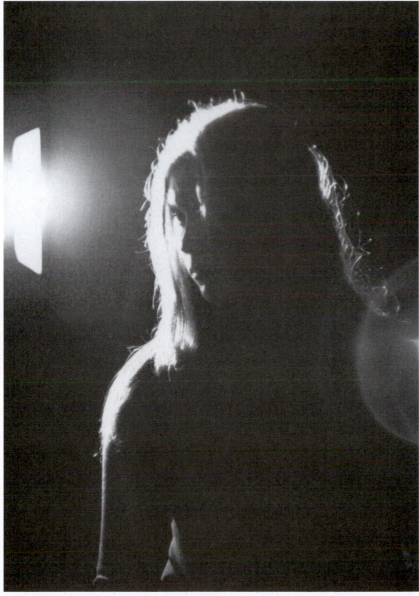

(e)

FIGURE 7.2 (continued)

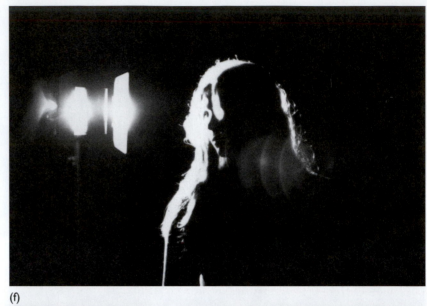

(f)

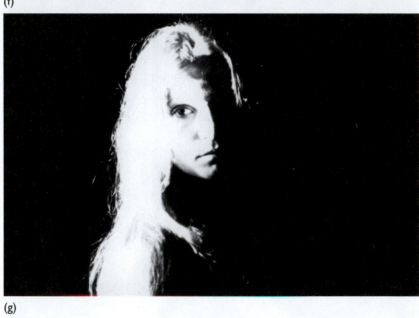

(g)

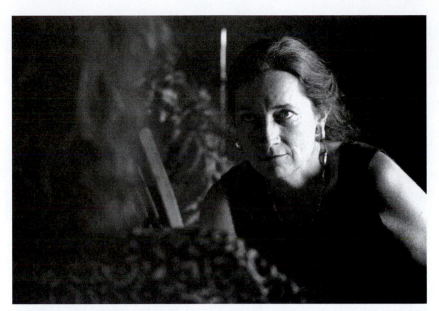

FIGURE 7.3

KEEPING THE FOREGROUND
ACTOR SEMISILHOUETTE IN
TWO-SHOTS

PARTIAL LIGHTING

This refers to a facial lighting technique, popular in the 1930s through the 1950s. In *noir,* melodrama, and other dramatic films, cinematographers shaded light from the forehead and body so that it would not draw attention away from the face and eyes. This technique is still used in music video and color noir films, though often as a form of intentional artificiality, a deliberate visual quoting of older film forms.

Another standard practice derived from the 1940s and 1950s is the emphasizing of one actor in a two-shot by keeping the foreground actor silhouette or semisilhouette. This often results from **cheating**—the slight repositioning of actors, props, and lights for better effect—and is done to focus the audience's attention on a particular character (see Figure 7.3).

T-STOP CONSISTENCY

As we saw in Chapter 3, feature-film cinematographers often work to a predetermined T-stop, a stop used, for example, for all the interiors in a film. The theory is that such consistency will give uniformity to the various shots in a scene and enhance the illusion of reality. Sometimes a particular T-stop is fundamental for the lighting setup, such as when depth of field is required. In low-budget productions, T-stop consistency is not always possible, although consistency within a given scene is possible and should be maintained.

LIGHTING MOTIVATION

As stated in Chapter 1, most cinematographers approach lighting a scene by using existing light sources—a window, doorway, or table lamp—as motivation for the direction, quality, and color of the illumination. Selection of the main motivating light source determines the direction and angle of the key light and the corresponding lighting logic for the entire scene.

Where there is no motivating in-shot light source, we usually invent one off-screen. For example, in a night bedroom scene, the lighting can be motivated by an imaginary streetlight outside the window. In the case of nonrealistic lighting styles, a lighting setup with a logical spatial continuity is less important and sometimes unimportant.

PRELIGHTING OF SETS

Prelighting is common in feature films. It refers to a gaffing crew's lighting the next set or location while filming is going on at the current set. With prelighting we can usually perfect the background lighting but only rough-in subject areas, fine-tuning those when the principals are on the set. In low-budget films, prelighting of sets is uncommon.

LIGHTING SUBJECT OR BACKGROUND FIRST

Whether to light the subject or background first is often a matter of personal preference. As we saw in Chapter 3, theoretically, there should be no visible difference since both involve the establishing of the same subject/background ratio. However, where prelighting is being used, usually the backgrounds are perfected first. On low-budget films, we generally light the subject first—although in the poolroom example discussed earlier, where the background was already lit with beer signs and other lights, we would blend in our subject lighting accordingly.

ACTOR MOVEMENT

When lighting for movement, key areas of action are identified and each given its own lighting setup. For example, suppose we track an actor as she enters a door at frame left, walks screen right to sit at a table, gets up to dance, returns to the table, and then leaves. Each of these specific action areas will have its own setup. The overall plan might require the door to be darker than the table and the table brighter than the dance floor. Exposure might be referenced to the table at T 2.8 with the dance floor and doorway lit one or two stops underexposed.

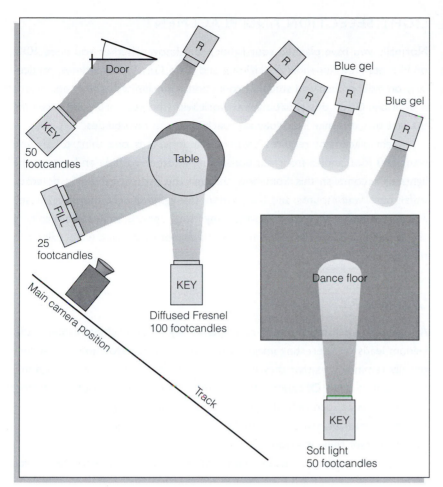

FIGURE 7.4

LIGHTING FOR ACTOR MOVEMENT

We plot our lighting for the scene described in the text.

Generally, it is a good idea to let actors enter and exit localized lighting setups rather than illuminating them uniformly throughout the shot space. In this example, we would not light the area between the doorway and table or between the table and dance floor. We might, however, accentuate the actor with rims, perhaps with blue gels, when she is in those areas. The complete setup might look like the plot in Figure 7.4.

The human eye and mind like variety. The moving actor is inherently interesting. Varying the lighting intensity throughout a shot adds to the visual interest.

CHECKING THE SHOT WITH A METER

Usually after all fine-tuning is completed, the cinematographer will walk through the shot pointing an incident meter at the camera to check for lighting variety and to measure the main areas for proper intensity. In our example, the cinematographer would enter through the door, go to the table, and proceed to the dance floor. This would ensure levels are set as planned. With a video shoot, the setup can be judged visually with a monitor.

LIGHT SELECTION AND PLACEMENT

Normally, you have planned your lighting and know whether you need 10Ks or Midgets (see Appendix A, "Lighting and Grip Gear"). Sometimes, particularly on independent and student productions, only limited lighting equipment is available. Given this situation, you work with the gear you have, accepting the fact that this may limit your approach and look possibilities.

Light placement requires creative solutions. It is one thing to say you want 100 footcandles from position X and another to hide and mount the lights to accomplish this. Somehow, through the use of scaffolding, polecats, gaffer tape, wall mounts, and imagination, the lights do get there (again, see Appendix A). On large crew shoots, many more options and workers to help are available. In any event, care must be taken not to damage walls, paint, and the like.

SUMMARY

A formulaic application of such concepts as key, fill, and subject lighting ratio seldom leads to interesting images, which is why cinematographers are continually reminding us that they light by eye, that they never measure lighting ratios, and so forth. Of course, their attitudes presuppose a lot of experience.

Techniques such as lighting in planes, cheating lighting in close-ups, using under- and overexposure to create lighting changes are just that—techniques. The important thing is vision.

In an interesting discussion of his approach to lighting, Nestor Almendros says:

> More and more I tend to use only one light source, which is what usually happens in nature. I reject the typical lighting of the forties and fifties, which consisted of a main or "key" light, supplemented by a "fill" light, with another light behind to show off the stars' hairdos and make them stand out against the background, yet another for the background itself, another to show off the wardrobe, and so on *ad infinitum*. The result had nothing to do with reality, where a window or a lamp, or at most both of them, normally provide the only sources of light. Since I lack imagination, I seek inspiration in nature, which offers me an infinite variety of forms. Once the key light has been decided, the space around it and the areas that might be left in total darkness are reinforced with a very soft gentle light, until what is reproduced on film is close to what the eye would really see.[3]

Almendros obviously takes a natural light position in this passage, but to be underlined for our purposes is that he emphasizes the observational, "seeing" element as an approach to lighting. Almendros is noted for his interesting images.

Try to imagine a lighting setup as the creation and lighting of a filmic space. Let the ideas flow from the initial conceptual breakthrough. Evaluate them by eye, always searching for a freshness to the lighting. Concepts such as key and fill will then function as reminders to aid you in fleshing out your ideas. This approach will help to keep your lighting from being overly mechanical. Ultimately, no book can teach lighting; it can only point out avenues to explore.

NOTES

1. See the discussion of natural light in Gerald Millerson, *The Technique of Lighting for Television and Film*, 3rd ed. (Oxford, England: Focal Press, 1991), pp. 244–46.

2. Ian Blair, "On the Set of *Madame Bovary*," *Film and Video: the Production Magazine* (November 1991): 6–8, 76–78.

3. Nestor Almendros, *A Man with a Camera* (New York: Farrar, Straus and Giroux, 1986), pp. 8–9.

DAY INTERIOR

CHAPTER EIGHT

Lighting Interiors

In this chapter, we address the considerations that arise in lighting interiors. We discuss lighting for long shots and the techniques for matching close-ups to those long shots. We look at a variety of other problem areas, including establishing and maintaining a lighting logic with time and spatial continuity. In addition, three common situations are examined in detail: Mixed interior/exterior situations, shots containing luminous objects, and night interiors.

In Chapter 9, we will look at lighting for exteriors. In Chapter 10, we will go over a detailed example of interior/exterior lighting. That chapter will also deal with the cinematographer's duties in setting up an actual production.

IGHTING INTERIORS entails creating interesting long shots and matching close-ups to those long shots. The cinematographer must establish and maintain a lighting logic with time and spatial continuity while providing visual variety and interesting facetone placements. Ideas for solving problems in lighting interiors are often found by going to the real place and observing the natural lighting. For example, visiting a bowling alley and studying the lighting aids the cinematographer in creating a "bowling alley" on film. Three situations occur so often they should be mastered as a matter of course: mixed interior/exterior situations, shots containing luminous objects, and night interiors. All three are controllable through techniques described in this chapter.

LIGHTING LONG SHOTS

Because of the numerous variables and large areas involved, the long shot is usually the most difficult to light. It is also usually the most important shot within a lighting scheme because it sets the mood possibilities for the other shots in the scene. Most of the lighting principles we have looked at so far concern lighting persons. Lighting for a long shot centers around lighting a place. The following elaborates basic considerations.

ESTABLISHING A LOGIC FOR THE ILLUMINATION

The long shot provides the audience with most of its geographic and spatial cues. The location of motivating light sources is established. A basic logic for the illumination is constructed by answering such questions as these: Is the interior lit by the large window? Does the fireplace light the den for the night interior? Are the card players lit by the table lamp? From the cinematographer's point of view, it is preferable to shoot a scene's long shots first; once that is accomplished, the lighting may be perfected for close-ups and other shots without the cinematographer having to worry about recreating the long-shot lighting setup.

(a) (b) (c) (d)

FIGURE 8.1

ESTABLISHING A LIGHTING LOGIC FOR A LONG SHOT

The lighting in the long shot (a and c) establishes a window effect coming from frame right with no fill and a subject/background ratio of about 8:1, two to three stops underexposed on the back wall. Note how the background light comes from the same direction as the foreground lighting. In fact, both windows are faked with lights placed outside the actual window and directed onto the subjects and the background. The background light is particularly effective in establishing the window effect on the table (c) as it falls off naturally to the darker back wall.

In the medium shots (b and d) and the close-up (e), this lighting logic is maintained. This means the shots would intercut and the illusion of a continuous space/time would be maintained. The increased facial ratio in (e) would intercut with (c) or (d) since the logic of the actor's head would allow for a change in the facial shadows, even though that change might have been a lighting "mistake."

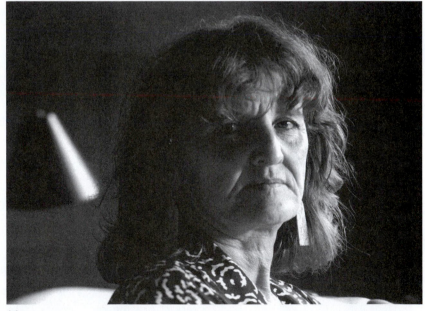

(e)

Lighting for a long shot involves establishing a lighting logic and maintaining a consistent balance between the relative intensities within the frame. For example, if the scene is a day interior as in Figure 8.1, the window area frame right may be lit two stops brighter than the couch area. The background wall may be two stops darker than the subjects.

In this example, we generally expose for the actors on the couch, but even then we have to pick which actor because the window effect provides more intensity on the actor frame right than on the other two. The logic of a window effect means that as actors move between couch and window, or couch and back wall, they will become lighter or darker depending on their distance from the window. This is generally desirable since it duplicates the real-life situation. Exposure could be based on the window area, in which case the actors on the couch would be two stops underexposed and four stops underexposed by the back wall. This technique could be used to create a gloomier, moodier rendition than the one basing exposure on the couch area. A film like *Portrait of a Lady* contains a wide variety of window effects.

From our discussion in Chapter 7, it should be clear that there is no one "correct" facetone placement within the changing lighting dynamics common to most films.

DAY AND NIGHT EFFECTS

For a given location or set, the lighting, in conjunction with the narrative's logic, will create the time frame for the scene. The lighting for a long shot establishes whether a scene is day or night. The differences between the two are easily summarized. With day interiors, subject/background ratios are lower than with night interiors. Day interiors use motivated sources such as windows and doorways. Night interiors rely on practicals—fireplaces, table lamps, and the like—to provide motivated sources. Actors in night interiors are lit with more rim lights and higher facial ratios than in day interiors.

LIGHTING SETUPS AND SHOOTING ORDER

Lighting is a slow, expensive process, so it is standard practice to shoot all the scenes with a given lighting setup before moving to the next setup. In our example, the director will likely want to shoot toward the window as well as the back wall. Lighting complications may result from tracks, pans, and crane shots. We may divide the physical space in Figure 8.1 into three main shooting positions. Changing from one position to another will require lighting adjustments, which should have already been planned into the overall lighting scheme for the scene.

To elaborate, assume three camera positions are used to shoot the scene in Figure 8.1: six camera setups from A (the basic long shot), 4 camera setups for close-ups from position B (toward the window), 5 close-up setups from C (toward the wall frame left). It would be desirable to shoot all the A setups, then move to the other two positions. Only a long shot from position A would require all lighting to be in place. From position B, the back wall lighting is irrelevant and may be turned off. Likewise, from position C the window is essentially a frontal key and can be cheated as necessary.

The cinematographer must have a clear grasp of the lighting's spatial logic and mood in order to maintain an overall lighting continuity in the mind of the spectator—which, after all, is the only place the illusory film space is perceptually intact.

MATCHING CLOSE-UPS TO LONG SHOTS

Because the lighting in a long shot concentrates on establishing a sense of place, the lighting on actors' faces is rough and in need of improvement for close-ups. In the long shot, this rough lighting generally does not matter since actors are usually on the move and small enough in frame so that unflattering facial shadows and the lack of eyelights are not visible on the screen.

We perfect the lighting setup on the actors as necessary when we film the close-ups for a scene. Fill light is added that was not present in the long shot. Key lights are diffused and repositioned for better facial effects. Backgrounds and actor positions are cheated to improve lighting and composition. The result is that close-ups maintain the illusion of the source motivation in the long shot, in this case the window effect, but give us better control over the image.

As you will recall from Chapter 7, cheating means a slight repositioning of actors, props, and lights for better effect. For example, we might turn an actor to obtain a more pleasing facial shadow, or we might seat the actor on a pillow to gain height, or add an eyelight to bring life to the face. None of this cheating will be noticeable on the screen if certain elements of the long-shot lighting setup are maintained:

- *The basic spatial logic* For example, in Figure 8.2, the window should be preserved as an overexposed back/rim light on the actors in close-up or two-shot.

- *The consistency of facial and subject/background ratios* In composing closeups and two-shots, facial ratios are best kept the same as in the long shot, although slight alterations are permissible. The same goes for subject/background levels (see Figure 8.2).

Matching close-ups to long shots requires care. Too much change will be noticeable as, for example, interjecting heavily diffused lighting for close-ups into nondiffused long shots—a common technique in the 1930s. Our goal: When we are done, our close-ups will match the logic of the long shot lighting but will allow us to maximize that setup for mood and dramatic effect.

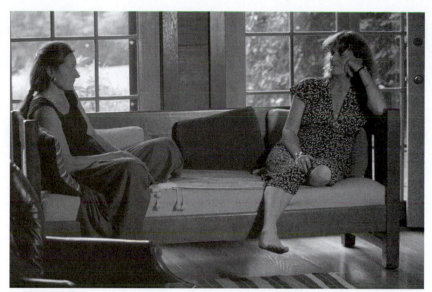

(a)

FIGURE 8.2

MATCHING CLOSE-UPS TO
LONG SHOTS

These photos result from fill light and rim
lights placed outside the windows to illu-
minate the subject's hair. This lighting
setup is analyzed in Part VI, "Lighting
Analyses," Figure 6.4a and b. ▮▮▮

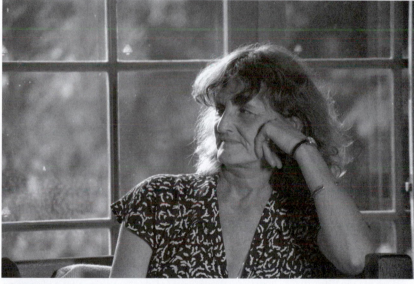

(b)

(c)

CONTROLLING BACKGROUNDS AND FOREGROUNDS: INTERIOR/EXTERIOR SITUATIONS

Mixed interior/exterior situations are common because windows, doorways, and other external light sources are often an unavoidable component of the shot. This exterior source may be an important factor in framing the shot or merely part of the background. There are three aspects to consider with mixed interior/exterior situations: (1) The maintenance of a consistent exposure level for the window, or any other exterior source, over time, (2) the balancing of interior and exterior intensity levels, and (3) the manipulation of indoor/outdoor color temperatures for effect.

MAINTAINING EXPOSURE LEVEL CONSISTENCY

The central problem when shooting on location is the changing light conditions caused by the sun's movement and weather variations. One day is sunny, the next gray. The cinematographer cannot rely on natural light outside the window for shooting any scene that requires more than a few hours. That is because one script interior may be shot at 9:00 A.M. and the next script setup at 3:00 P.M. The two shots will not cut together to create an illusion of reality since the lighting conditions will have changed dramatically.

In these situations, the cinematographer has to control the window effect over time with either total or partial simulation. Total simulation involves blacking out the natural exterior light and using HMIs or other artificial lights to replace it. Partial simulation means supplementing outside available light with artificial light to maintain a consistent window exposure level over time.

The choice of method depends on whether or not the window is part of the shot. If it is not in view, we can blacken out any available light and position our lighting to simulate the window light (see Figure 8.1). If the window is part of the composition, then we need to treat it as an in-shot element. We can use neutral density and color gels to control the intensity and color temperature of the window while positioning HMIs out-of-frame to simulate the daylight effect.

To maintain lighting consistency, it is essential to first shoot all setups where the window exterior is visible. This will allow you to fake the window effect for the other shots as needed. For scenes that can be shot in a short time, it is sometimes possible to treat the window as a consistent light source and balance interior lighting to it.

BALANCING INTERIOR AND EXTERIOR LEVELS

Our first decision in an interior/exterior situation is what to expose for, because, as we saw in Figure 6.5, the difference between indoor actor and outdoors is likely to exceed five or six T-stops. To select an exposure setting requires being able to answer the following questions: What is the "feeling" we want to convey for this window effect? What kinds of moods can be achieved given our specific situation, and what kinds of moods are sought for

this particular film? Answering these three questions allows us to decide whether the actor should be intentionally underexposed a stop or two or the exterior overexposed a stop or two in order to convey the feeling of outside light penetrating a darker interior (see Figure 8.1a).

Also, the time of day outside the window is very important. Is it early morning, a gray day, twilight? Is the light soft, hard, diffused, from high or low in the sky? Asking these questions brings to the foreground the elements necessary for solving the lighting problems inherent in an interior/exterior situation.

As a working example, assume that the natural interior reads T 2 and the exterior T 16. Suppose we want to see detail in both actor and exterior. This means that exposure for one or the other will be inadequate. Let us assume we decide to overexpose the exterior 1½ stops to convey a sense of outside brilliance—we could overexpose up to 3 stops for effect. Likewise, we decide to underexpose the actor 1½ stops, a slight semisilhouette effect, although we could underexpose another stop or so depending on our desired mood.

Having made these determinations, we still must decide whether to light the actor, use neutral density (ND) gels on the window to bring down the exterior, or combine both techniques.

Because the window establishes a strong directionality for the illumination, lighting the actor will essentially amount to simulating the daylight that would naturally reflect off the walls of the room with a soft fill. This situation presents two technical problems: balancing interior/exterior light intensities and color temperatures. Let us deal with each of these separately.

First, we must determine our working T-stop. In this case, we want to overexpose the outside by 1½ stops. We can determine the outside T-stop in two ways: (1) Go outside in the light falling on objects visible in the shot and take an incident reading, or (2) treat the window as a luminous object and utilize a reflected light technique. Here we will use method 1; we will deal with the second method in the next section.

Our incident reading gives us a T 16. Overexposing that 1½ stops means we will expose for halfway between T 8 and T 11 (T 8/11). As an aside, when referring to a particular T-stop, we need be accurate only within ¼–⅓ of a stop. The human eye cannot perceive variations less than a ¼ stop.

The next step is to determine how much lighting intensity to put on the actor. Because we previsualize underexposing her by 1½ stops, we need to light the actor to a T 5.6 level, 3 stops over the initial T 2 level and 1½ stops under the T 8/11 exposure level for the shot.

An alternative method is to reference exposure to the light level on the actor, which in this case is T 2. This means we expose the shot at T 2.8/4, halfway between 2.8 and 4.0, in order to underexpose her the desired 1½ stops. Having determined the outside level to be T 16, we then gel down the windows to the desired level. In this example, we wish to overexpose the exterior 1½ stops. Referenced to T 2.8/4, we need to bring the window down 3 stops, from T 16 to T 5.6. A .9ND window gel will do just that for us (see Appendix A, "Lighting and Grip Gear"). Of course, in this example, total simulation of sunlight makes it even easier to set the exterior level referenced to the actor.

These two examples reference exposure to the outdoors and the actor respectively. The two methods look identical on the screen except for the depth of field variations caused by the use of different T-stops. We could also use a combination of these two approaches to control the shot's final look.

Let us assume we go with the ungelled windows and base our exposure around the exterior level at T 8/11 as described. We will add a soft or diffused light as fill at a T 5.6 level on the actor. But we still must deal with the uncorrected color.

INDOOR/OUTDOOR COLOR TEMPERATURE BALANCE

There are various ways to handle indoor/outdoor color temperature balance. If we are shooting with a tungsten balance film stock, we can use quartz lamps inside (3200 K) and place RoscoSun 85 window gels over the window to convert the daylight to 3200 K. In this case, we have to recalculate our neutral densities since the #85 gel will cause a ⅔ stop reduction. For example, we might use a .6ND with the #85 gel to achieve a 2⅔ stop reduction. However, we have decided not to gel the windows. This leaves us with two choices. We can leave the windows uncorrected and let the outside go bluish on the assumption that contemporary audiences are used to the convention that outside is "blue" and inside is "warm." Alternatively, we can shoot with a daylight-balanced stock and either blue-gel the interior lighting to bring it up to a daylight balance or use daylight-balanced HMIs. We could also use ungelled quartz lights and let the actor go warmish, but this is rather unflattering on facetones and not very common.

We have worked through the permutations in this example because interior/exterior situations are so common. The cinematographer has a choice of methods to use to solve intensity-level differences and balance color temperatures. What we decide to do is a matter of style and the moods we wish to create on the screen. Ultimately, interior/exterior situations invoke the same concepts and considerations as the subject/background and semisilhouette range of choices described in Chapter 6 and Figure 6.3.

WARM AND COOL COLOR EFFECTS

There are two ways to control warm and cool color effects: (1) by use of colored gels on the lights—ambers, blues, greens and so forth—or (2) through an intentional mismatch of color temperatures. Many cinematographers leave keys and fills at a standard color temperature while gelling rims and background lights. For example, your keys may be 3200 K and your rims warmed to convey a candlelight effect. Other cinematographers gel both keys and fills. Good examples of these effects may be viewed in *The Two Jakes*, *Love at Large*, and *The Fabulous Baker Boys*.

We sometimes shoot outdoors on tungsten balance stock without using the color correcting #85 filter. This causes the image to go bluish and can be used for a "cool" effect. We can let part of the frame go blue while maintaining correct color temperature on the main subject as in the window example just discussed.

Working with color requires a developed artistic sensibility and sensitivity to color nuance. In many cases, color effects are best left to the set and costume designer. We will revisit this topic when we discuss color in Chapter 13.

LUMINOUS OBJECTS: LAMPS, CANDLES, AND OTHER PRACTICALS

We dealt with exposure for luminous objects in Chapter 6; here, we deal with how to incorporate them into the lighting scheme. The chief factors in dealing with luminous objects are:

- Their presence will usually determine T-stop possibilities unless the cinematographer can control their intensity by using dimmers or altering their wattage, for example, by replacing 100-watt bulbs with 25-watt bulbs.

- The T-stop must be determined with a spot meter or averaging reflected reading instead of an incident meter. Such T-stops are surprisingly high, a T 5.6–T 64 range.

- As a rule of thumb, if luminous objects are in the shot but not overexposed, and it appears the actor is lit by them, then, in fact, the actor is lit by auxiliary lighting from outside the frame simulating the luminous object.

Let us look at each of these factors in detail.

PRESENCE OF A LUMINOUS OBJECT DETERMINES T-STOP

A luminous object sets the parameters for the T-stop setting because T-stop values for luminous objects are relatively high, T 5.6–T 64, compared with normal ambient light values, T 1.4–T 2.8. As with the window in our preceding example, the presence of a luminous object of significant size results in a subject luminance range greater than a film stock can handle. This means we either light the rest of the shot around the luminous object's T-stop value— the general solution with large or uncontrollable luminous objects—or reduce the value of the luminous object to fit in with our lighting setup. This can be done by decreasing the source voltage, changing the bulb wattage, or applying neutral density filtration.

In Figure 8.3, the neon signs and mirrored bar area were metered and overexposed about two stops. Key light was added based on that calculation (see Figure 8.3b). Overexposure and underexposure effects for the same subject/background ratio are also shown.

FIGURE 8.3

WORKING WITH ACTORS
AND LUMINOUS OBJECTS—
BAR INTERIOR

In this example, the neon lights in the bar mirror were overexposed intentionally two stops (b) after taking an averaging reflected reading. The reflected meter indicated a T 11 setting, and the shot in (b) was exposed at T 5.6 after a key light was added to the actors to bring them up the appropriate T 5.6 level. In (b) the actors are given a zone 5 exposure, that is, exposure for their faces. In (a) they are overexposed two stops and in (c) under-exposed two stops to show the range of possibilities in this simple, one-light setup based on available bar lighting.

(a)

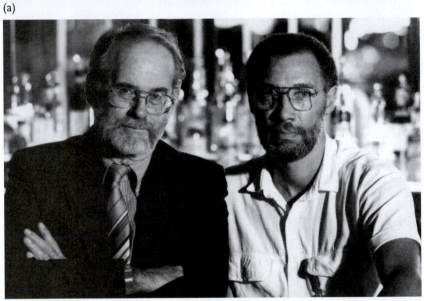

(b)

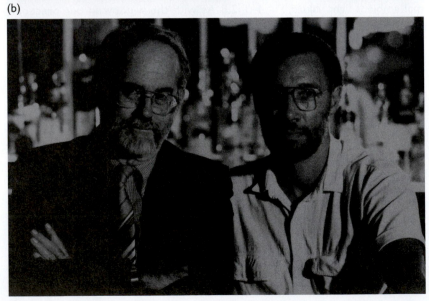

(c)

T-STOP MUST BE DETERMINED WITH A SPOT METER OR AVERAGING REFLECTED READING

As we saw in Chapter 6, where there is a significant in-shot luminous object, it is necessary to first meter the luminous object and determine a zone placement for it, usually from zones 7 to 9. The T-stop required for the desired zone placement establishes the T-stop for the shot. These levels are surprisingly high, usually T 5.6 and up. Once this T-stop is established, lighting the shot may proceed as usual.

In our example in Figure 8.3, we could not control the intensity of the luminous objects. On feature-scale shoots, another method of working is available. The cinematographer first decides which T-stop to use. Luminous objects are then reduced in intensity to fit in with that T-stop. The principles used to balance luminous objects and incident illumination are identical to our example. They are used only from the opposite direction.

A RULE OF THUMB FOR LUMINOUS OBJECTS

In-shot light sources (practicals) or other luminous objects may be used to light actors or to serve as props. A luminous object greatly overexposed, four stops and up, is most likely being used for lighting. A luminous object not greatly overexposed is functioning as a prop and not being used for lighting unless another kind of cheating is going on. Methods for cheating include painting the side of the bulb toward the camera, cutting holes in the lamp shade away from the camera, hiding small light units ("peanuts") on the fixture, and gelling the side of the bulb toward the camera.

The rule of thumb, then, is this: An in-shot light source is only lighting parts of the shot if it is greatly overexposed. Where it is not greatly overexposed, its effect is being simulated by other lights outside the frame. Although there are ways to avoid this rule—for example, by gelling, painting, or dulling the camera side of the practical with spray paint—in general the rule holds.

A good example of our rule of thumb is found in the banquet scenes in Stanley Kubrick's *Barry Lyndon*, which were lit by candlelight. Whenever the candles are not in shot, the lighting has a certain soft feel and beautiful quality; but whenever the candles are in shot, they are greatly overexposed, so overexposed they appear as jets of light and we know they are lighting the shot. Because of this extreme overexposure, the standard practice is to simulate the practical with auxiliary lighting.

Consider the example of an actor standing by a table with a shadeless lamp apparently lighting him (see Figure 8.4b). The cinematographer has four choices:

- Light the actor with the bulb, expose for the actor, and overexpose the bulb.
- Light the actor with the bulb, expose for the actor, and tone down the side of the bulb toward the camera (using gel or spray paint).
- Light the actor with the bulb and expose for the bulb. This leaves the actor severely underexposed.
- Light the actor with a "Midget" outside of frame balanced to a zone 6 placement for the actor. Overexpose the bulb a couple stops. This was done in Figure 8.4b.

FIGURE 8.4

SIMULATING PRACTICALS

In (a) the actor is lit by a key from the front left. This leaves the lamp on the wall frame left as a prop. There is a suggestion of motivated light. In (b) the actor looks as if he is lit by the naked light bulb, which is overexposed about two stops. Exposure for the bulb was determined with a reflected reading. Once that T-stop was determined, a 650-watt Fresnel quartz light was situated just outside of frame left. It is that Fresnel which lights the actor as a three-quarter front key. The illusion is more convincing in (b) because of the duplication of the direction of the in-shot source and because of the overexposure of the source.

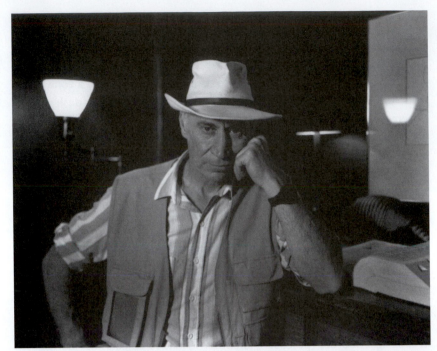

(a)

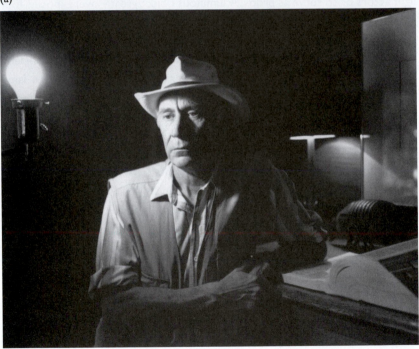

(b)

As with the window example, there are color temperature considerations here because the light bulb (c. 2600 K) will yield warm facetones if used to light the actor, whereas the out-of-frame "Midget" will not. Depending on context some cinematographers might put a gel over the "Midget" to warm the image on the theory that we all know household bulbs produce a warmish light.

If a shade is on the lamp, then our rule does not hold. By cutting out the lamp shade away from the audience, we can light the actor with the bulb and use the lamp shade as a neutral density filter to contain the bulb's exposure value. Alternatively, we can use a small auxiliary light hidden behind the lamp shade to simulate the lamp effect.

Lamps are a common practical. The lamp shade itself can be treated as a luminous object since it is generally translucent. To convey the feeling of a lamp with shade requires overexposing the base and sometimes the top of the lamp to create the feeling of light. You might also have to shine a small spot on the background to simulate spill-off from the lamp. An incident meter can be used to control this situation.

Lamps are also likely to be turned on and off during a shot. This involves a two-stage lighting design—with and without the lamp. A good working parameter is to establish a two- or three-stop difference between when the lamp is off and on, including the simulating auxiliary light if present. A "correct" exposure level with standard facetone placement is usually set for when the lamp is on. When the lamp goes off, we have a darker, gloomier lighting setup. Sometimes a bluish color balance is used to simulate night or moonlight effects.

NIGHT INTERIORS

A study of night interiors reveals the following:

- Windows, doorways, and the like are dark because it is night outside.
- Lamps, overheads, and other practicals are on, but ambient light is much less intensive and more localized than with a day interior.
- Facial ratios are higher, from 6:1 to 32:1.
- Rim and back lights are used more as keys to create large shadow areas on the face.
- Subject/background ratios are higher, in the order of three to five stops.

With these differences in mind, night interiors may be approached along the general lines of day interiors (see Figure 8.5). Interior/exterior balance considerations are the same as for day exteriors except that with night exteriors you have much more control because you are usually lighting the exterior. For example, to establish "reality" and pictorial depth outside the window, we put rim lights on trees and bushes to simulate streetlight. Even when using available night lighting, such as on a brightly-lit downtown street, the exterior level and lighting directionality do not change over time as during the day. This gives us from dusk to dawn to shoot without lighting continuity problems.

FIGURE 8.5

EXAMPLE OF NIGHT INTERIORS

The cinematographer has used a soft rim and key effect with a partial lighting technique on the face, shading off the top of the actor's head and her arm area. The patch of light on the window ledge quickly transitions to shadow. The result is a soft, mysterious nighttime bedroom lighting effect (*The Third Man,* Studio Canal Image, 1949). The lighting setup here might also be planned for her to turn on or off a bedside lamp.

COLOR TEMPERATURE EFFECTS AT NIGHT

Conventional color codings use a bluish gelled lighting for night/moonlight effects and a light coral or amber gel for "warm" interior effects. These two are generally coupled with a white light because their effect is relative to context. For example, in night indoor/outdoor effects, bluish rim light can be applied to a figure in a doorway, in conjunction with a warmed key and a "white" fill. It is best not to overuse these color effects as they tend to draw attention to themselves.

SUMMARY

The general rule of lighting is this: When you have something to light—a night club, filling station, kitchen, whatever—go to the actual location and observe its lighting. In a studio situation, this is very important as the danger of looking too artificial is always present. On location, you often have available light to work with. As long as you can define for yourself the essentials of a location in terms of lighting ratios, you will be able to duplicate the feeling of any particular place—a bar, living room, restaurant, or bowling alley. Using the natural as a source for ideas solves the key visualization problem. The rest is execution.

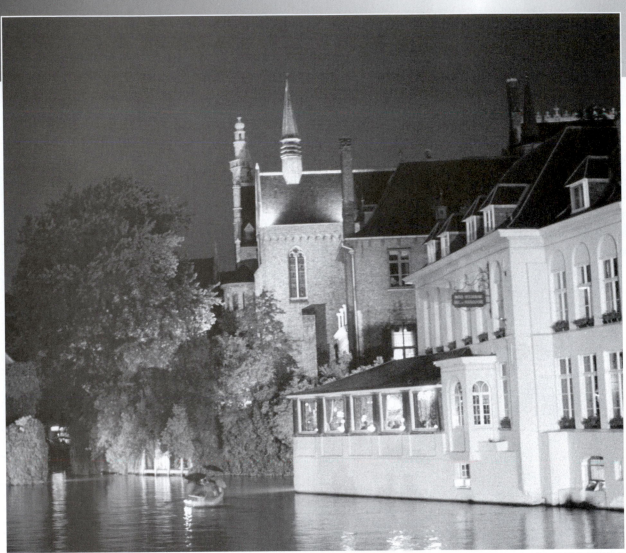

NIGHT EXTERIOR

CHAPTER NINE

Lighting Exteriors

In this chapter, we look at ways to work with and control sunlight—from bright daylight and gray skylight to twilight and sunsets. We discuss ways for controlling contrast outdoors and ways for dealing with a number of recurring day exterior situations. We then proceed to examine magic hour and how to control it, and end with a discussion of lighting for night exteriors.

EXTERIORS INVOLVE the same lighting principles as interiors except the cinematographer has less control over the natural elements, sunlight, skylight, and weather. We shall see that the principles we have developed for interior lighting—concepts such as subject lighting ratio, subject/background ratio, color temperature balance, key, fill, and rim light, the zone system, and motivated lighting setups—work equally well for exterior situations.

TIME OF DAY

The angle of the sun affects color saturation and subject/background balance. Much contemporary lighting avoids direct sunlight on faces because of the resulting full-color saturations and dark facial shadows. Using the sun as a back light or shooting under a light gray sky is often preferred because colors are less saturated.

The sun's position in the sky relative to our camera setup determines whether we can use it for key or rim purposes. As a key, the sun causes high facial ratios, so exterior fill light is often needed. HMIs are standard for exterior fills. They may be softened by bouncing them onto the subject or by shining them through diffusion, which converts them into soft lights. Reflectors are also used to fill shadow areas (see Figure 9.1).

High facial ratios can sometimes be avoided by diffusing the sun with butterflies and overheads, or by placing actors in the shade or shadows. Diffusing harsh, direct sunlight is a standard technique that gives a soft light effect. The diffusion lowers the sunlight's intensity, however, so that care with the subject/background ratio is required. The alternative is to stage the shot so that actors are lit by overall shade. Shade gives a nice-quality soft light on the faces but can present color temperature problems because it is bluer than standard daylight. Again, there may be subject/background ratio problems due to the lowered intensity on the actors.

From about 10:00 AM or 11:00 AM to 2:00 PM or 3:00 PM, depending on the geographic latitude and time of year, the high sun causes particularly ugly

135

FIGURE 9.1

EXTERIOR SUNLIGHT
REQUIRES FILL

Fill light is evident on the face in (a). Lack
of a fill leaves the subject too dark as
in (b).

(a)

(b)

facial shadows and dark eye sockets. Many cinematographers either avoid shooting during this time frame or diffuse the sunlight. This effect is similar to the effects of frontal keys from the high position that we looked at in Figures 2.2c and f.

Using the sun as a rim has two consequences: An overall desaturation of the colors (see Color Plates 1, 2, and 3) and usually the need for facial fill lighting (see Figure 9.1).

Shooting outdoors requires care with lighting continuity and the matching of close-ups to long shots. The cinematographer must be aware of sun positions throughout the day. Shots destined to cut together are often filmed hours apart, in which case the sun's continuity must be maintained with artificial lighting. It might even be necessary to shade actors from the actual sunlight and simulate the sun with HMIs. One old-time solution was to film the

close-ups against a rear screen, which solves the control problem but is considered too artificial for today's image looks.

On gray days, using HMIs allows the cinematographer to simulate sunlight. In this case, the natural daylight functions as a soft overall fill. Shooting early morning and late afternoon gives warm sun effects with interesting angularity to the sunlight. These warm effects are often enhanced with graduated filters.

Twilight, or *magic hour*—the time from just before sunset until dark—is a favorite time to shoot. A similar magical quality light is obtained at dawn. Magic hour will be discussed shortly. Sunrise and sunset offer semisilhouette and silhouette possibilities. Colored filters may be used to enhance and control the color effects.

TIME OF YEAR

Choice of time of year to shoot, coupled with choice of location, has a decisive impact on overall look. First, there is the difference in light based on geography. The summer light in North Africa has a different feel than the summer light in Denver. Time of year also influences feel because the difference in the sun's height in the sky alters the directionality of the illumination. Sun position can give very different looks to big city exteriors and urban landscapes. There are also obvious differences in the seasonal character of a location—winter versus summer; barren landscape versus verdant foliage; fog, rain, and snow.

The cinematographer may be able to state only a preference for shooting dates as economic considerations, director or star availability, and studio deadlines are apt to be more determinative than lighting considerations.

CONTROLLING CONTRAST

One important difference between exteriors and interiors is that much of exterior lighting is concerned with limiting image contrast, particularly on faces. Contrast impacts on the choice of film stock, the use of fill light outdoors, and whether flashing techniques are required.

CHOICE OF FILM STOCK

With contemporary practices, a stock's exposure index (EI) does not always determine how the stock is used. Just as slower stocks may be used indoors for effect, an outdoor scene may look best on a fast stock such as Kodak Vision 500T. Choice of film stock is determined by the desired final look. When fast stocks are used outdoors, neutral density filters are required to control exposure levels.

CONTROLLING CONTRAST RANGE

One way to cut contrast is to add fill light to the scene. This is possible with close-ups and midshots of actors but is impractical for larger areas within the

FIGURE 9.2

EFFECTS OF FLASHING ON FILM
NEGATIVE

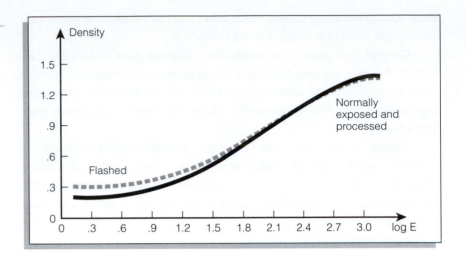

frame such as the shadow side of a building. To bring up detail in large shadow areas, we must utilize lab or on-camera flashing techniques.

LABORATORY FLASHING Flashing involves subjecting the emulsion to a low-intensity light in order to lower its contrast. Flashing may occur before normal exposure (preflashing) or after normal exposure (postflashing). There is no on-screen difference between the two. Postflashing is more flexible because it allows for flashing individual rolls differing amounts (percentages) depending on the actual lighting situation. Postflashing also allows for the possibility of running end tests before entire rolls are flashed and processed. Flashing affects only the dark areas of the characteristic curve and reduces overall contrast by raising the density values of the dark areas as in Figure 9.2.

It is possible to flash a negative with a colored light, thus affecting the overall color rendition as well as the contrast property. Flashing was in vogue during the 1970s, when cinematographers like Vilmos Zsigmond explored its possibilities and wrote about the results in *American Cinematographer*.[1] Today, on-camera devices such as Arriflex's "VariCon" and Panavision's "Panaflasher" offer a precise, shot-by-shot alternative to flashing in the lab.[2]

ON-CAMERA FLASHING DEVICES: VARICON AND PANAFLASHER Like laboratory flashing, on-camera devices result in a lowering of effective emulsion gamma by spreading small amounts of light into dark areas of the curve. These devices are mounted in front of the lens (VariCon) or between magazine and camera body (Panaflasher) and flash the image during shooting.

As with laboratory flashing, various degrees of enhancement and color effects are available. With VariCon the effect may be evaluated through the viewfinder to some extent. The advantage of VariCon and Panaflasher over laboratory flashing is that they may be used on a shot-by-shot basis. An additional benefit from on-camera flashing is that less fill light is necessary for actors. This would be true of laboratory flashing as well, but the on-camera flashing device allows for analysis in the field rather than later on at the lab.

VariCon can be used with video as well as film cameras. Since this device expands the effective log E range of the original, it is particularly useful when originating on limited straight-line media such as videotape.

TYPICAL DAY EXTERIOR SITUATIONS

Dealing with common exterior problems involves access to many specialized types of equipment, most likely unavailable to the student cinematographer. As mentioned earlier, patience and diligence will have to substitute for such equipment.

CAR SHOTS

Whether shooting from inside or outside a car, the lighting problem is how to bring car interior levels up to avoid silhouetted actors or overexposed backgrounds. The problem is identical to the actor in-front-of-the-window, interior/exterior situation we discussed earlier in detail, and the solutions are the same. We light the car interior, gel down the windows, shoot where there are dark backgrounds such as in a forest, or combine these techniques.

RAIN, FOG, AND OTHER ATMOSPHERIC EFFECTS

Atmospheric effects such as rain and fog (smoke) are used a lot in contemporary cinematography. These may be natural or artificially created, the latter being preferred for control purposes. Smoke in particular enhances the look of films, from *Indiana Jones* and *Robin Hood* forest scenes to stylized music video images. Atmospheres like smoke are used for interiors as well as exteriors.

Back lighting is mandatory for making such atmospheric effects visible on the screen. We must either use the sun as back light or add HMIs from rear positions. Without adequate back light, atmospheric effects will lose their "bounce" and look drab and dull, if perceptible at all.

FOREST, JUNGLE, AND OTHER EXTREME LUMINANCE RANGE SITUATIONS

Forest and jungle locations involve gloomy shadow areas with pools of light penetrating the darkness. Some films have exploited this forest darkness by intentionally placing actors in the shade and overexposing the sunlit backgrounds. This results in a light, desaturated background reminiscent of some Impressionist paintings. As a general rule, we expose for the shadow areas and allow the sunlit areas to overexpose. If available, we can use a VariCon to bring up detail as well.

John Alcott, the noted British cinematographer, was famous for shooting in the jungle without a #85 filter, for example, in *Greystoke*. He claimed this provided a certain green effect hard to obtain otherwise.[3]

DESERT AND BEACH

The feeling of bright sunlight is necessary for a desert shot. The problem is to create a fill light that blends in without looking artificial, unless artificiality is desired. Large overheads and butterflies are used to soften and bring down

the intensity over certain areas. Bounced or diffused HMIs make ideal fill lights. TV commercials are particularly good at utilizing these and other backgrounds to enhance their products—from designer jeans to luxury automobiles.

WEATHER CONTINUITY: FAKING SUNNY AND CLOUDY DAYS

One of the most aggravating tasks is maintaining lighting continuity outdoors. The economics of filmmaking are such that shooting often must go on despite changes in weather conditions. The cinematographer must be able to match shots filmed at various times of day. This includes adding HMI "sunlight" to make a cloudy day look sunny or diffusing sunshine to simulate a gray day.

Backup devices are held ready to fake weather conditions such as rain or snow. For example, garden hoses and even fire trucks can be used to simulate rain. Small independent and student productions generally wait until the weather is right to shoot.

CHEATING TWO-SHOTS

A routine technique outdoors is to cheat the background and lighting directionality of two-shots. Actor A is shot with the sun as a rim and actor B, who would logically be in frontal lighting, is also filmed with the sun as a rim. To do otherwise is to create shots that appear to lack lighting continuity when cut together.[4]

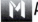 AGIC HOUR

One of nature's gifts to the cinematographer is the lighting available at **magic hour**, that time of day around twilight or dawn when colors seem iridescent and the world of objects magical. Cinematographers have long exploited this lighting condition, for example, the exteriors in *Days of Heaven*, an Academy Award winner for cinematography. Magic hour is also routinely used to represent night exteriors, the sky being dark enough for a night effect but with sufficient light intensity for filming (see Color Plates 5–12).

There are two separate definitions of magic hour. The narrow definition is the time frame from just after sunset until the sky loses its luminosity, a period of about 20 to 30 minutes varying with the latitude and time of year. "Just after sunset" is usually taken to mean when car headlights and the lights in office buildings and houses start coming on. The effect peaks when they are as bright as the sky. It is common to use glass skyscrapers, city skylines, and bodies of water to enhance the effect. This discussion of magic hour is referenced to the typical twilight situation. Cinematographers using a dawn magic hour would have to define the effect from the opposite direction because at dawn the sky becomes gradually lighter rather than darker.

In the looser, more expansive definition of magic hour, the time frame starts during the warm sunlight of late afternoon, about an hour before sunset, and runs until dark. This definition provides a longer time frame for shoot-

ing but a greater range of lighting changes to deal with. This longer magic hour was used in *Days of Heaven* to great effect.[5]

The problems involved in shooting a magic hour sequence are enormous since from moment to moment, the overall color and brightness of the sky and light changes. A further complication is that the magic hours from one day to the next exhibit great variations in color. It is not easy to shoot a magic hour sequence over a period of days, but with filtration and careful additions of supplemental lighting, usually rim or fill, a cinematographer can work with this effect.

The key to magic hour is in understanding that it is the light itself that is being filmed. Since the effect involves luminosity, a reflected reading is essential to control the sky. To maintain facetone consistency requires an incident reading. Monitoring these two readings over time is necessary to capture the effect.

The two photographs in Color Plates 5 and 6 reveal the passage of time from just before sunset to about 15 minutes later. In Color Plate 5, an incident reading was used. Color Plate 6 required a reflected reading for the sky as it was too dark for an incident reading. Color Plates 7 and 8 trace the passage of time from about five minutes after sunset to dark. Note that exposure may be based on either the sky or the lamp. Note also that the lamp's exposure value is the same in each photograph.

Control of magic hour derives from reflected readings of the sky. Generally, we determine our T-stop by opening up two stops from the averaging-type meter reading, just as we would with a sunset. Any supplemental lighting on actors is balanced to the T-stop determined from the sky as in Color Plate 16.

NIGHT EXTERIORS

Lighting night exteriors ranges from using huge Musco lights, crane-mounted banks of HMIs capable of providing enough intensity to film from a quarter mile away, to filming with available light and adding small amounts of supplemental illumination. There are aberrant color temperature problems with sodium vapor and other lamps popular with urban planners, but generally these are correctable (see Color Plate 13). With high-speed lenses and fast emulsions, we can film with only a few footcandles of illumination. Ironically, there is the danger of overexposing neons and other luminous objects when filming night exteriors with available light (see Color Plates 14 and 15).

Night exteriors involve the same problems as large interiors. We have to decide whether to use available light, where to place the lighting units, and what look to go for. In our examples in Chapters 7 and 8, lighting the night exterior consists of implementing an overall plan, establishing motivated sources and a logic for the illumination, and providing localized key and fill setups wherever necessary. The illustrations in Figure 9.3 and throughout this book attest to the variety of possible night exterior looks.

Trickier night situations involve campfire scenes and moonlit forests, but again there are no new principles involved beyond our standard set of basic considerations and our all-important previsualization of "what is a night exterior."

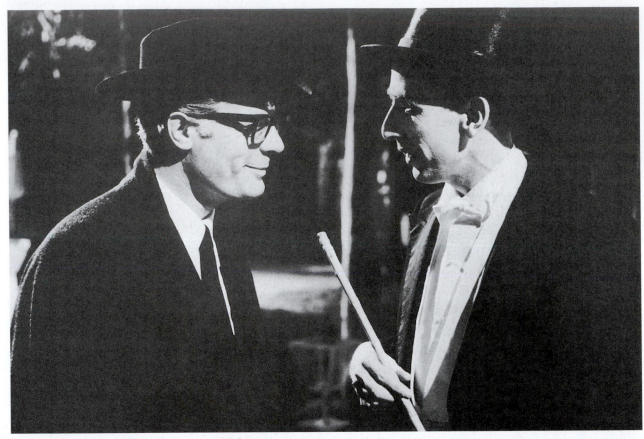
(a)

(b)

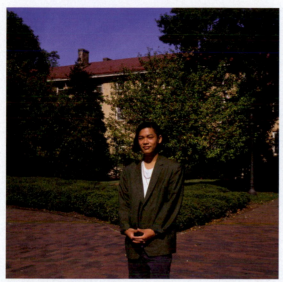

COLOR PLATE 1 Frontal lighting results in the fullest color saturation.

COLOR PLATE 2 Saturation decreases as the light source moves to the side and rear positions.

COLOR PLATE 3 Desaturation is most evident with backlighting

COLOR PLATE 4 All white or light-toned subjects, such as a white Siberian husky on snow, often require under-exposure to retain separation between the various highlight values.

COLOR PLATE 5 Early magic hour,
before sunset, incident reading.

COLOR PLATE 6 The same as Color
Plate 5 but 45 minutes later. Late magic
hour is often used for night effects.

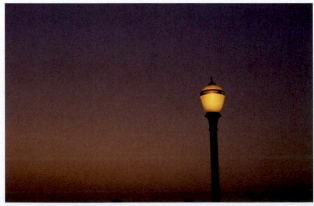

COLOR PLATE 7 A street light against the sky at magic
hour. The exposure was calculated with a reflected reading of
the lamp opened up two stops.

COLOR PLATE 8 The same as Color Plate 7 but about 15
minutes later. Again, exposure was given for the lamp.

COLOR PLATE 9 Magic hour effect enhanced by glass buildings (*photo by Nikola Stanjevich*).

COLOR PLATE 10 Late magic hour effect with buildings and neon lights (*photo by Mike Rubin*).

COLOR PLATE 11 Very late magic hour effect with timed exposure to create light streaks (*photo by Mike Rubin*).

COLOR PLATE 12 Late magic hour effect over water (*photo by Nikola Stanjevich*).

COLOR PLATE 13 Night exteriors with luminous objects pose special problems. The odd color temperature is due to the sodium vapor lamps that illuminate the parking garage.

COLOR PLATE 15 The mood of the foggy night would have been lost if the moon had been overexposed.

COLOR PLATE 14 The luminous effect is enhanced by overexposure and the reflection of lights in the water (*photo by Lee Scott*).

COLOR PLATE 16 For this shot, the first step was to determine an exposure setting for the sky with a reflected meter. Then an incident reading for the light on the subject was taken. When the two readings were about equal, the photograph was snapped. The warm color results from the bus stop's yellowish overhead lighting.

CARS AND STREETS

Car interiors at night are like car interiors in daylight except there is no window problem. Having determined a T-stop for the street exterior and gelled down overbright luminous objects, lighting from inside the car consists of hiding small units to light the actors. One possibility is to use optical fiber lights, which can be positioned wherever desired and powered from a unit hidden in the trunk. Such flexibility is marvelous for the cinematographer.

Where available levels are inadequate, streets may be lit with Musco lights or HMIs using the same basic principles as for interior lighting: key, fill, rim, subject/background ratio, and the like. When lighting a street, the convention is to use high-intensity back lighting with perhaps smoke added for effect. Another convention is to wet the street, which causes the high overhead back lighting to glisten and reflect nicely off the pavement (see Figure 9.3b).

SUMMARY

Because we have so little control over lighting conditions, the most important considerations affecting exteriors are: choice of location, time of day, and time of year. The cinematographer must be aware of natural light and atmospheric change in order to deal with the many contrast problems inherent in exterior filming. The cinematographer can do little to change the basic nature of the location. Besides the many difficulties in controlling daylight, there are the problems in working with magic hour, nighttime, and weather continuity. Ultimately, the secret to imaginative exteriors is patience and diligence—patience to wait for the necessary time of day or even weather conditions, diligence in finding the best location for the desired effect.

NOTES

1. Vilmos Zsigmond, "Behind the Cameras for *Heaven's Gate*," *American Cinematographer* (November 1980): 1110–13, 1164–65. Herb A. Lightman, "On Location with *Deliverance*," *American Cinematographer* (August 1971): 796–801. See also: Anton Wilson, "Cinema Workshop—Flashing," *American Cinematographer* (August 1974): 892; and "Cinema Workshop—Flashing II," (September 1974): 1016, 1099.

2. See Isidore Mankofsky, "Contrast Control Made Easier," *American Cinematographer* (July 1990): 81–86; and Arri Product Information "UPDATE," 1990.

3. Joss Marsh and Nora Lee, "Greystoke—the Legend of Tarzan and the Apes," *American Cinematographer* (May 1984): 58–68.

4. See discussion of this technique by Vilmos Zsigmond in Kris Malkiewicz, assisted by Barbara J. Gryboski, *Film Lighting* (New York: Prentice-Hall, 1986), p. 153.

5. Nestor Almendros, "Photographing *Days of Heaven*," *American Cinematographer* (May 1979): 562–65, 592–94, 626–32.

FIGURE 9.3 (opposite)

EXAMPLES OF NIGHT EXTERIORS

Night exteriors are usually a delight to light since the cinematographer starts with a dark frame, which allows for a true painting-with-light. A lot of back light is used along with high subject lighting ratios. Sometimes streets are wetted down to create a surface the back light can glisten off (b). Night exteriors use the same lighting principles we applied to night interiors in Chapter 8. Publicity still (a) is from *8½*, Corinth Films, Inc., 1963 and (b) is from *The Third Man*, Studio Canal Image, 1949.

DAY EXTERIOR

CHAPTER TEN

Setting Up a Production: The Cinematographer's Duties

The cinematographer is responsible for the overall look of the film. From generalized aesthetic style decisions to detailed lighting plots, we must arrive at a lighting design for the film. This chapter describes the cinematographer's basic duties and describes lighting a typical situation in detail.

FOR THE CINEMATOGRAPHER, setting up a production requires activity in three basic areas: (1) aesthetic decisions and research, (2) testing, and (3) planning the execution of the lighting. The questions posed in this chapter apply equally to film or video. We have utilized a feature film example because of the many details involved. With a student or independent production, the situation would have simpler solutions, although the same key considerations would apply.

AESTHETIC DECISIONS AND RESEARCH

Eastman Color and Fujicolor yield different looks on the screen. Because each emulsion provides a palette of color and mood possibilities, we must be aware of available emulsions and their look parameters. Testing and actual experience with each emulsion yield comparisons, as does studying the work of other cinematographers.

Selecting a look for a film requires consultation with the director and the production designer and determination of the ultimate meaning of the film. That determination will affect the final lighting style—for example, whether it is to be realistic or stylized.

We must determine the nature and quality of the light to be used: soft or hard light or a mixture; direct or indirect illumination; available or artificial sources or both, or to create an overall low- or high-key mood. All of these factors come into play in determining a film's lighting approach.

We can do research for the director by locating ideas in paintings, photographs, illustrations, and other films and videos. If a director is able to tell us, "I want this scene to look like X in such and such film," it is our professional responsibility to be able to duplicate that look.

ESTING

Although several types of tests are common, the most typical are lighting tests of the various locations and lab tests for various effects. We can use these to try out various lighting ideas and to determine what illumination is available to work with. Different lighting styles might be applied to the same scene as a means for helping the director choose between them. We can couple emulsion and equipment check tests with the lighting tests.

Exposure tests on emulsions include **push and pull development** (over- and underdevelopment), utilizing the **bleach bypass process**, overexposing and underprinting, **cross processing** of reversals, and other manipulations. Our goal is to determine the developing and printing parameters for achieving our desired look on the screen. These emulsion and exposure tests will be used to determine lab printer-light settings for night and day interiors and exteriors (see Chapter 14 "Lab and Postproduction Controls").

The equipment check or shakedown test is another important preproduction procedure. With the actual camera and lenses to be used on the shoot, we film scenes to make sure that everything is working—in particular, that the various prime lenses are compatible for intercutting and that the zoom is sharp enough to match the primes.

Testing is also desirable if we are using diffusion, filtration, or flashing devices. Other common tests center on the actors—their makeup and their clothes—and on the sets and props. On feature films it is standard practice to test all variables affecting overall look.

LANNING THE EXECUTION OF THE LIGHTING

Before shooting begins, we visit the sets and locations and determine equipment needs as well as an overall approach to the lighting and its execution. Although the execution of the lighting occurs at the production stage, preproduction planning is essential, preferably in conjunction with the gaffer who will aid in carrying out our lighting plan.

As we have discussed, there are two overall approaches to lighting a set or location. One is to light the background first and then build up the subject lighting areas. The second is to light the subject and then balance in the background accordingly. Sometimes the choice of approach is more a function of economics than of aesthetics or technique.[1]

Some setups involve large-scale lighting problems: for example, city night exteriors involving lighting three city blocks, a large circus interior, or the Vienna opera house. Some setups are small: a liquor store doorway on the city street, the circus band, or a dressing room in the opera house. As the scale changes, the equipment used to execute the setup varies, but the basic principles remain the same.

It makes a difference whether we are shooting in a studio or on location, mainly because on location we have less control over mounting lights and no way to remove walls and ceilings. From the audience's point of view there should be no perceptible difference. Viewers do not care whether the lighting is a 12K 40 feet away or a Kino-Flo stuck up in the corner of a room.

As mentioned earlier, it is our responsibility to be able to duplicate looks from real life, photos, films, videos, paintings, or any source whatsoever. To be able to do so, we must first be able to read the screen image, working backward to decipher how the image was lit or textured. This requires an extensive knowledge of lighting principles and concepts and the ability to control lighting.

We might use a stills camera on the set to aid in judging lighting. After setting the basic lighting with the gaffer, we can take a series of stills to help judge how the film will render the setup. As mentioned, it is useful to plot the actual lighting setup in case it is necessary to reshoot and match parts of scenes months later. Photos of the setup, even if digital, are helpful for reshooting.

DETAILED LIGHTING EXAMPLE

Let us go step by step through a lighting setup using a cafe for our set. Assume we have the following working parameters: day interior in an elegant cafe, two walls have floor-to-ceiling windows looking out onto street exteriors, two days to shoot, large actions such as people entering and exiting the cafe, although the main emphasis is on a couple sitting at one of the tables, and the director may want a tracking shot from exterior to interior. All of that will become the opening scene of what is to be a Hitchcock-like spy film (see Figure 10.1).

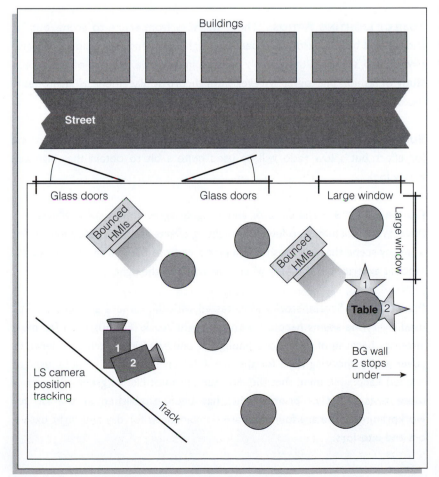

FIGURE 10.1

CAFE SCENE EXAMPLE—
DAY INTERIOR/EXTERIOR

This schematic shows the general layout of the cafe location described in the text. The central action areas are labeled and camera setups 1 and 2 indicated.

AESTHETIC CONSIDERATIONS FOR CAFE SCENE

There are a number of aesthetic considerations to address. The following discussion represents only one approach to this hypothetical situation. Other cinematographers would approach this lighting setup in their own way. Also, the problems and working parameters described here change from film to film—which is why cinematography is so interesting and challenging.

OVERALL LOOK The main look of the film has been imposed by the producer—a *James Bond* film, high-gloss look as in fashion photography. The director would prefer the contemporary equivalent of *film noir*, a color noir style like that of *Blade Runner*, rather than the high-glamour look. Guess who wins this one?

For the visual style, then, we will use a sharp, high-key glossy look with good color saturation and a lot of depth of field. Some scenes, particularly at night, will deviate from this overall style, but basically we will shoot with high-quality, matched prime lenses and go for a fine-grained look. Talks with the designer have emphasized how important the sets and colors will be in setting the overall mood.

LIGHT QUALITY The director desires hardish lighting, but not too hard. Tests show she prefers the look of diffused HMIs and spots with selective pools of light. For this opening scene, we can use a softer application to establish the romantic theme.

SUBJECT LIGHTING RATIOS These will vary from scene to scene, but 2:1 and 4:1 will be standard range because "high gloss" means fashion photography, a sharp, see-everything, richly colored image style. As part of this look, a study of fashion photography reveals a high, bright placement of facetones is useful, between zones 6½ and 7.

SUBJECT/BACKGROUND RATIOS The range will vary from scene to scene for effect, but a low ratio will be used quite a bit to obtain that high-key, glossy look.

COLOR EFFECTS The director and designer agree to put color effects into the sets and costumes, so few color lighting effects are anticipated except for a fantasy scene that will be shot in a jungle without a #85 filter and in several moonlit exteriors in the Alps where we will blue the light.

FILM STOCK Several stocks were tested with the camera and lenses to be used. Everyone seems happiest with a daylight stock (EI 250), even for most interiors, because of the colors. Enough of one emulsion batch is ordered to cover a 10:1 shooting ratio for the film. A faster film (EI 500) will be used as needed, keeping in mind that the director does not like its greens. As part of these tests, a set of printer lights has been established at the lab for workprinting. There are four separate combinations for day and night exteriors and interiors.

TYPES OF LIGHTS A new 18K HMI has been marketed, and we will be trying those out as well as using a number of 12K HMIs. We will need a lot of footcandles for our sharp images; they tested great at T 5.6. We will rely on large units with moderate diffusion for our standard quality. A Musco light will be needed for two large-scale, night exteriors. A variety of small HMIs Kino-Flo and quartz units will be available, as well as a selection of grip gear and a range of gels, silks, and frosts for diffusion and color temperature control.

The preceding aesthetic considerations and their technical solutions have resulted from the interplay among producer, director, cinematographer, and designer. We have all worked together before and have come to agree that films like *Flash Dance* and *Top Gun* have the look we are after.

For the opening scene, we will use bounced HMI lights to create a soft interior lighting balanced to the outside. Several visits to the location revealed that we can shoot from about 1:00 PM until 6:00 PM because the street outside the restaurant will be in shadow then as a number of large buildings block the sun. After 5:00 PM, we enter early twilight conditions that we can use to shoot the last few shots of the scene. We cannot shoot earlier than 1:00 PM because the sunlight creates a high-contrast background that we don't want. We will use mornings to rig lights, rehearse shots, and cheat close-ups that have other parts of the cafe for background. We thought about blacking out the windows to eliminate the time-of-day problems, but the producer says we can't afford that because it would require expensive digital effects to place backgrounds into the image.

TECHNICAL CONSIDERATIONS FOR CAFE SCENE

Listed below are the considerations and decisions relevant to establishing our lighting scheme. The gaffing crew will rough-in everything from our descriptions and working sketches while we are still shooting at a hotel set a mile away.

INTERIOR/EXTERIOR PROBLEM As mentioned, we can depend on a fairly consistent window effect from 1:00 P.M. until 5:00 P.M. This effect measures T 8 using an incident meter out in the street. During shooting we will monitor this T-stop to ensure a consistent subject/background ratio. The street should be in full shade all afternoon, and little change in intensity is anticipated. Should the exterior darken because of clouds, we will either wait for them to pass or alter the intensity of the interior accordingly. For example, we could scrim the HMIs to lower their intensity to maintain a consistent subject/background ratio with the outdoor street.

We have selected an ideal working stop of T 5.6, letting the background overexpose one stop. This gives us a 1:2 subject/background ratio that will ensure a light, bright image look. The background will go slightly bluish because of the color temperature (CT) of the shade. We could use window gels to warm that up, but tests have shown that the bluish look with properly balanced facetones is pleasing.

Were it necessary, we could have gelled the cafe windows for either intensity or color temperature, but by shooting when the street is in shade, we have solved this problem in a simpler fashion. For this scene we will shoot daylight balance with the HMIs and use the daylight-balanced stock (EI 250).

There are four main long shots. The most difficult is a dolly from the exterior into the cafe. The assistant cameraperson suggests we pull T-stop, from T 8 to 5.6 for the interior, but this might be too overt. Instead, we will shoot with a roving fill that will hold the actors between T 5.6 and T 8 (T 5.6/8). We will let them go to T 5.6 at the table, which will not have the exterior as background so we do not have to worry about its effects there. We will expose the entire dolly shot at T 5.6/8.

LIGHTING DIRECTIONALITY This is fairly simple because, ostensibly, the windows in the cafe are lighting everything for this afternoon interior. We have talked the director into shooting away from the windows at the back of the cafe. This means we can control the interior background at will for shots not involving the street exterior, which is beyond our control. However, the director says she can shoot all the long shots at the same time. This should minimize any street continuity problems.

For our interior lighting, we will establish our directionality by bouncing HMIs off white foam core placed on the window side of the cafe high on the walls or ceiling. We will also light the parts of the cafe away from the windows by bouncing light from the ceiling or self-standing foam core as necessary, being careful to maintain the window directionality. The basic bounced light amounts to a window-motivated side key. We will balance its intensity for T 5.6 throughout the cafe, letting it slowly fall off to T 4 and T 2.8 in the darker parts of the interior, particularly the background wall (see Figure 10.1).

Our lighting is soft and the walls are light enough to fill in facial shadows with scattered light to a natural 4:1 ratio. We decide to add some very soft, bounced fill to bring the faces at the table to 3:1; we make sure there is enough reflection from these to function as eyelight. We add a slight rim light for the close-ups, again prompted by the windows (see Figure 10.2).

CAMERA ANGLES We are lighting two camera positions for long shots as shown in Figure 10.1. close-ups will be shot from camera positions 3 and 4 as shown in Figure 10.2. We are going to cheat the backgrounds in the close-ups from camera position 3 to eliminate the window in the background. As mentioned, we are planning to shoot all four long shots first. Once the above lighting is set up, we will notate it on a lighting plot.

A POSSIBLE OCCURRENCE: CHANGING THE CAFE TO A NIGHT INTERIOR

The above was shot and screened as described. When the lead actor saw the dailies, he objected to his makeup and demanded a reshoot. The director was happy to reshoot since she felt the scene lacked "punch" and wanted to rewrite the dialogue one more time. She also wanted to change the scene to

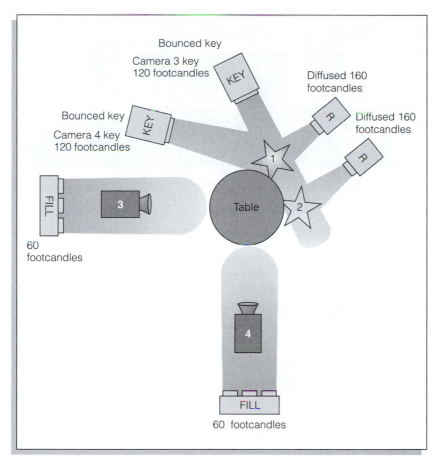

FIGURE 10.2

DETAIL OF TABLE LIGHTING SETUP FOR DAY INTERIOR

This schematic indicates how the table area is lit for two-shots and close-ups as described in the text.

a night interior. The producer relented because of his relationship with the actor. A reshoot was ordered.

On a night visit to the cafe, the cinematographer noticed the following: The place was beautifully lit with subtle, intimate lighting—but only to a T 1.4 level. This would not yield enough depth of field, so the decision was made to establish a higher level at T 4 and switch to a faster stock (EI 500), and shoot tungsten balance.

The street outside the window was empty except for an occasional passing car. It would render at zone 1, below the threshold of the stock. Lighting the street was in order. Cars could be hired to drive by, and colored neons and fake street lighting could be ordered. A basic illumination was applied to bring the buildings across the street to around T 2. Two banks of daylight-balanced 12K HMIs were adequate for this purpose. Neons were added to the buildings, and a large number of lights were arranged inside some of the windows. These were balanced by eye (see Figure 10.3).

Once the street was at a basic T 2 level with neons and other luminous objects around T 5.6, the interior lighting setup was tackled. Basically, each table had an artificial lamp shaped like a candle and a white tablecloth. Small spots were used to fake the candle effect and the candle bulbs were changed to a lower intensity so that they would not burn out. Soft, fill light was added to the actors and the ratio set at 4:1 (see Figure 10.4). The back wall of the

FIGURE 10.3

CAFE SCENE EXAMPLE—
NIGHT INTERIOR/EXTERIOR

This schematic shows the general lighting setup for converting the cafe scene into a night interior/exterior. Details of the lighting for the tables is shown in Figure 10.4.

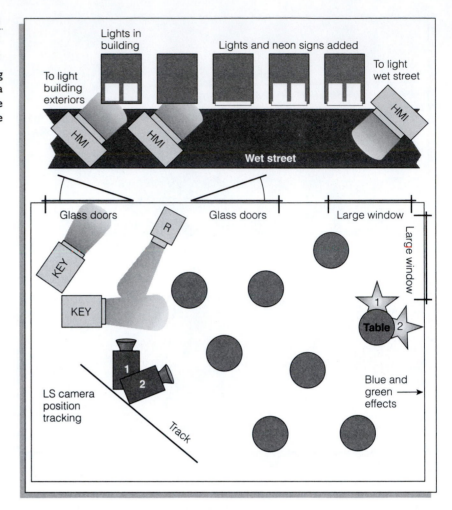

cafe was lit with colored lighting, mostly greens and blues. A piano bar was installed in the background for visual variety. Strings of lights were added to various interior walls for effect. Finally, after two days, the night lighting setup was ready for shooting.

The overall feel was more dramatic than the day interior. The tracking shot from exterior to interior was particularly effective. Water was added to the street so that lights reflecting off it created a wet-pavement, "big city" look. A slight rain effect was needed to justify the wet pavement. The director liked the effect so much that she decided to make the rain an integral part of the scene. Back light was added so that the rain would be visible.

Instead of the roving fill, a series of spotlights were used to illuminate the actors as they entered and went to the table. Inside the cafe, quartz lights were bounced off foam core to provide fill light for dark areas of the frame. Altogether, about 20 lights were used outdoors and about 40 indoors, mostly because of the large size of the cafe. The tungsten-balanced stock (EI 500) was used, with the bluish night exterior deemed appropriate.

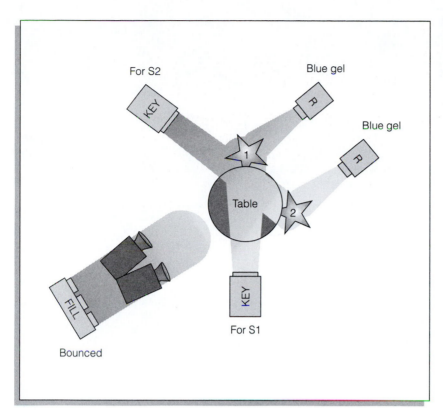

FIGURE 10.4

DETAIL OF TABLE LIGHTING
SETUP FOR NIGHT INTERIOR

This schematic indicates the lighting set-up for two-shots and close-ups for the night interior described in the text.

SUMMARY

The art of lighting consists of working with the location, adding lights step by step, then reacting to the setup. Our example is intended to provide a question/answer framework for the beginning cinematographer, a position from which to start lighting. Faced with the assignment presented in this chapter, different cinematographers would arrive at different solutions; this is why cinematography is so creative.

NOTE

1. Gaffer Richmond Aguilar says: When I started working with Laslo Kovacs, I would be roughing-in when he was working with the director blocking the scene. I would be lighting the set from the background, or maybe outside, working toward the foreground, to the principals in front of the camera. By that time he will know where they will be on their marks and whether he will want to key the scene from the window or not. . . . I start lighting from the background because we do not really know what the actors will do in front. When the director is working on that, I will go and do the windows outside and we will talk and establish, for example, that perhaps the sun comes through the window back there, so we have something to work from. The other school is to light the foreground action and to cut it off from where you don't want it, and then work your background. The basic question is: Where the hell will you start lighting the scene? Every scene has a key to it, something that will work for you. . . . You find this one key, and if you like it you work from there. Many times it is awfully hard to get that one thing. (As quoted in Kris Malkiewicz, assisted by Barbara J. Gryboski, *Film Lighting* [New York: Prentice Hall, 1986], pp. 94–95.)

PART IV

DIGITAL CINEMATOGRAPHY

lectronic cinematography com-bines the most sophisticated techniques of film production with state-of-the-art video equipment. The object is to give video production the same potential for creativity and aesthetic refinement that exists in film and to take full advantage of the creative possibilities of the electronic medium that do not exist in film.

~ HARRY MATHIAS AND
RICHARD PATTERSON
*Electronic Cinematography: Achieving
Photographic Control over the Video Image*

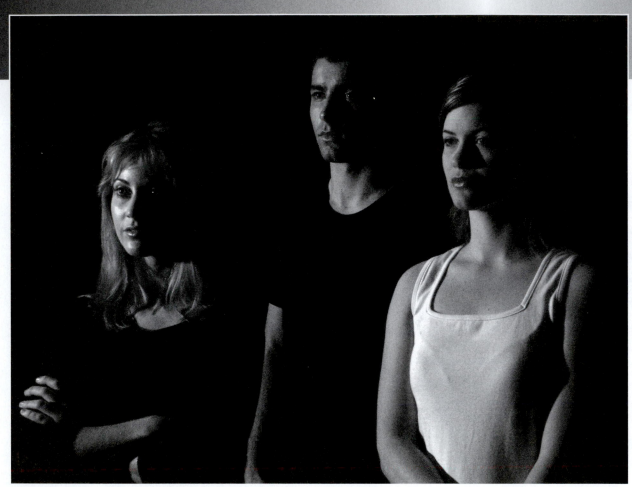

VIDEO THE FILM WAY

Video the Film Way

The application of film techniques and attitudes to video production introduces a new concept, "electronic cinematography." From this point of view, video is treated as another film stock and film techniques are applied to video. The introduction of 24p HD is also causing cinematographers to explore the new medium, or perhaps better put, the old medium in new ways. In any case, our basic concepts—lighting ratios, zone system, and luminance range—all apply to video.

THE VIDEO revolution has succeeded. Digital high definition television (HDTV) has arrived and many cinematographers have begun to explore the new kid in town—**24p HD video**. Lucas's *Star Wars: Episode II* originated on 24p HD video and was released on HD video as well as film. Although the verdict is still out, video manufacturers may finally have caught up with film technology. Years of research and development in video technology have led to digital imaging, high definition, cameras with increased sensitivity, and digital video projectors. Independent features have even been shot on **standard definition digital video** and released on 35mm film.

A Sony brochure on high definition television production reveals the video state of mind as it works hard to make itself the equal of film technology for all purposes. The brochure states unequivocally that 24p HD video—which Sony markets as "CineAlta"—is the "electronic emulation" of 35mm film, that the lower-end **Digital Betacam** equates with Super 16mm, and the **DVCAM** with 16mm; the term 24p refers to a system with a 24fps frame rate and **progressive scanning**. This is sometimes called **1080/24p** referencing the 1080 lines of resolution of HDTV, whose standard calls for 1920 pixels per line with 1080 lines at a 24fps frame rate progressively scanned.

The system 24 frame video eliminates the 2:3 pulldown associated with telecine and the conversion of 24fps film negatives to 29.97 ("30fps") NTSC video. Sony asserts that the "film look" can be arrived at with either 1080/24p HD or **1080/60i HD**. The "60i" refers to 60 field—30 frame—video with interlaced scanning. Elements constituting the film look are identified as tonal and color reproduction, exposure latitude, and picture sharpness. The brochure goes on to state that digital HDTV can compete with 35mm film in each of these areas constituting the film look.[1]

Not everyone agrees with the Sony position. For example, director James Cameron has this to say:

> At the other end of the spectrum, Sony has been actively proposing the adoption of their HDTV standard as sufficient to simulate 35mm release print look. They are wrong. We have seen the results, and it just looks like big video. Many people are fooled by the clarity of HDTV on a 30-inch

monitor, and say it looks like film, but comparing it side-by-side with a 35mm print on a 30-foot screen would show that it is only about one-third of the resolution of film.[2]

Of course the wide-scale use of film negatives, with telecine transfers to video masters for subsequent digitizing into digital, nonlinear editing workstations and possible release on television or video, long ago forced cinematographers to understand video technology and processes. Now the two technologies are merging, and cinematographers are faced with origination on 24p HD video with cinema release. Nevertheless, confronted with a finished product on a television monitor instead of a screen, many a cinematographer has concluded that video, even digital video, is inherently inferior as an imaging technology. Yet video's relentless thrust must be analyzed and experimented with because, for the moment, taking advantage of the merits of both technologies is the order of the day.

Film manufacturers have responded to the video challenge by developing faster emulsions with improved image quality. The availability of stocks with exposure indices of 500 and 800 has led to the development of lighting styles and techniques beyond the ability of most current video technology, although that also is rapidly changing. Sony, for example, rates the CineAlta camera (the HDW-F900) with an EI of around 300.

We must distinguish between the quality of video as broadcast over-the-air and the quality of video used for production. For years, video production gear has been able to produce quality levels exceeding NTSC standards for television. The broadcast standards attach quality limits to over-the-air video that are not applicable to nonbroadcast video systems. The problem is most video is encountered over-the-air. Over-the-air HDTV should improve the situation drastically, once we get the HDTV sets to receive the signals. For the moment, digital video via satellite is the best signal we have over-the-air.

What follows is a discussion of the limits of analogue and digital video, particularly as broadcast. It is hoped an examination of these limits—hopefully soon to be historical—will lead to a better understanding of fast-arriving, high definition video's possibilities. Throughout, we have used the film quality standard as a reference point for video, not because of a pro-film bias (most of our own work is with video), but to show how much better video has become—indeed, how the video impetus has improved film itself.

We will use the term "standard definition video" to represent analogue video, such as Beta SP, as well as digital video—mini-DV, Digital Beta, and the like. The various standard definition video formats will be discussed next. Without a doubt, we will all—feature cinematographers to documentary videographers—will be working in electronic imaging data storage systems before long—no film, no videotape, just hard drives and the images.

THE VIDEO FORMATS: FROM STANDARD TO HIGH DEFINITION

Videography, as distinct from television, came into existence about thirty years ago with the introduction of reel-to-reel, half-inch black and white videotape. Independent and experimental filmmakers converted in large numbers to the new visual possibility. But, unlike film formats which have remained

rather stable since the 70s, video has progressed through a large number of not always compatible analogue formats—3/4 Umatic, Super VHS, 3/4 SP, Betacam, Hi-8, and Beta SP being the major stages. Of these, only Beta SP survives in any meaningful sense because the networks remain analogue, and the Beta SP is the only analogue field format meeting broadcast standards.

Next came the digital video revolution of the late 1990s. These are the formats we use in universities today for the most part—mini-DV, and, if we're lucky, DVCAM or even Digital Betacam, to use the Sony designations. However, like the analogue formats, it appears these digital formats are in for a limited life span as well, as high definition video rapidly approaches on the horizon. Together, the analogue and digital formats are sometimes referred to as standard definition video in comparison to high definition that has about double the quality—1080 lines to 525 in NTSC video.

Whereas the digital formats offer increased resolution and sensitivity compared to the older analogue formats, compared to film stocks they still suffer from limitations concerning luminance range. This obviously impacts on lighting and will be discussed in Chapter 12. For now, the following chart gives an overview of current video formats along with some film formats (see Table 11.1). High definition is included for reference and is discussed later in the chapter.

Table 11.1 Video Formats

Analogue	
Beta SP	Resolutions in the range of 600 lines prior to broadcast. Els equal to about 100.
Standard Definition Digital Video	
	Resolution in the order of 700+ lines, about 3 million pixels for high end DV cameras. Els in the order of 200.
mini-DV	From low end consumer models to top-of-the-line Canon XL1s costing about $3500. XL1 resolution = 800,000 pixels.
DVCAM	Sony system which it equates to 16mm film quality-wise. Cost: about $15,000. Resolution = 1,400,000 pixels, 700 lines.
Digital Beta	Highest end system costing in the $30,000 plus range. Highest resolution of these three digital formats—according to Sony the electronic equivalent of Super 16. Digital Beta is a component system meeting the ITU-R 601 international standard.
HD video	Usually referred to as 24p HD video. Progressively scanned 1080 lines at 24 frames per second with an aspect ratio of 16:9. Resolution is standardized at 1920 pixels per line; this equals approximately 6 million pixels.* Els are approximately 300.
2K and Higher	Film scanners used for digital effects and mastering from film negatives exceed the resolution specs for HD video. Scanners like C-Reality, Spirit Datacine, and Millenium offer 2K resolution at 2048x1536 and 3K and 4K resolution at 4096x4096 for 70mm film and other applications.
16mm	1400 lines with Els up to 800
35mm	3112 lines** with Els up to 800

*1920 pixels/line with 1080 lines = 2,073,600 pixels/frame for each primary color. This totals 6,220,800 for each frame of HD video, about twice the pixels of standard definition digital video.

**4,096 pixels/line with 3112 lines = 12,746,752 total pixels per frame, about twice the resolution of HD video.

NOTE: the above figures come from Sony and Kodak literature and the Ohanian books listed in the bibliography. The actual numbers vary from source to source.

FILM QUALITY VERSUS STANDARD DEFINITION VIDEO QUALITY

Producers of quality television programming, TV series, TV commercials, and music videos are likely to shoot on film negative, transfer to video, and edit in computer workstations. These producers shoot on film because they desire a high-quality, feature look—the fabled "film look." Part of the film look comes from greater concern for production values than in television production—in particular, by allowing time for lighting and, more important, by using film-style, single-camera shooting procedures. The lighting resulting from single-camera production is greatly improved over multicamera techniques, which invariably involve lighting compromise.

Other factors in making the film look the quality standard are film's superior technical properties such as resolution and longer straight lines, which can translate a greater luminance range than standard analogue or digital video cameras, leaving HDTV to the side for the moment.[3] The "video look" has thus resulted from a number of causes, both economic and technological, all of which foreground video's inability to translate visual values as successfully as film.

The highest quality translation of visual values is not always important—news reporting, documentary production, experimental video, and installations using video—all are mostly independent of lighting style and technical considerations concerning fidelity to physical "reality." In cases where we intend to finish on film directly from video masters, shooting with PAL, rather than NTSC, will give us more lines of resolution with which to work.

DIFFERENCES BETWEEN FILM AND STANDARD DEFINITION VIDEO

For our purposes, there are two key differences between film and standard definition video systems:

- Film negatives have straight lines of about 6 zones and useful ranges of from 8 to 10 zones, 512:1 as a rough average, whereas the broadcast video signal offers only a 4½ zone range, about 25:1. Even though pickup tubes can handle 40:1 and CCD cameras up to 50 or 60:1, the overall range is clipped back to 25:1 when broadcast. This means video as televised offers the rendition possibilities of 16mm color reversal stocks (see Figure 11.1).

- Film curves exhibit sloping toes and shoulders. That means they gradually approach and depart from nominal straight-line proportional responses, whereas the **transfer characteristics** for most video cameras exhibit sharp cutoffs of values. Video lacks the curved toes and shoulders that film has.

High-end cameras with **gamma compression circuitry**, can extend the log E reproduction range by 1 zone to 5½ zones. They do this by compressing, though still differentiating, two upper zones into one. Luminances from 80–120 IRE are compressed into 80–100 IRE on the scale. These subject luminances, though differentiated, are still broadcast with a 25:1 range. This flattening of values approximates a film stock's shoulder and gives some of that film look to the video signal (see Figure 11.2).

FIGURE 11.1

COMPARING FILM AND VIDEO IMAGING SYSTEMS

(a) Transfer characteristic curve for a typical video signal graphed as a positive image. Note the sharp cutoff on the toe and shoulder areas. For a transfer characteristic, the log E is plotted against the log of the voltage level of the signal. This is very similar to the film characteristic curve. (b) Transfer characteristic curve for a video camera graphed as a negative for comparison with film negatives. Video cameras have log E ranges greater than the 25:1 range of the broadcast signal, but these are clipped back when broadcast. (c) Typical color-reversal film curve provided for comparison purposes.

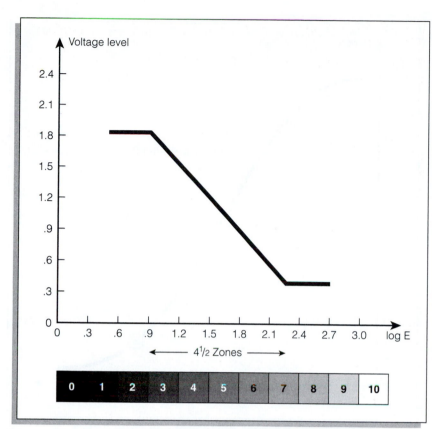

(a)

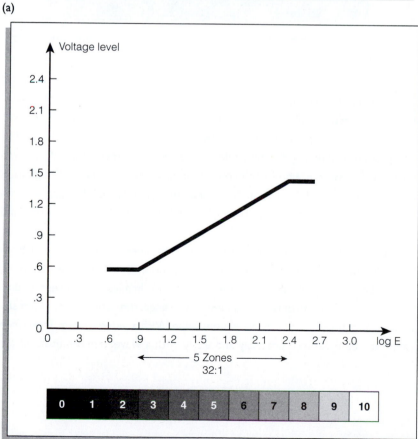

(b)

FIGURE 11.1 (continued)

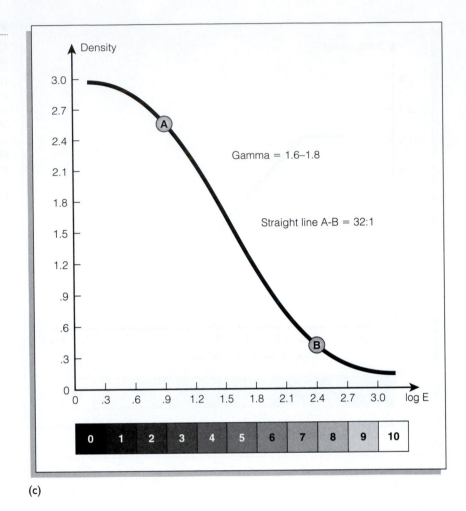

(c)

The film straight line provides an immense advantage in translating visual values. According to Mathias and Patterson, a film negative can represent over 100 shades of gray whereas a video camera is limited to about 72.[4] Origination on film negative thus offers a greater amount of visual information to the video system when compared to origination via a standard definition video camera. This information is represented by a range of densities sufficiently low in contrast to be preserved even when transferred to video and broadcast.

Nevertheless, a cinematographer, knowing video's useful range is from 4½ to 5½ zones, depending on whether the camera has a compression circuit, should be able to light in such a way as to create images of sufficient quality. The key thing to control is overall luminance range, the ratio of maximum significant brightness to significant shadow value. With a video system, luminance range can be measured precisely and easily with a waveform monitor.

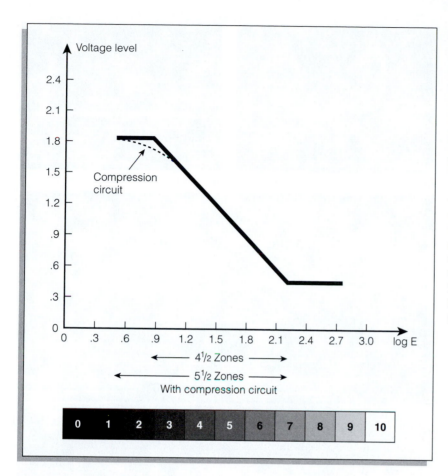

FIGURE 11.2

GAMMA COMPRESSION CIRCUITS

To obtain a film look, it is necessary to alter standard video curves by electronically creating a shoulder. This takes away some of the sharp changes present in the video look at the highlight end. These shoulders are created by gamma compression circuits and function much like a limiter on a Nagra tape recorder.

This graph shows a transfer characteristic curve for a video system using a camera with a hypothetical gamma compression circuit. The gamma compression circuit expands the straight line response about a zone to 5½ zones. Even though that signal is compressed on broadcast to 25:1, the extra information still provides luminance value differentiations greater than from the standard camera.

W AVEFORM MONITORS

The waveform monitor is an electronic means for measuring the video signal. In essence, it provides an accurate series of spot meter readings for the entire video signal. Where there is a highlight value, the waveform monitor gives a high reading, and vice versa for a low value. Study carefully the display of black and whites in the examples in Figure 11.3.

The scaling on waveform monitors is in **IRE units** (Institute of Radio Engineers) and, except for the initial 7.5 IRE units, is incremented in units of 10. The zero part of the scale is used to adjust the monitor when setting up. Standardized video signals run from black values of 7.5 IRE to white values at 100 IRE units. Luminance values falling lower or higher than these figures are clipped when broadcast.[5]

Figure 11.4 provides additional examples of waveform monitor displays. Some of these displays are from photographs in this book. The reader may thus compare the image with its corresponding waveform monitor display.

(a)

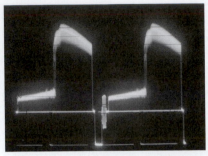

(b)

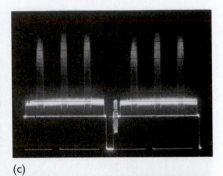

(c)

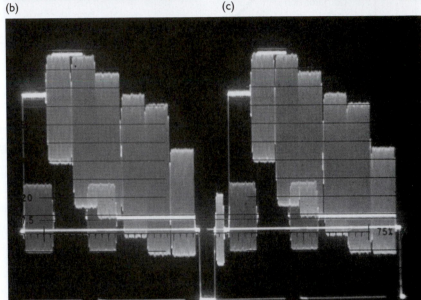

(d)

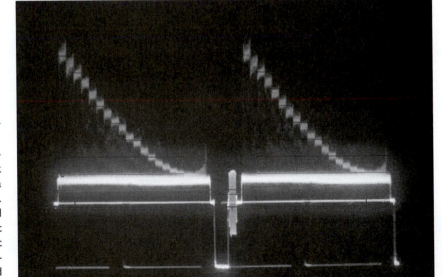

(e)

FIGURE 11.3

WAVEFORM MONITOR DISPLAYS

(a) Waveform display for half-black/half-white frame—created by placing a black card in the bottom half of frame and a white card in the top half of frame. (b) Same as (a) but with the black card left half of frame and the white card right half of frame. (c) Black cloth with light gray, rectangular-shaped decorative patterns. (d) Waveform display for standard color bars. (e) Waveform display for multi-step gray scale.

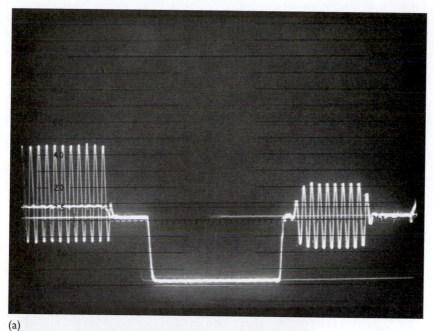

(a)

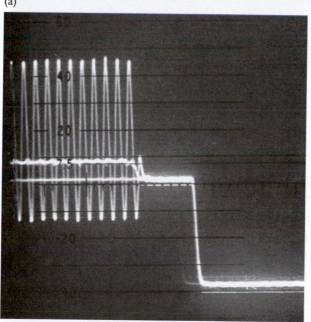

(b)

(c)

(d)

(e)

FIGURE 11.4

WAVEFORM MONITOR SCALING
AND DISPLAYS OF
PHOTOGRAPHS IN BOOK

(a)Waveform display. The waveform moni-
tor displays technical information con-
cerning sync, color, and blanking. We are
concerned only with the video portions of
the display. (b) Close-up detail of (a) show-
ing IRE scaling on waveform monitor.
(c) Waveform display for high-key photo-
graph as in Figure 2.13a. (d) Waveform dis-
play for photograph opening Chapter 1.
(e) Waveform display for dark, low-key
photograph as in Figure 4.12a.

Each 20 IRE units on the scale is equivalent to 1 T-stop, 1 zone, assuming the gray gamma is at the standard .45 setting. Since the broadcast video signal can range from 7.5 to 100 IRE units, we arrive at the following zone-placement possibilities:

100–80 = 1 zone

80–60 = 1 zone

60–40 = 1 zone **Total: 4.6 zones = 25:1**

40–20 = 1 zone

20–7.5 = .6 zone

Because the waveform monitor represents a series of spot meter readings across the image, it is a highly accurate representation of relative subject luminance values. However, it also suffers from the limitations of all reflected readings and presents the problem of ensuring consistent facetones for a variety of lighting conditions. With this in mind, the waveform monitor will be useful to some cinematographers and little used by others.

HARACTERISTIC CURVES AND GAMMA IN STANDARD DEFINITION VIDEO

Overall gamma for video is defined as the sum of the individual gammas in the imaging chain. Most variables are at a nominal gamma of 1.0, but a receiver picture tube is around 2.2, and thus standard camera gamma is .45 to ensure an overall of 1.0. One key difference between film and video is that video systems utilize a three-gamma concept whereby it is possible to electronically manipulate white, gray, and black gammas independently. In fact, gamma in video refers to the middle gamma, the gray gamma value. When we say the gamma is at .45, this is the one we mean.

Alteration of **black value gamma** is termed adjusting **pedestal** or black level. Adjusting black level gamma is equivalent to flashing film; that is, the IRE value for blacks is raised, effectively reducing the original subject contrast. Besides high-end cameras, some industrial-quality cameras allow for pedestal/black value adjustment electronically. Some of these cameras also provide overall sensitivity adjustments that can affect final image look (see Figure 11.5).

FIGURE 11.5

PEDESTAL (BLACK GAMMA EFFECTS)

The three photographs were taken off a video monitor while the black gamma was adjusted: (a) Minimum black gamma setting—note the flashing effect derived from lightening the blacks electronically; (b) standard black gamma midsetting; (c) darkest possible setting for black gamma.

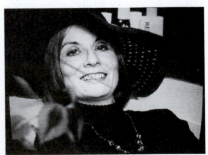

(a) (b) (c)

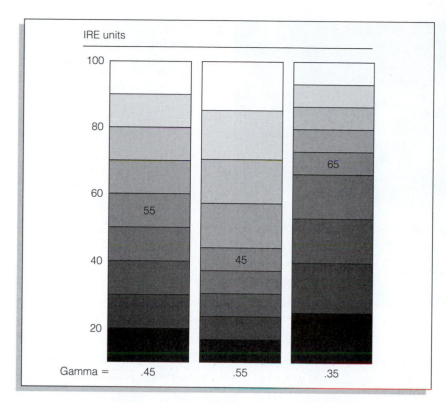

FIGURE 11.6

EFFECTS OBTAINED BY ADJUSTING GRAY GAMMA

Standard gray gamma (.45) evenly spaces gray values. The midgray is at 55 IRE units. Raising the gray gamma to .55 lowers the placement of the midgray to about 45 IRE units. This effectively stretches the higher values as illustrated in the middle column. Lowering the gray gamma to .35 raises the midgray to 65 IRE units and stretches the black values as shown in the right column.

Alteration of **white value gamma** is called adjusting white level or gamma compression. White value or highlight gamma is adjusted automatically by circuits built into the few cameras that allow for this, but where those circuits start to take effect is sometimes adjustable (see Figure 11.2). Utilizing the gain circuitry to boost exposure index also affects white value gamma by giving it a higher value. This results in increased contrast in highlight areas. This is accompanied by an increase in video signal noise and is generally not a good way to vary white value gamma.

Adjusting the **gray gamma** does not affect black and white extremes, but it does affect how lower and upper zones are represented. Raising gray gamma from the standard .45 compresses black values slightly and provides more room for highlight values. Lowering gray gamma has the opposite effect (see Figure 11.6).

ONE THEORY APPLIED TO VIDEO

As we have seen, the fundamental assumption of exposure is that an 18% reflectance placed at a mid-density point on the negative yields prints of acceptable quality with good facetones, consistent middle grays, and controlled highlights. Let us elaborate this for video, taking as an example the simplest possible lighting scheme: Full frontal lighting where no shadow range is created. In this situation, a normal zone 5 exposure places an 18% reflectance at zone 5, a 36% at zone 6, a 72% at zone 7, and, were there such a thing, a 144% reflectance at zone 8. A maximum reflectance of 96% would fall at about zone 7½.

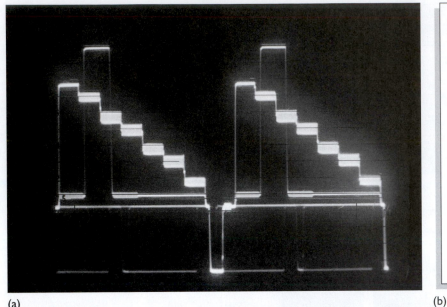

(a)

(b)

IRE UNITS	
100	
	zone 7 (90 IRE)
80	
	zone 6 (70 IRE)
60	
	zone 5 (50 IRE)
40	
	zone 4 (30 IRE)
20	
	zone 3 (10 IRE)
7.5	

FIGURE 11.7

PLACEMENT OF MIDGRAY CHIP AT 50 IRE UNITS

This display reveals how the standard IRE gray scale reproduces when the midgray chip is placed at 50 IRE units. This is a lower placement than normal (midgray chip at 55 IRE units) for the reasons specified in the text. Note the white value is placed at 100 IRE units and the black value at 7.5 IRE units.

From 18% to 96% represents 2½ zones of change (5 to 6, 6 to 7, 7 to 7½). With video, a 96% white reflectance, zone 7½ value, should be very near 100 IRE units on the waveform monitor to avoid the clipping effect. This placement would retain separation between important highlight values. A zone 5 value (18%) would then fall around 50 IRE (see Figure 11.7). The simplest way to accomplish this placement would be to use a waveform monitor to set an 18% gray card to the desired setting. Note that placing zone 5 at 50 IRE units means zone 6 will be at 70 IRE and zone 7 at 90 IRE. Likewise, zone 4 will fall at 30 IRE and zone 3 at 10 IRE, giving us our total range of about 4½ zones.[6]

The video exposure technique proposed here parallels film exposure; however, we are using a waveform monitor in place of a spot meter. We have assumed the simplest possible lighting scheme. Any increase in luminance range will create contrast reproduction problems for the video system.

Exposing video would be simpler if we could work out an "exposure index" for the video system and use the incident meter to peg the 18% midgray. If desired, we could still use the waveform monitor to check luminance range placement on the video curve.

 OW TO CALCULATE AN EXPOSURE INDEX EQUIVALENT FOR A VIDEO SYSTEM

It is fairly simple to determine the EI for a particular video camera. Basically, you set up the video camera for tungsten balance and hook it to a waveform monitor. Light a gray card or a Kodak gray scale, and put the gray value or middle chip on the Kodak scale at 50 IRE units. This is done by adjusting the T-stop on the video camera until the chip is at 50 units. This will give the zone 5 pegging illustrated in Figure 11.7.

Next take your incident meter, put it in the light falling on the gray card, point it at the camera, and take a reading. Normally for film, the meter is set for a particular exposure index, a reading is taken, and we arrive at a T-stop.

Here, we know the T-stop and meter reading and have to work backward to determine the exposure index. The type of meter determines how you do this. On the Sekonic, you line up the meter reading on the Hi or Lo scale mark and adjust the ASA/ISO ring until the T-stop on the video camera is lined up across from the 1/60th shutter speed.[7] The exposure index thus indicated is the speed setting for that video camera. Thereafter, readings may be taken in the standard film way with an incident meter.

A quick test is to increase or decrease the light on the gray card, take a reading, and set the indicated T-stop on the video camera. If all goes well, the chip is once again at 50 on the waveform monitor. We can now expose with this video system as we would with film, that is, set our lighting with the incident meter and "expose" the video image by setting the T-stop on the lens as indicated by a standard incident reading.

The typical analogue video camera will have an EI of around 100. Mini-DV and high-end digital cameras will rate higher. HD cameras also exhibit increased sensitivity. As mentioned earlier, Sony rates the CineAlta camera at EI 300. If we need more speed, we can increase the gain setting on the video camera. This can yield video speeds of 400 or better. Increasing gain is equivalent to pushing film emulsions and has similar drawbacks with image deterioration. Reflected metering techniques will be used as in film, except that with video you can use the waveform monitor to expose luminous objects more precisely.

USING A MONITOR TO "EXPOSE" VIDEO

On a professional shoot you will be able to work with a video engineer and use waveform monitors to place subject zones. One thing is crucial: You can't let the engineer set levels independent of your lighting goals. Teamwork is the answer.

As discussed, another alternative is to work out the exposure index for the video system and use the incident meter for the T-stop reading, although again you work with the engineer to finalize exposure settings. In both these cases, you will be looking at a visual monitor to see the effect created even though you will not be using that monitor to make crucial decisions.

Another alternative is to allow the manufacturer's autoexposure system to determine zone placement, but remember the auto system relies on several assumptions you might not want. For example, it might be center-weighted while you wish to expose for other parts of the frame. In the worst possible scenario, the system changes exposure as you do a pan or tilt—a highly undesirable T-stop pull. It is hard to do good work with image look relying on the auto system.

The last alternative is to expose and light by eye using the visual monitor as the sole guide for your decisions. Some cinematographers would argue that this ability to expose and light by eye with a monitor is one of video's more powerful features—the ideal, with no mechanical interfaces like waveform monitors between you and the image.

In order to expose video by eye, you will have to set up the monitor standardized to color bars or a known reference. If you can do that, you will

be working directly with image look. The problem: You will have no clue about your IRE settings, including white and black settings, and thus for broadcast purposes might be outside FCC technical limits. But this is only a consideration if you are broadcasting; other uses of such video would be unaffected.

High-end cameras generate the standard color bars necessary for initial setup of the monitor. You basically do this by memory, adjusting the monitor until the color bars and black and white settings seem right. In many cases, the monitor can be adjusted in a dark room and then brought onto the set, because ambient light on the set can make it hard to set up the visual reference. As well, wherever possible, it is best to keep the monitor in as dark a place as possible while you set T-stop on the camera and perfect the lighting on the shot. It is very important to adjust camera settings only after you have set up a monitor for a scene. This will ensure your effects are on the tape and not the monitor.

This may sound complicated at first, but after you get used to adjusting the monitor, you will find the process relatively easy to accomplish. Not only that, your lighting and use of color will be visible instantaneously. Color temperature effects are instantly reviewable. All in all, a very symbiotic process arises.

On cameras that cannot generate color bars, you will have to preadjust the monitor elsewhere and bring it to the set ready to go. On mini-DV cameras with color viewfinders, you will expose by eye using the viewfinder as a reference. Again, setting the viewfinder for normal parameters is the hard part. Keeping ambient light from fooling you as you expose or light is the tricky part, especially with the LCD screen.

Obviously, lighting and exposing by eye are good things, but the calibration of the monitor to the tape is of key importance. As well, monitors are not all the same, so using the same one regularly will help.

During a lighting demo conducted by Allen Daviau using HD video, he developed the setup and balanced in rims and fill. Not once did he use a waveform monitor, although he did use an incident meter occasionally to set initial light levels on lamps. All fine tuning of lighting and the choice of T-stop were done by eye referenced to the projected video image.

Some cinematographers will like using the eye as central reference for the image look. In spite of the fact that the eye is easily fooled by circumstances, there is something intuitively right about using the eye to create lighting setups and choosing exposure. It is almost like the painter choosing colors by eye under a variety of lighting conditions. Others will prefer the precision of waveform monitors and spot or incident meters. We are all different; that is why our images differ. Perhaps the best advice is to choose the technique that suits your personality and explore the possibilities.

FILM ATTITUDES IN VIDEO PRODUCTION

Although we want consistent facetone densities in film and video, those densities are placed within a wide variety of background contexts. Control and variation of the ratio between face and background is an essential facet of the cinematographer's artistry and one of the central techniques in creating mood

with lighting. The cinematographer essentially pegs his or her exposure and then lights around that initial zone placement to configure the images, a painting with light.

Approaching video with these attitudes, the cinematographer would think nothing of pegging Caucasian facetones to zone 6 and having that represent the brightest value in the subject. But this "film" attitude would immediately collide with standard television engineering procedures that routinely place the brightest value in the scene at 100 IRE units without regard to the nature of the desired lighting style or even as to what that brightest value actually is.

In this case, a placement at 100 IRE would destroy the mood of the face and image by brightening two stops overall—equivalent to pegging midgray at zone 7 by intentionally overexposing two stops. We would never accept this from a film lab nor should we from a video engineer.

Of course, cinematographers long ago learned to "trick" the video system by incorporating **reference whites** into dark-toned, low-contrast film shots destined for television. In the preceding example, a shaft of light on an off-white object would be incorporated into the composition for no other reason than to provide something other than the face to put at the 100 IRE level. In like manner, a **reference black** can be included to protect light-toned, low-contrast images. High-contrast images will peak at both ends in any event and do not require such references.

The above placements should be regarded only as starting points. Experimentation with the zone 5 placement is equivalent to determining the best exposure index rating for a film stock. This is standard practice in feature work where EI is varied to create particular effects or looks. For example, color negatives are sometimes rated at 640 rather than 320, not because of the gain in speed but because of the resulting differences in look—contrast, color saturation, and overall feel. For the same reason, it is not unheard of to shoot high-speed negatives outdoors in bright sunshine even though you need neutral density filters to control exposure. The texture and look of your images are all-important.

Obviously, tests are needed to determine standards and individual value preferences. It could be that for a particular purpose facetones render better at 40 or 45 IRE units.[8] Video offers sophisticated signal-processing possibilities in postproduction, so your careful work can be undone if you are not alert.

Be aware, however, of the standard broadcast rule: Caucasian facetones should be between 60 and 80, around 70 IRE units. Darker brown and black facetones will fall on zones 5 and 4, at 50 and 30 IRE units respectively. Also, remember that engineers are apt to ignore facetone consistency altogether and place any maximum brightness at 100 IRE and darks at 7.5, letting facetones vary from lighting setup to lighting setup. With these considerations in mind, use of the zone system in video is simple. As with film, it allows for previsualization of the image, though previsualization is easier in video than in film. For one thing, a waveform monitor aids in previsualization. For another, a TV monitor can be hooked up for direct viewing of the image.

THE DIGITAL HD VIDEO REVOLUTION

Many of the drawbacks of working with standard definition video and broadcast television are on their way out. Although we are still at the exploratory stage, it is clear that there is a new kid in town and cinematographers are rapidly, if sometimes reluctantly, jumping on the bandwagon, not so much for aesthetic reasons, because most feel film is still different/superior to even HD digital video, but for economic reasons. The following lists the main changes that are fast upon us as digital approaches the ideal, electronic, nonmechanical imaging system:

- Elimination of negative scratches and other mechanical problems.

- Elimination of any insecurity about exposure and what the shot is going to look like. You can see it on a video monitor at the shoot.

- Increased overall useful ranges and video straight lines (increased latitude). If Sony is right that the CineAlta rivals 35mm, then 24p HD would have to be able to translate 10 zones of photographic reality, a ratio of 1024:1.

- Increased resolution. The CineAlta has approximately 2 million pixels per frame for each RGB CCD making a total of approximately 6 million. A 35mm frame has over 12 million pixels per frame according to Kodak.[9] Thus, HDTV has about half the resolution of film.

- Capability of a large variety of tonal and color effects and the use of current film lighting styles.

- Increased camera "speed." Manufacturers even give suggested EIs.

- DPs can work with engineers to create image looks. With origination on video, the lighting look is the goal not the NTSC transmission standard concerning IRE placements.

In other words, HD video would be treated as a new film emulsion. It would be tested for its look properties and possibilities as with a new film stock. It would be used where it would be the best tool for the job. Many cinematographers still believe that digital video, even HD video, has a different look from film. And that different look is inferior with poor blacks and a limited response to luminance range. But the attitude that it is a useful look is becoming the rule as cinematographers use HD video, and manufacturers adopt video cameras to filmic configurations with matte boxes, film-style viewfinders and the like. Pretty much everyone agrees that analogue video is dead as a production medium—long live digital, high definition video.

SUMMARY

In this chapter, we have examined several basic differences between film and standard definition video in terms of exposure and zone theory. In general, we have seen that the standard video image can be approached from a film point of view and that the exposure concepts we developed in Part II can be applied to video. We can thus compare a video system's straight line and overall useful range with those of a film stock.

We have looked at the important role the waveform monitor plays in video and have shown how to determine an exposure index (EI) equivalent for a video system. With these technical basics understood, we can now turn to lighting and image looks for video—digital cinematography.

NOTES

1. "Arrival of a 24-Frame Progressive Scan HDTV Production System." The Sony Corporation, 1999, pp. 7, 16. See also the discussion of HDTV and film in the *American Cinematographer* April 2001 issue. The key book at the moment is *Digital Filmmaking*, 2nd ed., by Thomas A. Ohanian and Michael E. Phillips, Focal Press, 2000.

2. Ohanian and Phillips, *Digital Filmmaking*, p. 246.

3. The 35mm film image remains our standard for quality because 35mm offers a longer straight line with finer resolution than do the rival production media. Origination on 35mm film is still the choice for most cinematographers. On the other hand, digital editing systems like Avid or Final Cut Pro require scanning the film neg to video or data files for entering the computer environment. These systems offer powerful advantages—the central one being computerized controls. Utilizing time code, coupled with switchers, digital video, and other black-box special effects, these systems have eliminated film as far as postproduction goes. Along with digital audio workstations for posting audio tracks, digital editing has revolutionized film and video postproduction procedures because it offers all the aesthetic advantages of film with the technological advantages of digital storage and computerized controls.

4. Harry Mathias and Richard Patterson, *Electronic Cinematography: Achieving Photographic Control over the Video Image* (Belmont, CA.: Wadsworth, 1985), p. 84.

5. IRE units have no particular relationship to percentage reflectance. For example, an 18% reflectance is not equivalent to 18 IRE units. Clipping is done to ensure noninterference with the sound track on the highlight end and noninterference with syncing information on the black value end. Clipping is a feature of the broadcast system and may be avoided with cable transmission and other video signal modes.

6. Video cameras are generally set up using the EIA (Electronics Industries Association) nine-step gray scale. The middle chip, a 13.4% reflectance, is rendered close to 55 IRE units. The next step up in the EIA scale is a 19.5% reflectance. At a gamma of .45, this reproduces at 68 IRE units. This makes 18% equivalent to 65 IRE units. Zone 6 (36%) is at 85 IRE units, and zone 7 would fall at 105 IRE units. This means we lose most zone 7 renditions because of clipping.

7. It does not matter which shutter speed you use as long as you use that same setting when shooting with the video camera later. However, 1/60th (the nominal time for one field in NTSC) is close to film camera shutter speeds and thus allows for direct comparison of EIs between film and video. The 1/60th shutter speed will also be useful with cameras having electronic shutters calibrated in 1/60th increments.

8. Mathias and Patterson point this out with reference to *Raiders of the Lost Ark*, which they estimate has facetone placements around 30 IREs in its video release. Mathias and Patterson, pp. 11–12, 104.

9. The high definition standard is 1920 pixels/line with 1080 lines of resolution per CCD, whereas 35mm film provides roughly 4000 pixels/line with 3000 lines. According to Kodak, the exact number is 12,746,752 pixels per frame calculated as follows: 4,096 pixels \times 3112 lines.

ALTERNATIVE LOOKS

CHAPTER TWELVE

Lighting Techniques for Digital Cinematography

Film lighting practices can be used to create more varied and interesting images on video by moving it away from television conventions. Alternative looks are available to video through experimentation. Video offers one advantage over film in that, if care is taken with the visual monitor, it is possible to evaluate the lighting and image look while on the set.

MUCH OF THE UNINTERESTING look of work originating on video results from unimaginative applications of technical rules without variation. An example is the familiar "put the whites at 100 IRE and the blacks at 7.5," or the typical studio 150fc overall light level. The result: Most of the interesting lighting on television originates on film, from series such as *NYPD Blue* and *The Sopranos* to alternative programming like music videos. Experimentation with video image surfaces, textures, and lighting is primarily relegated to video art and its outlet in museum screenings. But with the increasing use of digital video by filmmakers, it is necessary to develop new video concepts like electronic cinematography.

As in the previous chapter, we are forced to distinguish between the main production video modes found today—Betacam SP (analogue) and digital formats such as Digital Betacam or mini-DV—and HD video modes on the horizon.

To recap: The key technical differences between film and standard definition video from the standpoint of lighting are as follows:

- Film has a longer useful straight line, 256:1 versus 25:1 in video.
- Film emulsions exhibit curved toes and shoulders, not sharp cutoffs as with video.
- Film emulsions are generally faster and thus allow for more low-light techniques, though newer video cameras are rapidly gaining in sensitivity.

With these limitations in mind, let us look at some video lighting possibilities.

HE STANDARD VIDEO LOOK

The key to lighting for video is holding the subject luminance range to the 4½ zones allowed by the standard system or 5½ zones when working with a camera with a gamma compression circuit. All the rules concerning video in the literature—subject lighting ratios no greater than 3:1, facetones at 70 IRE, subject/background ratios no greater than 4:1—are an attempt to deal with this limited straight line.

Lighting from any angle other than frontal creates problems for the video system, problems well known to those familiar with color reversal film stocks: (1) contrasty, unpleasant facetones, (2) an inability to convey dark value detail, and (3) the lack of a subtle discrimination of visual values. The standard video look, like its color reversal predecessor, relies on low facial and subject/background ratios with rim light for accent.

The use of footcandle levels on the order of 100-150 fc in studio situations yields a routine set of color saturations as well. The result is that conventional, bright, happy television lighting found on innumerable game shows, sitcoms, and news shows.

N ALTERNATIVE LOOK

One way to open up the video look is to use low-intensity, softish, overall frontal illumination—the kind of light naturally available in day interiors. This light may be created by bounced light, heavy diffusion, and softlights. With this type of lighting, there are no significant shadow areas.

As an experiment, take three desk lights with 60-watt bulbs. Find a day interior with enough ambient light to reach T 2 at EI 100. Hook up a monitor to the video camera. Look at the variety of low-light possibilities. Ignoring the warm color temperature, use the desk lamps to illuminate and fill as necessary. Note that what is gloomy to the eye—for example, dark areas of a naturally lit room—looks interesting on the video monitor. This natural lighting is soft, indistinct, and fuzzy. Colors are muted in comparison to the standard over-the-air look. The point is that it is possible to light video in ways that are not considered broadcast quality but that make interesting video images. Except for video artists, few of us know the possibilities and limits of video. Not enough exploration has yet occurred.

In the following discussion, it is assumed you are lighting with an incident meter and checking luminance range with a spot meter or waveform monitor as necessary or you are exposing and lighting the video image by eye with a monitor as guide.

NTERIOR/EXTERIOR SITUATIONS

In the actor-in-the-window example discussed extensively in Chapter 6, we saw that exposure determination for the window involved choices about how much to overexpose the window or to underexpose the actor, choices that were crucial to the final feel of the image. The immediate problem with video is that such a film technique, possible because of film's ability to translate long

luminance ranges, is beyond the video system's capabilities. With video, you are forced to reframe in order to exclude the window or to light the actor so bright relative to the window that you lose the window effect altogether. Use of gamma compression circuits improves the final result. Also, the subject/background ratios are restricted to such a small range of possibilities in video that you are in constant danger of having each scene look like the next. The result is that the same mood is created over and over again.

The difficulty here is to retain detail, create visual variety and mood, and avoid a repetitive lighting style. Use of colors, rather than luminance variety, suggests a solution and a way to open up the video look. By use of color we mean, as with the Impressionists, a painting with color, rather than, as with Vermeer, a painting with light. The electronic cinematographer will have to work much more closely and creatively with the set designer, because lighting concepts such as subject/background ratio are helpful only within a very narrow range of possibilities. Many of the ideas concerning color in Chapter 13 are open to video exploration.

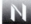UMINOUS OBJECTS

As with mixed interior/exterior situations, luminous objects present problems for video. It is difficult to retain the feeling of their luminosity. Eliminating the luminous objects in the shot will not necessarily work either because then the shot might not look realistic. Large luminous areas, such as steamed window panes or a sunset, will work in video if you are able to utilize a silhouette/semisilhouette effect on the actor. Unfortunately, standard film uses of practicals, lamps, candles, and the like are borderline. It is necessary to reduce luminance values on practicals or accept over-bright, "burned out" effects. Such situations are best evaluated with a video monitor.

IGHT INTERIORS

With video it is difficult to obtain the kinds of black values available in film. Dark grays predominate. Contrasty lighting styles such as *noir* are hard to achieve. Night interiors lose much of their feel. It is difficult to establish high lighting and subject/background ratios to convey "night" without creating too much contrast for the system to handle. For the reasons given in Chapter 11, better night effects are obtained by going via a film negative and video transfer to the final broadcast signal.

COLOR TEMPERATURE EFFECTS

As discussed in Chapter 1, color temperature effects work very well in video and in ways not available to the cinematographer. For example, video cameras require white balancing. This is equivalent to matching the color temperature of a film emulsion with that of the illumination, for example, putting on a #85 to shoot outdoors. But white balancing is more exact than the film equivalent. It fine-tunes the color balance similarly to a lab timing of the film negative.

It is possible to white-balance to nonwhite hues: Off-whites, grays, creams, even yellows, oranges, or blues. This technique can be used to "warm" or "cool" the video image in very subtle ways. The effect has to be evaluated over a monitor and can be enhanced or toned down in postproduction.

VIDEO COLORS

To avoid that richly colored, sharp image built into current video systems requires working with low-intensity light levels and small amounts of supplemental soft light. This represents an alternative look. Such a look results from the change from a richly saturated, brightly lit color palette to a muted, subdued range of hues. Control over production design—the colors of set design and costumes—can also yield a different look. VariCon on-camera flashing and filtration with nets are other ways to work with video colors. Color can also be controlled electronically in postproduction where electronic color controls allow for subtle effects.

A more serious problem is encountered when shooting video for day exteriors since bright, saturated video hues are even more predominant. As with color negative film stock, it helps to avoid direct sunlight and shoot in shady situations or under gray sky conditions. Videographers have come to realize that a good rule for sunny days is to shoot early morning or late afternoon and avoid shooting from roughly 11:00 P.M. to 3:00 P.M. This minimizes the impact of those bright, saturated video hues.

There is a great danger your video images will all look alike. Shooting on rainy days, in the winter, and at dusk are all techniques that will help defeat the built-in color palette. As with film, night exteriors are best shot at twilight or in places with a lot of ambient street light, neon signs, and so forth. No new principles are involved with electronic cinematography, just an awareness of the limitations of video listed at the beginning of this chapter.

USE OF VISUAL MONITORS ON THE SET

In *Electronic Cinematography*, Mathias and Patterson argue that the central problem in video production is the lack of a director of photography (DP) who is in charge of the look of the image. They contend that, from the cinematographer's point of view, video lighting requires no new principles. They further argue that, if film techniques and practices are followed and control over the image look is given to a DP rather than an engineer, video lighting effects comparable to film's will result.

There are three principal approaches to lighting for video:

1. *Traditional studio way.* Use a spot meter and incident meter to set lights, follow the traditional ratio rules with three-point, key, fill and rim lighting, 2:1 subject lighting ratio, 2:1 subject/background ratio, everything at 100 fc, and, without looking, allow the engineers to "expose" the image using waveform monitors. The central problem is that exposure is divorced from lighting and is used noncreatively. This method is too mechanical, standardized, and conventionalized.

2. *Mathias and Patterson way.* Establish an exposure index equivalent for the video system, and use an incident meter to set lights and determine T-stops. Use a

waveform monitor to check subject luminance range, and light with ratios suitable for a film emulsion with a 32:1 overall straight line. This method relies heavily on the waveform monitor for image evaluation.[1]

3. *Use of on-set monitors.* This amounts to lighting and even exposing by eye should you choose. The lighting is built up with reference to a monitor. You can use an incident meter for setting T-stop if desired. You use your eye to evaluate ratios and special effects and to create an overall mood. You still may use a waveform monitor to monitor exposure and to check overall luminance range.

The central advantage of method 3 is that it makes possible a painting with light and color by eye. Using the monitor, we see as the video system "sees." This has always been the dream of the cinematographer: to see as the film stock "sees" without having to wait for processing and workprinting.[2]

There are technical problems associated with using a monitor as in method 3: Monitors vary and light hitting them can give false indications of the actual image look. All the cinematographer can do to avoid these pitfalls when working in video is to accept them and try to minimize their effect, knowing inconsistencies can be corrected in video postproduction.

The advantage of lighting by monitor is that you can see as you work, like a painter. The disadvantage is that you are trying to achieve a final timed look without waveform data. Judging the look off a monitor can be misleading, given the perceptual adaptability and relativity of the human eye.

Color bars are one means to achieve standardization when using a monitor. The cinematographer can adjust the color bars on the reference monitor before lighting and refer back to the bars as needed throughout the shooting day, to readjust the eye so to speak. It is essential not to change or readjust monitor settings until a particular scene is completed because that will tend to yield inconsistent images. With this technique, it is possible to light and expose referenced to the monitor. Method 3 is at least worth experimenting with because it holds much promise for lighting artistry. Multiple shadows, hot spots, uneven intensities, ugly facial shadows, and the like can all be avoided via the monitor without having to learn through years of experience to see as the video system "sees."

THE PROMISE OF 24P HD VIDEO

If it is true that HD video can handle luminance ranges in the way that film can, then video would be, in effect, just another film stock. None of the problems mentioned above—luminous objects, day and night interiors and exteriors, and the in-built color palette—would be any different from film. These situations would still present problems but the problems would not be magnified because of video itself.

There would still remain certain questions:

1. Can video systems be designed so as to have different responses to light and color the way various film emulsions do? Specific Kodak and Fuji stocks look different on the screen prior to our applying lighting and color controls. Would the different video manufacturer's cameras present a variety of possibilities in the way Fuji's and Kodak's different emulsions do today? Or, would all video look alike as it tends to do today?

2. If video can be varied in the way it responds to light and color, would we need several video cameras to obtain these different responses, or would that be controllable by the cinematographer with software? Would we have to wait until postproduction to apply these controls? If so, this would be very difficult for the cinematographer who traditionally has moved on to another production. As well, we would like to be able to see the finished look during production so as to work with it—control it and vary it for effect.

In other words, before video can replace film, it will have to provide the variety of image looks and control possibilities that film negatives currently allow. It is true that many of video's color and luminance controls happen in postproduction, at telecine, in the computerized editing system, or in on-line sessions. That means that the cinematographer would have to be present or run enough tests to be certain of effects. In this sense then, the above questions would be less important. They would just require another way of working.[3]

The HDTV revolution remains at a preliminary stage. More experience with the new "film emulsion" is necessary. This will all be reported and discussed in *American Cinematographer* magazine. Though cinematographers have already reacted differently from one another as to working with HD video, there seems to be a willingness to explore the new possibilities provided by the new "film emulsion."

A CASE STUDY: SHOOTING ON DIGITAL VIDEO

Let us revisit the hypothetical shoot described in Chapter 10, but this time from the point of view of shooting on standard definition digital video. Two things immediately become more important: (1) use of color instead of light and shadow to differentiate visual values, and (2) the potential use of subtle color temperature effects.

The working parameters were described in Chapter 10 as follows:

> Day interior in an elegant cafe, two walls have floor-to-ceiling windows looking out onto street exteriors, two days to shoot, large actions such as people entering and exiting the cafe, although the main emphasis is on a couple sitting at one of the tables, and the director may want a tracking shot from exterior to interior. All of that will become the opening scene of what is to be a Hitchcock-like spy film (see Figure 10.1).

OVERALL LOOK

As per the hypothetical, the producer wants a high-gloss, James Bond film look. This means we can use high footcandle-levels and frontal lighting setups to take advantage of video's in-built sharp, richly colored palette. We will need frontal lighting because that yields the most saturated colors. Our biggest problem will be the windows that will require our gelling them down to a much lower level than we would with film. We will need to talk to the art designer about the set, its colors and layout. If we are at an actual cafe, we can shoot tests on video and then discuss the overall feel with the designer and director. If we are on a student shoot, we will have to take what is there because we will have little control over the interior decor.

LIGHTING RATIOS

We will shoot this almost 1:1 on faces depending what the video monitor reveals. Because we want a bright high-gloss look, we will try to place face-tones around 60 IRE units on the waveform monitor, a slight overexposure. Our subject/background ratio will also be "high key," maybe 1:2 if measured. But these ratios come at a price; there will be no shadow areas to create depth and mood. We will have to do everything with set and costume colors.

COLOR TEMPERATURE

Will we go for normal colors? An overall tinted effect using color temperature and white balancing techniques? Will we use a warm/cool effect, say a golden warm subject plane with a cooler background balance? These are very important questions. The actual location or set would determine these answers but the good thing about video is we can try a variety of ideas and see what we are getting on the monitor. A day or two for experimentation before principal shooting would be good, so that we could shoot several tapes of ideas to show to the director. Again, on the student-type shoot, we will have to live with in-shot colors, but luckily we can try any of these color temperature ideas. However, we might not get the two days to experiment—working fast and cheap being the rule.

TYPES OF LIGHTS

We will use bounced HMIs as with the film example—very soft light, except we will have little direction to the keys and only a minimal feel of a window-lit day interior. Rims on the actors will help us establish some feel of the windows.

Technically, the central problem is the background windows. We could let them go totally white through overexposure, but if we need detail, we will have to gel them down using neutral density gels. Because we are using HMIs, we are working at a daylight balance. This means we will have to use bluish window gels along with the NDs if we prefer a cooler background. As much as possible, we will try to minimize the windows through our compositions. Depending on our budget, it might be possible to darken the windows and insert exteriors later in post.

For the dolly shot, we will try to let the actors go in and out of light realizing that this will be much less drastic than with film. On the student shoot, we are in trouble because we will never have enough lights for such a large scene. All we can do is turn on every light in the cafe and then use our 3-light kit(s) with tough frost as frontal keys/fill on the actors—a tough assignment.

A POSSIBLE OCCURRENCE: CHANGING TO A NIGHT EXTERIOR

Perhaps we shoot this cafe scene on film as per Chapter 10. If we have to shoot video, as is most likely, then we will have to scale back our ideas somewhat compared to the film approach. All the ideas we discussed in Chapter 10

can be tried and evaluated by monitor. One requirement was to light the street, which is visible through the windows. This is clearly impossible for the student production, but a few well-placed lights along with careful compositions might solve the problem. A heavy use of close-ups will help as well.

In the end, we will arrive at a look different from the film shoot in Chapter 10, but hopefully with enough variety and color effects to justify the term, "video look."

SUMMARY

Electronic cinematography liberates video from television standardizations and invites the infusion of film practices and attitudes. The key advantage of video is that it offers what cinematographers can only dream about: the ability to visually analyze the final image with a monitor at the shoot itself. Video assist on a film camera does not really tell you what the film response will be. The eye and the medium can thus collaborate in lighting and exposure without the necessity for a mechanical, metered interface. The system's limitations and possibilities are instantly visible. Used with care, the on-set monitor allows for a true painting with light and color. As well, high definition promises to allow for a more film-like approach to image look controls in video.

NOTES

1. The problem is that you still have to imagine how the image will look. Experience is necessary to evaluate the data from the waveform monitor. Mathias and Patterson do not recommend use of a visual monitor at the set because of potential inaccuracies and the danger that producers, directors, and actors will attempt to make lighting decisions based on the monitor's inaccurate visuals. See discussion in Harry Mathias and Richard Patterson, *Electronic Cinematography: Achieving Photographic Control over the Video Image* (Belmont, CA: Wadsworth, 1985), pp. 161, 180–82.

2. Why throw away this immense advantage? The answers are many for Mathias and Patterson, but mostly involve concerns in large production situations—too many cooks spoil the image, so to speak. By using method 2 and not having monitors on the set, the DP retains control over image look as in film, at least until the post-production sessions. On smaller shoots, and particularly in student situations, Mathias and Patterson's arguments have less force. It is more feasible to evaluate the look on the monitor while lighting rather than waiting for a later screening session.

3. For a discussion of how this might work, see, for example, Debra Kaufman, "Spike Lee's New Documentary Gets a Digital Finish," *American Cinematographer* (Sept. 2002): 14.

CONTROLS OVER COLOR AND IMAGE LOOK

Cries and Whispers marked another important step in my appreciation of how to use coloured light for dramatic effect. We developed a colour scheme for the interiors based on the colour red—every room was a different shade of red. Audiences watching the film might not realise this consciously—but they feel it. My experience has taught me that people are held spellbound by the mood created through proper utilisation and integration of light and design.

~ SVEN NYKVIST
Cinematography/Screencraft

Lighting for Color

Color is fundamental to film and video, yet is often treated as secondary. The reason is simple: The human eye is more sensitive to light and shadow than to color. Some cinematographers have mastered color in film and are able to use it in ways that resonate directly with the viewer's unconscious. Techniques are exemplified by a number of paradigm examples which should be studied on video.

THE CENTRAL QUESTION to be answered when shooting a color film is whether to foreground color. Answering in the affirmative, films like *Red, Blue, The Conformist, The Last Emperor, Raise the Red Lantern, Hannibal, Seven, Portrait of a Lady*, to name a few, illustrate the variety of uses for color on the screen. Eisenstein believed that color works like music and goes directly to the emotional level of the viewer. He argued, however, that the effect of a particular color was not automatic, that it was necessary to recreate the power of color within each film. You could not just show a color, say yellow, and assume a happy sunshine reaction in the viewer. You might get a reaction of depressed or jaundice-like illness instead, as there is no language of color. The power of the particular yellow and its context is what needs to be created within the film. With this in mind, we will investigate a number of techniques for utilizing and controlling color and then proceed to a discussion of some paradigmatic examples.

COLOR, LIGHT, AND THE EYE

A number of facts about how humans perceive color warrant emphasizing:

1. Humans are more sensitive to light and shadow—luminance differences—than to color. The human eye has approximately 125 million **rods** which respond to luminance differences and only 7 million **cones** that respond to color. Presumably luminance is more important for survival than color. The percentage is interesting: 90% of viewers are luminance (form, shape) dominant and only 10% color dominant.[1] Some viewers are relatively insensitive to color effects on the screen. In this sense, lighting conceptualized as luminance difference will be more powerful for most viewers than color.

 On the other hand, luminance difference is present in color film. A good cinematographer is able to create both simultaneously. Films like *Portrait of a Lady* or *Seven* use color effects throughout but simultaneously provide a wide range of luminance values in constant change mode. In other words, they would look pretty good in black and white as well. It is just that color effects might be appreciated by a smaller number of viewers than you might expect, and subtle uses of color might be lost to most altogether.

Not surprisingly, black and white film became standardized before color film. For years, up until the 1960s, reality on the screen was considered as black and white. Color was equated with fantasy, nonreality. With the conventionalization of color since the sixties, in particular color television, the opposite is now the case. Color is real; black and white is another world, abstract, poetic, fanciful, or historic. Think, for example, of the Coen Brothers' *The Man Who Wasn't There* and the strange nonreality of its images. On the other hand, some directors and cinematographers evoke times past through black and white—for example, *Schindler's List*. Like color, black and white must be retextualized from film to film and its evocative power recreated anew.

2. Color is the psychological reaction of the brain to a combination of certain wavelengths of light. The cones in our eyes can respond to only three hues: Red (nominally **700 nanometers**), Green (550 nanometers) and Blue (450 nanometers).[2] All other colors are constructed automatically by the brain from combinations of those three hues. It is no wonder we all do not see the same precise hue when a word, say blue, is invoked.

3. Film-stocks and color video are based on the same three primary hues our eyes respond to—red, green, and blue. All colors are constructed by our brains, and film and video systems form combinations of these wavelengths.

However, film and video lack a brain to understand context during color perception. For example, our hand always looks like our hand whether lit by the sun at noon, skylight in the shade of a tree, a candle, or a table lamp. In contrast, film emulsions render the hand as different colors depending on the color temperature of the light illuminating the hand.

The brain uses knowledge to render our hand the same color under a variety of lighting conditions. It assumes we are lit by a standard white light. When it cannot do this because of extreme conditions, it assumes the hand is lit by colored light. In other words, our brains ignore as much as possible the color temperature of the light, and film/video do not.

4. With colored light effects, such as bluish night lighting, our brains habitualize to the color and after a few minutes no longer react to it. This is a common experience. If you put on sunglasses with a tinted hue, you see the world as yellowed or blued; but after five minutes or so, the world looks natural again. You no longer perceive the yellow or blue tint. This means that in a film, you must not stay with a color effect too long, but must vary it from scene to scene somewhat in order to maintain its effects. To keep the viewer interested and responsive to our blue effects, you must interpose a standard scene or a warm scene. Cool requires warm; warm requires cool. Our brain requires variety.

This is not a book on color perception, but several books are mentioned in the endnotes as good sources for ideas and Gestalt psychology findings regarding color.[3] Knowledge of color and sensitivity to color are prerequisites for creating effective color effects.

LIGHTING TECHNIQUES

Color is better controlled through production design—sets, props, costumes and the like—than through lighting. Having said that, it is the lighting that brings the incipient color effect alive and provides its power. Obviously the two must work together. Another consideration is whether the color effect is for one scene or whether it dominates the entire film. In this sense, we will have scene-to-scene effects which themselves blend into a more overriding color style. We use words like dark, moody, airy, and upbeat to describe these overall style effects. A particular scene may be lit cool; the film as a whole may be lit "nightmare-ishly." The effects of color on the viewer are hard to put into words.

As we saw in Chapter 1, one major cinematographic choice is the quality of the light to use. The history of film lighting provides a vast interplay between hard light and soft light. Consider the progression from a grossly generalized list:

1. *Soft light* was created in the original studios by using white muslin stretched over a roofless room—diffused sunlight and skylight.

2. *Hard light* developed out of Billy Bitzer's work for Griffith and German expressionistic lighting in the 1920s as well as studio lights developed during the 1930s after the advent of sound.

3. *Hard light* became dominant in the films of the 1940s and 1950s, from *Citizen Kane* to the noir films—dramatic, painting with light and shadow.

4. *Soft light* with color, as in the work of Sven Nykvist, gradually overtook hard light, which had been used initially with color. Color negatives liked soft light.

5. *Soft and hard light* techniques—from softened hard light to dramatic soft light—are both used in contemporary films. *Portrait of a Lady* evidences these effects.

BASIC SOFT LIGHT TECHNIQUE This involves the principles we looked at in Chapter 1. Essentially you ensure that no direct hard light hits the subject and that natural falloff does not go too dark. In *Portrait of a Lady*, cinematographer Stuart Dryburgh lit several scenes in palaces where it was necessary to shine large lights through windows. This provided areas of soft light and large areas of darkness in the frame. Characters could then walk in and out of the basic effect. This is dramatic, but soft light has also been used to allow color to "speak" directly to us. In this case, an overall softness from above illuminates everything, more or less equally, allowing the colors to differentiate shot depth and mood. A comparison of *Cries and Whispers* and *Portrait of a Lady* reveals the differences in these two extremes. Of course, color video also likes soft light because of its inherently low contrast.

BASIC HARD LIGHT TECHNIQUE Again we looked at the main properties of hard light in Chapter 1. A film like *Seven* utilizes hard light and falloff to pools of darkness to establish its moods. The difference between hard and soft light is that hard light techniques have sharper edges which somehow allow the colors to collide more and coalesce into a visual dissonance, at least in *Seven* where the design department used "sickly" colors which, coupled with the "dark" lighting, created one version of hell. Another example would be in *Natural Born Killers* where Robert Richardson used overhead and over-exposed hard light along with a variety of color effects to suggest the psychotic nature of the main characters.

Another major choice in creating color effects is the choice of emulsion to use. Test after test is run in conjunction with the lab to work out gamma development and RGB printer light combinations to ensure a consistent control over the color effect desired. Luckily, cinematographers tend to be forthcoming with their techniques. Almost every issue of *American Cinematographer*, offers discussions with cinematographers on how they created certain effects for a given film. *Hannibal* and *Gladiator* are films with a variety of color effects within a more overall color key. *American Cinematographer* covered both extensively. Choice of film stock and lab controls for the negative are two major considerations.

To be effective, color must be used with some subtlety. That is why utilizing film/video's inability to adapt to color temperature is often manipulated for color effects. For example, with tungsten-balanced emulsions, we let light outside windows go bluish. What is subtle is that the "bluish" has a lot of variety depending on time of day, the ratio of sunlight to shade, how much over-exposure we are giving the window, and so forth. We cannot use gels with this degree of sophistication.

Subtle filtration and light gelling are sometimes possible, but heavy colored-gel lighting or color filter effects are not realistic and thus tend to stick out. For example, think of the Roger Corman and Hammer Studio horror films of the 1960s and 1970s. Today, such techniques are left to music videos and experimental styles for the most part.

Telecine provides a myriad of color controls. Prior to going to video, the negative can be adjusted and graded for a variety of color effects. Hopefully the cinematographer is there making, or at least influencing, the choices and not a producer or technician less visually sensitive—particularly regarding color. Color effects are also obtainable inside a computer editing workstation like Avid or Final Cut Pro. But these tend to be ideas to follow through on later in on-line or lab answer print stages. Wherever the final output is determined, the cinematographer needs to control the intended color effects.

Ⓟ ARADIGM EXAMPLES

Few books go into a detailed analysis of color effects common to feature films, but, ultimately, the central concern of the cinematographer is lighting style, including how color is used. The following examples are taken from films that are readily available at video stores. For convenience, their major effects on the narrative are given as categories. You may not agree with the break-down, but that is unimportant. To do them justice in printed words is not possible; that is why they must be viewed and studied for their lighting and color effects. After all, films like these are the only texts for cinematography.[4]

COLOR TO CREATE ENVIRONMENT In some films, color is used not for emotional effect, but rather to capture and create the mood of a particular place and time. *Lawrence of Arabia* is a film that uses a conventional Hollywood-style lighting to allow the colors of the desert and locations to come through directly to the viewer. A you-are-there feeling comes across strongly, setting the context and mood for the unfolding narrative.

COLOR FOR FUN The artificial colors of *The Wizard of Oz* are there to simulate the fantasy visit of Dorothy to Oz from the black and white world of Kansas. *Pleasantville* was even more overt with its use of color. It contrasted color with black and white in order to show the differences between nonconformists and society. But ultimately the color in these films is for fun, to stimulate happiness—just as it is used in countless other musicals and many animated films such as *The Lion King*.

COLOR FOR GOTHIC MYSTERY *Batman, Taxi Driver, Seven,* and *Delicatessen* submerge us in the grotesqueness and black humor aspects of color. Just as horror comic books come alive, these films explore color effects of the dark side.

COLOR FOR PASTICHE Color can counterpoint a film's narrative and reference earlier film genre conventions. *Far From Heaven, Blue Velvet, Babyface, Pleasantville, Natural Born Killers,* and others yield color effects not in sync with reality or the conventions of the movies. Think of the German expressionist painter colors used in the bordello scene in *Blue Velvet*—colors from Berlin of the 1920s—as Dean Stockwell lip-syncs a Roy Orbison song.

COLOR AS MEANING The sensuous pleasures and meanings of color are explored in films like *The Conformist, The Last Emperor, Ju Dou, Raise the Red Lantern, Blue, Portrait of a Lady, Red,* and *Cries and Whispers.* Color can be foregrounded with a serious intent, and these films show how that works.

COLOR AS THE REAL *Fat City, To Live* , and *The Vertical Rays of the Sun* establish their realities through the quiet colors of the day-by-day. *McCabe and Mrs. Miller* uses a highly-manipulated flashing technique to simulate the grim reality of a nineteenth-century mining camp.

COLOR FOR HOLLYWOOD *Magnificent Obsession, Terminator, Predator, Harry Potter* and almost any Academy Award winner reveal the sometimes real, sometimes unreal, colors accepted as "real" by the conventions of our society at any given moment.

SUMMARY

Color in film is a powerful meaning component of the image. Strengthened with lighting technique, the cinematographer can use color creatively to express any number of narrative themes. At the same time, the cinematographer can offer our visual senses strong stimuli—from the pleasing to the revolting. Color's hold over us is profound, at least if we are sensitive to its effects. Unlike lighting, with its emphasis on luminance difference, color is often more foregrounded, overt and less hidden in favor of the story line. In the next chapter, we will look further at controls the cinematographer can use for color—controls that are of a more technical nature.

NOTES

1. Jack Myers, *The Language of Visual Art: Perception as a Basis for Design* (Fort Worth: Holt, Rinehart and Winston, Inc. 1989), p. 304.

2. Ibid., p. 207.

3. Besides the Myers book, good explorations can be found in Sergei Eisenstein, *The Film Sense,* rev. ed., (New York: Harcourt Brace Jovanovich, 1969); Rudolph Arnheim, *Art and Visual Perception: A Psychology of the Creative Eye* (University of California Press, 1974); Johannes Itten, *The Art of Color* (New York: Reinhold Publishing Corp, 1961); and the many books by Faber Birren on color.

4. Color is seeing; images are seeing. You can analyze color effects with words but, ultimately, important things will not translate into words. For that reason, we have not described the text examples of color effects in great detail. Instead, we refer the reader to articles by cinematographers themselves, articles that describe and explain the intended effects. Even so, the reader must attempt to analyze videotapes of the films on her own. This work will pay off in better screen images. Analysis of color effects can be lectured with video examples, but it is very difficult to convey moods and other color effects in a book. In other words, we have left all the work for the reader to do.

 With all that in mind, here is a short list of articles about some of the films we have discussed briefly. The reader is strongly encouraged to read the article and then study the video version. These articles are all available in *American Cinematographer* where the reader may confront the cinematographer directly:

Schindler's List (Jan. 1994, p. 48), *Natural Born Killers* (Nov. 1994, p. 36), *Red* (June 1995, p. 68), *Evita* (Jan. 1997, p. 38), *Portrait of a Lady* (Jan. 1997, p. 50), *Saving Private Ryan* (Aug. 1998, p. 31; and Dec. 1998, p. 56), *Pleasantville* (Nov. 1998, p. 60), *The Wizard of Oz* (Dec. 1998, p. 100), *Blade Runner* (Mar. 1999, p. 158), *American Beauty* (Mar. 2000, p. 80 and June 2000, p. 75), *Gladiator* (May 2000, p. 35), *Moulin Rouge* (June 2001, p. 38), and *The Man Who Wasn't There* (Oct. 2001, p. 45).

American Cinematographer conducted a poll of its readers in March 1999. The question to answer was what were the 100 best-shot films of all time. Reader responses—and remember these are mostly readers from the profession—were tabulated and published in the same issue. See the March 1999 issue at page 100 for the starting point. A study of these films would give a thorough grounding in the art of cinematography, as would a study of all the Academy Award nominees and winners, along with the American Society of Cinematographers's own award nominees and winners.

IMAGE LOOK

Lab and Postproduction Controls

Film lab practices are used to create and control image looks. Testing must be done first to work out the exact effect intended and to ensure consistency. HD video allows for many controls at the postproduction phase. Film is equally versatile using data cines, recorders, and computers like Quantel IQ. A frame of film can be scanned, manipulated in a computer, and then recorded back onto a printing master for generating prints. Given today's high resolution data cines and recorders, the printing master can be film or HD video. Thus, the computer has minimized the postproduction differences between HD video and film.

FILM EMULSIONS—to know them is to love them. Without a basic knowledge and experience of the effects of light and color on the emulsion—indeed love for those interactions—the cinematographer is out of touch with his or her basic materials. Such a cinematographer would be hard-pressed to create image looks beyond the elementary. This applies not only to film negatives, but to print stocks and intermediates as well.

The film lab is where the image look comes together. Unfortunately, the cinematographer is not always there for postproduction controls. Perhaps this is not always crucial in film practice, because much of the look is built into the negative to start with, but with fast-developing computer postproduction practices, the absence of the DP means a loss of control over the final look of the production, whether for video or cinema release.

The traditional path for a film through the lab consists of five stages: (1) negative/workprint, (2) timing of the cut negative after editing, (3) interpositive, (4) internegative, and (5) release prints. Creative intervention is possible at any of the stages. In this chapter, we will first survey film lab techniques for enhancing image looks and then proceed to HD video possibilities. It must be emphasized, however, that these controls change only the basic color palette you are working with. You still have to merge lighting and creative exposure techniques with the original—be it video or film—in order to create interesting images.

FILM CONTROLS

A still photographer routinely uses lab procedures to create image looks, particularly in black and white. The photographer alters the development of the negative to control its gamma and how it will later print. The photographer prints the negative creatively—selecting from a number of printing papers and applying printing gamma controls through development. We might say that in black and white work, the still photographer uses lab procedures artistically. This is the ideal. For economic reasons, such controls are less common in color photography. Of course with the development of computer software, such as Photoshop, the economic factors are less important and even more "look" possibilities are opened up.

In cinematography, such postproduction controls would be cost prohibitive because the cinematographer has no personal lab to work with. As well, postproduction controls over image look are often in the hands of the producer, telecine colorist or lab timer. As mentioned, much of a film's look is built into the negative and choice of print stock, although it can be undone by careless neglect during postproduction. Hopefully, expensive computerized film systems may give the cinematographer more control over the image since their effects will be tested and norms worked out during preproduction.[1]

Generally, a lab effect will alter gamma and thus contrast. There will be effects on color renditions as well. These are both important considerations in creating image look and lighting styles. The techniques listed below have all been tried and written about in *American Cinematographer*. Keep in mind that it is possible to combine techniques for additional effects. For example, you could pull development, flash the negative, and apply one of the silver retention techniques to the interpositive. Needless to say, most of these lab controls are expensive.

FLASHING As discussed in Chapter 9, flashing varies negative or print stock gammas which in turn impacts on the contrast of the final image. This technique was popular during the early 1970s and may be used to control color as well as contrast. A classic example would be Vilmos Zsigmond's cinematography in *McCabe and Mrs. Miller*. Lab flashing affects the negative prior to development although it is also possible to flash an interpositive or print stock. On-camera flashing devices like Panaflasher or Varicon can be used on a shot-by-shot basis to desaturate color and control contrast, and are thus preferred over lab flashing.

EXPOSURE AND DEVELOPMENT Changes in exposure or development impact on gamma and color rendition. The combinations are myriad. You can overexpose and underdevelop the negative—pull development. You can underexpose and overdevelop the negative—push development. You can expose normally and then underdevelop or overdevelop the negative with subsequent correction in printing. You can underexpose or overexpose the negative and then give it normal development with subsequent correction in printing. You can expose and develop normally and then print the negative on different print

stocks, for example a low contrast stock. You can under- or overdevelop the print stock itself. You can cross-process reversals as though they were negs. At one time or another, all of these combinations have been tried. As a rough generalization, pull development will yield desaturated colors and contrast. Pushing development will give you more saturation and contrast.[2]

SHOOTING COLOR AND PRINTING BLACK AND WHITE For years, the Italians shot black and white films using color negatives. The reasoning was that the color negative allowed for better control over black and white since the R, G, and B printer lights had differing effects on the tonal renditions in the print. Another reason was that a producer could release the film in color if it ever became necessary, as it did with the advent of color television. The alternative is to colorize the black and white films. Of course, a black and white print from a color negative looks different from a black and white print from a black and white negative. Even so, it is safer to shoot a color negative—just in case. And, of course, in-computer manipulations are available.

Roger Deakins used the Italian technique on *The Man Who Wasn't There* (2001), for which he garnered a number of nominations and awards. Interestingly, the film was to be released in black and white as well as color video in some markets. Tests were run by printing both color and black and white negatives on black and white print stocks. In the end, the lab suggested printing on an extremely high contrast, black and white titling stock. After testing various gammas, Deakins printed on this stock and shot on Vision 320T. The result was an Academy Award nomination. To be emphasized here is the need to run tests to lock down the printer lights and gammas. In addition, color effects, like warm or cool scenes, print differently from one another on a black and white print stock. In *The Man Who Wasn't There*, various printer light combinations were used to even out these differences in the black and white version.[3]

BLEACH-BYPASS/SKIP BLEACH TECHNIQUES A popular technique used to desaturate and minimize color is to develop the color negative without bleaching it. Normally bleaching is used to remove silver after it is replaced by color dyes. If you skip the bleach, you leave the silver in the negative along with the color dyes. When you print, the silver acts as a barrier to some of the dye and the result is a markedly desaturated effect.[4] See, for example, *1984* shot by Roger Deakins where the technique was first used. See also Darius Kondji's cinematography on *Delicatessen*. You can accomplish a similar effect by printing the color negative along with a black and white dupe negative which also blocks out much of the color. You can use computers to generate like effects also.

SILVER RETENTION TECHNIQUES More subtle than bleach-bypass, these lab techniques retain silver in the final prints or intermediate printing masters. The advantage is they offer more measurable results and thus can be varied with precision for differing effects on color and contrast. **ENR** is Technicolor's process and is named with the initials of the Italian lab technician who

developed the technique for Vittorio Storaro's color style in *Reds*. Instead of skipping the bleach stage, ENR adds a black and white developer stage which results in various amounts of silver being retained. This development stage is variable and measurable and capable of a variety of effects. Films that have used the technique include *Saving Private Ryan*—Janusz Kaminiski, *Evita*—Darius Khondji, as well as Storaro's *The Last Emperor*. Deluxe film lab has two processes that allow for similar effects—**CCE** (Color Contrast Enhancement) and **ACE** (Adjustable Contrast Enhancement). More costly than bleach-bypass, these labs tend to specialize in A-level features.[5]

CROSS-PROCESSING REVERSALS Pushing for new looks led to the cross-processing of color reversals—development of reversals as though they were negatives. As one article puts it: Cross-processing is ". . . described by Kodak as a highly unstable misuse of their emulsion . . ."[6] The technique results in an increase in contrast and has saturating but deviant effects on colors—which is, of course, why we use it. For a good look at the process, view *Buffalo Springfield, U-Turn*, and the parts of *Three Kings* discussed in the cited article.

FILM TO COMPUTER TO PRINTING MASTER

If you can afford it—and people like George Lucas can—then you can go directly from film negative into a computer system, such as Quantel IQ, correct everything inside the computer, and then record a new master directly from the computer files. The master may be a film intermediate or a digital master on HD video, or both. No fuss, no muss. The originating medium is the limiting part of the system. All controls are possible over color, gamma, and image look. The only problem is the cost—several hundred dollars per frame currently. *Pleasantville* explored this alternative by shooting color negative, scanning and manipulating around 163,000 frames of negative, and then recording the frames back onto a color interpositive for generating prints. The film involved extensive use of black and white with parts of the frame in color.[7]

24p HIGH DEFINITION VIDEO

The 24p HD video system can handle many of these effects electronically. Some would argue that HD video is still not the same as film, that the effects are too overtly electronic, and that there are still significant differences between the two. If HD video is conceptualized as a new film emulsion, then we would want there to be differences, so the observation may not be important, assuming that HD video is as effective as film negatives in translating reality onto the screen.

If we originate on film, we use a high-end telecine to translate the negative to video. There is a comprehensive control over color rendition, gamma, saturation, and rendering the color original as black and white. But HD video demands more than a standard telecine which is limited by resolution and bandwidth relative to film. New transfer machines have improved resolution to 2000⁺ **pixels** per line in each of the three color layers with **14 bit scanning**. It is claimed that only then can you translate film to video with any degree of accuracy.[8]

Postproduction controls allow for gamma controls after the fact and provide for precise, subtle color effects. The interplay between film and HD video has opened up a number of new postproduction paths and promises to offer interesting look controls as well.

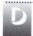 ## OES ANY OF THIS APPLY TO INDEPENDENT/STUDENT PRODUCTIONS?

Well, yes and no. If you use a lab in L.A. or N.Y., you should be able to try out skip bleach and cross-processing in 16mm at a reasonable cost. The same goes for other techniques like pull development, flashing, and printing black & white from color. But when it comes to computers like the Quantel IQ or working with high resolution data scanners, recorders or high definition video, you are probably out of luck, except most of us have access to systems like Final Cut Pro and Avid Express DV. These provide a lot of effects for experimenting. Of course, they are of standard quality, and, compared to high definition, are of marginal quality for going directly to film; nevertheless, they allow us to explore and learn about some of the image looks common to feature films.

SUMMARY

A cinematographer has a large repertoire of lab and electronic techniques for controlling and creating color and other image look effects. Testing and sensitivity to on-screen values are essential to maintaining these effects consistently throughout a film. In the final analysis, the cinematographer should be involved in final on-line and postproduction stages to ensure effects created are not lost inadvertently.

NOTES

1. See the discussion of how this might work in Debra Kaufman, "Spike Lee's New Documentary Gets a Digital Finish," *American Cinematographer* (Sept. 2002): 14.

2. *American Cinematographer* featured two articles that reported and illustrated the results for push and pull development for the Fuji and Kodak camera negatives available at the time. See the April and May 2000 issues.

3. Deakins discusses his experiences with this in Jay Holben, "The Roots of All Evil," *American Cinematographer* (Oct. 2001): 48–57.

4. Christopher Probst, "Soup du Jour," *American Cinematographer* (Nov. 1998): 82–93.

5. Ibid.

6. Jay Holbein, "Unusual Developments," *American Cinematographer* (Nov. 1998): 101–104. This article also will lead you to articles on *Clockers* and *U-Turn*.

7. Bob Fischer, "Black-and-White in Color," *American Cinematographer* (Nov. 1998): 60–67.

8. See the C-Reality machine at www.cintelinc.com. Also, see David E. Williams, "Firepower in Post," *American Cinematographer* (Feb. 2002): 50–51, which discusses Efilm Digital Lab's ColorStorm digital intermediate process which can exceed 2K scanning. "We can go to 3K, 4K, 6K—whatever is necessary."

LIGHTING ANALYSES OF SELECTED SHOTS

To analyze a lighting setup and determine the number and direction of lights, we have to be like Sherlock Holmes and work backward from the lighting evidence. We look for significant shadows so as to determine light angles. We look for significant highlights and reflections so as to determine the presence of fill light, eyelight, hair light, and so forth.

The following analyses from Chapters 1, 2, 4, and 6 show the technique one has to use to learn lighting from the screen. In many ways, this is the most important part of the book, since once the analytic ability is developed, the cinematographer may learn directly from film, video, and photographic examples. In the examples provided here, the lighting has been frozen with a still frame, which does not allow for an analysis of the film's lighting as it accommodates actor movement. Only analysis of a video clip can illustrate lighting's handling of movement.

Sometimes it is very difficult, even impossible, to figure out a lighting setup with certainty. Alternate explanations are equally possible. But that is all right. What we are interested in is an accurate observation of the visual data and the construction of a plausible hypothesis as to how the effect was created. It does not matter how the shot was "really lit"—that is often very difficult to know because light is such a complicated phenomenon. Besides, from the point of view of re-creation, it does not really matter which analysis is right, as long as it accounts for those visual elements you would need to duplicate if

asked to re-create the effect. Suggested exercises for practicing analysis and diagramming are provided at the end of Appendix B, "Suggested Exposure and Lighting Exercises."

It is the cinematographer's duty, if asked, to provide a reasonable imitation of a given lighting effect, even if it is done with a different lighting setup. Whether you use one light or three just doesn't matter. Of course, if actually asked to duplicate a specific effect by a director, you would put the actor in a similar set or location and observe the various effects created by different lighting arrangements as you work with the lights. You would observe your own lighting, previsualize the final on-screen results, and try to duplicate the desired effect. Awareness of the effect is what a lighting book can teach. The rest is up to the cinematographer and his or her creative awareness.

List of Shots Analyzed

CHAPTER 1					
Figures	1.1	1.3	1.5b		
CHAPTER 2					
Figures	2.6	2.16	2.18	2.19	2.20
	2.21	2.23			
CHAPTER 4					
Figures	4.12d				
CHAPTER 6					
Figures	6.1	6.4	6.5	6.8g	

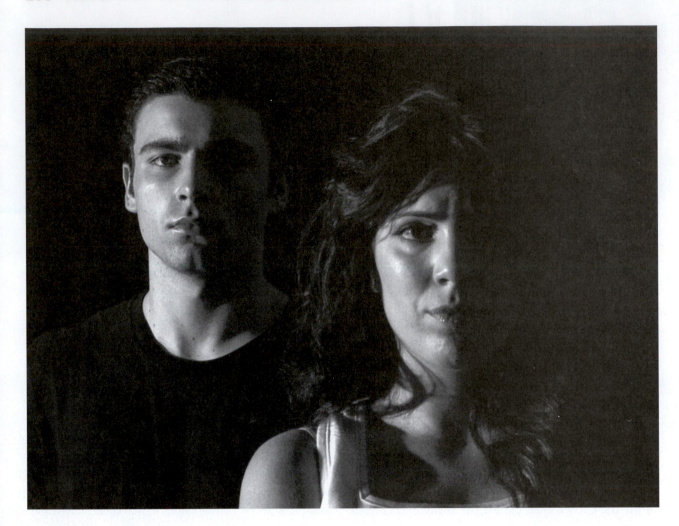

FIGURE 1.1a (page 4)

Side key.

Key Used for Lighting Diagrams

KEY	= Key light (hard light unless specified as soft)
FILL	= Fill light
R	= Rim light
B	= Back light
BG	= Background light
	= Camera
☆	= Subject

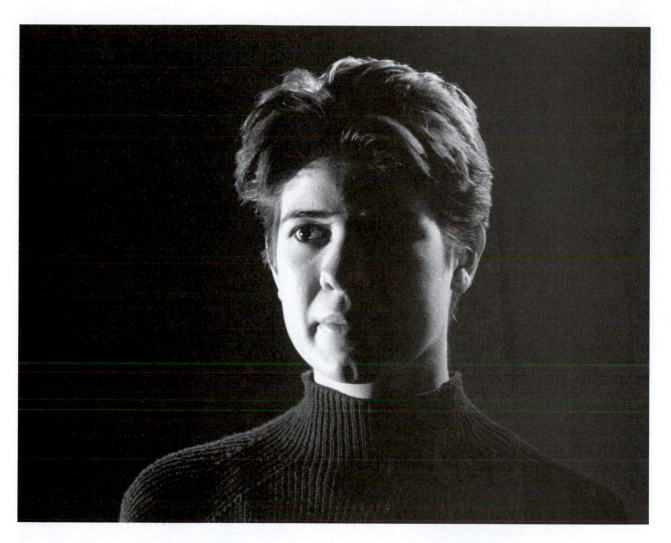

FIGURE 1.1b (page 4)

Here a modeling light has been added to the side key effect in Figure 1.1a. This supplemental light rims the person's hair and neck and is about one stop darker than the key light, which comes from the left side.

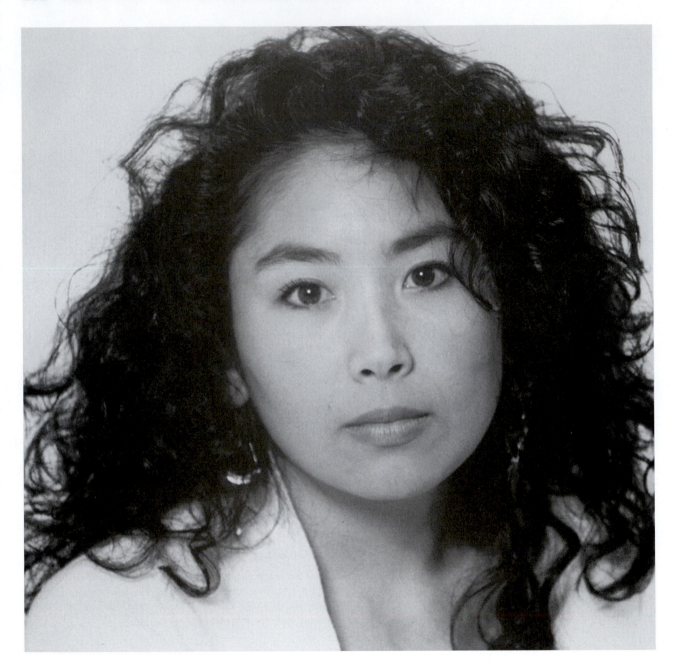

FIGURE 1.1c (page 4)

The white background in this shot gives it a high-key, bright feeling.

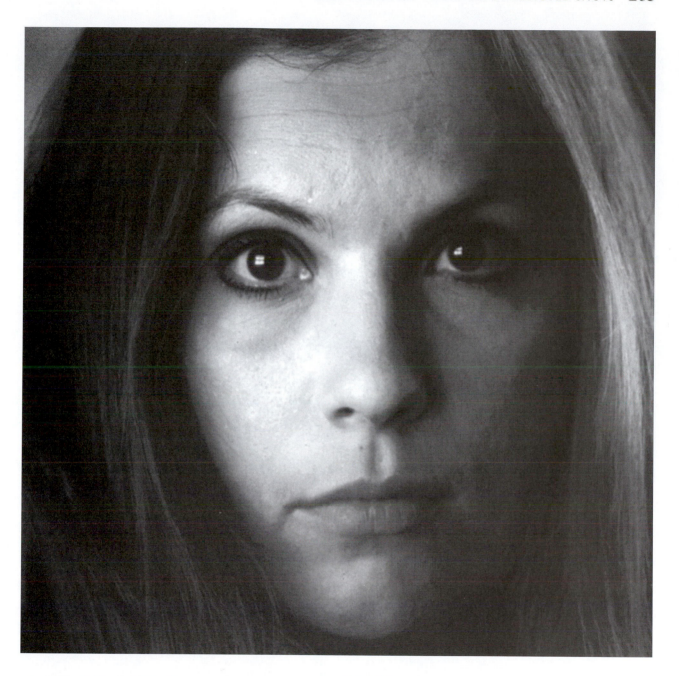

FIGURE 1.1d (page 4)

In this example, the key light is very soft, hence the gradual transition to the shadow areas. The rim light from the right side is also soft and has about the same intensity as the key. This rim light accents the hair. Note the large light source reflected in the eyes, indicating the key is large in size, such as from a softlight or a window. Compare how the darker background in this shot changes the mood from that of the example in Figure 1.1c.

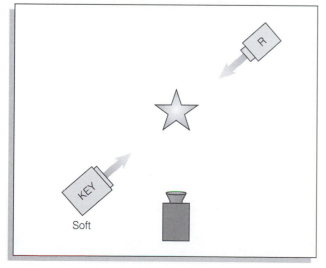

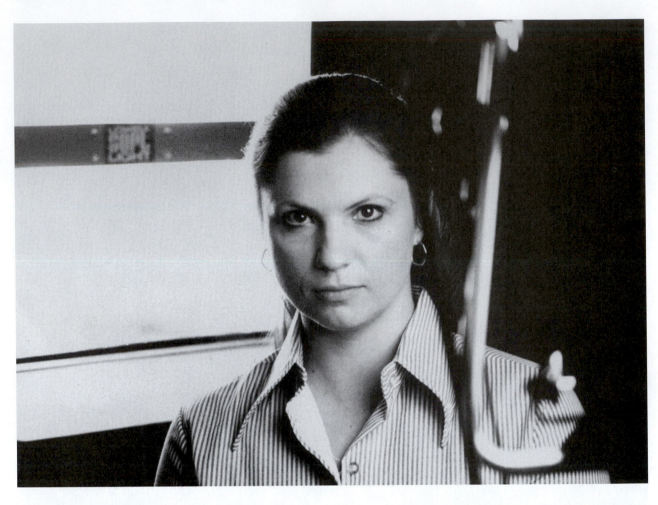

FIGURE 1.3a (page 6)

Both key and rim are Lowell softlights. They can be partially seen in the shot. The key comes from slightly off-center right. The back light is in the kicker position, across the circle from the key. Both lights are about the same intensity. Note how the kicker softlight is completely burned out, a luminous object problem.

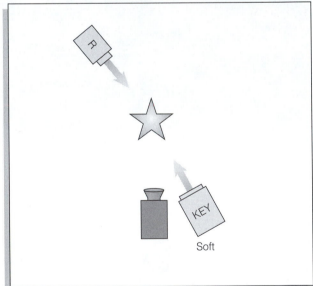

FIGURE 1.3b (page 6)

This is a more complicated setup than we have had so far. The first light we look for is the key on the face. We immediately notice the shadow-side triangle patch of light, which means the key is coming from the left three-quarter front position. We can tell the key light is fairly hard by noticing how sharply defined the facial shadows are on the subject. Light from the three-quarter front left cannot illuminate the hair on the right side of the model; therefore, we conclude there is a rim light from frame right creating these effects.

Both of these lights are confirmed by observing their effects on the mannequin as well as the Styrofoam cup. Note that both of these objects are more easily analyzed by viewing their reflections in the piano top. The key light has caused a hot spot reflection on the mannequin as has the rim light from frame right. The light coming from frame right is far enough behind the subject so as not to light her face, only her hair. Its presence is particularly evident on the neck and shoulder of the mannequin.

The Styrofoam cup is lit from the left and right in approximately equal intensities—note the shadow line on the front of the cup; therefore, we may conclude the key and rim lights are roughly of similar intensity. The shadows on the face are black, which indicates there is no fill light being used.

FIGURE 1.3c (page 6)

Note how the hair is used to create interesting facial shadows in this hard light example. The strong side key from the left is four or five stops overexposed. But even so, the shadow side of the face is left black since there is no fill light. The side key also emphasizes the texture on the hair.

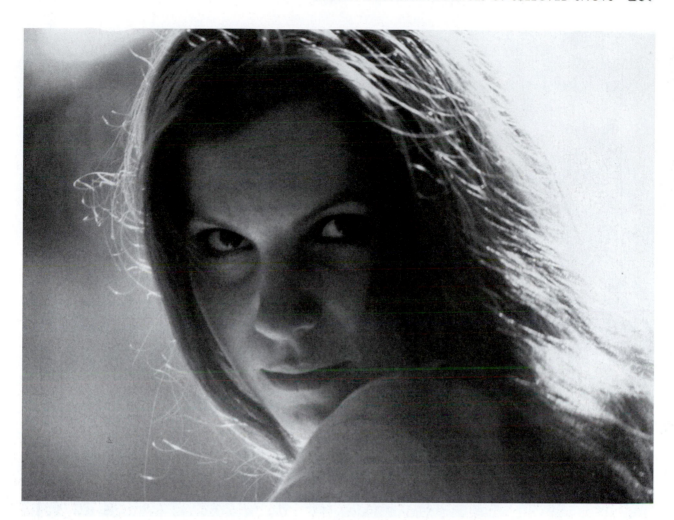

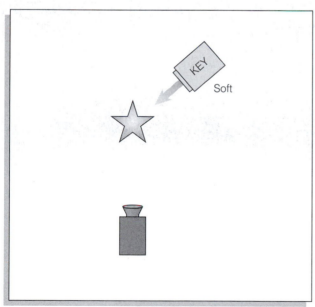

FIGURE 1.3d (page 6)

The soft light in this example contrasts with the hard light in Figure 1.3c. The key light comes from the back right direction and does not strike the face. Presumably it is diffused sunlight, like on a light gray day. We can see the front of the subject because of the light bounced off her white blouse. Note how the chin is hotter than the rest of the face and that the reflection of the blouse is visible in the bottom of the subject's eyes. No evidence exists for arguing there is any additional fill.

The background is out of focus and is presumably lit by ambient light like the face. Probably this is an available light shot. Note how the cinematographer uses grays to convey mood in comparison to the blacks and whites in Figure 1.3c.

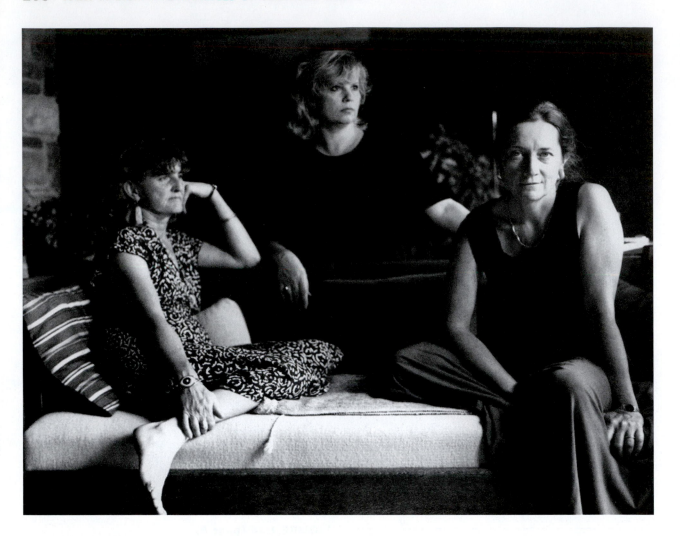

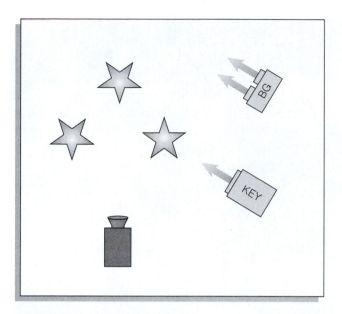

FIGURE 1.5b (page 9)

This shot conveys the feeling of a window frame right. The directionality of the light establishes the effect. The shadows are fairly soft. In fact, this shot was lit with two open-face quartz lights diffused with Tough Frost. One light was used for the women, from a three-quarter front right position. The other was placed on the background from the same angle. It was of lesser intensity and serves only to bring up the table and plants frame right and the picture on the back wall. No fill light was used as light scattered about the couch area was sufficient to lighten shadow areas.

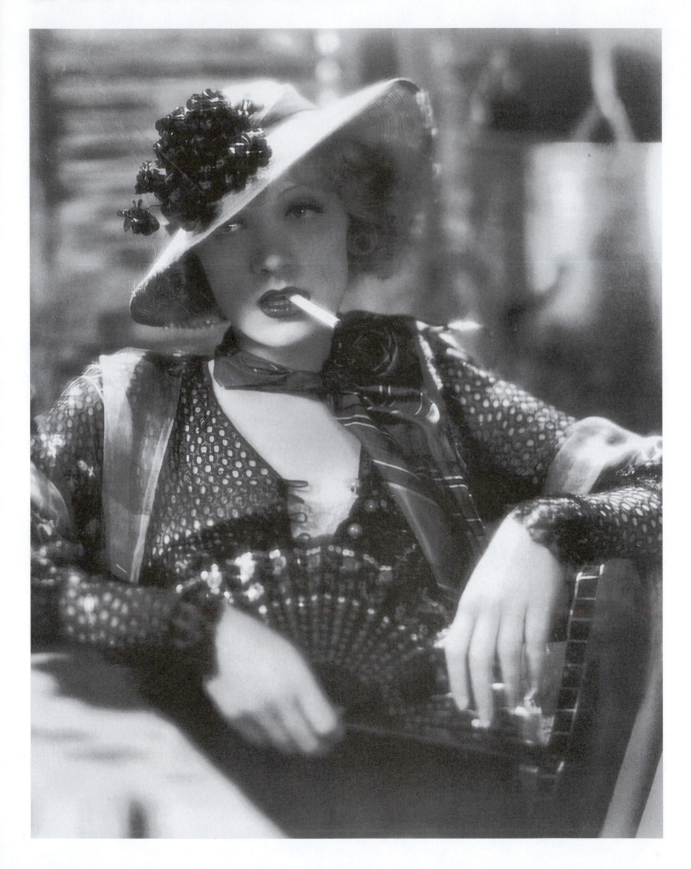

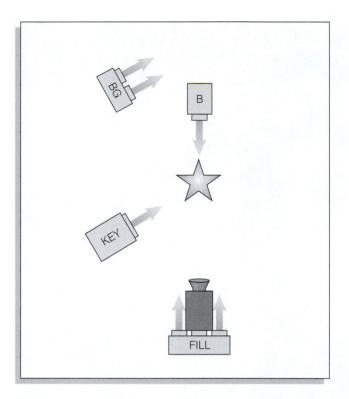

FIGURE 1.7 (PAGE 11)

(*Blond Venus,* © 1932 Paramount Publix Corporation. Courtesy of Universal Studios Licensing LLLP) This shot is relatively complicated and probably a publicity still. A back light from the top highlights the hat, shoulder frame left, and arm frame right. There is a fill light since we see the reflection in the subject's eyes. Sounds simple, but duplicating the lighting in this shot is a difficult task.

The question is how to best account for these effects. One possibility is that there is an overhead key coming from above the frame left that illuminates her hat, chin, cigarette, shoulders and blouse area. A fill light lightens the facial shadows. The best argument for this two-light setup is the small blouse-eyelet shadows on her chest and the shadow her upper lip projects onto the cigarette.

However, it could be the fill light is actually a frontal key used with a partial lighting technique (patches of light and shadow) so that it accents her chin, the cigarette, the tip of her nose, and her blouse area while filling in the rest of her face and body. An effect such as this can created by using a translucent "cookie" or even Tough Frost with holes patterned on it. In this case the highlights on the hat, shoulder frame left and arm frame right would result from a separate overhead back light. I prefer the former explanation, but it is very difficult to tell.

One interesting thing, there are two differently shaped reflections in her eyes. One is simple circle shape, the other looks like a bank of footlights in a theater. The brightness of the latter gives quite a spark of life to the face. These lights indicate that a separate eyelight might have been used for one of the eyes or that the angle of eyes caused an uneven reflection pattern.

The background light is set about a stop darker than the key area so that it does not distract from the star. There is so much diffusion that the shadows are softened to almost nonexistence as are her frame-left hand and lower body. Probably vaseline on glass was used to create the diffusion effect. On analysis, the lighting setup is very complicated. After all, the film, *Blonde Venus,* was directed by Josef von Sternberg, famous for his lighting of Marlene Dietrich.

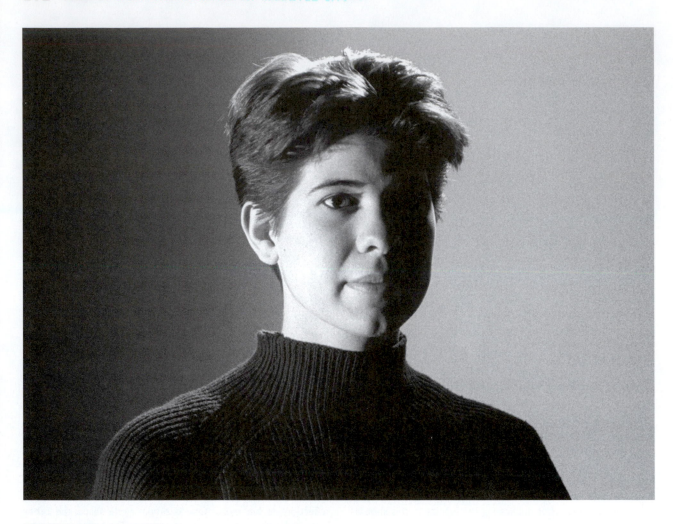

FIGURE 2.6a (page 22)

Note how the key from the left illuminates part of the background and falls off gradually to frame left. There is no fill light; thus the facial shadow is very black, about a 32:1 ratio. The hair light is about a stop brighter than the key and accents the shoulder frame left and the subject's cheek frame right besides providing a strong emphasis for the hair.

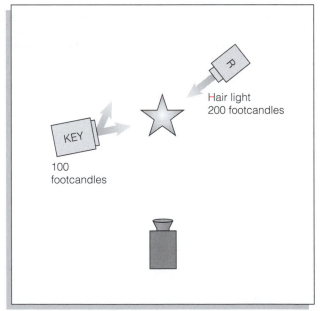

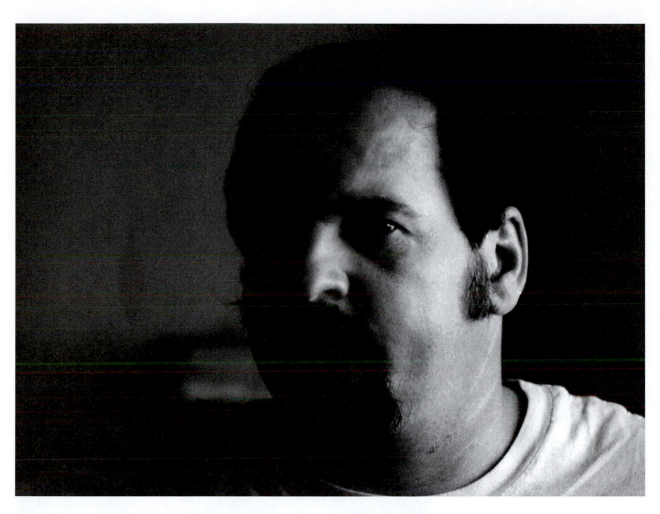

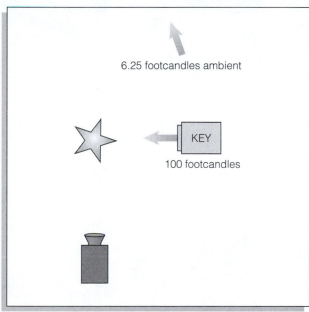

6.25 footcandles ambient

KEY

100 footcandles

FIGURE 2.6b (page 22)

This shot employs an available light side key effect. There is no fill; hence the shadow side eye is lost in darkness. Available light on the wall behind the subject is about 6.25 footcandles, four stops underexposed compared *to* the key on the face. This amounts to a four stop subject/background ratio.

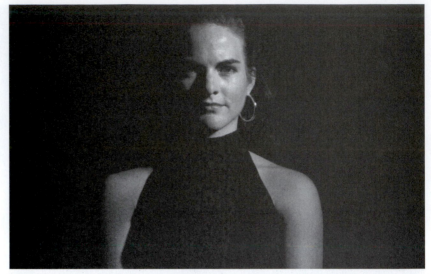

(a)

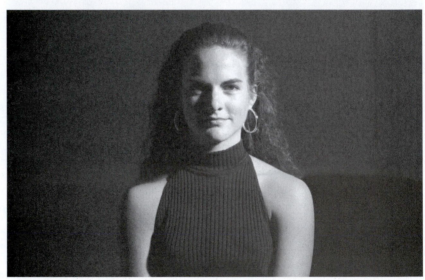

(b)

(c)

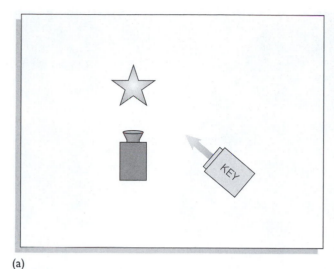

(a)

FIGURE 2.16 (page 31)

Classic, Rembrandt lighting effect with three-quarter front key only (a), the addition of a slight fill at about an 8:1 lighting ratio (b), and the addition of the kicker in (c). The kicker comes from across the imaginary circle from the key, provides a rim effect on the hair and shoulder, and is set to about the same intensity as the key. The slight amount of background light in (b) and (c) comes from the fill itself. In reality the wall was white.

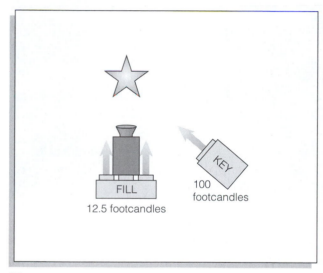

(b)

(c)

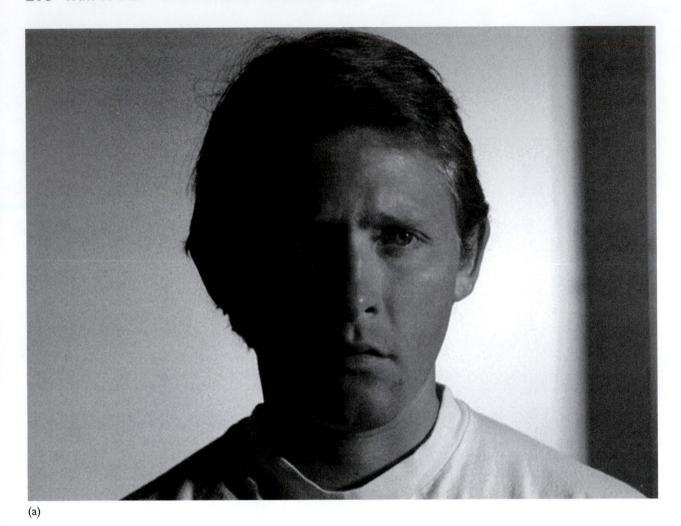

(a)

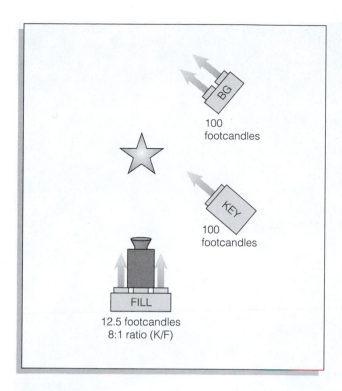

FIGURE 2.18 (page 33)

(a) Three-quarter front key, 8:1 facial ratio; (b) three-quarter front key, 2:1 facial ratio; (c) three-quarter front key, 6:1 facial ratio. The point of these three shots is to show how the background lighting can be controlled so as to render the background white (a), midgray (b), and black (c). In fact, the wall was white. This means the wall was lit to approximately the same level as the key light in (a) so that it rendered as its true white zone 9 value. In (b) the zone 9 value was reduced by four stops to a zone 5 level, and in (c) by eight stops to a zone 1 value. The lighting diagrams indicate how this is done.

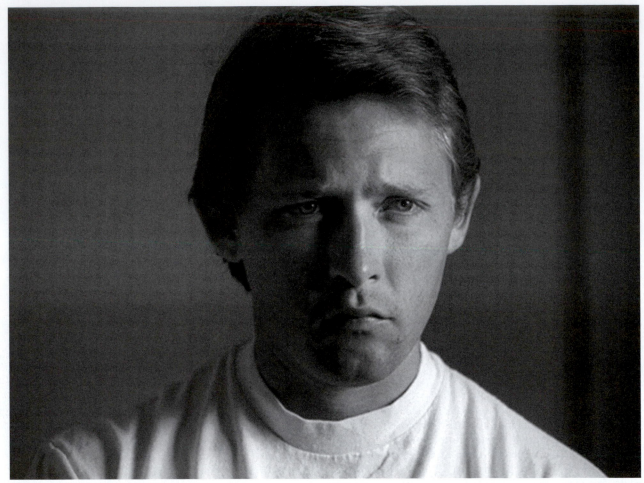

(b)

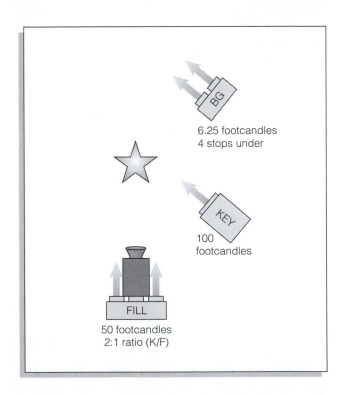

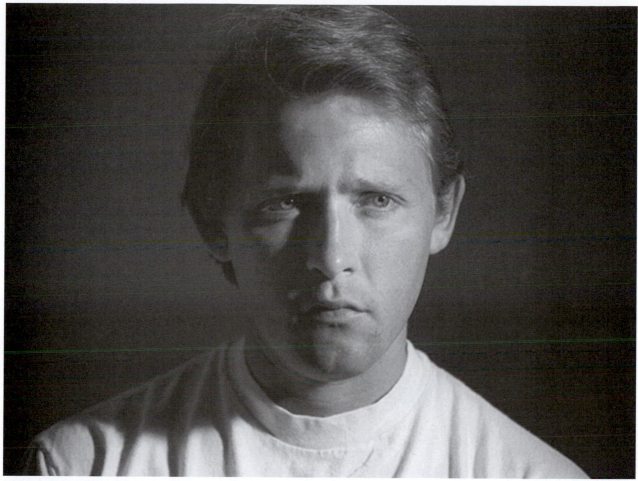

(c)

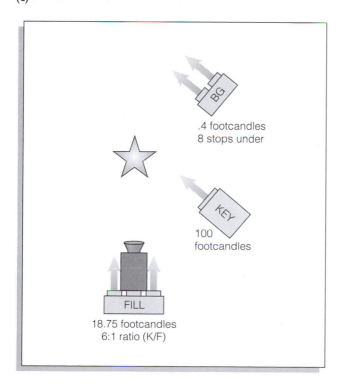

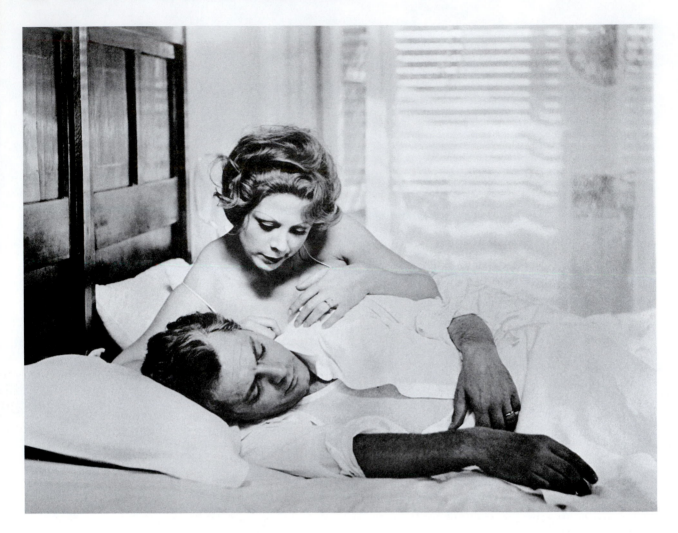

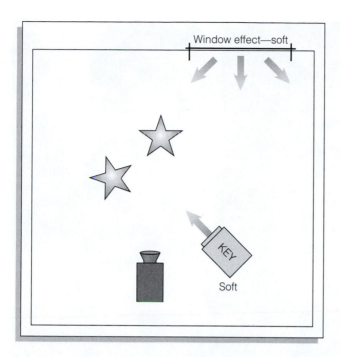

FIGURE 2.19 (page 33)

(*8½*, Corinth Films, Inc, 1963) This shot uses a high-key background, a window effect with much gauze. There is a lot of softish window light pouring into the back half of the frame through the window and onto the bedstead area. Note how the venetian blind pattern is visible on both the curtains and bedstead. The feeling is bright, early morning. The level of realism is low in this photo since the actors are obviously not lit by the window, which functions more as an interesting background. If we assume the window was exposed at T 5.6, then they are lit to about T 5.6 as well. They stand out too brightly relative to the window for a natural light effect. This is more a star-style lighting treatment.

The woman has an overhead frontal key on her face. There is no attempt to simulate the window's directionality. The neck shadow indicates the direction of the key light. The man's key appears to be a softened version of hers—note the nose shadow on his face—and could be either a spilloff from hers or a separate light. His nose shadow is lighter than hers, which would normally indicate a separate fill light, but here there is so much white sheet to reflect light that the nose shadow may be lighter than her neck shadow only because it is closer to the sheet.

The key light effect comes from above, frame right, and has been shaded off along his foreground arm and the pillow area bottom frame right. It is fairly softish, particularly on him. She is given a harder, glossier look in comparison to the more natural light on him. This may result from her makeup as much as the lighting. The final result is a high key effect: It is all white sheets, white pillows, white curtains, and white shirts. The background is more for establishing time-of-day than realism.

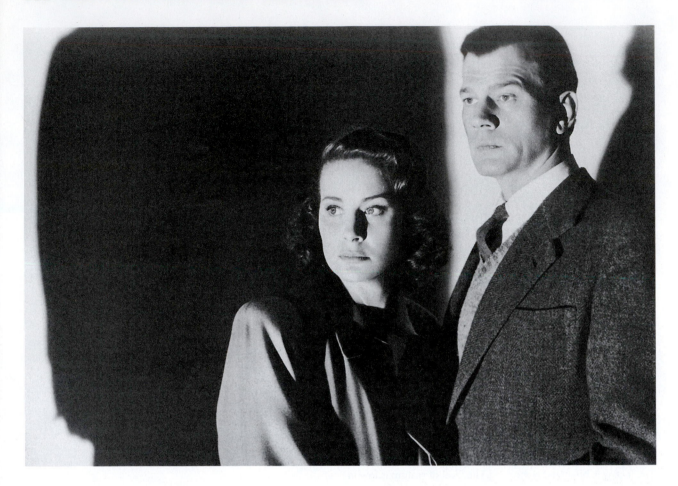

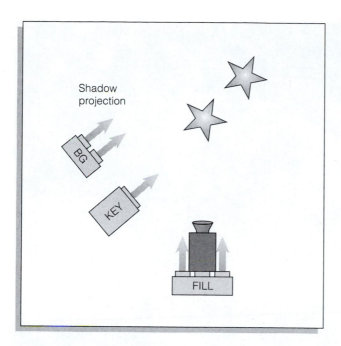

FIGURE 2.20 (page 34)

(*The Third Man*, Studio Canal Image, 1949) Another example of a subject/background effect. Here the door outside frame left has been opened, lighting the two actors and creating a pattern of black and white on the background. The key light comes from a frame left position and throws a shadow on the wall behind the actor frame right. The key comes from about a three-quarter front position and throws strong nose and coat shadows. The key is hard and comes from a camera-level position as evidenced by the nose shadows. The edge of the shadow between the black and white portions of the wall, presumably created by the door itself, has been carefully positioned so as to fall between the two actors. There is no evidence of fill light though the key provides an eyelight for both actors.

A standing figure appears to be in the doorway. Presumably, this is "Harry Lime, the Third Man." A shadow of a large man frame left is evidence of this. If this is so, then the lighting on the background may be more contrived than it appears since it would be necessary to project the figure and doorframe shadows precisely to maintain the compositional balance as visible in this shot. In this case, the background and key would come from different sources.

This shot is a good example of the use of black and white patterning on the background, to create not only mood but meaning as well—the implication is that she is "evil," or untrustworthy, in comparison to him. This results from her being placed against a black shadow and him against white. This patterning also creates visual variety and a strong nighttime effect in a world of intrigue and mystery.

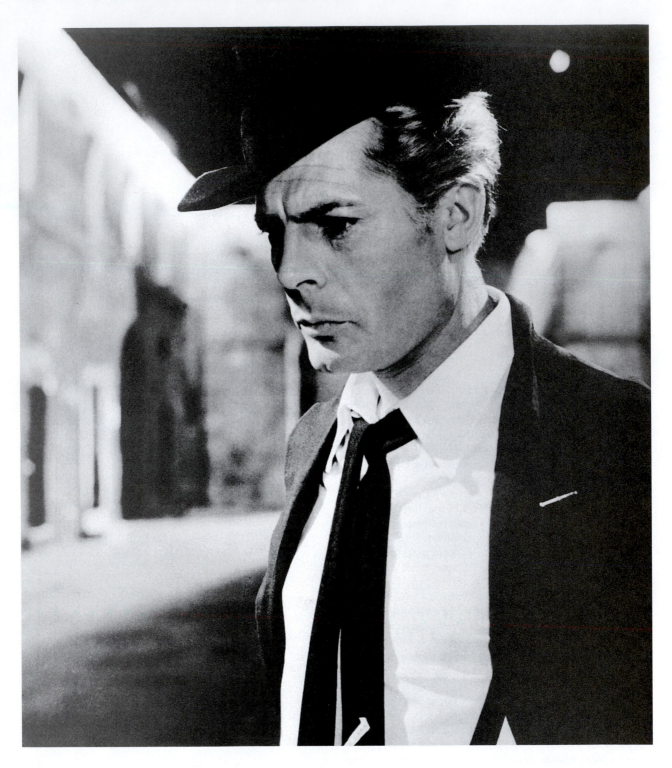

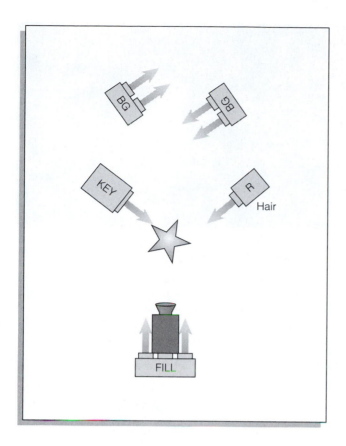

FIGURE 2.21 (page 34)

(*8½*, Corinth Films, Inc., 1963) This shot reveals how lighting can be used to create a balanced composition. The lighting on the actor is independent of the background lighting. The actor has a three-quarter rear key striking his hat, chin, and body from frame left. The fill is set to about a 4:1 ratio. A back light rims his shoulder, neck, and hair frame right. Exposure appears to be for the fill on the face.

The background lighting is arranged so that the buildings and part of the pavement frame left are highlighted. The top of the building frame left and the edge of the shadow frame left create two vectors that lead our eyes to the character's face. Note how the bright vector from the top of the building is continued by the key light on the actor's chin. The actor's bright white shirt is balanced against the dark pavement frame left. His face holds our attention because of the two graphic vectors and also because the blackness at the top of frame holds our eye "down" onto his face. Obviously, the first function of the background lighting is to establish the night exterior, but having accomplished that, the cinematographer may utilize background lighting for compositional purposes.

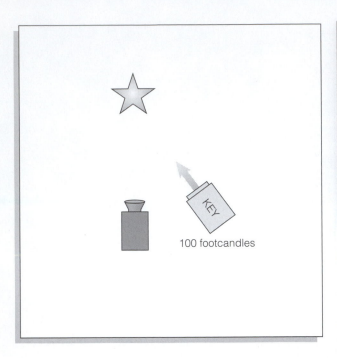

100 footcandles

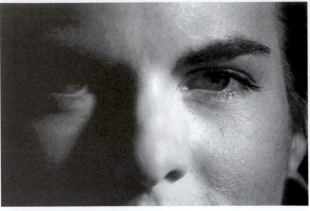

FIGURE 2.23a (page 36)

This view uses only a three-quarter front key from the right. The shadow-side eye is mostly out of the triangular patch of light. There is a certain deadness to the eyes, particularly on the shadow side.

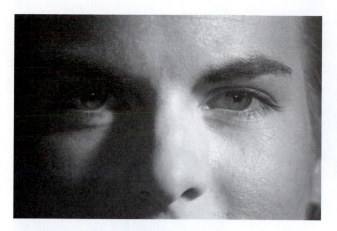

FIGURE 2.23b (page 36)

A fill light has been added to the setup in Figure 2.23a. The lighting ratio is at about 8:1. The fill light also reflects as a tiny dot from each eye. It thus functions as an eyelight, bringing life to the eyes of the subject. The effect is more visible in the reproduction on page 36.

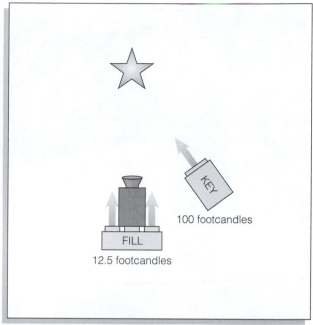

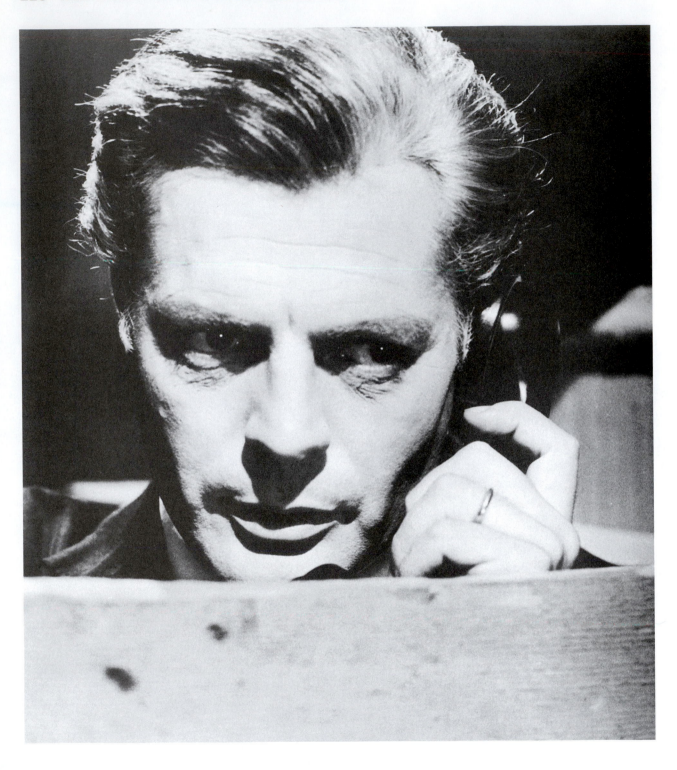

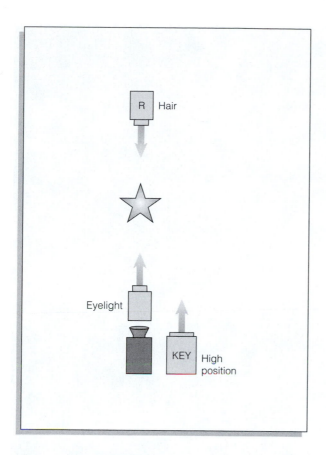

FIGURE 2.23c (page 37)

(8½, Corinth Films, Inc., 1963) This shot shows the same tiny eyelight reflection in the actor's eyes, which serves to bring them alive. Here there is a fairly hard, overhead frontal key. Note the blackness and hard edges of the nose shadow. There is a strong hair light from the back as well. A very weak fill functions mostly as an eyelight. It could be there is no fill, but that the cinematographer used a flashlight or other tiny light to create the eyelight reflections. In any event, the light was so weak in comparison to the key, it had little effect on the shadows; yet without that eyelight, the actor's eyes would have been pools of blackness.

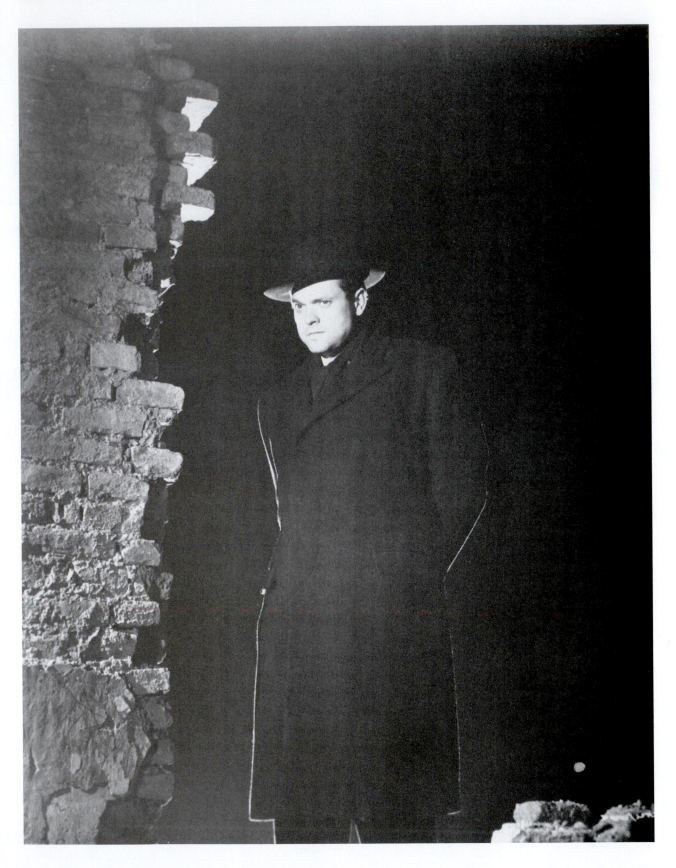

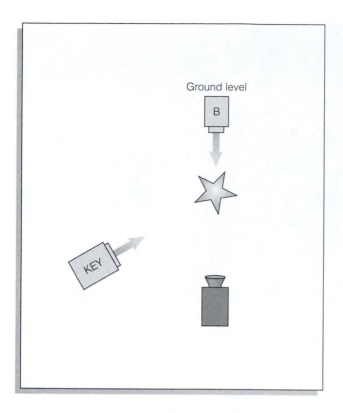

FIGURE 4.12d (page 63)

(*The Third Man*, Studio Canal Image, 1949) Night exteriors exhibit the same lighting principles as day exteriors, but cinematographers use a lot more light than you might imagine. In this shot, a frontal key rakes the brick wall and lights the actor's face. A back light from ground level behind the actor rims both sides of the body and the underside of his hat, accents the brick wall at top left frame, and puts some light on the ground at frame right, although this latter could come from a separate light unit or even the key. Nighttime exterior lighting allows for many painting-with-light possibilities. There may or may not be sources to motivate the setup.

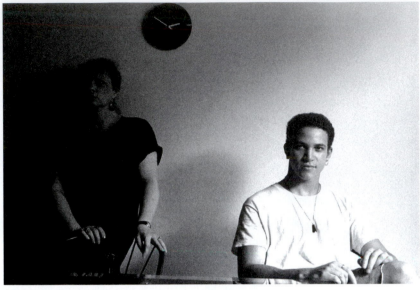

(a)

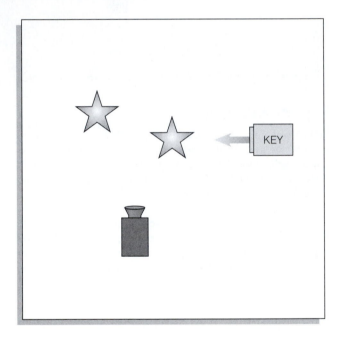

FIGURE 6.1 (page 80)

In this series of shots, a window effect was created by placing a softlight outside the house and shining it back through the glass door onto the actors. Available light was also coming into the room, but the artificial light was necessary to obtain a T 2 on the subject at frame left. The softlight was arranged so that it had an interesting falloff on the back wall with about a two-stop difference in intensity between the two actors. In (a), exposure was for the man foreground right and the woman was about two stops heavy. In (d), exposure was for the woman, which left the man about two stops overexposed. (b) and (c) represent compromise exposures. The main point here is that you cannot really tell how the shot was lit, whether natural or artificial light was used, or a mixture of both, as in this case.

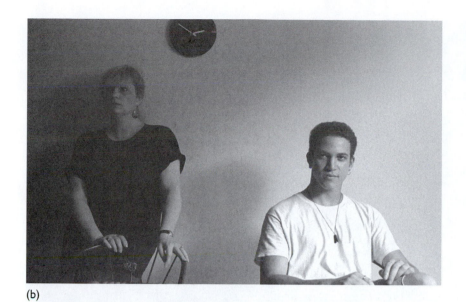

(b)

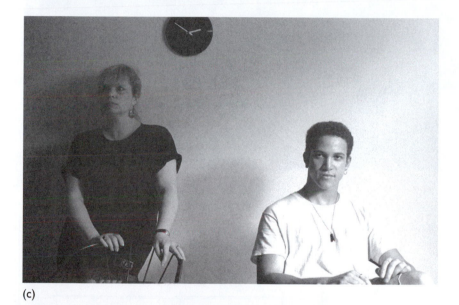

(c)

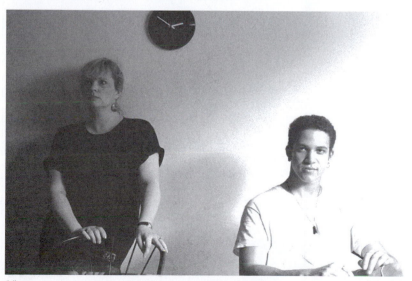

(d)

(a)

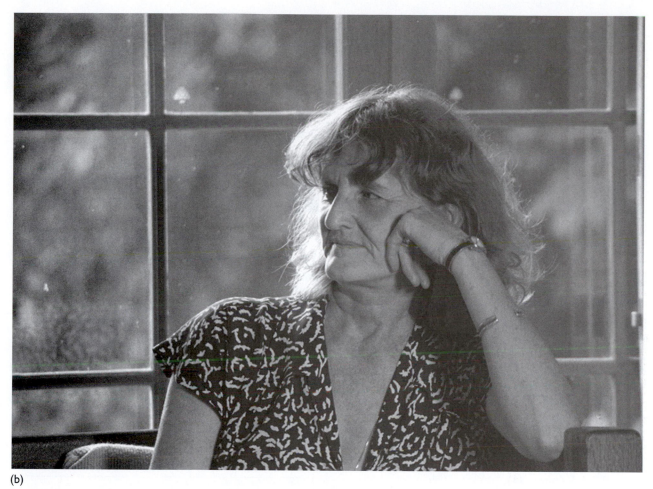

(b)

FIGURE 6.4 (page 84)

For this window effect, the exposure was based on the level obtained by filling in the subjects with frontal key light and exposing for their faces. This key is a little too overt as it creates a glistening reflection on the small wall area between the two actors in the long shot (a). As well, the shot should have been underexposed a stop or two to create a more realistic, semisilhouette effect. As is, it is overlit and, hence, not realistic. Inside levels were around T 2.8. The outside was at T 32 in the sunlit areas and about T 5.6 in the tree shadow areas. Outside the window was overexposed about seven stops for the left side window and about two stops for the frame right window with tree shadows.

For both long shot (a) and close-up (b), a rim light was placed on both actors from outside each window. These rims were overexposed about three stops and are very important in creating the feeling of light outside the window, particularly in the close-up (b). Note how effective the reflections on the leather chair foreground left and the floor bottom right are in creating the feeling of a daylight interior/exterior. These reflections result naturally from available light (skylight) coming through the window and are strong visually because they are overexposed.

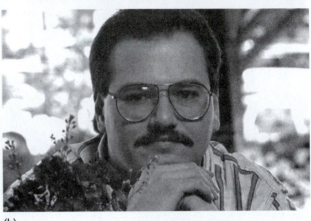

(a)

(b)

FIGURE 6.5 (page 86)

A soft fill light was added to the two subjects sitting in the window to bring them up to about T 4. The outside level was around T 22, a difference of five stops. A series of exposures were given, from exposure for the face (a) to exposure for the outside (f). Each shot in the series represents about a one-stop difference in exposure. Note that the black facetone reacts differently to underexposure (e) than does the white facetone. Consequently, it might be best to give the woman an extra stop worth of fill intensity if both faces are to be in the same shot (as in a long shot).

This series was shot to illustrate exposure possibilities. Were it necessary to preserve detail in both subject and background, the cinematographer would have two choices. The first would be to place window gels on the cafe windows to bring down the outside intensity. For example, a .9 neutral density gel would leave the outside two stops hotter than the inside fill level. This would be appropriate for a day interior/exterior effect such as here and would leave the background approximately as in (d) with facetones as in (a). The second choice would be to bump up the fill level inside to T 11. Again, this would leave the outside two stops overexposed assuming you expose for the faces.

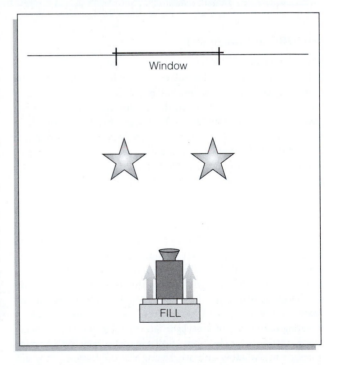

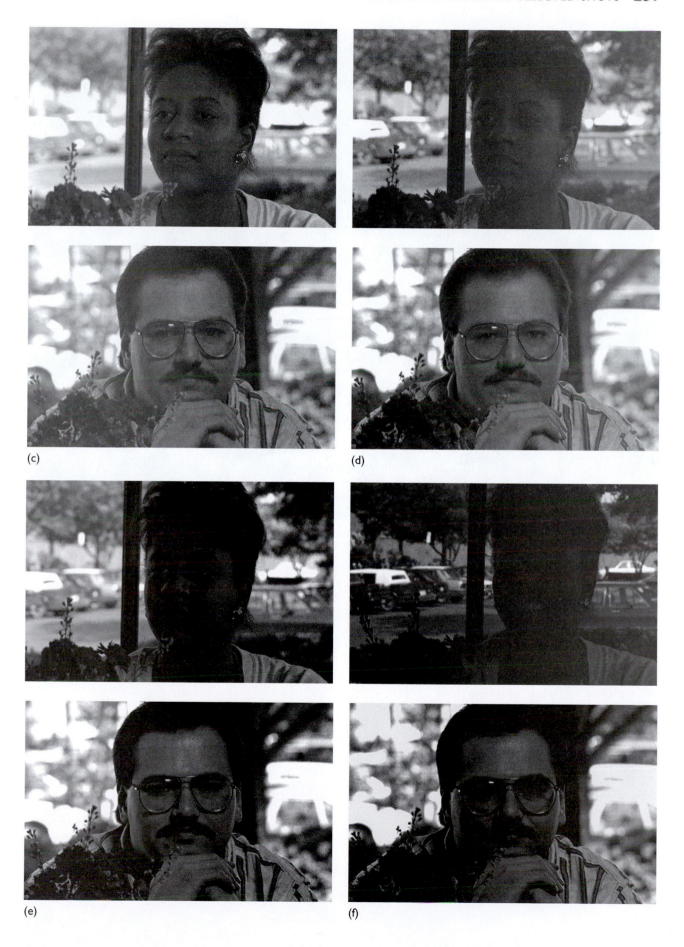

(c)

(d)

(e)

(f)

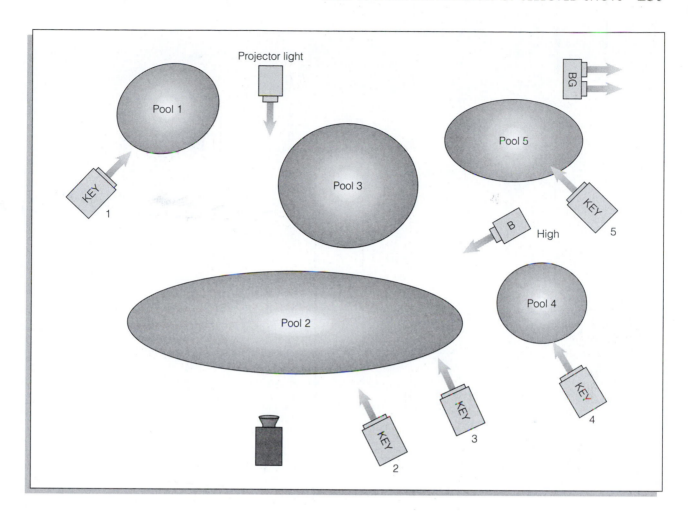

FIGURE 6.8g (page 91)

(*8½*, Corinth Films, Inc., 1963) In this night interior long shot, the cinematographer has selectively lit various parts of the theater. There are five principal pools of light. They are all at the same intensity except for the first row foreground, which is about a stop brighter than the rest. This is to suggest that because the front-row actors are closer to the (unseen) movie screen, they are brighter. Four of these keys come from frame right, but the one lighting the top left of frame comes from frame left. All five pools of light are unmotivated and thus subject to being noticed if we are not hooked by the plot at that particular moment. In fact, within the context of the film, this lighting setup works because shots from this angle are intercut with shots of the screened images.

A projector light effect emanates from the projection booth in the background. This is fairly easy to simulate with a 35mm xenon projector. Note the beam is highly overexposed relative to the actors, but this overexposure is held to a small total part of the frame and is accepted as realistic rather than aggravating. Smoke could have been used to enhance the back light effect even more. The aisle lights are just visible indicating they are of low intensity as luminous objects. Back light is visible on the hair of the five foreground actors and probably derives from the projector light effect itself, though it could easily be rigged separately from high above the top of frame. Another back light hits the seats and back of the actor foreground right. The shadows under the seats show this light comes from the rear and frame right, not from the projector effect. There is also a theater-aisle lighting effect in top frame right.

Three points are to be emphasized here. First, lighting a large area involves breaking it down into meaningful units and selectively lighting those smaller areas. Second, the overall lighting logic, source motivation, and so on are generally maintained, but not perfectly. Cheating and unmotivated effects are often necessary. And third, this lighting is so complicated, a director would have to shoot all the setups, at least the long shots, from this angle before shooting other angles, such as toward the screen. Lighting a setup of this size might take 6 to 8 hours. It would be very difficult as well as expensive to tear it down and redo it a day later.

Lighting and Grip Gear

THERE ARE a variety of books available that go into lightning and grip gear in great detail. Recommended are Verne Carlson's *Professional Lighting Cameraman's Handbook*, Kris Malkiewicz's *Film Lighting*, Gerald Millerson's *Lighting for Television and Film*, Michael Uva's *Basic Grip Book*, and the equipment catalogs of the various manufacturers that feature illustrations of virtually every item available.

BULBS AND LAMPS

Bulbs and lamps range in quality from hard (carbon arcs) to soft (frosted household bulbs). Intensities vary from 12K (12,000 watt), HMIs (halogen metal iodide) and 350 amp (DC) Titan arc lamps, to quartz bulbs less than 100 watts, and 25-watt household bulbs.

Filament Type Bulbs	Arc Type Lamps
Quartz (tungsten halogen)	AC types—gas discharge metal halides (HMIs)
PAR (parabolic aluminized reflector—sealed beams)	DC types—carbon arcs (Brutes)
Photofloods	
Tungsten filament bulbs Including household bulbs	

Though usually AC powered, the above may be DC powered as well.

QUARTZ FIXTURES

Quartz housings are designed for both hard and soft light effects. Hard light is obtained by focusing the beam with a Fresnel lens or by designing the housing to concentrate the beam as with an ellipsoidal spotlight. Softer effects are obtained by using an open-face housing or internal reflected design as with a soft light. The commonly used Fresnels allow for focusing or spreading the

beam by moving the bulb and reflector relative to the lens. The following charts the salient features of Fresneled quartz hard lights.

RESNELS

FEATURES:

- controls the shape of the beam, from wide to narrow
- controls how large an area is covered
- has a hard quality with sharp shadows, contrasty
- light intensity falls off slowly along beam
- edge of beam falls off quickly to shadow values
- the beam is made more narrow (more focused) by moving the bulb away from the lens and vice versa

Fresnels are used as key lights, as back lights to accentuate objects and actors, and to create distinct light and shadow patterns—to "paint" with a light.

Fresnel housings are designed over a wide range which increases in size and intensity. A typical series follows. Only a sampling of the many names given to these lamps is provided.

Inky Dink	20–250 watt
Midget	200–600 watt
Baby	1000 watt
Junior	2000 watt
Senior	5000 watt
Tener	10,000 watt

Removing the Fresnel lens converts the lamp into an open-face type which produces more lightning intensity but with a broader, less focused beam.

⬤PEN-FACED

Open-face units are not as controllable as Fresnels, though some, such as the Lowell DP, allow for beam-size change by movement of the bulb relative to the housing. The advantage of the open-face design is more light output relative to size. This makes the unit effective for filling in large areas with overall illumination and for bouncing light off foam core. Open-face units can be diffused to obtain a softer light quality. The more specialized designs, such as soft lights, are usually limited to specific applications such as a soft fill.

Open-face units have the following features:

- broad overall illumination, though parabolic housings narrow beam somewhat
- fall-off of beam obeys inverse square rule as compared to slower fall-off with Fresnels
- edge of beam falls off gradually to shadow values, thus half tones are more prominent than with Fresnels

Like Fresnels, open-face units come in a variety of types designed with a variety of names and purposes, from nooklights to soft lights. Here is a sample.

Typical Open Housing Types

Lowell DP	1000 watt
Mighty Mole	2000 watt
Broads and Scoops	500–2000 watt
Set and Nook	250–1000 watt
Soft lights	1000–8000 watt

THER LIGHT TYPES

Besides Fresnels and the variety of open-faced lights, cinematographers use sealed beam PAR type bulbs, fluorescents, photofloods, photographic enlarger bulbs, highly specialized lights such as LTMs fiber optic system (small HMIs connected to heads with optical fibers), homemade "coffin" soft lights, and practicals like candles, kerosene lamps, and firelight sources.

HMI/ARC TYPES

Large-scale lighting requires large HMIs or carbon arcs. These are generally powered by generators. HMIs are arc-type sources which are very efficient, about three times more efficient than quartz bulbs. Large HMIs are designed to replace arcs and Nine- and Twelve-Lights (FAY and PAR types). HMIs offer substantial advantages over arcs: less heat, no smoke when operating, no need for an operator to adjust carbons, and more efficient luminous output.

HMIs range from 10 and 12Ks to small units which compete with quartz lighting. The smaller HMIs—from 200 to 2500 watts—are available in both Fresnel or open-face (with safety glass) designs. HMIs require ballasts to eliminate flicker and strobing effects. Newer designs automatically remove flicker from the lights electronically and thus allow for shooting with a variety of shutter angles and camera speeds.

The "Brute" arc draws 225 amps at 215 volts DC and puts out the hardest (most like the sun) light beam. Brutes and other arcs and HMIs require glass, either a Fresnel lens or a Pyrex safety glass, to protect the crew and actors from their ultraviolet radiation.

Both HMIs and arcs require color correction to establish and maintain a consistent daylight balance as their operating color temperature varies from the standard 5500K and changes over time. The HMIs in particular vary greatly in their color temperature because the color temperature of each bulb varies with its age, about 1 degree Kelvin per hour of use. Some HMI systems record the amount of time a bulb is used and you can calculate an approximate color temperature from that information. The better practice is to use a three-color color temperature meter to measure actual color temperature and the amount of correction required.

LIGHTING UNIT SELECTION

Equipment selection is a reflection of lighting philosophy as well as budgetary restraints. The following charts the types of lights most frequently used in contemporary cinematography.

Feature/TV Commercial	Small Scale–Student and Independent
Day Exteriors:	
HMIs	Quartz with Tough Blue
Carbon arcs	Reflectors
FAY nine- or twelve-Lights	Sunguns (battery-powered quartz lights)
Quartz with Tough Blue	
Reflectors	
Night Exteriors:	
HMIs	Available light
Carbon arcs	Quartz
PAR lights	Anything that will illuminate
Neons and other signs	
Day/Night Interiors:	
HMI/Quartz of all types	Quartz
Soft lights	Soft lights
Bounced light	Bounced light
Available	Available
Photofloods	Photofloods
Household bulbs	Household bulbs
For Outside Window to Create Daylight Effect:	
Large HMIs	Available
Nine- or twelve-Lights	Quartz with Tough Blue
Arc	

RIP GEAR FOR LIGHTING

Lighting units have accessories that are designed to control or change a lamp's intensity, beam pattern, color, and light quality. These accessories also have other special applications. The following devices either mount on the lamp or are C-stand mounted between light source and subject. Most of these devices were developed in the studio era to make studio light controllable. Those shooting in natural light styles require less of these devices than those working in artificially lit situations. To mount these devices, gaffers need asbestos gloves, gaffer's tape (heat resistant), alligator clamps, black tinfoil and a host of tools to avoid cutting and burning their hands.

ACCESSORIES THAT MOUNT ON THE LIGHTING FIXTURE

BARNDOOR The familiar attachment with adjustable leaves (two or four) which allows for restricting the light beam's path. Fits onto the lamp housing's mounting device.

SCRIM Stainless wire net which mounts in the holder behind the barndoor and reduces light intensity. Available in single (half stop), double (one stop) and half single and half double (used to reduce the intensity of part of the beam). Scrims may be stacked for greater effect.

GEL HOLDER Frame for mounting gels and diffusion materials on lamps. Smaller productions often use clothespins to hold gels to the barndoor leaves.

SNOOT Cone-like metal device which mounts on lamp housing and converts the beam to a very narrow pattern.

PATTERN PROJECTION A snoot-like device designed to hold and project shadow patterns. Metal cutouts can be shaped to duplicate familiar shadows such as Venetian blinds, jail windows, tree branches, and the like.

FRENCH FLAG A flexarm that mounts on the light and positions a small black flag to help control the beam spread. French flags are also used on cameras to prevent lens flare from stray light.

SELF STANDING ACCESSORIES

FLAGS/CUTTERS Opaque fabrics stretched over rectangular-shaped frames. Designed to cut out light from selective areas of the shot. Usually mounted on C-stands.

CUCALORIS Opaque patterns placed in front of lights to throw shadow patterns into the shot, for example, to make it look like the light is coming through tree branches. Commercial "cookies" come in a variety of patterns. They may also be made of translucent cello plastic. The plastic yields a lighter shadow pattern as light passes through parts of the cookie. Cookies may also be homemade using posterboard or cardboard.

C-STANDS AND SANDBAGS C-stands (Century stands) are all-purpose stands designed to hold flags, cookies, gels, nets, scrims, and even lighting units. The C-stand utilizes grip and gobo heads with extension arms to allow for placement in a variety of positions. Sandbags are used to secure the C-stands.

NETS Nets are metal or cloth screens that come in a variety of meshes. Like scrims, they are used to cut light intensity. Nets come in a variety of framed sizes for a number of applications. Some nets are framed open ended so as to hide the scrim holder. Nets are also colored to assist in subtle reductions of intensity and color change.

DOTS AND FINGERS Small scrims or flags for selective use on small areas within the shot.

SILKS AND SCREENS These are diffusion materials for large areas. When large and secured by several stands, they are referred to as overheads,

although the overhead frame might also contain scrims, reflection materials, or opaque materials.

OVERHEADS Large frames for mounting silks and other materials. Typically 9' x 12' up to 30' x 30'.

BUTTERFLIES Small overheads, usually held by one stand.

WO BASIC ELECTRICAL CONSIDERATIONS

W = V × A

One of the first things a cinematographer does, or has the gaffer do, is work out power requirements and check the capacity and location of circuit breakers/fuses and outlets. Large loads require specific size cables, extension cables, switches, and so on (consult Malkiewicz, Ritsko and Carlson for details).

To calculate the size of generator needed or determine how many watts one can draw from a household circuit, use the formula: W = V x A (watts equal volts times amps—easily remembered as the "West VirginiA" rule). For example, a house circuit has a 20-amp circuit breaker. At 110 volts, we can draw 20 x 110—2200 watts maximum, two 1K Fresnels, for example, or one 2K soft light. A 250-amp generator could power 27,500 watts (250 x 110), one Brute arc or ten 2K soft lights plus seven 1K Fresnels. One handy device is a step-down box, which converts a 220 volt electric stove circuit into four 20 amp 110 volt circuits for quartz lights.

SAFETY

AC lights are deadly around water and humidity. DC power is safer. Most quartz lights can be powered AC or DC by changing the bulb. Feature films typically utilize DC/AC generators for their power. Independents typically utilize available circuits.

One important safety consideration concerns the use of tie-in boxes. A tie-in taps into the main power supply to a house or building, bypassing the building's mains and circuit boxes. Only qualified electricians should attempt this tie-in (see Ritsko, pp. 208–13, for details). Likewise, a proper grounding of all electrical connections is very important.

One other thing to be careful of, particularly on location, is to make sure that cables are taped down so that people will not trip and fall or pull lights over. A gaffing crew (even of one person) is very handy here.

SUMMARY

The size and budget of your production generally determine the type and quantity of lighting units you have access to. A feature must be prepared for all situations. The cinematographer must fit needs of actors into the scheduling as well as deal with a large variety of weather conditions. Rare is the direc-

tor who has the power to wait for a lighting condition to develop. If the sun goes in—fake it with a Brute! The result is obvious: trucks full of lights, gels, grip gear, ready for anything.

At the opposite end we find natural light and documentary approaches. Take your light as you find it. Carry as little gear as possible. Documentary crews often show up with a basic portable kit (say three 650-watt quartz lights with Tough Frost and maybe some foam core) and "go with the flow." On features, you control all light; on documentaries, you utilize all available light and supplement it as necessary. In between is where most of us operate.

Suggested Exposure and Lighting Exercises

THE FOLLOWING EXERCISES are designed to test many of the concepts discussed in this book. They may be performed individually or in groups. The exercises may be shot on film stock, videotape, or slide film. It is possible to obtain some of the Fuji and Eastman Kodak motion picture negative stocks in 35mm cartridges, which are processed, printed, and then mounted as slides

EXPOSURE EXERCISES

LIGHT METER EXERCISES

1. *Incident meters.* Shine a variety of keys on a face and full figure, practice exposing for back, rim, and three-quarter rear positionings. Try readings taken with the meter pointed at the camera, at the light source, and halfway in between. Take notes and study the relative effects of exposure technique on facetone and shadow area renditions. Shooting 24 of these will alleviate fears of how to take readings for backlit situations.

2. *Incident meters.* Go outside and take a series of slides with the sun positioned as frontal key, three-quarter front key, side key, three-quarter rear, and back key. Note the effect on color saturation as the sun moves from frontal to rear. As with exercise 1, a variety of exposure readings are possible for the three-quarter rear and back positionings.

3. *Spot meters and averaging reflected meters.* Take a high luminance range subject and measure the various luminances. Expose for each luminance, and see how the meter puts it at midgray on the characteristic curve. Notate the range of luminances, and expose for an 18% reflectance (use a gray card or an incident meter). Analyze the slides and the resulting luminance range placements. Intentionally underexpose and overexpose the subject, and analyze those effects.

ZONE SYSTEM EXERCISES

4. On the slides from exercise 3, correlate the notated luminance values in foot-lamberts with their resulting zone values.

5. Find a series of photographs, and label zone values. Do this for color as well as black and white.

6. Take a black object and through one-stop exposure increments place it on zones I through 9. Do the same for a white object and a midgray object.

7. Expose a face lit with a side or three-quarter front key and no fill. Expose for the light side, shadow side, and halfway in between. Compare the feel of the resulting images.

FILM STOCK TESTS

8. Set up a series of gray scales so as to create a very long luminance range (e.g., light three gray scales seven stops apart so that the middle chip on scale B is seven stops brighter than the one on scale A, and the middle chip on scale C is seven stops brighter than the one on B). Measure the actual luminances with a spot meter and notate them. Expose several film emulsions (expose for the middle scale "B"), and compare the resulting prints.

9. Take a number of color negatives, and shoot the same scene with each. The scene can be interior or exterior, night or day, or all of these. With each stock, overexpose I and 2 stops, underexpose I and 2 stops. Have the lab time these to the correct exposure so that you can see the effects of printing down and printing up on each negative as well as the differences between the individual film stocks and how they respond.

10. As in exercise 9, take a selection of negatives (e.g., an Eclair with eight different magazines loaded with a different stock), and film the exact same scenes. Pick a variety of scenes, from day exterior to night exteriors with a range of backlit and cross-lit situations. Compare the stocks. For this test it is best to film a gray scale and color chip chart at the head of each roll so the lab can time to that and provide a one-lite workprint for evaluation. These two series of tests will give a working knowledge of the look possibilities of each emulsion. Don't forget that Fuji and Kodak also have their own print stocks. Generally, labs will print on the brand of your choice. Print stock will also affect final image look.

EXPOSURE EXPERIMENTS

11. Perform the face/background test described in Figure 3.3. Use an incident meter and change the backgrounds; then repeat the series using a spot meter and averaging meter.

12. Using a spot meter, expose a variety of luminous objects with intentional under- and overexposure. Do the same with an averaging meter. Compare the results. Tackle a large variety of luminous objects: light bulbs, sunsets, water reflections, neon signs, stained-glass windows, and so on. (see Figure 6.8).

13. Overexpose a selected exterior and interior in one-stop increments (see exercise 8). Study the feel of these overexposed shots.

14. Find all-light and all-dark situations, shoot using a range of over- and under-exposures, and evaluate the results. Do the same for a panoramic longshot with haze or fog.

15. Perform the person-in-the-window series as described in the text (see Figure 6.5 and "Balancing Interior and Exterior Levels" in Chapter 8). Study the various exposure choices and their resulting look on the screen.

16. As in exercise 15, but experiment with the various color temperature choices (see "Indoor/Outdoor Color Temperature Balance" in Chapter 8).

17. Perform the person and lamp series as described in the text (see Figure 8.4 and accompanying text). Get comfortable with integrating and combining reflected and incident readings, by mixing luminous objects with incident lighting setups.

18. Perform the magic hour series as described in the text (see "Magic Hour" in Chapter 9 and Color Plates 5–9). Note the variety of color effects possible, from late, golden afternoon to night looks. Study the differences between shooting away from the setting sun and toward it. Take time to sit one night and observe the magic hour and the changing sky.

EXPOSURE FOR DIGITAL CINEMATOGRAPHY

19. Redo exercises 2, 8, and 15–18 as described above. Note how video differs from the film responses. (It would have been possible to use video at the same time as conducting the film tests.)

20. Perform the waveform monitor series of displays described in Figures 11.3 and 11.4.

21. Conduct pedestal (black gamma) tests in a variety of situations. Change the gamma and notate the results for reference.

22. Practice setting midgray at a variety of IRE positions on the wave-form monitor, and note the resulting differences in look.

23. Work out the exposure index equivalent for your video camera (see Chapter 11).

LIGHTING EXERCISES

Almost all the examples and photographs discussed in the book may be used for lighting exercises. These will supplement the more intense experience resulting from working on actual films.

24. Find examples of films on video that exhibit a variety of lighting styles. Analyze a scene or two from those films in detail. Lay out lighting plots, identify ratios, and so on.

25. As in exercise 24, but analyze a particular cinematographer's style throughout a series of films (e.g., Sven Nykvist's work in the Bergman films or Conrad Hall's work in the 1970s).

26. As in exercise 24, but analyze the entire film's use of lighting ratios, luminance range, and so on. Make a scene outline of the film and try to account for the variety of lighting setups in terms of the script/film's meaning.

27. Take a number of short poetic phrases (Haiku, imagist poems, lines from rock songs) and translate those words into visual images. The goal is to create images that convey moods similar to the words.

28. Take a scene from a feature and recreate that lighting setup and look paying attention to the composition, lighting, and colors. You can do this with film or video or even slides. This is a very difficult exercise, particularly if you are incorporating movement and filming it.

29. Shoot slides of night exteriors with available light. Add to those street scenes an actor whom you light (see Color Plates 13 and 16) .

30. Take an actor in a night interior and experiment lighting him or her with a variety of sources: flashlights, kerosene lanterns, car headlights, candles, and so on. Become aware of the lighting and color effects possible with such sources.

31. As exercise 30, but strive to change and experiment with light quality (e.g., use diffusion, bounce, silks, Fresnels, etc.). Become aware of the range of light-quality possibilities and the resulting differences in feel on the screen (see Chapter 1).

32. Practice with the various keys from a variety of angles (see Figures 2.1–2.10).

33. As in exercise 32, but add a variety of fill lights at the various ratios (see Figures 2.11–2.13 and 3.1–3.2).

34. Practice with the various rim and back light positionings (Figures 2.14–2.15).

35. Photograph a mathematical series of facial ratios—2:1, 4:1, 8:1, 16:1, and 32:1—on a variety of different facetones. Compare the results (see Figures 3.1–3.2).

36. Create silhouettes and semisilhouettes (see Figures 3.3 and 7.2).

37. Practice with interior/exterior color temperature effects as in Chapter 8, "Warm and Cool Color Effects."

Here are several more advanced examples (Exercises 38–41).

38. Choose an interior location that gets no natural light, or build a set in a studio. Light this location for early morning, afternoon, and night. Pay careful attention to lighting angle, shadows, and color. Then light the same scene for a very unrealistic, highly stylized look.

39. Choose a large interior location. Block out areas of actor movement as in Chapter 10, and light for these various areas.

40. Shoot a night interior with all lighting provided by natural sources (e.g., a fireplace, table lamp, or television). Hold these intensity levels to around 5–10 foot-candles, and push the film to obtain sufficient exposure.

41. Supplement the sources in exercise 40 with artificial light to raise the exposure level by two stops. Maintain the natural quality, direction, and color of the luminous sources.

LIGHTING FOR DIGITAL CINEMATOGRAPHY

All the preceding lighting exercises may, of course, be conducted on video as well as on film.

42. White-balance the camera to various colors, and note the different, subtle color effects possible (see Chapter 12, "Color Temperature Effects").

43. Conduct the luminous object experiments described in Figures 6.8, 8.3, 8.4 and accompanying text.

44. Take your video camera and actors outdoors, and shoot in bright sunshine. Videotape the same location during late afternoon and magic hour. Compare the differences in color. In Part VI, we analyzed in detail a number of lighting setups. There are a number of other examples in the book that would prove valuable to analyze.

45. *Day interior/exterior window effects.* Analyze and diagram the window lighting effects in Figure 8.2. Compare your analyses with the one for Figure 2.19 in Part VI. Then reshoot one of these examples on film or video.

46. *Luminous object simulation.* Analyze and diagram the luminous object effects in Figure 8.4a and b (light bulbs). Reshoot these examples both by using the actual light source to illuminate the actor(s) and by simulating the effects of the practical with an out-of-frame light unit.

47. *Night interiors.* Analyze and diagram the lighting setup in Figure 8.5. Compare and contrast this with the night interiors in Figures 1.3b, 2.20, 2.23c and 8.4b.

48. *Night exteriors.* Analyze and diagram the lighting setups in Figure 9.3. Identify the ways these exteriors are the same as the night interior in Figure 8.5. Identify the ways they are different. .

GLOSSARY

ACE (Adjustable Contrast Enhancement) A process, which shares many of the same features of the CCE, but is also scalable, like its Technicolor cousin, ENR. It was introduced by Deluxe laboratory. In the hierarchy of silver-retention techniques available at Deluxe, the ACE process works where the filmmakers want deep blacks, but still want the colors to look true and have a good level of chroma and texture in the mid-scale regions.

angle of light-incidence Refers to the direction the lighting comes from in a particular setup as referenced to the camera/subject axis. Also called **light source directionality.**

available light Light naturally present at the location. May be ambient daylight or artificial light; for example, the daylight coming into a room from a window, or the neon signs and street lights on a big city street at night.

back light In most general terms, light from the rear of the subject is called back light or back lighting. Back light supplements key and fill lights and models, accentuates, and separates actors and objects from backgrounds. Back light may be further differentiated, depending on the angle it comes from and its effect on the subject (see Figures 2.14 and 2.15).

We use three terms to describe the different types of back light: "back light," "rim light," and "kicker light." "Back light" is light coming from directly behind the subject, usually from above. It is used to highlight hair and separate the subject from the background. See **rim light** and **kicker light.**

background light Illuminates backgrounds relative to key light intensities. Sometimes called **set light.**

background plane The important part of the shot behind the subject. Lighting is controlled by dividing the shot into different planes. The most common are the **subject plane**, the background plane, and the **foreground plane.** Levels for the background are set by putting the incident meter in the lighting on the background, pointing it at the camera and comparing that reading to the one for the subject.

bit scanning The electronic scanning of the smallest unit of information in the digital world. Bit stands for "binary digit."

black value gamma/black gamma The gamma for the black values in the video signal as compared to the gray and white gammas. Black gamma is controlled by adjusting pedestal or black level. Adjusting black level gamma upward is equivalent to flashing film; that is, the IRE value for blacks is raised, effectively reducing the original subject contrast. Besides high-end cameras such as Panacam and Betacam SP camcorders, industrial-quality cameras, like the Sony DXC-327, allow for pedestal/black value adjustment electronically.

bleach bypass A laboratory process that can be applied either to the camera negative or internegative, which includes either the partial or complete skipping of the bleaching function during processing. This results in extreme contrast, deepened blacks, desaturated colors, and increased grain. Several labs have created proprietary bleach-bypass processes that can be applied in varying strengths.

bogus shadow An area where light has not reached; therefore, not truly a shadow (caused by an object obstructing light), but a dark area in the subject where there is no light. Photographically equivalent to a shadow area, the bogus shadow is really a matter of tonal gradation.

brightness range Older term for the range of luminances in the subject, the overall luminance range. We use the term **subject luminance range** in its stead.

cast shadow The standard shadow type that an object or person forms by shutting out light from an area of the shot.

CCE (Color Contrast Enhancement) A scalable process to heighten the film's blacks and add a palpable texture and tonality to the film's look. A proprietary silver-retention process developed by Deluxe Laboratories. Similar to Technicolor's ENR process.

characteristic curve A graph depicting the reaction of an emulsion to light. The cinematographer places the subject luminance range onto the emulsion's characteristic curve when exposing. This recreates the luminances as a corresponding range of density values, first in the negative and subsequently in the print.

cheating Means a slight repositioning of actors, props, and lights for better effect. For example, we might turn an actor so as to obtain a more pleasing facial shadow, or we might move an object slightly for a close-up. Cheating implies the change is not noticeable to the viewer.

color temperature A measurement, expressed in degrees Kelvin (K), that provides color information about a light source. Originally referred to the different hues of metal at increasing temperatures. The lowest numbers are reddish and are described as warmer; the highest numbers are bluish and are described as cooler. Daylight is generally around 5600 degrees Kelvin, while tungsten sources are generally 3200 degrees Kelvin.

compromise exposure Exposing between two readings so as to retain values from both ends of a long subject luminance range. A typical example would be a person sitting in a window. We take a reading for the outdoors (T 16) and for the actor (T 2) and expose about halfway in between, say, T 5.6. Instead of compromise exposures, wherever possible we light the subject so as to reduce the subject luminance range to a manageable amount.

cross-processing In the motion picture lab, when an exposed image shot on Ektachrome film is developed through a color negative process. While Ektacrome was not manufactured to be processed as a negative film, this technique allows you to obtain a negative image on a clear-based original reversal film. The effect on the screen, either by a workprint or video transfer, is usually a higher-contrast and increased-grain image.

cucaloris ("cookie") The name for a flat, patterned object placed between a wall and the set light so as to create a shadow on the wall.

diffuse reflectance or **reflection factor** Most objects reflect a percentage of the light falling onto them. This property of the object is termed its diffuse reflectance.

digital Betacam The component digital tape format which uses the ITU-R 601 standard and then employs discreet cosine transform (DCT) compression at a very low ratio of 1.77:1.

DVCAM A digital video variant introduced by Sony Corporation.

ENR A proprietary silver-retention process developed by Technicolor that employs an additional black-and-white developing bath during color-positive processing to reintroduce silver into the emulsion, rendering a greater degree of contrast and desaturated colors. ENR is an acronym for Ernesto Novelli-Raymond, the Technicolor Roman technician who developed the process for Vittorio Storaro, ASC, AIC.

exposure The placing of the subject's luminance range onto the characteristic curve of the negative in a controlled manner. In more technical terms, exposure is the scientific way to relate **subject luminance range (log E values)** to negative density values and, ultimately, print values.

exposure index (EI) Measures the relative speed by which an emulsion reacts to light. For example, a film with an EI of 200 is twice as fast as one with an EI of 100. By setting the ASA/ISO scale on the light meter, we calibrate the meter to that particular film stock's "speed."

eyelight The light used to create a reflection and give a sense of aliveness to the eyes (see Figure 2.23). The eyelight does not have to illuminate the subject in the exposure sense, just reflect off the eyes. Eyelights are generally of low intensity. Any open-filament bulb will suffice. The eyes are often illuminated by key and fill lights so that a separate eyelight is unnecessary.

facetone placement Refers to where the faces are placed on the characteristic curve in the zone system. A normal placement—called a zone 5 exposure placement—renders black facetones at zone 4, brown facetones at zone 5, and Caucasian facetones at zone 6. Some cinematographers place facetones a zone higher or lower for effect.

facial ratio A synonym for **subject lighting ratio (lighting ratio)**. Used where the subject in question is an actor or actors and the representation of the face is of prime importance.

feel Refers to the emotional, subjective nuances of a shot—the rhythms, textures, colors, and tonal values that cause a viewer to say that the shot has the feel of emptiness, boredom, nostalgia, and the like. Feel goes to the depth of the image, its meaning level.

5600 degrees Kelvin Generally the temperature of daylight on the thermometric scale where absolute zero in degrees Kelvin equals minus 273 degrees Celsius.

fill light The light used to control the degree of blackness in shadow areas particularly of faces (see Figures 1.7 and 3.1–3.2). The key light determines shadow placement. The fill light is used to lighten (fill in) those shadows while avoiding the formation of new shadows. Fill lights are almost always soft, even when keys are hard. This is because the slow fall-off of soft light provides a more natural fill, almost invisible in its effects.

flashing Involves subjecting the emulsion to a low-intensity light in order to lower its contrast. Flashing may occur before normal exposure (preflashing) or after normal exposure (postflashing). There is no on-screen difference. An alternative to lab flashing is the use of a lense-mounted device such as a VariCon.

flying spot scanner A device, such as the Rank Cintel or the Bosch, which provides high-quality transfers of film negatives to videotape. Flying spot scanners transfer the film image line by line to videotape and are superior to film chains. Flying spot scanners are used to release feature films on video and to post music videos shot on film negative.

footcandle Unit of measurement for incident light used by incident meters. Technically the light arriving on a 1-foot square surface as lit by a standard candle at a distance of 1 foot.

footlambert Unit of measurement for reflected light used by spot meters and averaging-type, reflected meters. Technically, the light reflected by an ideal surface (100% diffuse reflectance) lit by 1 footcandle. Reflected and incident light are related as follows: footlamberts = footcandles × reflectance (%).

foreground plane The important part of the shot that lies in front of the subject and is lit separately from the subject (see the discussion under **background plane**). The foreground plane is balanced to the subject by taking an incident reading and then comparing that reading to the one for the subject.

gamma The slope of the straight line on an emulsion's characteristic curve. Mathematically, gamma = difference in density (X_D) divided by difference in log E (X_E). Theoretically, a gamma of 1.0 means the film stock faithfully reproduces the subject's luminance range, or at least the important part of it, by providing a corresponding density range such that increments of X_D and increments of X_E are equal.

gamma compression circuit Device for electronically creating a "shoulder" for a video camera. Effectively extends the log E reproduction range of the video camera by 1 zone to 5½ zones. The circuit compresses two upper zones into one. This flattening of values approximates a film stock's shoulder and gives some of that "film look" to the video signal (see Figure 11.2). Currently, only high-end cameras have this feature.

gray card Refers to the 18%, midgray card used for calibrating light meters so that they yield **zone 5 exposure** readings—that is, the meter places 18% subject reflectances at the mid-density point on the characteristic curve for that emulsion.

gray gamma Gamma setting for gray values in a video camera. Adjusting the gray gamma does not affect black and white extremes but does affect how lower and upper zones are represented. Raising gray gamma from the standard .45 compresses black values slightly and provides more room for highlight values. Lowering gray gamma has the opposite effect. (See Figure 11.6.)

hair light Back and rim light directed at the hair so as to emphasize it. Used often in shampoo commercials and glamour cinematography. There are several types of hair lights (see Figure 2.24).

hard light Descriptive term for direct, high-contrast light from small, intense light sources such as the sun. Hard light is inherently high in contrast and thus gives us very black, sharply defined shadows. Hard light is highly directional and focused as with a spotlight. Direct sunlight, arc lights, and ellipsoidal and Fresneled spots are good hard light sources (see Figure 1.1 and Appendix A, "Lighting and Grip Gear").

high definition television (HDTV) Emerging video technology with greater definition than current systems which attempts to provide a higher-quality video image, one more able to compete with film images. The system uses a widescreen aspect ratio on its television sets.

high-key Descriptive term for a lighting setup that conveys an overall light, bright, cheery mood. The term is used very subjectively (loosely) to stand for an image with mostly gray and white values that does not have a lot of moody shadow areas.

highlight method Exposure method that concentrates on the placement of highlight values. Essentially the same as the **incident method**.

incident light The light that illuminates objects. It may come directly from a light source: the sun, the sky, or a light bulb, or it may be reflected onto an object from other objects. For example, the moon reflects light to the earth; a white wall reflects light around a room. Incident light meters measure the intensity of incident light in units called **footcandles**.

incident (highlight or **keytone) method** The exposure method that arrives at an exposure reading by measuring the light incident upon the subject with an incident meter. The incident meter is designed to reproduce zone 5, midgray, 18% reflectances at the **mid-density point** on the characteristic curve. The incident method ensures constant densities for certain "keytones" (zones 3–7) independent of their context. For this reason, the incident method is also referred to as the **keytone method** since we concentrate on placing certain keytones—faces and 18% midgrays—on the characteristic curve and ignore other subject luminance values, although we take these into account in our lighting. After facetones, we worry about highlight values in film work. The theory of the incident exposure method attempts to ensure safe placements for highlight values, if need be, at the expense of shadow values.

IRE units The scaling on waveform monitors is in IRE (Institute of Radio Engineers) units and, except for 7.5 IRE, is incremented in units of 10. The zero part of the scale is used to adjust the monitor when setting up. Standardized video signals run from black values of 7.5 IRE to white values at 100 IRE units (see Figure 11.4). Luminance values falling lower or higher than those two figures are clipped from the video signal when broadcast.

key light or **key** The key light is the main subject light that sets the tone for the rest of the lighting and establishes how the subject will be represented. As its name implies, the key light, or key, is the most important light source affecting the shot. It establishes the spatial logic and motivation of the lighting and determines the placement of facial shadows and shapes and thus overall image mood. A number of lights may be used to simulate the effects of one key light source.

keytone method The exposure method that emphasizes certain "key" tones for exposure purposes. In cinematography, facetones are of primary importance. The middle zones contain most facetones and are thus pegged or placed on the characteristic curve so as to ensure their optimum reproduction and differentiation. The keytone method thus pegs zones 4, 5, and 6 onto the middle of the character-

istic curve. In theory, the keytone method is identical to the **incident method**, which emphasizes a zone 5 placement as discussed above. To summarize: through exposure we place (peg) the keytone (zone 5) at a predetermined point on the characteristic curve (mid-density point); the remaining zones then fall into place automatically.

keytones The most important zones (keytones) for cinematography. The middle zones (4, 5, and 6) and the highlight zones (7 and 8) are of central importance because they represent most facetones and highlight values.

kicker or **kick light** Used in this book to stand for a particular type of rim light, light from a three-quarter rear position used in conjunction with a three-quarter front key (see Figure 2.16). The term is also commonly used in the United States to stand for **rim light**, the latter being the more common term in England. Kicker is also used to mean a light that selectively highlights a certain portion of the shot, say, a bottle of perfume in a commercial. This type of kicker would not necessarily come from the back positions.

latitude The traditional term for the length of the straight line of the characteristic curve as projected onto the log E axis and measured in log E units. Latitude is the same as **log E range of the straight line** and is discussed more thoroughly there. Latitude is an unfortunate term since it implies there is room for error in exposure, which there isn't except with very low contrast subjects. Latitude has little to do with "permissible error," but rather with the range of log E values translated into density values by the straight line portion of the curve. We shall avoid the term and use "length of the straight line" and "log E range of the straight line" in its place.

length of the straight line The length of the straight line of the characteristic curve as projected onto the log E axis and measured in log E units. Same as **log E range of the straight line** discussed more thoroughly under that heading.

light source directionality Refers to the direction the lighting in a particular setup comes from as referenced to the camera/subject axis. This is usually determined by the placement of the key light. Light source directionality is also called the **angle of light-incidence**. Light source directionality has an important influence on the amount of shadow area in the frame.

lighting Technically, lighting is the creation or control of **subject luminance range**. Exposure is the

relating of that subject luminance range to the emulsion. Aesthetically, lighting is the use of light on the subject so as to create the desired image mood and meaning. These are simple definitions, but it takes the entire book to flesh out their ramifications.

lighting contrast ratio A collective term for the various lighting ratios used in film: subject lighting ratio, subject/background ratio, and subject luminance range. Contrast, the relation between highest value and darkest, is integral to all three ratios. Lighting ratio is often used to stand for what we call subject lighting ratio. This is explained in the text.

lighting ratio The ratio of key light plus fill light to fill light alone.

log E value The logarithmic value of exposure (E) and the scaling used on the horizontal, exposure axis of the characteristic curve. Both zones and T-stops relate simply to the log E axis of the characteristic curve where an increment of .3, the log of 2, is equivalent to a doubling of the exposure given, a doubling of the subject luminance value. Moving from zone 6 to 7 represents an increase of .3 on the log E scale.

log E range of the straight line (latitude) By projecting the straight line portion of the characteristic curve onto the log E axis, we can calculate the amount of luminance range in log E values that the emulsion can handle accurately. This we will refer to as the log E range of the straight line. A typical negative might have a log E range of 2.4, that is, eight increments of .3 log E where each increment amounts to a doubling of the previous value. We use log E range to plan our lighting since the log E range represents the amount of subject luminance range the emulsion can translate into screen densities.

look Refers to the image's surface properties, its particular style. From the look of Almendros's work in *Days of Heaven* to the look of contemporary music videos and commercials, the look of an image—which is instantaneously accessible and confrontable—is fundamental for lighting style.

low-key The opposite of **high-key**. Low-key effects involve shadows and a lot of dark tones with their accompanying mysterious, morose, dark moods. Like high-key, low-key is a subjective term identifying a lighting setup that emphasizes middle and dark tones with only small areas of bright light.

luminance Refers to the actual quantitative measurement a particular subject reflectance gives off under a given amount of illumination as measured in footlamberts. For example, a subject reflectance of 90% will give off 90 footlamberts of light if illuminated by 100 footcandles. Ultimately, the subject to be photographed constitutes a series of luminance values that we must reproduce on the emulsion.

luminous object An object with a photographic luminance value independent of incident light. These are mainly light sources such as fires, light bulbs, neons, fluorescents, candles, and "glowing objects" such as television sets, backlit photographic slides, stained-glass windows, computer terminals, sunsets, sun in fog, and so on. Large areas of brightness within a shot may also be treated as if they were luminous objects. This category includes large windows, stained-glass windows, shower stalls, mirrors, and water reflections. The presence of a luminous object has important consequences for exposure as discussed in the text.

luminance range, *see* **Overall luminance**

magic hour One of nature's gifts to the cinematographer is the lighting available at magic hour, that time of day around twilight or dawn when colors seem iridescent and the world of objects magical. Cinematographers have long exploited this lighting condition as in the exteriors in *Days of Heaven,* an Academy Award winner for cinematography. Magic hour is also routinely used to represent night exteriors, the sky being dark enough for a night effect but with sufficient light intensity for filming.

There are two separate definitions for magic hour. The narrow definition is the time frame from just after sunset until the sky loses its luminosity, a period of about 20–30 minutes varying with the latitude and time of year. The effect is at its peak when car headlights and the lights in office buildings and houses become as bright as the sky. It is common to use glass skyscrapers and large city skylines to enhance the effect (see Color Plates 9 and 10). This definition of magic hour is referenced to the more typical twilight magic hour. Cinematographers using a dawn magic hour would have to define the effect from the opposite direction because at dawn the sky becomes gradually lighter rather than darker.

In the looser, more expansive definition of magic hour, the time frame starts during the warm sunlight of late afternoon, about an hour before sunset, and runs until dark. This definition provides a longer time frame for shooting but a greater range of lighting changes to deal with. This longer magic hour was used in *Days of Heaven* to great effect and is discussed in the *American Cinematographer,* May 1979 issue.

mid-density point If we project the toe and shoulder of the characteristic curve horizontally to the density axis, we obtain two density points for that

emulsion. The mid-density point is halfway between. The incident meter is designed to reproduce zone 5, midgray, 18% reflectances at the mid-density point on the characteristic curve.

midgray The average for all naturally found diffuse reflectances was calculated to be an 18% reflectance by Hurter and Driffield. This is called midgray and is the basis for a zone 5 exposure.

motivated lighting Means that illumination appears to come from a particular light source such as a window, table lamp, or ceiling light. This light source is either in-shot or has been previously identified as present. In some cases, the cinematographer invents a plausible imaginary source based on our shared experience of lighting. Lighting that is not motivated may come from anywhere and tends to be more symbolic as compared to the realism of motivated lighting.

nanometer One-billionth of a meter.

natural light The lighting philosophy that believes we should light shots as they would be found in nature and everyday life. The natural light approach was in vogue during the 1960s and 1970s and was made possible by the introduction of high-speed lenses and faster film emulsions. Philosophically, the natural light approach was a reaction against the glossy, overly fine-tuned studio lighting of the 1940s and 1950s.

normal exposure A zone 5 exposure is the normal exposure in film and results in a faithful reproduction of key middle zones by placing the zone 5 subject luminance at the mid-density point on the characteristic curve. The rest of the zones then progress outward from that key point. Zones that fall onto the toe or shoulder are, of course, distorted.

overall gamma A camera original is but one link in a complete system involving print stock, internegative, processing method, and so on. Overall gamma is the term for linking these disparate elements together. Overall gamma equals the product of the gammas of the individual components in the imaging system.

overall luminance range The same as **subject luminance range**—the ratio of highest significant luminance to the lowest. The overall luminance range of the subject commonly extends to 500:1 or more (see Figure 4.2).

overall useful range The combination of straight line plus toe and shoulder as projected onto the log E axis. The longer the straight line and overall useful range, the larger the subject luminance range that can be translated and the more subtle the visual rendition possible (see Figure 4.8).

overexposure A placing of the subject luminance range too high on the characteristic curve. The result is an untrue subject reproduction with the highlights becoming compressed and the lower tones being lightened to gray. The overall feeling of such a picture is washed-out (see Figures 6.2c and 4.11).

overlighting The tendency to use too much light, particularly fill and rim on actors and overly high intensities on backgrounds, which causes low subject/background ratios. Overlighting destroys the moods inherent in an actual location and inhibits the creation of mood in a studio situation.

partial lighting This is a lighting technique popular in the 1940s and 1950s in *noir*, melodrama, and other dramatic films. The cinematographer shades light from the body to emphasize the face or shades light from the forehead so that it will not draw attention away from the eyes.

pedestal/black value gamma The gamma for the black values in the video signal. Black gamma should be distinguished from gray gamma and white gamma. Black gamma is controlled by adjusting pedestal or black level. Adjusting black level gamma upward is equivalent to flashing film; that is, the IRE value for blacks is raised, effectively reducing the original subject contrast. Besides high-end cameras such as Panacam and Betacam SP camcorders, industrial-quality cameras, like the Sony DXC-327, allow for pedestal/black value gamma adjustment electronically.

pixels Short for picture element. Light sensitive picture elements, the smallest unit of visual information in a recorded image. The storage of images in a digital system is achieved by sampling the pixels in the source material.

placing (pegging) facetones Refers to the **incident method** for exposure and its emphasis on placement of the middle zones. The normal facetone placement in film results from a **zone 5 exposure**, which renders black facetones at zone 4, brown facetones at zone 5, and Caucasian facetones at zone 6.

practicals Refers to in-shot light sources such as a table lamp, a candle, or a light bulb. Practicals are used to establish motivation for the lighting setup and as props, but generally are not used to light actors.

prelighting A common technique in feature films. It refers to a gaffing crew lighting an upcoming location or set while filming is going on at a previously lit location.

printing contrast The best prints are obtainable when the negative gamma is around .6–.7. An emulsion with a gamma in this range is said to have printing contrast since that emulsion is designed for printing rather than projecting. These stocks are low contrast since their density increments X_D are less than their plotted X_E values.

progressive scanning An alternative to interlace scanning, whereby each video line is scanned sequentially, or drawn progressively, resulting in the viewable image. Progressive scanning provides better rendition of motion and is better adapted for transfer to film.

projection contrast The most acceptable on-screen images come from prints with gammas in the range of 1.6 to 1.8. This is known as projection contrast. This gamma range is reduced by projector flare, screen reflectance, and ambient light to near the ideal 1.4 by the time it is on the screen.

proportional density differences On the negative, the straight line assigns a density difference to a given log E increment. These need not be equal but do have to be proportional for the film to provide a replica of reality on the screen.

pulling T-stop Involves moving the T-stop ring while filming. It is similar to a focus pull but much harder to hide.

push and pull development Push development extends the development time relative to the specified standard, and pull development decreases development time. These techniques are used to change overall image look or to compensate for exposure conditions. Push and pull development is one kind of emulsion test used to determine "look" possibilities. Other techniques include such manipulations as overexposing and underprinting or underexposing and overprinting, both with standard development.

reference black A black subject value inserted into light-toned, low-contrast film images to prevent their being automatically darkened when broadcast over television.

reference white A white subject tone inserted into dark-toned, low-contrast film images destined for television. Without a reference white the television system will boost the brightest subject luminance to a white level and alter the mood of the film image.

reflectance (reflection factor) The same as **diffuse reflectance**. Most objects reflect only a percentage of the light falling onto them. This property of the object is termed its diffuse reflectance or reflection factor. We say a white object has a reflectance of 90%, a black object a reflectance of 4%, and so forth.

reflected light Light is reflected to the eye from objects. Reflected light is the light we see and the light we use to expose film. The light reflected by an object is measured by a reflected light meter in units called **footlamberts**.

reflected method The exposure method that uses the light reflected from the subject to determine an exposure setting. This is in contrast to the **incident method**. The reflected light meter, like the incident meter, is designed to reproduce an 18% reflectance at a mid-density point on the characteristic curve. The difference is, the reflected meter assumes that what it is measuring is always a zone 5 value even when it is not. This means the user has to make an adjustment to the indicated reading to arrive at a "correct" exposure.

Rembrandt effect A standard film lighting technique derived from some of Rembrandt's paintings. A three-quarter front key is used to create the familiar triangle-shaped patch of light on the shadow side of the face. Fill and a kicker are added to arrive at the standard three-point lighting effect, which also utilizes a chiaroscuro, light and shadow, patterning (see Figure 2.16).

rim light Angled light from the rear that rims or outlines all or part of the subject. Rims are used to create on hair and edges of cheeks the highlights to which we have become accustomed. Rims supplement key and fill lights and, like back light, model, accentuate, and separate actors and objects from backgrounds.

Some authors use the term kicker for this light. Still others call it a back light, but we shall use the term rim, which emphasizes the effect and allows for more than one of these lights in a particular setup (see Figures 2.14 and 2.15).

roughing in The establishment of a tentative, initial lighting setup that will be perfected when the actor positions are finalized and the camera position determined.

roving fill Used with tracking and dollying shots. The light is mounted on the camera or dolly or carried by a grip. The idea is that wherever the camera goes, the fill will follow. Referred to as a basher or Obie when mounted on the camera and used as a general fill for any shot.

semisilhouette A person about two stops underexposed usually foregrounded against a light-toned background. Similar to a silhouette except the actor is not completely black.

set light A light used to illuminate parts of the set, usually a background. Same as a **background light**.

shadow projection device A special spotlight designed to project a variety of shadow patterns onto walls, for example, venetian blind shadows familiar in the *noir* style.

shoulder The part of the characteristic curve where the straight line ends and where subsequent exposure yields a nonproportional response that distorts luminance values.

side key A key light that comes from the side of the camera/subject axis. A camera-level side key on a frontal face is a classic lighting setup. The lighting divides the face in half with a vertical shadow (see Figure 2.6).

silhouette Lighting a white background five or more stops brighter than the subject and exposing for the background results in the familiar black outline against a white background.

soft light Light is soft when its shadows have indistinct edges and result from a gradual fall-off of light. Soft light is lower in contrast than hard light and consequently has lighter, more gray shadows. Soft light is less directional than hard light and is often called omnidirectional, or "directionless." Large light sources that are heavily diffused, bounced, reflected, or filtered yield light which is soft in quality. Examples are: the painter's north light—reflected sky light such as in a Vermeer interior—the shadows under a tree, a gray overcast sky, floodlights, and bounced lights (see Figure 1.1).

specialized lights General term for lights having specialized functions such as eyelights and hair lights. Generally used to fine-tune the lighting setup.

spot meter A special type of reflected light meter that measures the light coming from a very narrow angle of view.

straight line The part of the characteristic curve where log E differences are given proportional differences on the density axis. Luminances placed on (pegged to) the straight line will be accurately represented on the screen.

subject/background ratio Subject/background ratio refers to the difference in lighting intensity expressed as a ratio between the subject plane and other planes, principally the background plane.

subject lighting ratio (lighting ratio) The ratio between the light and shadow sides of a subject created by the key and fill light. Two technical definitions are used: (1) key + fill/fill, (2) key/fill. The subject lighting ratio impacts on the overall mood of the image. Subject lighting ratio will sometimes be referred to as the **facial ratio** where the subject in question is an actor or actors and the representation of the face is important.

subject luminance range The range of luminances in the subject, from the highest significant luminance to the lowest. This is also called **overall luminance range**, or sometimes, brightness range (see Figure 4.2).

subject plane Since we light in planes, the main subject area, the subject plane, is usually the most important plane for lighting purposes since actors are generally the most important part of the shot. Other key planes are the **background plane** and the **foreground plane**.

three-point lighting The triple combination of three-quarter front key, fill, and kicker (three-quarter rim) applied to an actor forms a lighting triangle called three-point lighting (see Figure 2.16). The term is also used to refer to any combination of key, fill, and back light.

three-quarter front key The favored position for the key in classic Hollywood-style lighting. It comes from above at a 45-degree angle and creates the familiar triangle-shaped patch of light on the shadow side of the face (see Figure 2.5).

three-quarter rear key The back side version of the three-quarter front key. The three-quarter rear key is a very dramatic, moody key often used for night exteriors. It works best using a hard light source with a *film noir* or melodrama lighting scheme (see Figure 2.8).

3200 degrees Kelvin Generally the color temperature of tungsten sources.

toe The lower part of the characteristic curve where dark values fall. Like the shoulder, the toe distorts subject luminance relationships but is nevertheless useful in translating those luminances into on-screen differentiations.

T-stops Calibration of the lens light-transmitting power arrived at by measuring the transmitted light for each lens and each stop individually. Considered to be more accurate than f-stops.

24p HD Video 24p is a format that has 24 frames per second and is progressive in nature. 24p HD Video uses the 24p format in High Definition Video. In HDTV, in the television broadcast industry, it refers to 1920 pixels by 1080 rows progressively scanned at 24fps, with an aspect ratio of 16:9.

underexposure Represents a placement of the subject too low on the characteristic curve with an accompanying lack of separation in the dark tones and a loss of the white end of the scale. The overall impression of underexposure is dark, dreary, and murky (see Figure 4.12a).

variCon Lense-mounted device for flashing when shooting. The effect reduces contrast by lightening black subject values and may be monitored through the viewfinder.

waveform monitor The waveform monitor is an electronic means for measuring the video signal. In essence, it provides an accurate series of spot meter readings for the entire video signal. Where there is a highlight value, the waveform monitor gives a high reading, and vice versa for a low value (see Figure 11.3). The scaling on waveform monitors is in **IRE** (Institute of Radio Engineers) **units** and, except for 7.5 IRE, is incremented in units of 10.

white value gamma The gamma in the video signal applied to highlight values. Controlled by adjusting white level or through gamma compression. White value or highlight gamma is adjusted automatically by circuits built into the camera, for example, the gamma compression circuits in a Panacam, but where those circuits start to take effect is adjustable (see Figure 11.2). Utilizing the gain circuitry to boost exposure index also affects white value gamma by giving it a higher value. This causes other image deteriorations, however.

zone 5 exposure The incident meter is designed to reproduce zone 5, midgray, 18% reflectances at the mid-density point on the characteristic curve. This is called a zone 5 exposure. Exposing for (pegging) zone 5 places the other two middle zones, 4 and 6, highlight zones 7 and 8, and lower values 2 and 3, at their respective density points (see Figure 4.10). A zone 5 exposure renders black facetones at zone 4, brown facetones at zone 5, and Caucasian facetones at zone 6. Also see **mid-density point**, **midgray**, **reflectance**, and **zone system**.

zone range of the straight line The number of zones the straight line of the negative can accommodate. To calculate this, divide the log E range of the straight line by .3. For example, if a color negative has a straight line of 1.5 log E, it has a five-zone range (1.5 divided by .3 = 5). If a color negative has an overall range of 2.4 log E, this is equivalent to an eight-zone overall range.

zone system The 11 steps or zones of the gray scale form the basis for the zone system as devised by photographer Ansel Adams. The gray scale, which can be applied to both subject luminances and density values on the negative, is ultimately viewed as screen values. Figure 4.1 describes the typical contents of each zone. Since each zone of the gray scale represents a .3 log E, it is simple to correlate zones to the characteristic curve. The 11 zones are represented on the negative as indicated in Figures 4.3, 4.5, 4.8, and 4.9.

SELECTED BIBLIOGRAPHY

ADAMS, ANSEL. *The Negative*. Boston: Little, Brown, 1981.

ALMENDROS, NESTOR. *A Man with a Camera*. New York: Farrar Straus Giroux, 1986.

ALTON, JOHN. *Painting with Light*. New York: Macmillan, 1949.

AMERICAN SOCIETY OF CINEMATOGRAPHERS. *American Cinematographer Magazine*. Hollywood: ASC Holding Corp. Current.

ARNHEIM, RUDOLF. *Art and Visual Perception: A Psychology of the Creative Eye*. Berkeley: University of California Press, 1974.

ASCHER, STEVEN and PINCUS, EDWARD. *The Filmmaker's Handbook: A Comprehensive Guide For The Digital Age*. New York: Penguin Putnam, Inc., 1993.

BEACHAM, FRANK. *American Cinematographer Video Manual*. Hollywood: American Society of Cinematographers Press, 1994.

BERGERY, BENJAMIN. *Reflections: Twenty-One Cinematographers at Work*. Hollywood: The American Society of Cinematographers, 2002.

BOX, H. *Set Lighting Technician's Handbook,* 3rd ed. Boston: Focal Press, 2003.

BROWN, BLAIN. *Motion Picture and Video Lighting,* rev. ed. Boston: Focal Press, 1996.

BROWN, BLAIN. *Cinematography*. Boston: Focal Press, 2002.

CAMPBELL, RUSSELL, ed. *Photographic Theory for the Motion Picture Cameraman*. New York: A. S. Barnes, 1981.

———. *Practical Motion Picture Photography*. New York: A. S. Barnes, 1979.

CARLSON, VERNE, and CARLSON, SYLVIA. *Professional Lighting Cameraman's Handbook*. rev. ed. Boston: Focal Press, 1994.

CLARKE, CHARLES G. *Professional Cinematography*. 2nd ed. Hollywood: American Society of Cinematographers, 1968.

COURTER, PHILIP R. *The Filmmaker's Craft: 16mm Cinematography*. New York: Van Nostrand Reinhold, 1982.

DAVIS, PHIL. *Photography*. 6th ed. Dubuque, Iowa: Wm. C. Brown, 1990.

DUNN, J. F. and WAKEFIELD, G. L. *Exposure Manual*. 3rd ed. Kings Langley, England: Fountain Press, 1981.

EASTMAN KODAK COMPANY. *Eastman Professional Motion Picture Films*. Rochester, New York: Eastman Kodak, Co., 1992.

———. *Student Filmmaker's Handbook*. Rochester, New York: Eastman Kodak, Co., 1996.

EISENSTEIN, SERGEI. *Film Form: Essays in Film Theory*. New York: Harcourt Brace Jovanovich, 1969.

———. *The Film Sense*. rev. ed. New York: Harcourt Brace Jovanovich, 1969.

ETTEDQUI, PETER. *Cinematography*. Boston: Focal Press, 1999.

GILLETTE, J. MICHAEL. *Designing with Light: An Introduction to Stage Lighting*. 2nd ed. Mountain View, CA: Mayfield, 1989.

HAPPÉ, L. BERNARD. *Your Film and the Lab*. 2nd ed. Boston: Focal Press, 1983.

HAUSMAN, CARL and PALOMBO, PHILIP J. *Modern Video Production: Tools, Techniques, Applications*. New York: HarperCollins College Publishers, 1993.

HIRSHFELD, GERALD. *Image Control: Motion Picture and Video Camera Filters and Lab Techniques.* Boston: Focal Press, 1993.

HUMMEL, ROB, ed. *American Cinematographers Manual.* Hollywood: American Society of Cinematographers Press, 2001.

KALLENBERGER, RICHARD and CVJETNICANIN, GEORGE. *Film Into Video: A Guide to Merging the Technologies.* Boston: Focal Press, 1994.

LASZLO, ANDREW and QUICKE, ANDREW. *Every Frame a Rembrandt: Art and Practice of Cinematography.* Boston: Focal Press, 2000.

MALKIEWICZ, KRIS J. *Cinematography: A Guide for Film Makers and Film Teachers.* New York: Simon & Schuster, 1992.

————. *Film Lighting: Talk With Hollywood's Cinematographers and Gaffers.* New York: Prentice Hall, 1999.

MATHIAS, HARRY and PATTERSON, RICHARD. *Electronic Cinematography: Achieving Photographic Control over the Video Image.* Belmont, CA: Wadsworth, 1985.

MCDONOUGH, TOM. *Light Years.* New York: Grove Press, 1987.

MILLERSON, GERALD. *Lighting for TV and Film,* 3rd ed. Boston: Focal Press, 1999.

NURNBERG, WALTER. *Lighting for Photography: Means and Methods.* 16th ed. Philadelphia: Chilton Book Company, 1968.

————. *Lighting for Portraiture: Technique and Application.* 7th ed. Philadelphia: Chilton Book Company, 1969.

OHANIAN, THOMAS A. and PHILLIPS, MICHAEL E. *Digital Filmmaking: The Changing Art and Craft of Making Motion Pictures,* 2nd ed. Boston: Focal Press, 2000.

PALMER, RICHARD H. *The Lighting Art: The Aesthetics of Stage Lighting Design.* Englewood Cliffs, NJ: Prentice Hall, 1985.

POYNTON, CHARLES. *A Technical Introduction to Digital Video.* New York: John Wiley and Sons, 1996.

RAY, SIDNEY F., ed. *Photographic Lens and Optics.* Boston: Focal Press, 1994.

RITSKO, ALAN J. *Lighting for Location Motion Pictures.* New York: Van Nostrand Reinhold, 1979.

ROGERS, PAULINE. *More Contemporary Cinematographers on Their Art.* Boston: Focal Press, 2000.

RYAN, ROD, ed. *American Cinematographers Manual.* Hollywood: American Society of Cinematographers Press, 1993.

SALT, BARRY. *Film Style and Technology: History and Analysis.* London: Starwood, 1983.

SAMUELSON, DAVID W. *Hands-on Manual for Cinematographers.* Boston: Focal Press, 1998.

————. *Motion Picture Camera & Lighting Equipment.* Boston: Focal Press, 1986.

————. *Motion Picture Camera Techniques.* Boston: Focal Press, 1984.

————. *Panaflex User's Manual.* Boston: Focal Press, 1996.

SCHAEFER, DENNIS and SALVATO, LARRY. *Masters of Light: Conversations with Contemporary Cinematographers.* Berkeley: University of California Press, 1984.

SPOTTISWOODE, RAYMOND, ed. *Focal Encyclopedia of Film & Television Techniques.* Boston: Focal Press, 1969.

STERLING, ANNA KATE. *Cinematographers on the Art and Craft of Cinematography.* Metuchen, NJ: Scarecrow Press, 1987.

UVA, MICHAEL G. *UVA's Basic Grip Book.* Boston: Focal Press, 2001.

VON STERNBERG, JOSEF. *Fun in a Chinese Laundry: An Autobiography.* New York: Macmillan, 1973.

WARD, PETER. *Basic Betacam Camerawork,* 3rd ed. Boston: Focal Press, 2001.

————. *Digital Video Camerawork.* Boston: Focal Press, 2000.

WHEELER, LESLIE. *Principles of Cinematography.* London: Fountain Press, 1965.

WHEELER, PAUL. *Digital Cinematography.* Boston: Focal Press, 2001.

————. *High Definition and 24p Cinematography.* Boston: Focal Press, 2003.

————. *Practical Cinematography.* Boston: Focal Press, 2001.

YOUNG, FREDDIE and PETZOLD, PAUL. *The Work of the Motion Picture Cameraman.* New York: Hastings House, 1972.

ZETTL, HERBERT. *Sight/Sound/Motion: Applied Media Aesthetics.* 4th ed. Belmont, CA: Wadsworth, 2005.

————. *Television Production Handbook,* 8th ed. Belmont, CA: Wadsworth, 2003.

CREDITS

Demonstration photos in this edition that appeared in the previous edition are by Dave Viera. Demonstration photos new to this edition are by Patrick Van Osta with lighting by Kevin O'Brien.

Chapters opening photos:
Chapter One, page 3, Dave Viera
Chapter Two, page 17, Patrick Van Osta
Chapter Three, page 43, Maria Viera
Chapter Four, page 53, Patrick Van Osta, with lighting by Kevin O'Brien
Chapter Five, page 69, Patrick Van Osta
Chapter Six, page 79, Dave Viera
Chapter Seven, page 101, Patrick Van Osta
Chapter Eight, page 119, Dave Viera
Chapter Nine, page 135, Patrick Van Osta
Chapter Ten, page 145, Patrick Van Osta
Chapter Eleven, page 155, Patrick Van Osta, with lighting by Kevin O'Brien
Chapter Twelve, page Patrick Van Osta
Chapter Thirteen, page 185, Maria Viera
Chapter Fourteen, page 193, Dave Viera

Other images:
Figure 1.7, pages 11, 228: *Blonde Venus,* © 1932 Paramount Publix Corporation. Courtesy of Universal Studios Licensing LLLP.

Figure 1.8, page 12, James Naismith
Figure 2.15c, page 30, *8½,* Corinth Films, Inc.
Figure 2.19, pages 33, 220, *8½,* Corinth Films, Inc.
Figure 2.20, pages 34, 223, *The Third Man,* Studio Canal Image
Figure 2.21, pages 34, 224, *8½,* Corinth Films, Inc.
Figure 2.23c, pages 37, 229, *8½,* Corinth Films, Inc.
Figure 4.12, pages 63, 230, *The Third Man,* Studio Canal Image
Figure 4.14, page 65, Kodak published curve for Kodak Vision 200T, 7274, Image Courtesy © Eastman Kodak Company. KODAK is a trademark.
Figure 6.4c, page 84, Rafael Zepeda
Figure 6.8, pages 91, 238, *8½,* Corinth Films, Inc.
Figure 7.1b, page 106, *Raggedy Man,* ©1981 Universal Pictures. Courtesy of Universal Studios Licensing LLLP.
Figure 7.1c, page 106, *8½,* Corinth Films, Inc.
Figure 7.1d, page 107, *A Touch of Evil,* © 1958 Universal Pictures. Courtesy of Universal Studios Licensing LLLP.
Figure 8.5, page 132, *The Third Man,* Studio Canal Image
Figure 9.3a, page 142, *8½,* Corinth Films, Inc.
Figure 9.3b, page 142, *The Third Man,* Studio Canal Image

INDEX

265